Wilderness Dreaming

To my long-suffering wife, Claire

Wilderness Dreaming

Memoir of a Wildlife Photographer

Greg du Toit

HPH Publishing

First edition, first impression 2022
Published by **HPH Publishing**
50A Sixth Street, Linden, Johannesburg,
2195, South Africa

www.hphpublishing.co.za
info@hphpublishing.co.za

Copyright © 2022 by **HPH Publishing**
First Edition
ISBN 978-1-77632-325-8
Edited by Alison Lowry
Publisher: Heinrich van den Berg
Proofread by Jane Bowman
Design, typesetting and reproduction by Heinrich van den Berg and Nicky Wenhold
Cover painting by Peter Gray
Printed by novus print, a division of Novus Holdings

Photography and text by Greg du Toit
Copyright © Greg du Toit

'The rollicking life of one of Africa's finest wildlife photographers.'
Tiara Walters, Daily Maverick

CONTENTS

PART TWO: NOT WITHOUT MY CAMERA

PART THREE: NOT WITHOUT MY LIONS

Maps

From Hluhluwe to Mashatu (Southern Africa)

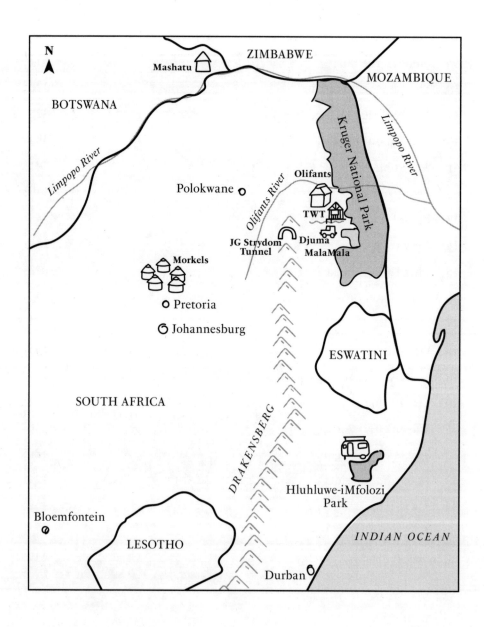

Southern Kenya

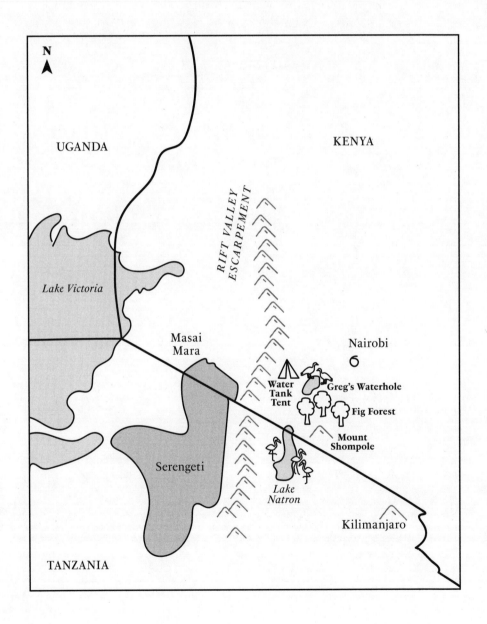

Author's note

I am an African wildlife photographer and this is my story. My journey, like most taken in Africa, has been a zigzagging one. Thankfully, it was only when looking back and recording my memories that I suffered from a sense of vertigo. As you will soon discover, my life has not been a planned and plotted set of waypoints. My Africa wanderings have been more filled with mishaps and misadventures than I would have wanted to consider at the outset and I am reminded of something apt a magistrate once said to me and this is that 'fact is stranger than fiction'! The only aspect on this wild ride that I take credit for is in always clinging to my passion for the bushveld.

Along my path have come characters (whom you will soon meet) who happen to be of the utmost storybook variety. At times, and to remain discreet, some names have been changed, although most of the time real names are used for both people and places. All the events in this book really took place. When I sat down to record my memories, I did so with two things front of mind. The first was Africa. This colourful continent, filled with its incredible wildlife and people, is the reason that I have such wonderful memories to share. My life (and therefore this memoir) is simply my love affair with Africa. The second thing on my mind when writing this book was you! You are the passenger in my VW Beetle alongside me, going through the ups and downs of my life in Africa. You are meeting and getting to know the same people and animals I did. You are running away from buffalo, collecting dung beetles, speaking to wild animals, dealing with self-professing rednecks, sitting in a waterhole and being stalked by lions. You are experiencing my Africa and we are searching for the lost Africa together. Buckle up and enjoy the ride ... and please do excuse the smell of rotting giraffe bones!

Prologue

The human mind is remarkable.

In what I am certain are the final moments of my life, my mind draws me out of my body – out from the perilous situation I am in. Perhaps I am on my way to heaven and God is simply sparing me the pain of experiencing being torn apart? But no, all of a sudden my vertical travel stops – abruptly. It seems the lift has gotten stuck on its way up and has left me suspended, looking down at myself and my current precarious position, sitting in a waterhole, fearing for my life. Twelve months and 270 hours have culminated in this moment.

Like Superman stuck to a flytrap, I hover above my waterhole. Arms outstretched and my legs spread-eagled, I watch my desperate attempt to escape being prey play out below me.

Gazing down, I see the Great Rift Valley sprawled across Africa. In its vastness my waterhole is a mere puddle, with a barely perceptible dot in the middle of it. That dot is me. I am all alone and suffering the close attention of two lionesses, whose flattened ears and twitching tails speak volumes. Is this how it all ends, before it has even properly begun?

There is no time to answer this question because now the showreel of my life has started playing. The scenes it chooses are intriguing. I have heard of the proverbial 'life flashing before your eyes' event, which is supposed to take place in the moments preceding death, but it is strange to actually be in that cinema. Like an old black and white Charlie Chaplin movie, there is no sound, just moving visuals. These vignettes of my life, although detailed, strangely do not include what I would have thought might be 'package highlights': like the fact that I have had malaria six times or that an elephant bull once nearly trampled me in front of my wife. Surely almost having my throat slit on top of a sacred mountain in northern Kenya should qualify as a significant event? Or what about paddling down the Zambezi River and having a gigantic crocodile nearly land in my canoe?

While these experiences seem to be missing from my biopic, other less significant ones are present: like the time I was standing dripping wet and

being electrocuted by a fence designed to keep elephants out of our camp (if having 8 000 volts flow through your body can be 'less significant', that is). As the story of my life unfolds, I wonder if the final instalment will include the worm living inside my foot or the fly maggots hatching out of my back ...

Getting to watch the story of your life is a rare privilege, even if you are about to die. It should not bother me that the director has created a showreel that only captures a sample of the dangerous sequences of my human existence. This is, after all, not a blockbuster Hollywood trailer; it is the intense and personal telling of my own life. I am the only one in the audience. It is a private screening. Yes, some of the dangerous highlights are included but what amazes me more are the finer details, and how far back these stretch. Moments of seeming insignificance from my youth flash in front of me, or more accurately, below me. These insignificant flashes are now the very significant milestones of my life. It seems appropriate to get philosophical. What better time is there to get philosophical than when you are suspended in mid-air, watching yourself about to be ripped apart by lions?

As the movie plays on, I see myself sitting in high school watching *Dead Poets Society*. The motto 'carpe diem' has been a central theme in my life ever since. Any professional wildlife photographer will tell you their career depends upon just that. It is in fact the pursuit of a photograph that has landed me in my current state of zero gravity. Come to think of it, a photograph is but a moment suspended in time – much like I find myself in this one, suspended above my waterhole. Seeing my body flailing in the mud below, the two lionesses, crouching like coiled springs, watching my every move, I wonder if I have really, truly carpe diem-ed? Not just for my chosen profession of wildlife photography, I mean, but have I lived, really lived? Was I fully present and alive in those moments that are now flashing past my eyes?

It is nearly dark and with no help in sight and my life hanging in the balance, the movie reel speeds up. It spins at a furious rate, the pictures flashing, illustrating my colourful life but without colour – in black and white only, and with short, jerky movements on my part. Flashing, squiggly lines dance about like the worms of time. I am the Charlie Chaplin in my own story, except that I have never worn a moustache and there is nothing funny about this situation.

PART ONE:

NOT WITHOUT MY BINOCULARS

1

The Du Toit family and other animals

Although the movie reel is flashing scenes only from my own life, if I had a metaphorical remote control in my hand I would rewind the movie 11 generations – back to the late 1600s and the arrival in Africa of the first Du Toits. Each generation of my family since has lived on this continent that is an intoxicating mix of mystery, beauty, danger – and just general craziness. Arriving on a ship aptly called *De Vrijheid* (The Liberty), fleeing France under religious persecution, and avoiding being burned at the stake, the original two Du Toit brothers were among the first Huguenots to arrive on the very tip of the continent. François, from whom I am a direct descendant, was a winemaker and, perhaps because of this, was an influential man in early Cape society.

The Huguenots owned large farms set between the stunning folded mountains in the fair Cape and life was good for them – that is until the British arrived a century later. My Du Toit ancestors must at some stage have been among those who undertook the epic expeditions into the hinterland, known in the history books as the Great Trek, to find a different life for themselves beyond the reach of British rule. With fully laden oxwagons the Voortrekkers, as these pioneer travellers were known, followed ancient elephant paths over and around the mountains, disassembling their wagons to do so, before penetrating the deep heart of South Africa.

Back in those days the entire continent teemed with game, big and small. Of all the Du Toit generations, I am sorry that I missed that generation and was not born in that time of great adventure. Seeing in a new millennium, which was my privilege as a Du Toit born in the 1970s, was hardly as epic as my ancestors' early travel. And somehow dealing with the Y2K bug and the Covid-19 pandemic have not been as exciting as fending off wild animals while camped in a laager. To my early ancestors, life beyond the year 2000 would have been utterly unfathomable, with the marvel of

the internet and Google Maps far beyond their imagination. I mean, they could have just ubered to the interior!

The Voortrekkers, however, had only the most rudimentary of maps, if any, and no way of knowing how far they had really travelled. It is said that when some of them reached an area with large, almost triangular-shaped hills, or koppies, with a river flowing close by, they thought they were in Egypt. They even gave the name Nyl to the river, thinking it was the Nile. In reality they were only 135 kilometres north of what today is Tshwane (formerly Pretoria), the administrative capital city of South Africa. But let's give the Voortrekkers their due: it is still a good distance from the Cape, especially by oxwagon. My ancestors must have disliked the thought of living in Egypt and they must have turned around, because I was born in Pretoria.

I grew up not on a farm like most of my more recent ancestors from Worcester, but in a decidedly suburban setting. We had no vineyards in our garden and we rarely even drank wine. My dad was a beer man – a Lion Lager man, to be exact. I was just a regular boy, like many others in those days. I watched *The A-Team* and rode my BMX bicycle with my brother Clive, who was three years younger than me, and the other neighbourhood boys. It was only many years later, as an adult, that I came to realise that I grew up in a dark, pre-democracy period in South African history, where violence, insurrection and repression were the order of the day. My primary school even had a bomb squad. This was not a professional bomb squad but rather a group of schoolboys, my classmates, who had been selected to walk the school grounds each morning with walkie-talkies, looking for concealed or suspicious packages. They would check the dustbins and report any foreign objects. I say 'they' because I was not a member. In fact I was very jealous of the 'bomb squad boys', all of whom got to use walkie-talkies like MacGyver.

At home we spoke English, which was strange as 'Du Toit' is actually a very Afrikaans surname in South Africa. My grandad had done a short stint working overseas in London, which saw my dad educated early on in English; upon returning to South Africa, he was duly sent to English-medium schools. Despite being 'English-speaking Du Toits', a thorough cultural oxymoron, bordering even on a skandaal, Afrikaans was a

compulsory subject at school for me. The original Du Toits, the ones who actually lived in France, went by a different surname altogether until they hid the king of France in their attic and saved his life. The king changed their name to Du Toit, meaning 'of the roof', and so our family name was changed forever, and we were made nobility in France. I am not totally convinced this is historically correct, but it sounds impressive.

Africa is a lot of things but one thing it is not is boring. In fact it is the complete opposite of boring. Perhaps one could even say that life in Africa is bipolar in nature. By this I mean to say that life here is either incredibly wonderful or incredibly terrible, but never boring. Often you will experience both extremes of this 'incredibleness' in the same day. Life here can seldom be described as 'just okay'. It is either spectacular, unbelievably good, beautiful and wonderful or it is utterly crazy, corrupt, mad and bad. There is very little in between. Perhaps this lack of a middle ground is what makes living here so addictive.

Whether I am walking in the bush, keeping a look-out for lions, elephant and/or buffalo, or whether I go out to buy milk and bread at my local supermarket, I am taking my life in my hands. Living in Johannesburg, performing the most ordinary of errands on any given day means that I will have to dodge hurtling minibus taxis, appease beggars, make sure my car doors are locked, and cling onto my wallet. At traffic lights, called robots here, I have to watch out for potential hijackers, keeping my car idling in neutral gear and with enough space between my bumper and the car in front of me so that I can race away without stalling if a situation arises. When I finally make it to the supermarket and I lock my car, I need to check that it is in fact locked as it is common practice for thieves to use remote jammers.

Every day lived and survived in Africa is a victory. We live on the edge. We live on adrenalin. The most mundane of tasks, like successfully renewing a driver's licence or getting a passport, becomes a victory. Heck, just having electricity and water is a good start to any day. You could say Africa

is a place where one survives, not exists. But surviving is much more interesting than existing, surely? Surviving is a form of living. I am acutely aware that whether I am in the bush on safari or at home in suburbia, my life could change in an instant. This motivates me to live in the moment. And everything does, after all, boil down to just a moment. My life – and yours – is nothing more than a series of moments, spread across the days, months, years and decades of our existence.

My life has therefore seldom been boring. This wonderful continent would never allow for it. When the early explorers came to Africa's eastern shores, they were soon dubbed 'wazungus', a Swahili word of Bantu origin meaning 'someone who roams around'. In search of the river Nile, many explorers literally walked in circles and this did not go unnoticed by the locals. The explorer or 'mzungu' gene must still linger in my being as I have done my fair share of 'roaming around' this great continent. Perhaps I am an 'African mzungu'? I don't mind what you call me really, but this Du Toit would like it to have the word Africa in it.

2

Obsessed with birds

There was no Great Trek for me to be part of and there has been no enemy as clearly defined for me as the colonial British or the warring Zulu impis. I have not had the privilege of following old elephant paths into a land not yet recorded on a map and I have not galloped across Africa on horseback, like my ancestors did when fighting in the Anglo Boer wars.

In fact I can't even ride a horse very well, yet flowing in my veins is the same blood of the pioneering stock that brought my family to Africa all those centuries ago. I have had the dubious task of carrying this gene into a new millennium, something that, as I mentioned earlier, was probably unimaginable to my Voortrekker ancestors, who were not convinced that life existed beyond tomorrow, let alone beyond 2000 – the name of another popular TV show when I was growing up in the 1980s. I must say that looking at the cup of steaming coffee next to me as I write this memoir, I am surprised that I had to pour it myself and that there is not a robot doing it for me.

I grew up in a traditional white South African home in a leafy suburb in the east of Pretoria in a house that retained some Cape Dutch echoes in its architecture. It had a red-tiled stoep flanked by white circular pillars, creaky wooden floorboards and white pressed-steel ceilings with extravagant floral designs. We spent most of our leisure time on the stoep or, in summer, standing around the braai and cooling off in the swimming pool after slices of sweet, pink watermelon. Most importantly to me, as a young boy, was that our back yard was full of big trees and birds.

The best thing about the house was its zinc roof. A highveld thunderstorm is a spectacular event, but having a tin roof makes it so much bigger and better. Standing at the lounge window, I would watch as the sky turned from a light grey to a sinister dark black in a matter of minutes. The ominous cumulonimbus clouds mushroomed high into the heavens, swollen

and pregnant with the deluge they carried. It was silent, dead silent, in an eerie kind of way. The birds had already retreated to the boughs of trees and fallen still as they clung tightly onto the branches, as if they knew what was coming. Even the barking neighbourhood dogs fell silent.

Swoosh, swoosh, swoosh. Each gust caused even the biggest trees in our garden to sway backwards and forwards in a slow, rocking motion. The thunder, at first a distant rumbling, soon grew louder and louder until finally the first raindrops fell from the heavens, like the first bombs being dropped in battle. The raindrops in Africa are gigantic and each one splattered on the roof's zinc sheeting with an audible rattle. With the thunder soon on top of us, the deep rumbling caused the wooden floorboards to shake. The pitter-patter of raindrops grew in crescendo until one could not hear oneself speak.

The rain beat down on the roof with a deafening flurry and fell in torrents on the garden. Flash-flooding was no more evident than in the swimming pool, which was transformed into a boiling jacuzzi, the water level rising by the minute. The slamming of raindrops turned into a more violent thudding sound, as golf ball-sized hailstones rained down, sounding like someone was playing African drums on our roof. I watched the hailstones bouncing in the back garden as if dancing to the rhythm of the drumbeat above. The only sound that could be heard above the deafening drumming of the hailstones pounding the zinc sheeting was the house's earth leakage switch as it tripped, snapping down in protest against the flashing bolts of lightning and leaving the house dark, except for the sinister blue ambient light of the storm that came in through the windows.

Almost as quickly as the storm arrived, it departed. This was the moment I was anxiously waiting for. As soon as the storm moved off, my friends and my brother and I jumped on our bicycles and raced down the hill to our local park, where the Apies River, named after the monkeys that were once everywhere in the region, had its source. The air was earthy and warm, filled with the fresh smell of rain, and the sun shone with a new purity, causing all exposed surfaces to purge steam. The tarmac roads released their breath in a way that reminded me of the escaping vapour from the valve on top of my mother's pressure cooker, which had a bright orange lid and permeated the whole house with the delicious smell of beef stew.

In the park we rode our bikes along dirt tracks that had been designed for joggers and wound our way through beautiful groves of bamboo and other tall trees. We followed the river downstream, marvelling at how it had swelled and transformed from a gently bubbling brook into a raging torrent of frothy white terror. Each rain puddle that lay in our path protested our riding through it by spraying its dirty, muddy contents in straight lines up our backs. We were young – the dirtier we got the better!

Rain brings life and in Africa it is as if every drop is celebrated. Piet-my-vrous (the red-chested cuckoo) and diederik cuckoos sang their onomatopoeic calls from the treetops and the bubbling sound of the Burchell's coucal, or 'rain bird', as it is commonly called, could be heard from deep within the suburban hedges. Cape robin-chats and Karoo thrushes splashed about in the puddles, celebrating the rain with exuberance equal to ours. A woodland kingfisher down by the river gave its trilling call. Tok-tokkie beetles scampered and shongololos (millipedes) crawled about as we attempted to ride our bikes to the end of rainbows. After an afternoon of mud and water, I went to bed lulled to sleep by the baritone a cappella sound of giant African bullfrogs. *Kwaak, kwaak, kwaak.*

As young as 10 years old, I was already obsessed with birds. I would rush home from school and cycle straight to the CNA in Brooklyn Mall, where I would page through the *Roberts Birds of Southern Africa* field guide from cover to cover. Staring at the beautiful illustrated colour plates, I dreamed of one day owning the book myself, a dream that came true on my 13th birthday, along with a pair of 9x35 magnification Bushnell binoculars gifted to me by my mom and dad.

Growing up I leafed through 'the Roberts', as the bird book is affectionately known, each night before falling asleep. I became so familiar with the book that you could turn to any page and I could give you the names of the birds on it. This was a party trick that intrigued my longtime childhood friend Guy. He would march me through to the TV room of his house and insist that his parents stop watching *The Thorn Birds* and marvel at Greg's

knowledge of Southern African birds instead. Covering up the names on the pages, he would make me identify each bird. I will confess that for the short-tailed cisticolas, which are the definitive LBJs (little brown jobs), I simply memorised the order in which they appeared.

In the school holidays Clive and I would walk to the hardware store and buy offcuts of wood to make bird feeders for our back yard. Our house was just a block away from the Austin Roberts Bird Sanctuary and I spent most of my weekends and school holidays (when not building bird feeders) sitting in the hide there, or riding my bike around the periphery, staring through the high diamond-mesh fence, wilderness dreaming about a life of adventure and exploration. The late Austin Roberts, renowned South African ornithologist, had left this block of urban wilderness in his will, specifically requesting that it be set aside as an avian refuge. Still today, in the middle of suburbia and in South Africa's administrative capital, there is an entire city block set aside just for the birds – how wonderful is that!

This famous bird lover was the first conservationist to impact my life and even though I was young, his legacy influenced me profoundly. With the imagination that only a child can possess, the bird sanctuary was to me far larger than a suburban block in size. In my mind it was a vast wilderness wonder, perhaps the size of the Okavango, promising great adventure and full of dangerous creatures, and gigantic fish – catfish as big as sharks! – in its dam. On my way home from the bird hide in the evenings, I would pass a small rusted square black sign that had been placed just inside the fence. It read in bold white peeling letters: 'Trespassers will face a fine of R200'.

The threatening message notwithstanding, me and Paolo, my best friend, planned our great escape to go and live in the bird sanctuary, far from nagging parents and homework. We would build ourselves a tree-house and live off the fish we caught in the dam. When our Peter Pan imaginations threatened to run away with us, reading the sign again made us reconsider. The enormous sum of R200 amounted to 10 months of pocket money.

Clive and I did all the normal things suburban children do growing up, but I was also always a little different in that I had an obsession for birds and the bush. I woke before dawn and went outside to make a fire in the back yard. Admittedly, this might have seemed slightly weird but it was

my regular routine. Even if I had friends sleeping over, I would drag them down to my early morning fires, where they would humour me with their presence. They'd stand around in the smoke and flames for a few minutes, yawning and rubbing the sleep out of their eyes, before going back to bed.

I had another strange habit in that I would climb a tree at sunset, as high up as I could, to watch the setting sun. On more than one occasion my poor mother had to help me down by directing my foot placement – it can be easier to get up a tree than down it ... Perhaps it was due to the French origins of my surname, but I spent a lot of time in trees. I used to sit for hours in the stinkwood tree above the bird feeder in our yard watching the birds. I'd look out especially for the tiny Cape white-eyes who betrayed their presence with their faint trilling calls as they gleaned the shiny surfaces of the green leaves. I would also search for nests. By placing a stick into a new hole that a barbet was chiselling, I could measure its progress by how much of the stick disappeared.

Looking back, despite my suburban upbringing, my destiny of having a close affinity to all things wild and wonderful was already written. At the time, of course, as a child the future didn't exist. Children are able to live in the moment, adults less so. Sitting high up amongst the leaves of the stinkwood tree – which gets its name from the stink bugs that live in it – it was easy to live in the moment. And the view from up there was always worth the stink.

One bird I sometimes saw in the neighbourhood was the Indian myna. It is believed that these birds, which are native to southern and south-east Asia, were introduced into Natal around 1900, when the British colonial government brought indentured labourers out from India to work in the sugar cane fields there. The Indian mynas spread inland, displacing indigenous African birds, and came to be considered avian vermin.

Even though I was a young boy, I felt it my duty to rid our neighbourhood of the mynas (it would seem the conservation gene was there from the very beginning). My dad had a pellet gun. This was strictly out of bounds, but when he was at work I would take it out from the built-in cupboard at the end of the passage where it was kept and practise shooting at the far end of our back yard. To begin with I placed a Coco Pops cereal box to aim at, the monkey on the front of the box being my target. Occasionally

the pellets would ricochet off of the concrete wall and one afternoon a pellet bounced back at me, hitting my upper lip with a stinging vengeance. Looking back, I was lucky it didn't take out my eye, which is a very sobering thought: that would have changed my destiny of becoming a professional wildlife photographer.

I kept practising with the pellet gun, the breech of which, annoyingly, I would regularly accidentally close on the flap of skin between my thumb and index finger – I still have the scars today. Eventually, I was able to hit the silver 50 cent coin that replaced my cereal box target. I became a crack shot. With one eye closed, I stuck the cool grey gun metal against my cheek and with a sideways grin, I disposed of the avian cockroaches one by one. Not wanting to upset the neighbours, I would sneak over the wall to remove one dead bird at a time, unless, as happened a few times, a bird fell upside down behind their pool's pumphouse, which made retrieving it trickier.

On Saturday mornings Paolo and I would ride our bikes to the top of the hill on which Fort Klapperkop was built by the Boers to protect the capital city from Uitlanders (foreigners). It was a steep 10 kilometre climb from our houses to the top, which gave out a beautiful view of the city bowl. Inside a fenced-off area on the top of the hill were some large water reservoirs. Paolo and I schemed for months to find a way to get inside this section and swim in a reservoir, imagining how cool it would be to swim in a giant concrete cylinder. Eventually, we found a way through the fence and were more than a little disappointed when we discovered that the reservoirs were covered in a cement ceiling with gravel on top of them. Jumping in was impossible. After that, we plotted how we were going to blow the reservoirs up and flood our entire neighbourhood. First we would need to build a boat to save ourselves. That meant saving our pocket money, so we abandoned the idea and came up with a less sinister reason to ride to the top of the Klapperkop hill. We decided to decorate a tree with the copious amount of litter that was discarded there – empty chip packets, red Coke cans and white cigarette boxes. Once we thought the tree was sufficiently adorned we raced our bikes back down the hill to Paolo's house. From his bedroom window we had a good view of the hill. We used my binoculars to find our tree and felt thrilled with our accomplishment.

It seems silly now but back then we got a real kick out of seeing our tree decorated in rubbish and we gained immense satisfaction knowing that we had been up there and that we had left our mark. If you think about it, adult explorers are not much different. They conquer a mountain peak or go to the North Pole just because it is there, and leave a flag to mark their achievement. Our flag might have been litter and our mountain might just have been a little hill in suburbia, but our imaginations were altogether without summit.

3

A call to the wild

I was still in primary school when I first enjoyed exposure to the bushveld and this carried on into my teens. There was a small game reserve about two hours north of our home in Pretoria and just west of the town of Bela-Bela (in those days it was Warmbaths). On family holidays, especially over Easter time, we would regularly visit this reserve. Called Morkels, after the owner, in all honesty it was not much bigger than the bird sanctuary down the road but in my child's mind it was an epic and massive chunk of dangerous African wilderness.

The camp consisted of about five very basic bungalows and a kitchen with an old-fashioned screen door, the kind you see in butcheries in small towns, and which very diligently, even violently, snaps shut behind you, refusing to let even a single fly in. The best part about the camp, however, was the fireplace on its periphery, close to the edge where the bush began. This fireplace was really just a circular piece of cement with a few rickety old camping chairs positioned around it but to me it was a magical spot. We did all our cooking on the open fire. The wood we burned was very different to the wood I was used to burning in our back yard. It was harder, much harder, so hard in fact that it would burn all through the night and into the next morning and could be coaxed back into life simply with a gentle prod. With wood either burning or smouldering almost around the clock, the camp was always permeated by a wonderful sweet smoky aroma. At night a soft breeze carried the wafting smoke through the mosquito netting to where I lay in bed. To me that smell was the very essence of the bushveld. It imprinted indelibly on my young brain, carrying into my adult life so that whenever I smell burning bushveld wood, it is like a homecoming.

On our trips to Morkels I would wake several times during the night in sheer excitement and anticipation of another day to be spent in the African

bush. Lying on my back, my hands cupped behind my head, I would listen to the bush's nocturnal chorus, my favourite sound being the 'good Lord deliver us' cries of the nightjars. These birds time their breeding cycle around the phases of the moon: their eggs hatch when the moon begins its waning, and as the moon waxes and gets bigger, so do their chicks; the parents then have more light, and more time, to hawk insects to feed their young. The nightjar's call is synonymous with the bushveld. It can even be heard in the background track of the movie *Out of Africa*, never mind that the bird would need to have been seriously lost to have landed up in central Kenya. Be that as it may, it is a stunning litany, with the 'good Lord' part rising in steep crescendo and shortly followed by the equally dramatic descending 'deliver us' part. It is a lilting whistle of incredible beauty.

As soon as the inky blackness of the sky on the horizon began to turn a lighter yet still a deep rich and dark blue, I quietly crept out of bed. With the rest of the camp still fast asleep, this precious time was my own. Walking to the fireplace barefooted, the dusty earth was just cool enough to send a chill up my spine. I squatted fireside, absorbing whatever heat was left in the dying coals. The nightjars and jackals were silent now, as if having finished their shift while the rest of the diurnal bushveld creatures still slumbered. It was a changing of the guard, so to speak. While the cool blue and white stars twinkled in the heavens above, the umbrella-shaped boughs of the surrounding acacia trees etched their way into the inky sky.

I picked up bits of bark and small broken splinters of wood for kindling and placed them on top of the coals, then bent down low and blew on them gently. Smoke was the first sign of life and then, after more persistent blowing, a flame flickered. The orange lick with its blue base echoed the colours of dawn on the horizon where the glow of the sun was beginning to appear. Sitting on my haunches and holding out my small hands towards the flames, I warmed myself as the bush around me came to life. Usually first to herald the dawn of a new day were the jerky calls of the crested francolins shouting 'Tina Turner, Tina Turner, Tina Turner' at the top of their lungs, piercing the silence like a hot knife through butter.

By now the horizon was tinged in rich orange and blue hues and, lifting my head up and away from the mesmerising flames, I gazed around me, taking everything in. The acacia trees, sentinels of the bushveld, were

strong silhouettes, their wide arms facing the heavens as if praising their creator. Once the trees began to lose their silhouetted look, I took my binoculars and my bird book, the latter placed in a sling pouch that my gran had made for me, and headed out of camp and into the bush. I followed a pathway that was extra special to me because it was one not made by man but by animals. Treading on the exact place where wild animals had trod, possibly just moments before me, was an exhilarating feeling for my young soul. I could feel my senses awaken. The further down the path I walked the more acute they became. Living in cities our senses, and especially our sense of hearing, become somewhat dulled, but when you are out in the African bush, especially on foot and along a game trail alone, your senses quickly become resuscitated as a primal survival instinct kicks in.

Ever since I had seen a pearl-spotted owlet in the Roberts bird book I had wanted to see one in the wild, but trying to follow their faint calls nearly always proved futile. I often landed up at a bird that sounded almost exactly like the owl but was jet-black in colour and had a deep forked tail. The fork-tailed drongo is a really clever little bird in that it mimics the call of the owl. It does this predominantly at dusk, causing any real owls in the area to think that the territory is taken. The owls then leave and, since they often prey on other birds, this is a good thing, because everyone can then enjoy a peaceful night's rest.

This genius strategy of the drongo might be misplaced, however. An ornithologist in Zimbabwe once embarked on a quest to taste every kind of bird in the bush in the belief that by eating birds he would learn something new about the avifauna of Africa. He could personally testify that the only bird as foul-tasting as a vulture was a drongo! Drongos taste so bad, it seems, that not even owls hunt them, which makes them effective sentinels, providing a security service to all the other, and more pleasant-tasting, small birds. Drongos are also known to hawk and dive-bomb eagles, chasing them out of the area. Eagles being much larger and more powerful birds, they could, if they wanted to, pluck the drongos out of the air and gobble them up in a heartbeat but they never do – and we now know why. It's because the drongo tastes so damn horrible.

One morning while walking down the path, I heard the call of a 'pearly', and this time it sounded somewhat crisper than the other imitations I had

heard. This owl, like many South African cities and streets post-democracy, has undergone a name change: it used to just be called the pearl-spotted owl but this was changed to pearl-spotted owlet. I wonder what a baby owl of this species is then called but, this conundrum aside, memorising 900 'old' bird names was hard enough, let alone trying to learn the new ones.

Scanning the tree branches carefully through my binocs, I saw a tiny and very grumpy-looking, yet utterly intriguing owl. 'It's a real live pearly,' I whispered to myself. Although no bigger than your hand, these birds have a real street thug look about them and with good reason. They are the toughest of little raptors – a honey badger with wings, if you like – and often kill prey much larger than themselves. Peering through my binoculars I could see the large white and scaly talons protruding from beneath its fluffed-up, down-like plumage. The little owl was enjoying having the warmth from the rising sun caress its back. With its feathers all ruffled and hiding its goosebumps, it looked like it had just used a hairdryer. I kept my binocs trained on it, hoping it would turn its head away from me. The pearl-spotted owlet possesses something very special: fake eyes – two large round discs on the back of its head that look just like eyes. This allows the owlet to close its real eyes and get some daytime shut-eye. Any pesky birds wanting to mob him leave him alone as the fake eyes appear wide open and look very menacing. Like Janus in Roman mythology, this little bird also has two faces.

I was just a young boy and seeing things for the first time, things I had only before seen in books. Solitary walking allowed me to discover a world far more wonderful than I could ever have imagined. My young heart was being fanned into flame, in much the same way that I coaxed the campfire into life with a gentle blowing.

Startled by a sudden grunting sound, I quickly dropped my binoculars from my eyes to see a sounder of warthogs trundling down the pathway. Game paths in Africa always lead to waterholes, and therefore by default also always lead away from waterholes, a fact worth considering if you're ever lost. Warthogs are water-dependent creatures and need to drink every day. As is typical, the big sow was in front with her family in tow, all with tails raised high like radio antennae. Because I had been standing off the path looking at the owl, mother warthog did not see me until the last

second. I froze, she froze, and her babies behind her froze. Their tails began drooping as her twitching wet nose sampled the air to ascertain exactly what kind of creature I was. Her piglets heeded her caution and then, as if all agreeing at once that I was a smaller version of a fully grown human being, the most dangerous creature there is, they shot off the path as one, their tails high again in disdain. Their small sharp hooves kicked up the earth, creating an ethereal orange plume of vanishing dust in the early morning rays of the sun.

With my heart beating faster after this face-to-face encounter with the warthog, whose face is one that can only ever be described as beautifully ugly, I felt truly alive. Perhaps this is the best way for me to explain how the African bush makes me feel, even all these years later. Truly alive! What is even better is that being in the bush, anywhere in Africa, always makes me feel like a kid again.

Continuing down the pathway, walking slowly, trying to delay getting back, and peering into every bush I could with my binoculars, it was on one such walk that I saw my first ever golden-breasted bunting. Its breast looked extra golden in the golden light of the dawn. In Afrikaans this small bunting is known as a rooirugstreepkoppie, which translates to red-backed stripey-head. The English and Afrikaans names are both accurate for this bird but each highlights completely different aspects of its plumage. It is not only the street and town names that pose a problem in South Africa, or the new and old bird names, but also the English and Afrikaans names.

All of the game trails I walked along led to a waterhole close to the camp. Here there was a small rudimentary hide consisting of a wall of chopped thorn bushes, which acted as a screen, or skerm, and after breakfast we would go and sit behind it, waiting and watching. Water, like elsewhere, but perhaps especially in Africa, brings life, and an African waterhole is usually the busiest at around 8 or 9 am. Sitting and waiting always seemed like an eternity to me and when the first wary antelope finally popped its head out of the bush, staring straight in our direction, it was hard for me to contain my excitement. I would often let out a squeal of delight while vigorously pointing and waving to get everyone's attention. Of course the antelope would immediately turn and run off, barking profusely in alarm, tail curled high, letting all the other creatures in the vicinity know to run

too. It took ages before any animal ventured to the waterhole to drink again. I was just a kid, still needing to be taught the ways of the wild, but my excitement was irrepressible. After repeated scoldings from my parents, it was only when they threatened to send me back to the camp that I learned to contain it.

The biggest antelope in Africa is the eland. It is absolutely massive, heavier even than a moose. With their pale cream-coloured fur these creatures roam the African bush like silent ghosts. They are truly mysterious in their existence, which is perhaps one of the reasons that they were favoured subjects of many rock artists in days long ago. The big bulls turn an almost blue colour with age. A thick mat of hair protrudes from their foreheads and emits a rich musky smell, and their horns are short and spiralled. The large flap of skin that hangs off their necks and sways in the wind helps with thermoregulation. When the really big bulls walk, if you listen carefully, you will hear a clicking sound. While this is commonly attributed to the clicking of their knees, it is more likely the result of the taut tendons in their muscular legs.

As a young boy, peering between the branches of the thorny screen, I was utterly mesmerised by my first sight of a herd of eland coming down to drink. They were huge. As their lips pursed against the water surface, their sucking was the only audible sound – that was until a go-away bird (called a grey loerie back then) betrayed our presence. 'G'waaay, g'waay' came the call. The eland all lifted their heads in fright, long lines of silver saliva and sparkling water droplets falling back into the water in slow motion. Looking up at the towering beasts, I was spellbound. And just as quickly as they had appeared, so they disappeared, melting into the bush and vanishing like the ghosts they are. How do such massive creatures survive in the dry African savannah and how do they remain so aloof, so mysterious? These are questions that fascinate me to this very day.

I didn't know it then, of course, but African waterholes would play a major role in my adult life and I would spend thousands more hours sitting at, and even inside, waterholes across the continent waiting for the perfect shot. Photos from a waterhole in Kenya would take me all the way to the high streets of London for a lion exhibition at the National Geographic Store's gallery. And a photo of an elephant taken at a waterhole in Botswana

would win me the highest accolade in world wildlife photography. But it all began with me sitting as a child at a waterhole, behind a skerm, and my parents teaching me to remain calm and composed, a skill that would one day save my life.

4

So fair and foul a day

At the age of 13 I was enrolled at Pretoria Boys High School, the largest all-boys school in South Africa. Perched high on a hill in the east of Pretoria, across from the Union Buildings, Boys High, as the school is known, has a beautiful campus of some 85 acres in size. The main school buildings, built out of giant sandstone blocks, are large and imposing.

The original school building served as a prison for captured British officers during the Anglo Boer War and had included among its prisoners none other than Winston Churchill, who was a war correspondent at the time. He was detained but managed to escape, adding an intriguing chapter to the history of the school. The city of Pretoria was taken in 1900 by the British forces, under Lord Roberts, and the formerly independent Transvaal Republic was brought under British rule.

Boys High was officially founded in 1901. General Jan Smuts, who was a signatory to both peace treaties that ended the First and Second world wars, and who went on to help establish the United Nations, sent his own sons to the school. It has since produced two Nobel Prize laureates, 18 Rhodes scholars, eight supreme court judges, one Elon Musk and, more importantly to many of the boys, a few Springbok rugby players and captains.

As it was only a few kilometres away from my home, I cycled to and from school every day along the city's beautiful jacaranda-lined streets (Pretoria is also known as 'Jacaranda City'). Once inside the school gate I took the narrow pathway between the slender trunks of tall pine trees to the bike shed. The route took me past Loch Armstrong. This man-made lake on the school's premises, named after a former headmaster, was a small oasis in the surrounding indigenous bush. Fringed with stands of bulrushes and with water lilies growing in the middle, for me it was another waterhole, a place to wilderness dream about the bushveld. If I had a couple of minutes

to spare, I would pause to birdwatch or stop to just take in the atmosphere, unless of course I was really late for class. Passing by the lake twice a day was a constant reminder to me of my ultimate dream to one day become a game ranger – if somehow I survived high school, that was. After parking my bicycle safely in the bike shed, which was surrounded by more tall pine trees, it was a steep walk to class up a hill called Suicide Hill, so named due to the physical education teacher, Mr Anthony, being partial to making us run up and down it.

High school was a daunting experience, to say the least, for a young 13-year-old boy. Initiation was a tradition at Boys High in those days and I was petrified of what I saw as my impending doom. The matric boys, although only five years older than us, had deep voices like my dad's and hair in places I didn't know hair could grow. On the day of the opening assembly of the new school year, as per tradition, all the new boys sat on the school stage hidden behind the curtain. Sitting there in the dark, I remember the hall had a distinctly musky smell, the kind that storerooms get when the doors have been closed for a long time. We sat in nervous silence as the rest of the school filed into the hall. What we couldn't see we could certainly hear. The din was incredible! The floorboards creaked under the stomping of the feet of over 1 000 boys as they crowded in, exchanging their Christmas holiday stories and calling out to friends. Actually, they sounded completely out of control; it was like a riot, with lots of whistling and cackling in amongst the foot stomping and the rattling of chairs. I wanted to say a Hail Mary but, not being Catholic, I didn't know the words. Thankfully, we were already sitting cross-legged as I think all of us needed to pee, out of pure fright. Just as the din was reaching fever pitch, all of a sudden it stopped. Absolute silence. So silent you could have heard a pin drop.

It was tradition at Boys High for the head prefect to flick a light switch when he saw the headmaster walking down the passage towards the hall. This was what had happened. The crazy chaos ended in a millisecond as the whole school waited for the headmaster to make his appearance. In the silence the stage curtain was raised and there, sprawled out before us, was a tumultuous sea of faces, the entire school. The teachers and matrics were in the balcony peering down and the rest of the school was spread out

below. As was longstanding tradition, we new boys had to sing a song to the school and although I have forgotten all of the other words, I can still remember the first line: 'Five hundred faces all so strange, life in front of me and home behind'.

The headmaster was a tall, imposing man with grey hair and a distinguished nose. He wore a black academic gown and stood behind an important-looking wooden lectern. Mr Schroder, who would become known to me only as 'The Boss', was a man of impressive stature. After addressing the school he turned to walk off the stage. Immediately all the boys sprang to their feet in respect, causing the chairs to scrape the floor as they slid backwards. Just when I thought it was over the boys sat back down. I noticed some of the matrics rubbing their hands together, grinning at us grommets with a sinister glee. It was time for us to be inducted into the main school body. One by one we had to walk down the stage steps into the hall, filing past the entire school like lambs being led to the slaughter. If you looked slightly awkward, if your face was pimply, or if you missed a step, raucous laughter and whistling broke out. Taking my turn to stand up and walk down, it no longer *felt* like the entire school was watching me – I *knew* they were.

With assembly thankfully over, after a few classes the bell rang to signal break time. The matrics ran out into quads like rabid hyenas, looking for Form 1 boys to initiate, in the same way they themselves had been subjected to just four years prior. Twenty-five minutes of break time every day, for the whole of my first year of high school, was a lesson in survival and each was like an instalment from *Lord of the Flies*. It wasn't long before I began to loathe my shiny new school tie, which drew attention to the fact that I was a newbie. Despite following all the top tips on how to blend in, including which areas of the school to avoid, I was soon accosted by a rogue group of matrics and made their 'skivvy' (which might as well just read 'slave'). I had to report to them at break time each day where they would make me run errands for them, mostly to the tuck-shop and to their lockers.

On one of my first days and, worst of all, after they had made me bark like a dog and cluck like a chicken, they pulled my socks over the toes of my school shoes, tied big knots in them and left me sitting sheepishly in

the middle of the now empty and very quiet quad, with the end-of-break bell having rung. I tried frantically to undo the knots in my socks so that I could get to class – to no avail.

I found the campus disorientating; I had to use a map to get around, it was so vast. It took me a while to find which classroom I was supposed to be in for which class, even without socks tied over my shoes. Not being able to untie the tight knots that the bigger boys had made, I decided to walk to class on my socks, knowing that my mother would kill me if I got holes in them. Walking on the grass was okay but once I got onto the highly polished red tiles of the hallway that was another story. I slipped, my feet going in opposite directions, and fell against the railing, scrunching the map in my hand as I clung on for dear life. It was like being stuck in a bad dream. I was completely lost. I turned the map in every direction, trying to figure out which building I was in, but whenever I set off in a particular direction, my feet slid about as if I was on an ice-rink.

More than anything I feared being late for class as the teachers in my new school were very strict; they had canes and dished out 'jacks' like Smarties. Trying to figure out where I was and where I needed to go seemed to take forever but eventually I arrived – late – in the right classroom. Our English teacher, Mr Webster, looked over his glasses and down at my feet and the two big knots protruding like the pompoms on the end of a clown's shoes. Thankfully, he smiled, offering me a moment of much-needed sympathy, before motioning for me to take a seat. The class was about to start reading *Macbeth* and because I was late I was picked to read aloud one part of a dialogue between two of the play's characters.

The only problem was that I had grown up with a very bad stutter, which got worse when I was nervous or put directly on the spot – like being made to read a dialogue. In a weird twist of fate, the other boy who was chosen to read with me, David, stuttered just as badly as I did. Between the two of us it turned out to be the slowest dialogue that had ever taken place between the Elizabethan era and the twentieth century. After allowing us to persist for some time, Mr Webster finally conceded defeat and passed the little blue books on to other boys. Sitting back down in an old desk that still had a hole in it for an ink-pot, I thought that the words 'so fair and foul a day' had never been more apt.

We had a master, or 'sir', we called Kasper. If Casper is the friendly English ghost, then Kasper was the decidedly unfriendly and terrifying Afrikaans version – he would pop up anywhere, at any time, to issue discipline. Despite being Afrikaans, Kasper spoke English in a mightily prim and proper way, except that he over-pronounced his r's so that the words 'prim' and 'proper' would be pronounced 'prrrim' and 'prrroper'. The subject he taught was career guidance. One assignment he gave us was to research the career we wanted to take up when we left school. I was ecstatic. I knew that I wanted to work in the bush as a game ranger. The following week I presented my future career to the class with fervour. When I had finished speaking about my love for the bush and how ever since first visiting Morkels I had wanted to become a game ranger, there was a moment's silence. Then Kasper flew off the handle. Wagging his finger at me, he yelled, 'My boy, if you fink that you can rrrun away into the bushes and hide frrom the worrrld, then you arre verrry bloody well mistaken.' When I sat back down in my chair I was shaking like a leaf.

When Kasper was not at school enforcing rules and giving us 'career guidance', he was a passionate breeder of mallard ducks. There must have come a point when he had too many ducks because he introduced a few mallards to Loch Armstrong. These birds are exotic and, not unlike the Indian mynas in my back yard, are an introduced alien species. A few senior boys from our wildlife society were indignant at Kasper's mallards swimming about the lake as if they owned it and one night a few of them snuck out and executed to perfection what was dubbed 'Operation Goose'. The next day Kasper walked into his classroom clutching a mallard in each hand. Holding them up high in front of the class, he bellowed, 'Who killed my gooselings?' He was mad as hell about it, his trembling arms causing the ducks' heads to wobble. When he was unable to discover who the perpetrators were he embarked on a crusade to discipline the entire school.

5

Dr Ian Player

My education at Boys High was perhaps at times unconventional but it was holistic, an education about life and not just a strictly academic one. Arts and culture were, and perhaps surprisingly so, emphasised as much as sports were. The artist Walter Battiss taught art to the boys for 30 years at the school. He famously graded papers by throwing them up a flight of stairs – those that landed on the top step got a distinction, while those on the bottom step failed.

A part of the school's cultural curriculum included the opportunity to sign up to any number of cultural societies. The wildlife society was of course right up my alley, and we met once a week, on Friday afternoons. It was an interesting club in that it was only half filled with boys genuinely interested in wildlife. The other half were reprobates interested only in the weekend forays into the bush. These allowed them to get out of the school's boarding hostel and drink beer, and to just generally get up to other and all forms of mischief. The wildlife society was not just great fun due to this eclectic mix of boys but it also had a significant influence over the rest of my life.

Guest speakers to the society included some of South Africa's most famous conservationists. One of these was the late ornithologist Kenneth Newman, whose *Newman's Birds of Southern Africa* was the other best-thumbed book I owned (of course I asked him to sign it for me); two others were the late Dr Ian Player and Clive Walker, both world-renowned rhino conservationists.

As a young schoolboy I hung onto every word these speakers uttered and still to this day I remember their talks almost verbatim. I was absolutely fascinated by how Kenneth Newman had taken tiny reed warblers – they weigh just 11 grams – into a planetarium to learn more about their navigation skills. In so doing he proved that these tiny birds navigate

their way from the southern tip of Africa all the way to their breeding grounds in Europe by following the stars. The birds always follow a particular star that leads them in the right direction. As if this was not astounding enough, when Newman purposely tried to confuse the little birds by showing them a night sky far off of their course, the birds always knew which star to follow to bring them back to the night sky they were familiar with.

I also remember him making the point that when chimpanzees started using tools in the form of a stick – pushing it into a termite colony, then licking the termites off – the scientific world went into an excited frenzy because 'creating and using a tool' was very much a human attribute. He then told us boys about how he had witnessed a green-backed heron using a spider as bait. This had taken place on the Crocodile River. After catching the spider the heron dropped it back into the water, only half killed. As the current carried the spider downstream, the bird, with its hunched back and long yellow legs, followed it along the bank. When a fish surfaced to catch it, the tiny heron nabbed the fish. Newman's talk was rather aptly titled 'Bird Brain?'

These days the colour pictures in bird books are generated by computers, but Kenneth Newman painted, by hand, all of Southern Africa's 800 plus bird species at the time. There is no doubt that it was his talk that prompted me later in life to go for an interview to become an ornithologist at the Natural History Museum, but more on that later.

I was equally fascinated when Dr Ian Player retold the story to us boys of how as a member of a small reconnaissance unit moving across enemy lines during World War II, the men had discussed what they would do when they returned home – if indeed anyone survived the next day's insurgence. As it turned out, he was the only member of his unit to survive the war and upon returning home he stuck to his word: he canoed from Pietermaritzburg to Durban, something that had never before been done. It was the start of the Duzi Marathon which now, many decades later, is one of the most celebrated canoe races in the world. Dr Player also spoke about how the Zululand wilderness had helped heal the psychological wounds that he carried from war. He introduced me to the idea that there is an intensely spiritual element to the African bush.

He finished his lecture talking about the early days of rhino conservation. In the late 1950s there were around 400 white rhino left in South Africa, but he told the National Party government that there were half that number, just to get them to understand the severity of the situation. In spearheading 'Operation Rhino', Player played a pivotal role in bringing the white rhino back from the brink of extinction. The operation was an ambitious undertaking to distribute rhino across the world in order to safeguard the species. The initial population of 400 grew to some 15 000 as rhino were relocated from one small game reserve in Zululand to many others in South Africa, including the Kruger National Park where rhinos no longer existed. To this day his legacy can be seen in countries as far away as Kenya, where there are now pocket populations of the southern white rhinoceros.

As Dr Player stood in front of our wildlife society and simply spoke about his life, one that was full of danger, adventure and purpose, he instantly became my hero. I could not have known it then, but he would later in life, at the age of 86 and just before his death, write the foreword to my coffee-table book titled *AWE*. Interestingly, Ian Player was the older brother of the famous golfer Gary Player. They came from very humble beginnings, their father working on the mines outside of Johannesburg, yet both achieved worldwide acclaim in their chosen fields. Tenacity was the overriding quality these brothers shared.

Clive Walker was another riveting speaker. Recounting his close encounters with rhino had all of us captivated. He explained how rhinos have such bad eyesight that a charging rhino will run straight past you, if you just stand dead still. But you have to stand very still indeed, he added, because if you flinch at the last second the rhino can, even at full charge with a speed of 40 kph, turn on a dime and change its running angle by 45 degrees in the mere blink of an eye. He showed us the scars that had helped teach him this lesson. I made a mental note that day about how to behave around rhinos, creatures that would later become a big part of my life.

The wildlife society made regular forays into the bush and these were always great fun. We had one esteemed member of the club by the name of John Power, who would insist on arriving for the weekend excursions with only the clothes on his back and a R2 coin in his pocket. In all of the various national game reserves we visited, while we slept in our tents he would sleep outside; and while we took game drives he would walk – illegally, I might add. And when we unpacked our food for the night, he would scour the campgrounds like a hyena looking for morsels, nicking other campers' marshmallows. John also never packed a toothbrush and since his nickname in his boarding house was already 'Rectum Breath', this only made matters worse.

He once successfully got the society banned from a reserve when he jumped out of the school van and chased a monitor lizard through the bush. Just as the giant reptile was escaping down a hole in a termite mound, John dove like Jonty Rhodes taking out the stumps in the 1992 Cricket World Cup. Sliding through the dirt towards the fleeing lizard, he triumphantly grabbed it by its tail. The problem was that a ranger happened to be driving behind us and saw the whole incident. Even as he read John the rulebook, John refused to let the lizard's tail go, clutching it in his hand, nodding in agreement with the park ranger's every word, while the rest of us laughed nervously in the van.

John's best friend and our chairman, Duncan MacFadyen, was the member responsible for the incredible list of guest speakers we hosted. His modus operandi was simply to call each potential speaker, or their secretary, relentlessly, until they agreed to come and talk if he agreed to stop calling them. Duncan was an avid collector of birds' eggs. Being just as persistent at his hobby as he was at sourcing the society's speakers, he once offered to pay me and John R50 if we climbed a tall electrical pylon and retrieved for him a single egg from the nest on top of it. What we didn't know, and he did, was that the nest and its contents belonged to a pair of lanner falcons. Just when John and I were high enough to be able to plummet to our deaths, the falcon parents took exception to our presence and began dive-bombing us with great speed and aggression. Clasping the pylon with one hand and covering our heads with the other every time the falcons swooped in, we hung on for dear life until we couldn't take it anymore. We

abandoned our quest and the prospect of the reward and somehow made it safely back to terra firma. There we found Duncan rolling about on the ground in mirth. He had been there, in our exact precarious position, just a couple of weeks prior and knew full well what the outcome would be.

Two esteemed members of our wildlife society, both of whom were named Paul, made up the terrible duo notoriously known as the 'P-Squares'. They joined our bush excursions to drink beer and cause mischief, two things they excelled at. Both boys had an equally flagrant disregard for rules and with the P-Squares around there was never a dull moment on a camping trip. On one such trip to a small reserve north of Pretoria, the P-Squares wanted to swim in a river but, being unsure whether crocodiles were present, they had a problem. Their solution was to tell the Form 1 boys that swimming across the river was a part of their initiation and something they absolutely had to do right away. The boys looked nervous but the P-Squares, and much to the surprise of the rest of us who had never been there before, assured the newbies that we had all done it.

After making the Form 1s cross back and forth a few times, thereby satisfying ourselves that crocodiles were not present (or if they were, that they were well fed), we all leapt into the river for a swim. Before long, we were floating downstream, soaking up the rays and looking for a rare bird called a finfoot, which, due to its habitat of overhanging branches growing along streams, is seldom seen. Floating in the water gave us a better chance of seeing it.

This was the first of many African rivers that I would swim in during my lifetime. As we floated past an elephant bull who had come down to quench its almighty thirst, it gave an equally almighty trumpet in protest at the bunch of bobbing heads floating past. While we kept an eye open for finfoots, the P-Squares tugged on our legs, trying to simulate crocodile attacks. In typical schoolboy fashion, having once again successfully escaped the restraints of monotony and boredom, we blissfully continued floating downstream. But the river had gained considerable strength, something we had not noticed or appreciated fully until we piled into the fence that signalled the end of the reserve.

Not aware of our looming predicament, and still in high spirits, we clambered out of the river and onto the bank like drowned rats. By this

time our feet were wrinkled and were especially soft and pink under-
neath from being in the water for some time. We were downstream and
a good couple kilometres from camp but it wasn't the distance that was
the problem – it was the large acacia trees that lined the river and their
multitude of thorns that carpeted the ground. Walking back barefoot was
painfully slow, in the full sense of painfully. When we finally made it back
to camp some of us filled our socks with ice-cubes and tied them to the
undersides of our feet. The P-Squares, on the other hand, unfortunately
sought a different kind of pain relief from the cool-boxes. I say unfor-
tunately because later that night around the fire, the P-Squares having
consumed a few beers, they decided that we should go on a night drive into
the bush to look for 'African kangaroos', better known as springhares. Our
schoolmaster, whom we called 'The Fly' because he was very skinny and
wore Ray-Ban sunglasses, was fast asleep in his tent, but just in case, we
pushed the school's minivan a suitably safe distance down the road. One
of the P-Squares got behind the wheel and the rest of us sat on the roof
with our torches, ready to scan the bush. The P-Square managed to get the
engine started and, with a series of jerky gear changes, we roared off into
the night like Nigel Mansell on the F1 Kyalami racetrack.

Whenever we spotted a springhare – which looks and behaves just like
a kangaroo – we all leapt off and ran into the bush like madmen trying
to catch the elusive creature. This particular bunny rabbit, however, pos-
sesses a sidestep like David Campese, meaning that we returned to the van
empty-handed every time, although thoroughly bent over laughing because
inevitably someone had tripped when chasing the hare and had hit the dirt
in spectacular fashion, made all the more visible and hilarious in the van's
headlights. One of our astute society members, Michael Roy, had taken
the position of standing on the rear bumper, so that he could leap off with
greater speed and agility, thereby reaching the hare before the rest of us
did. In South Africa there is a tree called a 'wag-'n-bietjie' which translates
to 'wait a bit' because it has hooked thorns which, if you come into contact
with them, are sure to make you 'wait a bit' as you carefully and method-
ically free yourself. Most unfortunately for Michael, whichever P-Square
was driving at the time decided to do a U-turn and reversed straight into
a wag-'n-bietjie tree. Michael, who was still standing on the back bumper,

was impaled on the thorns like the prey of a common fiscal which, not for nothing, is known as the butcher bird. With all of us yelling to move the van forward, poor Michael was left dangling in the tree like a puppet. We managed to cut him free using our pocket knives and luckily we made it back to camp alive and without waking The Fly.

For schoolboys, everyone is fair game. On another occasion the wildlife society planned an excursion for the upcoming weekend to the Pilanesberg Nature Reserve. With much excitement I sought permission from my parents and feverishly began packing my bush rucksack. I had bought the maroon rucksack with my pocket money at the Dion's general store down the road from our house. To me that rucksack was no ordinary backpack; it was a magical symbol of adventure whose every compartment I stuffed with one sort of survival tool or another, including my brother's MacGyver knife, complete with a hollow handle filled with fishing tackle and a compass at the back. I loved that rucksack nearly as much as I loved my binoculars. The whole week leading up to the excursion I looked forward to the trip, so much so that by the time the school bell rang on the Friday, I was beside myself with excitement. We were to meet outside the front of the school at 2.30 pm sharp but I was already there by 2 pm, raring to go.

By 3 pm no one else had pitched and the school was very quiet – it was a Friday afternoon, after all. The buildings of the main school façade towered above, adding to the feeling of isolation. Nevertheless I was certain that the school van with its red, green and white stripes down its side would pull up at any minute, brimful of boys ready for a roaring weekend of fun in the bush. I must have got the time wrong, I thought to myself as I kicked a pebble with my brown Hi-Tec hiking boots. Finally, I spotted Duncan, our chairman, on the steps of the main school building. It was then that I heard laughter from the bell tower above. Duncan seemed slightly embarrassed, slightly nervous, slightly sorry and slightly pleased to tell me that there was in fact no trip, and that I had been pranked. Motioning towards the bell tower, he pointed to where the rest of the society had been watching me. When he saw the look of disappointment on my face, I could see in his eyes that he no longer felt just slightly sorry for me. He felt really bad. The other boys must not have been able to see my look of disappointment from all the way up in the

bell tower because they continued to cackle and jeer. Boys can be cruel. They had pulled off the prank and had gotten me hook, line and sinker in the process. With no cell phones back in those days I had to walk home through suburbia with my maroon rucksack stuffed full of survival kit items on my back and my binoculars hanging around my neck, swinging from side to side and adding to my already dejected posture.

One day the school was contacted by the owner of a large game reserve in the dry and arid bush country of the North West Province. He wanted to know exactly how much wildlife he had on his property. While the larger species of game are easy to count from the air, the smaller animals, and especially the predators, are far harder to count. Our wildlife society was contracted to build hides (also called blinds or screens) at every waterhole on his property and from these we were to conduct a game count, staking out every single water body on the reserve simultaneously, for a period of 24 hours. We were paired off for the task and my companion was my very good friend, the late Grant Burton, whose nickname was 'Flintstone' because he was a type of modern caveman.

Flintstone was at the time busy preparing to become a Springbok Scout, the highest honour for any Boy Scout in the country, so when we were dropped in the middle of nowhere and told to fend for ourselves and to build a hide, which would also serve as our shelter, I was especially glad to be there with Flintstone. Before we could even start discussing our plans to construct the frame, he disappeared into the bush, returning an hour later dragging a forest-worth of dead branches, all expertly cut and neatly lashed at the end of a single piece of rope, using some fancy knot I could not even pronounce, let alone tie myself. In typical Flint-stone fashion, being a man of action and not words, he began assembling a barrier at the base of a large acacia tree and in no time at all he had skilfully constructed a very suitable home for the night. All I had to do was add some garnish by placing a few green leaves on the outside, thereby increasing the camouflage effect.

By sunset we were seated beside each other on a log peering through the branches at a small waterhole about 100 yards away. The census had been timed to coincide with the full moon and the night became increasingly beautiful the higher the moon climbed in the sky, giving the surrounding bushveld a delicate twilight glow. Grant had a stillness about him that made me feel comfortable, even when sitting in total silence. We sat together listening to the silence and just soaking up the bushveld magic. Around midnight we became aware that a herd of something or other had descended from the high surrounding mountains and was approaching the waterhole. At first we could not make out their shape and, being unsure what type of creature they were, we climbed into the tree above us where I tried to use my binoculars to see. Our strange, clumsy, ape-like silhouettes caught the creatures somewhat by surprise, making them leap high into the air as if they had springs under each leg. Between their nervous jumps, they whistled loudly, either in protest or disdain at the arboreal Neanderthals who were occupying their space. Clinging to an acacia branch, under the luminescent full moon, and listening to the peculiar whistles of the mountain reedbuck, I found myself helplessly enamoured with Africa and the bush. Long after the reedbuck departed we remained in the tree, hoping that a leopard would come down to drink. The next morning Flintstone and I enjoyed processed cheese on dry crackers for breakfast, from the army 'rat packs' we had been given the day before, and in celebration of having survived our night. For two schoolboys to be left all alone in the African wilderness for a night, completely unsupervised, was no small thing. We felt like Chuck Norris the next day, despite having stayed high up clinging to tree branches for a good part of the night.

6

Olifants

My passion for the bush was being fuelled on one side by the wildlife so-
ciety and on the other by our holiday forays to the Kruger National Park
and another private game reserve on its boundary. Family friends Mike
and Michelle owned a lovely thatched bush house in a game reserve which
we simply called 'Olifants' because it was located along the Olifants River.
Most long weekends would see us taking the picturesque five-hour drive
from the highveld to the lowveld. It really is a beautiful drive. About an
hour or so before the then sleepy town of Hoedspruit, our route took us
through a tunnel at the bottom of the Abel Erasmus Pass.

There the road twists and turns, following an old mountain pass from
the late nineteenth century that was used by early pioneers journeying to
the port at Lourenço Marques (now Maputo) in Mozambique. Of course
those pioneers did not have a VW Kombi like we did to travel in or brakes
to apply on the multiple hairpin bends. In fact they didn't have brakes at
all. They needed to take the front wheels off their oxwagons in order to
better control their steep descent, and to avoid their carts entering the
lowveld ahead of them. In this modern era of travel, the journey through
the tunnel lasts just a few dark seconds as it bores its way through the
Drakensberg Mountains, which form the escarpment separating the high
country from the low country.

In my youthful imagination the tunnel was a significant landmark, not
unlike the Gates of Mordor in Tolkien's *Lord of the Rings*, which represented
a portal into another world, or perhaps even a metaphysical wormhole,
leading not to Middle Earth, as in Tolkien's tale, but to a lower earth. Once
through the tunnel, the air became gradually thicker, carrying the scent of
ripe marula fruit through my slightly open window. The rhythmic cadence
of cicadas rushed and buzzed the air, sounding like the pulley on a zipline
as we descended further down the escarpment. In the distance the Olifants

River was an uncoiled python, snaking its way ever deeper into the dry bush country and on to a faraway land. A land where fish eagles cry, elephants roam, lions roar and a sense of adventure lingers – as evocative as the smell of the neighbours' boerewors braaiing on a Saturday afternoon.

The lowveld, which houses the famous Kruger National Park, might as well be called the 'slowveld', for it is a place far from the hustle and bustle of any city. It is a place where bateleur eagles rock to and fro lazily in the heat haze of the day and languid rivers slide, petering out into a network of sandy veins that make this some of the finest leopard territory in all of Africa. It is not only the big and the hairy that thrive here, like the ancestors of the famous elephant bulls known as the Magnificent Seven. It is also the home of hornbills, with their banana-shaped bills, sleepy-yawning hippopotamuses that chuckle as if laughing at a joke, tall-stretched giraffes and tails-up-when-they-run warthogs. This is the place where the king of the jungle roars in the dark night but equally it is the place where the gentle wood dove coos and the guineafowl whistle gently in the late afternoon.

After completing the five-hour journey which, when including padkos picnics, somehow always became a seven-hour journey, we generally arrived at the Olifants' entrance in the dark. Our friends kept a decades-old, roofless Land Rover at the gate, in which we would complete our journey down to the house. First, though, it needed to be coaxed into life, which sometimes took a little while. What the Land Rover really needed was a new engine (or perhaps for a Toyota Land Cruiser to tow it), but Landys, as they are famously called by those who are devoted to them, are equally famous for needing lots and lots of TLC. This was an irritation for my dad, and especially for Mike, who owned the Landy, but for me it was part and parcel of the adventure.

Usually after about an hour of having the bonnet open and seeing only my dad and Mike's rugby shorts-clad bottoms and vellie bush boots with red laces perched on the old metal bumper, accompanied by the sound of tinkering spanners, the Landy spluttered into life. With its successful resuscitation there was a quick and frantic loading of bags into the back before it changed its mind. We then had a long, winding drive to the bush house, which was beautifully positioned on the bank of the Olifants. Standing

on the back, the smells of the bush mixed with the petrol fumes of the Landy created a heady aroma that made my young brain's synapses twitch, sending out signals interpreted only as the delirious scent of adventure.

As the tyres crunched their way along the granite gravel and mica-mineral-covered tracks, I slowly drifted off into a fantasy world. I was no longer a mere schoolboy on holiday but the head of the anti-poaching unit for the reserve, and we were no longer driving to the house – we were on a dangerous late-night anti-poaching patrol. Peering out into the bush looking for poachers, the kanniedood trees (which literally translated means 'cannot die' trees) stood like cement sentinels. The headlamps of the old Landy caused the mica minerals in the soil to glisten, as if winking back at the stars above. The closer we got to the river, the more the Landy's suspension rocked and creaked; the air became fresher, laden with scents, closing more bridges between the synapses in my head and sending me into a state of near nirvana (which, incidentally, was the name of one of my favourite rock bands at the time).

There was no electricity there in those days and, walking into the dark house, the smell of the thatch roof was everywhere. It was like a home-coming, akin to the smell of fresh bread baking. The sight of the Olifants River glistening in the moonlight at the bottom of the property, framed by the silhouetted contorted branches of an apple-leaf tree growing on its bank, heralded the successful end to our now 10-hour journey. The first order of business was to check under the beds for snakes and my mother always insisted that we inspect the toilet too. This was black mamba country. Once the house was declared 'mamba free', we were sent to bed, leaving my dad and Mike to have a cold beer by the fire and pretend it was their first of the trip when in reality I had been passing them more than just spanners when their heads were conveniently shielded from my mom and Michelle by the Landy's open bonnet.

I would wake throughout the night and it would still be dark when I fumbled my way through to the kitchen in the early morning, trying not to drop anything while I searched for matches and made myself coffee on the gas stove. First digging my hand deep into a box of Ouma buttermilk rusks and grabbing a handful, I set off down to the boma, which was posi-tioned in front of the house on a sandy patch beneath a beautiful sprawling

knobthorn acacia tree. Getting down on my hands and knees, I gently blew air over the faintly glowing coals, coaxing the previous night's fire back into life. Sitting in the pre-dawn glow around the fire under the knobthorn tree, with its tiny neat round leaves silhouetted against the twilight sky, I listened to the bush awaken. This was, and always has been, my favourite time of day.

After my coffee and fire ritual I slunk away into the bush, which to me was nothing less than a proverbial Eden, there to be explored. With my binoculars around my neck and my maroon rucksack on my back, filled with various field guides, including Clive Walker's *Signs of the Wild*, I stopped to measure the animal tracks in an attempt to identify the previous night's visitors. Once the baboons were awake and having spotted a younger pale version of themselves, they would bark at me, getting a massive fright when I, the seeming missing link, barked back. My city-dulled senses underwent a reawakening on these solo sojourns. It was as if an ancient primordial gene inside of me sprang back to life, causing my young heart to beat faster and more strongly.

Forgetting that my dad had told me to stay close to the house, I soon found myself exploring the forest along the river, where the smell of ripe figs permeated the air, towards a large pool upstream. I pushed my way through the prickly reeds to a clump of granite boulders on the edge of the steaming pool, now glowing red with the rising sun behind. In the early dawn, most of the hippos had already made their way back to the refuge of the water. The occasional puff of backlit water spouting towards the heavens was all that signalled their presence. There was a resident African fish eagle on that stretch of the river and I loved the way it threw its head right back when shouting its praises to the African skies, as if demanding more fish from God.

When the sun was fully up and I could see into the bushes, I began my search for the white-throated robin, a bird which to me was the avian equivalent of the Cindy Crawford poster I kept up on my wall at home – a perfect blend of mystery and beauty. Once, searching through the dense riverine vegetation for the robin, I crawled my way deep into a thicket and came face to face with a large russet-coloured bushpig. I am not sure who was more surprised, the pig or me, but the former dropped whatever it was eating and snorted in disgust, before vanishing back into the dark forest.

I also surprised a finfoot on the sandbank in the middle of the river, the bird I had been looking for when floating down the river with my wildlife society mates, and this 'lifer', as new birds are known amongst passionate 'twitchers', was a notch in my belt. It would elevate my status, rather significantly, back in the wildlife society. As the finfoot ran towards the safety of the water, its vivid red legs left me speechless. They were such a brilliant red they resembled blood ejected from an artery. This was a colour I knew well as one of the P-Squares had once crashed a farm bakkie into a termite mound, sending me flying forward over the bonnet and into a thorn tree that poked a hole in my leg.

I followed the river further downstream, through a grove of wild fig trees whose once green, but now yellow and brown leaves, curled and brittle, lay on the forest floor like a carpet. My mother was petrified of snakes and she had instilled in me a healthy dose of respect for them. Taking one careful step at a time, like walking a gangplank, I noticed a segment of the leafy forest floor rise and fall, ever so gently, to the breathing rhythm of what was concealed beneath. I stood there, motionless, until a flicking, darting forked tongue betrayed a puffadder's presence. The snake was lying in patient wait under the leaves for an unsuspecting passerby of the rodent type. Half moonwalking and half levitating my way out of the fig grove, I vowed to avoid leafy carpets from that day on.

Now finding myself even further downstream, I knew that my dad would kill me if he knew that I had walked all the way to the jackalberry forest, but this was the home of the official holy grail of birds, the Pel's fishing owl. This bird is what twitchers call a 'megatick' and being the only fishing owl in the region, it is the megatick of megaticks and one which, despite my best efforts, would elude me for another 20-odd years. Interestingly, all the other owls fly perfectly silently, possessing specially adapted and frayed feathers, but not so the fishing owl, who makes a noise when it flies. Fish underwater don't have ears and therefore cannot hear the approaching raptor as it swoops down, thereby negating the need that other large owls have for a silent approach. Peering into the canopy and searching to the very ends of the long brown boughs of jackalberry trees until my neck ached, and my tummy grumbled, I turned south and began my loop back home.

This loop took me on a game trail into the dry backcountry where on one occasion I found the large pugmarks of a lion. Nervously placing my hand in the exact place where a wild lion had recently trod, I felt in my young spirit a strange sense of being aligned with my destiny. Not comprehending the gravity of the moment, nor knowing that I would one day have my life flash before my eyes when I was at the mercy of lions, I continued following the path where it led downwards, into a dry riverbed, which became to me an artery of exploration, winding its way into the heart of the drier and increasingly inhospitable bush.

I knew there was a chance of bumping into the lion, although a remote one, so I walked with an ever-increasing and heightened sense of awareness. The dry riverbed eventually met a narrow two-track road. As I walked along it, kudu antelope sometimes sprang across ahead of me, bounding in their typical rocking-horse fashion with their tails curled high and white in protest at my presence. On one occasion the crunching of stones under gigantic hooves sounded almost deafening as a journey of giraffe ran ahead of me, giving more meaning to their name, which has Arabic origins meaning 'the swift one'. I knew I was close to camp when I passed by a large clump of dark basalt rocks and the place where I always thought I would find a black mamba sunning itself, but which I thankfully never did. I arrived back at camp just as the others were waking up. I could never tell of my morning experiences for fear of being grounded. All that I had seen and heard were secrets left in the wilderness.

Our days at Olifants were spent doing two long game drives, one in the morning and one in the afternoon, each as long as the beers would last in the cooler. In the middle part of the day, when the adults took a siesta, I would take another foray into the bush surrounding the house. This time I enjoyed the company of my brother Clive as we walked in the heat of the day exploring and birding together. Possibly by osmosis, Clive had become quite a good birder himself.

Being in the Landy, out in the sun and with a cold beer in hand, was simply my dad and Mike's 'happy place'. Sitting on the back wilderness dreaming and pretending that I was a game ranger was mine. We spent many an hour driving through the bush looking for animals or sitting at waterholes waiting for them to come down for a drink. In between

daydreaming about catching poachers and living in the bush permanently, I also learned while sitting at these waterholes to distinguish the differences between a greenshank and marsh sandpiper, and between a common sandpiper and a wood sandpiper.

A campfire and delicious braais of various varieties were how all days ended at Olifants. In the absence of electricity, the fire became the heart and soul of our evenings. After a day of sun and adventure, my eyelids soon grew heavy, but before I went to bed I had a ritual. This involved laying a small patch of fine leadwood ash on the ground at the base of the steps leading up to the house. I would then delicately drop one or two morsels of meat in the middle, and which I had left on my plate for that very purpose. Every morning, almost without fail, a creature of some sort visited in the night to feed on the morsels I had left out. It used to pain me that I never saw the creature and so, one night, I decided to run a piece of string from the morsel to the tip of my finger. My plan was that as soon as I felt a tug, I would jump up and shine my torch to see what creature was at the other end of the string. An ingenious plan, or so I thought, but for some reason it never worked: either the string was too long or I was too tired and deep in sleep. Moving to plan B, I assembled a large pile of enamel cutlery and crockery next to my bed, all balancing on top of a single inverted cup, to whose handle I tied my piece of string. On the other end I upgraded my tiny morsel to a sizeable and juicy piece of fillet steak, just to make sure that I would definitely entice a beast out of the bush. In the black of one fine night I, and the whole house in fact, heard an almighty crash as my pile of cutlery collapsed and the cup shot out of the door at a rate of knots! I leapt up and chased the dancing enamel mug down the steps and past the campfire, now just a heap of glowing coals. The poor critter, whatever it was, must have gotten such a fright. Perhaps thinking that the house was coming down on top of it, it ran for its life. It didn't let go of the piece of fillet, though, and the next morning I found the cup dangling at the top of a tall tree. The fillet was gone.

A coalition of lion eventually took up residence in the bush surrounding the house at Olifants and, roaring feverishly, they advertised their territory. Their nocturnal moaning and groaning had this time not gone undetected by my parents and my mom became particularly anxious, and rightly so,

about my early morning jaunts into the bush. Finally, one fateful night, my dad told me that I was not to get up before them and I was banned from walking on my own in the bush. This was by far the worst form of being grounded I had ever endured. The next morning I woke at the same time as usual, except this time I snuck out of the window next to my bed so as not to wake my parents. Still to this day I am convinced that my dad knew what I was doing as he was not ever one to have the wool pulled over his eyes but my mom, who always slept deeper and later, was none the wiser.

7

Zazu 1 and Zazu 2

When I turned 18 and most of my contemporaries were going off to university, I headed straight to the bush to pursue my dream of becoming a game ranger. I hitched a lift down to a camp called Pumba Pumba, which was situated in the north of the Sabi Sands Game Reserve and adjoined the Kruger National Park. I had spotted an advert for their camp in a magazine when I was supposed to be studying for my final matric exams instead of wilderness dreaming about the bush, and had written to them asking for a job. Frikkie, the camp manager, had sent me a brief reply saying that they could not afford to pay me and that they therefore could not offer me a job.

Just being in the bush was pay enough, I decided, and I literally pitched on their doorstep with a rucksack on my back and my binoculars around my neck. Put on the spot like that, Frikkie and his wife Sarie were like deers in headlights. I told them I was ready to do whatever they needed doing, free of charge. Being very Afrikaans and having a young pimply-faced English boy present himself as some kind of working orphan, well, let's just say that things were awkward, very awkward. The camp was also very small, consisting of just four thatched rondavels that overlooked the Manyeleti River. There was a large thatched dining area in the middle of the camp where meals were hosted and that was basically it.

To begin with Frikkie and Sarie put me in a guest room while they tried to figure out what to do with me. Actually, they ignored me completely, probably hoping I would just leave after a few days of getting my bush fix. Needless to say, I didn't. A small rustic camp in the middle of the bush was, and still is, my idea of paradise. Eventually they needed the guest room for some tourists who were shortly to arrive. They told me that they had no room for me except the storeroom, which was their way of saying 'pack your bags and get out of here'. That wasn't going to work. I wanted

to be in the bush. This was my childhood dream. And so I moved into the storeroom. This proved to be a bad idea, however, as it wasn't the best of accommodation. It was dark and full of old mattresses crawling with bedbugs and I got eaten alive. Soon my body was covered in festering little sores that oozed clear orange fluid for days afterwards and itched like mad. Frikkie and Sarie continued to ignore me and with nothing to do except scratch my sores all day like a flea-bitten monkey, I set out to do the only thing I knew how to do – build the camp a bird feeder.

I found an offcut of wood in a pile of junk behind the workshop and I assembled a bird feeder in the middle of camp. As I was finishing up, getting the feeder perfectly level, Frikkie walked over. For the first time he acknowledged me and – or perhaps I was reaching – he even seemed pleased that here was a young guy displaying some sort of initiative. The penny finally dropped, so to speak. He saw in me an exploitable resource in the form of a bright-eyed, bushy-tailed 18 year old. He could ask me to do anything and I would do it – and he didn't even have to pay me.

The next day he arrived back from the bush with two baby yellow-billed hornbills and told me that I was to raise them to be tame pets for our international visitors, and to get them to make the camp and my bird feeder their home. I asked him where he had gotten the chicks. He told me he knew where there was a nest and that he had stolen them out of it but that I was to tell the tourists that the tree they nested in had been struck by lightning, and that he had rescued them.

I was flabbergasted. But I could not indulge this feeling for long as the hornbill chicks were screaming for food. I soon learned that their favourite delicacy was a juicy grasshopper or two, so I constructed a butterfly net with a piece of netting and a wire loop tied to the end of a bushwillow stick and ran through the bush like a madman, flushing out and catching grasshoppers to feed to my little chicks. I caught dozens of grasshoppers but the more I caught, the more the baby birds ate. Those banana beaks seemed about as disproportionately large as their appetites. Zazu 1 and Zazu 2 had ferocious appetites and feeding them became a fulltime job, and one which instilled in me a great respect for parent birds. My foraging for grasshoppers led me deeper and deeper into the bush. One fine day a safari truck from another tourist camp passed me just as I was prancing

through the veld chasing after a grasshopper and wielding the net from left to right like a man possessed, or perhaps one being attacked by bees. The tourists took a few pictures of me like I was just another of Africa's strange creatures. I heard their guide yell out: 'This is what happens if you stay in the bush too long!'

I could not believe my luck when I stumbled upon a bush that was completely covered in grasshoppers. I raised my net in preparation to swoop in like an adult hornbill would and, using my extensive, albeit recent, grasshopper-catching experience, I swung the net broadly into the air above the bush. I caught not a single one. The grasshoppers were still all just there, sitting on the bush; not a single one had bothered to fly, not even to jump a little. On closer inspection, some seemed to have small dysfunctional wings. I pondered this for a moment. While they might not have been able to fly, surely they could hop? I was hopping, out of pure joy, because there were enough grasshoppers on that one bush alone to last my babies at least a couple of days – which meant I could get some rest. Forgetting about the net, I picked up the old jam jar in which I stored the grasshoppers and, plucking each brightly coloured insect off, one by one, my jar soon filled. With a grin and my jar full to the brim, I skipped my way back to my two hungry chicks.

Both Zazus refused to eat even a single one of my grasshoppers. I sat begging them to eat, just like any good parent begs their kids to eat their vegetables. After several failed feeding attempts, I went in search of an insect book. There, sure enough, I found the exact species of grasshopper, or to be more correct, locust. In bold black letters the name 'Stink Locust' appeared, causing me automatically to lift my hands to my nose, thereby immediately confirming that I had correctly identified the species. The stench stayed on my hands for days afterwards. Reading further I discovered that these locusts feed on poisonous bushes, which in turn makes them poisonous. Tasting as foul as they do, there is no need to escape anything really (let alone a net-wielding kid straight out of the city) and so they had mostly lost their ability to fly. I learned some important lessons that day, the first being that brightly coloured, slow-moving creatures are often poisonous. A few years later when studying nature conservation, I would learn that these bright colours are in fact a warning and what is known as

'aposematic coloration'. I also, on that fateful and rather smelly day, had an introduction to the 'nature vs nurture' theme that is so debated in both animal and human psychology. The young birds had not been taught to reject brightly coloured insects; they just knew to do so. So this was clearly an instinct rather than a learned behaviour. At the time I was so thrilled to have taught myself more about the bush that having smelly hands didn't bother me much, although scratching the itchy bedbug sores all over my body meant that I soon smelled like one giant stink locust myself.

Despite their inept caregiver, Zazu 1 and Zazu 2 grew up fast. Once they could fly, I set them free. Frikkie was furious with me for letting the birds go but that would not be the last time he was to get angry with me. Thankfully, coming from a high school where corporal punishment was dished out left, right and centre, I was quite used to being in trouble. I was also used to being called a 'soutie' by my Afrikaans sporting foe, which was a good thing, because it was Frikkie's new name for me.

The rainy season that year was incredible. We experienced major floods in the lowveld and witnessed the Manyeleti River bursting its banks. We even spotted a crocodile in the river floating past the front of camp. The safari vehicle was getting stuck on every safari drive and my job became one of retrieval, whereby I had to be on standby to, at the drop of a hat, drive a spare vehicle to the one stuck in the mud. The tourists would transfer with Frikkie onto the new vehicle and continue on their safari drive in search of the Big Five. I would be left behind to get the stuck vehicle unstuck. This was great fun for an 18 year old actually – I felt like the original Camel Man, except that I did not smoke.

My standard modus operandi was to jack each wheel up and place branches, which I would first have to cut, under each tyre. There are some lessons in life that you only need to learn once, like how to use a Hi-Lift jack properly. The first time I used the jack I pushed down on the handle and I was amazed at my own strength as the entire car lifted up, albeit ever so slightly. I then let the handle go to give it another pump and with a mighty force, it shot back up and hit me square in the jaw, causing me to go and sit under a marula tree where, like a drunkard after a bar fight, I clasped my nearly but fortunately not quite broken jaw. As the rain kept coming, the surrounding bush eventually turned to mud. Jacking one wheel

up at a time until all four wheels were on tree branches, I would drive a few metres forward at a time before getting bogged again. I was often performing this work in the rain and sometimes I would have to admit defeat and walk back to camp to fetch the tractor, eating ripe marula fruit along the way. And still the rain kept coming. All recoveries were now performed by tractor, but being the city slicker I was, I thought I was quite the big cheese driving a tractor!

Eventually, even the tractor started getting stuck and we began using an old Unimog, which was Frikkie's personal pride and joy. The Unimog was produced shortly after World War II and built to handle any terrain. As such, it had massive wheels, with almost enough ground clearance for a herd of elephant to pass underneath. According to Frikkie, it was impossible to get stuck, something I personally disproved. I got the thing stuck in the river crossing downstream from camp. We had absolutely nothing to use to recover the Unimog, which also weighed about the same as a herd of elephant, and yet again Frikkie was furious. I heard him shouting in his house to Sarie, 'Hoe die donner kry a mens 'n Unimog vas?'

That summer the rain did not let up. Supplies could no longer be delivered to the camp as the supply truck could not negotiate the muddy tracks and so we had to meet it at the gate to the reserve. I was on one such supply run when, soon enough, I found myself stuck in the main river crossing. It was raining cats and dogs. While I debated what to do, I placed a stick at the water's edge. A few minutes later I glanced at the stick and to my absolute horror, saw that it was nearly underwater. The river was rising, and fast! To make matters worse, much worse, I was in Frikkie's personal Land Rover, which was in ever-increasing danger of floating away. Thankfully, I was young and incredibly fit, being kept so by the constant manual labour of getting vehicles unstuck. I ran the proverbial country mile back to camp in record time, leapt onto the tractor and raced back to the crossing. I would have been on two back wheels if the tractor could have gone that fast but since it could not, I reverted to praying feverishly as thick black smoke spewed forth from the exhaust pipe above me. I got to the river just in time and managed to pull the Landy out before it got washed away, but not before its cabin and engine compartment had been thoroughly flooded with dirty brown river water.

Frikkie was livid. From that point on he insisted that I meet the truck at the river crossing and carry all supplies across to our side of the river by hand. I protested this new arrangement, reminding him about the crocodile we had seen floating past camp in the morning while we were having breakfast, but he told me not to worry. He would stand on the river bank with his rifle pointed at the water. The only problem with this idea was that I was more scared of Frikkie shooting me than I was of the crocodile!

The rains continued. Since there were no bookings anyway, Frikkie and Sarie decided to take some leave and send the rest of the staff home to catch up on their leave too. I was left in the camp all alone. It rained for days on end and all the rivers burst their banks, turning the camp into a literal island. For two weeks I was stranded. Never before had I experienced such isolation. One afternoon a helicopter hovered above camp and none other than John Varty himself, from the neighbouring Londolozi camp, gestured to me from the air with the thumbs-up signal, asking if everything was okay. I gave him the thumbs-up in reply, and the helicopter tilted forward and soon vanished, becoming a distant thudding off in the distance. It was thoughtful of him to check in with me, I reflected, but how I wished he had landed for a beer. There was a pool table in camp and over the course of the following days I learned that it is entirely possible to play a game of pool against oneself.

Despite the difficulties and loneliness I was experiencing in my first year out of high school, while my friends were doing fulltime partying and part-time studying at university, it was not all doom and gloom at Pumba Pumba. I was, after all, living my dream of being in the bush. Every spare minute I had I was out in the bush with my binoculars, and not just birding. I began to teach myself how to identify trees. I used the time of the flood to really focus on my trees as they grew everywhere and I could not go anywhere. I would find a tree, then stand in front of it paging through the tree book until I found its match. This was an approach I had used effectively for birds, but trees are a different story altogether; their size and shape vary considerably depending on the region, age of the specimen and the soil type. Looking back, I am surprised at how many trees I correctly identified using the naive, stubborn and painstakingly slow method of leafing (no pun intended) through the book.

When the camp was functioning again after the rains, I sometimes took a walk to the airstrip, where invariably I would find a white rhinoceros or two grazing peacefully. Stalking a little closer to get a better look always got my adrenalin pumping. As I walked back to camp, chewing on a succulent piece of buffalo grass, I felt strangely satisfied with my life.

This satisfaction was erased when I fell ill with a fever. After all the rain and the subsequent emergence of mosquitoes, I had a suspicion about what was wrong. Lying sick in bed, I was grateful that I had a good relationship with the camp cook, who was looking after me. A couple of days later I mustered up enough energy to crawl out of bed and ask to be taken to hospital. Frikkie exclaimed, laughing, 'The soutie has heatstroke, ag shame, man.' He then went on to say that the camp was full of clients so there was no vehicle free to take me to hospital.

A few days later the cook convinced me to go and speak to the neighbour who was visiting her camp next door. Somehow I managed to stumble over and ask her to please take me to hospital. She was leaving the next day for Pretoria and agreed to give me a lift. I lay delirious on her back seat while she drove. I have to say I was a little surprised when she stopped for pancakes in a local town called Graskop along the way, but I was too ill to say anything.

By the time I reached our family doctor in Pretoria I was sent straight to hospital, without even so much as a blood test. Usually when you get malaria you first diagnose the disease with a blood test to confirm the parasite's presence, but in my case I had already left it for two weeks. Jaundice had set in – my eyes had gone yellow – and the doc was alarmed. No time to waste on a blood test, he said. In hospital I drifted in and out of consciousness while the nurses changed my sheets every few hours in between my bouts of fever and cold sweats. Apparently in my delirious state, and according to my mother, I was quoting *The Great Gatsby* verbatim.

This was my first and by far the worst case of malaria I have experienced. After I was discharged from hospital, happy to be alive, I phoned Frikkie to say that I would not be returning to work. There was a long silence on the other end of the line. Then Frikkie said he would like his epaulettes back. These were tiny badges we attached to our shoulders to look the game ranger part and his, rather ludicrously, had pink warthogs on them.

And just like that I found myself back in a city, with nothing but a shattered dream and not even loose change in my pocket.

I took a job as a waiter at our local McRib steakhouse. My training went really well but when it came time to actually serve customers, I realised that I had a big problem. I had grown up in an English-speaking home and had gone to English-medium schools, but I was living in a decidedly Afrikaans town. One fateful night, a difficult customer asked me for some lemon in his Coke. When I set the Coke down on the table, with a slice of lemon in it, the customer seemed upset. He placed the same order again, this time with more emphasis on the word, saying 'LE-MON'. Again I brought him a Coke and this time a few slices of lemon in it, which seemed to set him off on a big rant, of which the only word I could understand was 'donner'. He told me that if I didn't bring him a 'donnerse Coke with le-mon' right away, he was going to complain to my manager. I went to the back storeroom, grabbed a handful of lemons and proceeded to jam a tall glass full of lemon slices. I then dribbled some Coke into the remaining space in the glass but there were still lemon slices left over, which I placed on a side plate. Setting both the glass and plate of lemon slices down before the customer seemed only to inflame the situation. In fact he hit the roof and this time his verbal complaint included insulting my mother. My manager declared my shift over and told me that if I did not want to, then I did not need to return. Her diplomacy in firing me was honourable. I suppose I should have known that a lemoen in Afrikaans is actually an orange, but I was probably not paying attention in that particular class. I was more likely gazing out of the window dreaming about the bush.

8

Happy

During my last year of high school, using the advertisements in the back of *Getaway* magazine, I had written to a large number of safari camps requesting a job. One of those had been the Timbavati Wilderness Trails (TWT) but they were not keen to take on someone who had zero work experience in the bush. Now that I had some experience, I tried again, and the owner, Mike Buchel, replied to say they would like to see me for an interview. My dad, who was handling the correspondence via email from his work address, omitted to tell me it was an interview as such; instead he told me that he had found me a job and that I must pack my bags for good. This time I didn't have to hitch a ride. My dad drove me down to the Timbavati, which also lies on the eastern side of South Africa and is adjacent to the Kruger Park. Of course this was a route very familiar to us because it was the same road we took to Olifants. Clive came along too, just for the ride.

Six hours later we were in a very rustic safari camp called Sesetse. Mike himself came to meet us. It was a lengthy interview, during which Mike interrupted himself periodically to ask me to identify whatever bird was making a sound in the background. I must have got them right because it was after I had successfully identified the trilling call of the striped kingfisher that he said he was prepared to give me a go in an apprentice role. When he suggested that I start in three months' time my dad quickly interjected. 'The boy's bags are packed. He is ready to start right now.' Before Mike could reply, my dad had pulled my bags out of the car boot and set them on the dusty ground. Mike was still shrugging his shoulders when my dad drove off, leaving us standing in his dust and Clive waving goodbye to me through the window.

My new employer looked a little shocked, even annoyed. I think he had just come down for some quiet bush time of his own and being suddenly saddled with an apprentice to babysit wasn't what he'd had in mind.

Having to quickly come up with a job to give me, he sent me down to the river to start the water pump. As I wandered down the narrow pathway towards the river, he shouted, 'Whatever you do, don't let the pump run dry!'

Now I had grown up in a city, where water is not something you pump – it just comes out of a tap. In suburbia pumps and engines and suchlike were all things handled by professionals and were largely foreign to me. I did know how to drive a tractor now, though, and how to operate a Hi-Lift jack, but I hadn't had to deal with a water pump. Arriving at the river and inspecting the pump, I found a cord to pull on, and when it spluttered into life I was well chuffed. With my first job successfully accomplished, I sat on the bank of the Sesetse River, chewing a piece of grass between my front teeth and thinking how good it was to be back in the bush, and to have been given a second chance at living my dream.

When I returned to the camp Mike seemed somewhat surprised to see me back so soon. He promptly walked me back to the river where he placed his hand on the side of the pump. It was boiling hot! The pipe that was supposed to be sucking the water out of the river pool was blocked with sand and the pump was running dry. He was very angry. I was having horrible déjà vu Frikkie flashbacks. I was also getting used to the fact that bosses seemed to be really very angry people. The difference this time was that I was actually getting paid a salary – the handsome sum of R400 per month – so this was no laughing matter.

Having failed my first task rather miserably, my second task of my first day was to drive to town, which was about an hour away, to purchase some basic commodities for camp. I was determined to do the shopping well as that is one thing a city dweller should know how to do. Although I had only just begun, Mike and I had already gotten off on the wrong foot and I really did not want to have a repeat of the relationship I had had with Frikkie. Coming up to the reserve's gate, which was a farm-style swing-gate, I was pleased to be driving a Toyota Hilux bakkie, which in South Africa is a pick-up truck of legendary proportions.

Not far after closing the gate I noticed tracks on the road. I stopped the bakkie and jumped out to investigate. I soon found myself surrounded by lots of big spoor that were round-ish and bovine-ish. I picked up the radio and, trying to remember what call sign Mike had told me to use if I had

any questions, I stammered, '93 ... Mmmike, co-co-co-come in fo-fo-fo-for Greg', trying to sound as professional as possible. I still suffered from a bad stutter, especially when I lacked confidence, which seemed to be most of the time.

'Roger, go ahead, Greg,' came Mike's reply.

'Ma-ma-ma-MIKE, an ent-t-t-t-ire herd of ba-ba-ba-buffalo has es-es-es-scaped from the re-re-re-reserve!' I exclaimed, speaking as fast as I could.

'Greg, where?' came Mike's concerned question.

'Ju-ju-just outside the ga-ga-gate, Mike.'

'The first or second gate, Greg?' asked Mike.

'Ah-ah-ah the the the fi-fi-first, Mike.'

'Greg, are you sure they're not cattle?'

'U-u-um ur-ur-ur, ya-ya-ya-yes, ma-ma-maybe, mi-mi-MIKE,' I spluttered, stuttered and stammered.

Crackle, crackle. Then radio silence. I could only imagine Mike nodding his head, understanding perfectly why this kid's dad had been so eager to drop him off.

What I didn't know was that Timbavati Game Reserve had a buffer zone in the south, separated by two gates, and in between these gates farm workers were allowed to graze their cattle. The entire reserve had just heard me call in an escaped buffalo herd. By the time I got to town I was still blushing, wondering if I should not have just carried on with my waiter career.

That night I lay awake in one of the camp's huts feeling pretty upset, at both my water pump and buffalo blunders. Since entering adulthood, I had felt like I was all thumbs and my lack of practical and mechanical knowledge was proving to be a real problem in the bush. When I did finally fall asleep, I was woken by various strange mooing and bellowing sounds, interrupted by the occasional 'clunk'. I lay in bed wondering what on earth was outside. As the clunking got closer and closer, I could hear a great amount of shuffling in the grass outside. The periodic guttural bellows were completely foreign to me. I climbed out of bed and rolled back the single large blind, which was all that separated me from the bush outside as, being a trails camp, it was rustic and the huts had no windows, at least not the kind with glass in them. Peering out, I beheld a most beautiful sight. It was full moon and the moonlight was reflecting and glistening off

the wet, muddy backs and horns of hundreds of buffalo as they grazed all around my little hut.

A feeling swept over me – and anyone who loves Africa will recognise it – that feeling of being hopelessly enamoured and entirely captivated by the sights, sounds and smells of the bush. Despite feeling far from home and very alone, I knew that the bush was where I belonged. I went back to bed, determined that in the morning I would study the tracks left by the buffalo so as to once and for all learn the difference between a cow and a buffalo.

While I might have been somewhat challenged in the 'bush mechanic' department, I was, however, and as mentioned, a fit young man and the next job Mike gave me was right up my alley. Not wanting to risk me breaking any equipment or driving anywhere, he asked me to fix the access road to the camp, which had been damaged by the rains. I grabbed a pick and a spade from the storeroom and set off to the top of the camp's 'driveway'. I worked right through the day, wielding the pick like Braveheart on crack and shovelling sand like a mineworker possessed. Every time I felt fatigue, I thought back to all my blunders: like getting Land Rovers, tractors and even a Unimog stuck in rivers; about how lemoens were not lemons; and, more recently, how I had let a water pump run dry. I didn't even know that was a thing – to not let a pump run dry. I thought bush living was about animals and birds, but all I was doing was breaking machinery of various descriptions. And besides, even if it was about animals, it seemed I couldn't tell the difference between a herd of cows and a herd of buffalo.

Harnessing all the embarrassment and the negative energy, channelling it down my pick and shovel and into mother earth, by the end of the day the road was finished. I returned to camp, where Mike asked if I had worked hard. I opened my hands and I showed him the blisters, which had all popped before they even had time to form, and the pink raw flesh exposed beneath. Although they stung like crazy, I was pleased at having just gotten through a day without breaking anything and without making anyone furious. That night, sitting around the fire and dipping pap into

Mike's delicious Durban-style curry, he told me that the next day I was going to meet my future boss.

Mike was the owner of the business and he came up once a month to help out for a few days, but my real boss was the late Eldred 'Happy' Hapelt. This seemed a bit strange to me but at least he sounded, well, happy, which I thought would be a nice change. Mike proceeded to give me a bit of background. Happy was born in South Africa in a year so far back that my mind could not comprehend the number. Quickly doing the arithmetic, I figured he was around 60 years old, which to me was simply ancient.

Happy had spent a large part of his life in Zimbabwe (then Rhodesia) at a time when large areas of wild bush country were being converted to cattle ranches. Part of Happy's job was surveying the land and advising the farmers on how many head of cattle they could run. The other part was a commission to hunt dangerous game to make way for the cattle ranches. But Happy's heart was not in it, Mike said, and the hunter was now a passionate wilderness game ranger, one that knew every grass, tree, animal and bird in the bush.

This was excellent news to me as I wanted to learn as much about the bush as possible. Just as I was beginning to smile, I saw a small frown forming on Mike's face, but it was only later, while we were enjoying our dessert of Ultramel custard and tinned peaches, that he put words to his frown. 'Happy is a tough sort,' he said nonchalantly. 'From the old school, you know, my boy?' Then, giving me a brisk smile and a pat on the back, he said, 'He will warm to you soon enough.' And with that he said goodnight, leaving me by the fire to contemplate my next new boss and what exactly he meant by 'from the old school'.

The following day he drove me across to the original trails camp, simply called Timbavati Camp due to its position on the bank of the Timbavati River, and walked me to a large wooden hut on stilts to meet Happy. I peered inside the basic abode. There was no door, let alone a doorbell. I was to be Happy's 'app', short for 'apprentice'. Hap was short for Happy, which meant that Mike introduced me by saying 'Hap, meet your app,' the rhyming syllables of which seemed to really tickle him. Happy, decidedly less tickled by the introduction, looked stern, very stern, and if he was indeed happy, I concluded that it must be a deep-down kind of happiness. Looking

around the hut, I noticed that there was no TV, sound system or computer. The entire camp, in fact, including his own wooden hut that I was standing in, had been supervised and built with his own bare hands.

There was no electricity, just an HF radio in the corner. His shower was a bucket outside and his loo was a 'long-drop' facing the river. I would go on to learn that Happy only ate what he killed, that he serviced his own car and that, although he lived in the bush permanently, he would go to the bush for holidays. Tall and fit, with bulging calf muscles, he had a white wiry beard that framed a hard-looking face. His leathery, sun-battered and wrinkled skin was more tanned on his arms and legs, especially around his kneecaps. He wore light tan-coloured veldskoens, short khaki pants and a short-sleeved khaki collared shirt, with a neat pocket containing a pencil and a notebook. A pair of spectacles dangled around his neck and a floppy green sun-bleached tennis hat, just wide enough to cover the top of his head, which I presumed was bald, completed the look.

He inspected me without speaking. With his white beard and protruding nose, I thought he resembled a vulture – one that had circled the block a few times, possessing the wisdom and shrewdness needed to survive a lifetime in the African bush. After Mike's witty introduction, and with just the three of us for dinner, later that night I enthusiastically tried to start a conversation with Happy. I wanted very much to make a good impression. This was one boss I did not want to infuriate. Having been told that Happy was a bush guru and having recently read an article in the *Africa & Environment* magazine on how wildlife scientists were baffled by the reason behind the whooping call of the hyena, I put the question to Happy. With bated breath I waited for what I was sure would be his insightful answer. He seemed not at all fazed by the question that had long puzzled the hyena scientists, and he had a very simple answer, which he gave after a long pause, so long in fact that I wondered if he had heard the question at all. Finally, he said: 'To say hello, of course.' Then he got up, poured another whisky into his enamel mug and sat back down at the table, swirling the ice around a bit, making it clang against the side of the mug with a hollow tinkling. Not really understanding his answer or yet understanding his sense of humour, I tried to make more conversation but failed dismally. Lying in bed that night I could not help but feel that perhaps Grumpy was

a more suitable name for the man.

Mike left me with Happy the next morning after showing me where my new permanent home in Timbavati Camp would be. It was right at the end of the camp, far into the bush and a considerable distance from the kitchen, which was a big concern for me. My house-to-be was in fact not a house at all, just a small one-bedroom hut raised up on stilts and positioned under a beautiful African ebony tree. It had a grass-thatched roof and was open in the front, with a knee-high wall separating my sleeping compartment from the small wooden deck outside. This meant that lying on my bed I had a view straight up the Timbavati River, which, although for a large part of the year is a sand river, made for a beautiful view. The hut had massive windows on either side, except, as I'd noted with Happy's hut, 'windows' is perhaps not the correct term. What they really were were two square holes cut into the hut walls, so big that not just a single lion, but an entire pride could have leapt through them and onto my bed. There were thin canvas blinds to drop over these 'windows' but I was too scared to unroll them as they looked like they had never been unrolled before, and who knew what was living inside of them?

My shower consisted of a reed cubicle outside, and a bucket dangling on a rope. My loo was a separate reed cubicle around a hole in the ground and located under a gwarrie bush, sufficiently far enough from my hut to make any night-time visits restricted to emergencies only, especially since the camp had no fence. It must be said, though, that the loo had a fine view, also looking onto the Timbavati River. As I unpacked my bags, placing my bird book and binoculars beside my bed, I was both excited and nervous. Excited to be living in the wild and nervous to be away from home. I was also feeling very alone, with only Happy for company.

In the morning I walked back down the narrow pathway towards the central kitchen and dining area, where Happy was quick to tell me that the rains had damaged the roads and that I was to go and fix them. My hands were still raw from doing the same at the other camp, where I felt I had already made my point to Mike. All I really wanted to do was learn about the bush, but it seemed that, just like at Pumba Pumba, I was destined to be the general dogsbody, or GDB for short.

Every camp has a GDB and being the apprentice, which is just a nicer

term for GDB, I mumbled to myself that a few more hours of hard manual labour would not kill me, and so I set off to work with a pick and shovel. After a few hours, and glancing back at the repaired road, I decided that I had done sufficient work for a morning and returned to camp, where I plonked myself down in a chair. Happy came around the corner and asked me what I thought I was doing. I explained that I had done sufficient work for the morning and that I had in fact placed no fewer than four bakkie-loads of gravel on the road. Happy was not buying it. He gave me my marching orders, telling me that lunch was at 1 pm and that he did not want to see me back a minute sooner.

The camp had no tourists for the time being. Tourists were in fact referred to as 'traillists' because the company specialised in offering walking safaris. With the camp empty, it meant that at night-time it was just me and Happy, all alone, for dinner. There was not even a fire. For conservation reasons, we never made a fire at night unless there were traillists in camp so as not to waste wood.

Happy and I would have a basic dinner sitting at a table under the large thatched roof in the dining area, which also had no walls. What is it with the no-walls thing, I wondered, as we sat in the dark with only a lantern or two to light our plates. With the camp having no electricity, of course TV was out of the question; in fact it was so remote there wasn't even FM radio signal, not even Radio Jacaranda, which growing up we had called Radio Back-veranda. That night, and in the nights that followed, I tried to make conversation with Happy but it was always to no avail. He seemed completely comfortable in total silence while I, coming from a city, was not. In fact, I felt very uncomfortable sitting in silence, especially with someone else; it seemed odd to me. Not only did Happy like silence, he seemed to loathe small talk and small talk was all I had to offer.

Later I would learn that Mike was in the habit of simply sending young men to fill the apprenticeship position without consulting Happy. Young men, like myself, came cheap and they performed the important, albeit mundane, GDB tasks of shopping, cleaning lanterns, filling gas bottles, digging holes, fixing roads and collecting firewood, among many other chores. The lonely bush lifestyle often proved too much for the apprentices, who soon quit. As a result of having numerous youngsters 'maaking droog'

(Afrikaans for 'not performing'), Happy was never keen on any new young recruits. He would have preferred to just run the camp on his own. And now he had me to contend with. His strategy seemed simply to keep me out of camp and therefore out of his hair. As a result I was out all day every day, seven days a week, fixing roads with hands that became hard and calloused. While I was performing my GDB duties, Happy was conducting walking trails with tourists. This, of course, was the heart and soul of the business.

We got a lot of corporate groups, who would come on a wilderness trail for four nights, mostly to get close to nature and to have a bit of an adrenalin pump, and to bond, which should just read 'to drink beer'. The traillists would be led by Happy on a walk every morning and taken on a safari drive every afternoon. I was desperately keen to join in on a walk or a drive, but Happy had me doing manual labour and fixing roads seemingly all the way to Timbuktu. If I was not repairing roads, I was digging holes for septic tanks so big that a rugby team could fit inside one. Finally, after I'd been there a month, I plucked up the courage to ask him if I could join him on the afternoon safari drive. For an answer, Happy looked around the corner at the pile of firewood lying at the entrance to the camp and told me that we needed more wood.

I made many more attempts to get on a drive or walk, including just going and sitting in the safari truck, but on every occasion I was pointed in the direction of the dwindling pile of firewood. Finally I decided that the only way I was going to get out into the bush on a walk or drive was to take care of the pile of firewood once and for all. And so I launched 'Operation Firewood'. The next morning, I pulled out of camp when it was still dark. I had already started collecting wood when the horizon in the east developed a red tinge. The dawn chorus signalled the start of a firewood-collecting ultramarathon, whereby I would run into the bush, grab a log and race back to the bakkie as if I was in a log-carrying strongman competition. I didn't stop for tea or lunch. I carried on collecting wood like a termite on tik. As soon as I had the wood piled high above the bakkie's roof, I lashed it down with a blue and white ski-rope and drove back to camp as fast as possible, the suspension creaking over the drainage humps I had spent the last few months building. I offloaded the wood quickly, jumped back into the bakkie like a rally car driver and was

off again to collect another load.

This exercise I repeated all day, finally rolling into camp at dusk with the bakkie's suspension groaning even louder because I had desperately tried to make the last load as big as possible. By now the woodpile was so tall I had to throw the last pieces as high as I could so as to land them on the top. After 12 hours of wood collecting, the camp's woodpile was now nearly four metres high and about six metres long. I stood back to take in a wide-angle view of my day's work and then, utterly exhausted, I trudged back along the path to my hut, where I kicked my boots off and enjoyed a hard-earned bucket shower. At dinner that night, and as per normal, Happy didn't say much beside 'Pass the salt.' I had been in camp for three months. That is three months of being sent daily into the bush to fix roads and collect firewood. All I wanted to do was get an opportunity to go on a walk or a drive, and to learn how to become a game ranger. All Happy wanted to do was be rid of this irritating pimply kid who talked too much.

Once our plates were clean, we left the dining area to walk back to our huts. I would always have to walk behind Happy as he scanned the bush for dangerous animals. Sweeping his torch-beam back and forth, we often, and sometimes quite narrowly, avoided stumbling into buffalo or elephants who came into the camp at night to feed on the lush riverine vegetation. Our path took us past the woodpile. On this particular night, the flashlight in Happy's hand stopped its toing and froing, momentarily that is, and came to rest on the pile of firewood, whose substantial black mass in the dark resembled a herd of elephants. 'Hmm,' said Happy, before muttering a short sentence that left a lingering whisky odour in the air. 'That's quite a pile of wood you got there, sonny.' With that he continued walking and the torch-beam continued swinging to and fro. It was a short sentence but I saw it as a victory. Happy had actually spoken to me, and thrown in a word of two syllables, and he had complimented me. Well, 'complimented' might be stretching it; let's rather say he had 'acknowledged' my work.

That night I lay in bed looking at my now hardly recognisable calloused hands. Perhaps Mike was right, I thought to myself, and Happy was from the old school. In which case I prayed that I had just paid my school fees. And with that I drifted off into a much-needed deep slumber.

9

Klepto the hyena and boomslangs in my roof

After 'Operation Firewood', Happy began using full sentences more regularly. More importantly, he allowed me to join him on walks and drives, with increased frequency. For the walks I would have to wake up in the dark, before anyone else was even stirring, and pack the rucksack. I would throw in a few oranges and apples along with some biscuits, cheese and water. This might seem like a simple job but I could not afford a mistake, especially since I loved going on walks and if I forgot the toilet paper, or a knife for the cheese, or the rubbish bag, I knew that the next day I would be fixing roads or digging holes again. To avoid this, I developed a method. First I assembled all the items on top of the gas chest freezer, and then I would count them. Knowing that there had to be 13 items, if I counted only 12, I knew I had forgotten something.

At first light Happy made his way down to the mess area to prepare his rifle and ammunition. He had been a big game hunter for many years in Zimbabwe and now, as a wilderness trails guide, a rifle was as much a part of his life as at any other time. I was not yet allowed to touch the rifle, but I watched as he pressed one large copper-clad bullet at a time deep down into the weapon, before snapping the shiny silver bolt shut. After enjoying coffee and rusks with the traillists we set off into the bush. I walked at the very back of the line, my job being to carry the rucksack. I wasn't complaining. To say that I enjoyed this part of my job would be an understatement – I loved it!

I was all ears every time Happy stopped to talk about a flower, bush or bird and I would watch him intently as he tracked big game. I especially enjoyed how, when we got close to a dangerous animal, he would dip his hand inside a leather pouch on his hip and bring out a fistful of fine, powdery ash that he'd collected from the campfire. Raising his hand, he delicately released a thin line of the white ash to detect which way

the wind was blowing. Like the puff from a cigarette, the falling powder detected even the slightest breeze, allowing us to reposition ourselves so as to always be downwind before stalking closer to whatever potentially dangerous animal we were wanting to get closer to. While many safari guides in Africa conduct walks, their intentions are usually more to avoid close encounters with big game. Happy's walks were different in that the aim was to experience big game on foot, and experience big game we did.

While my mundane GDB daily tasks, like shopping, digging holes and repairing roads still continued, these were now punctuated by morning walks or afternoon game drives. A large task that Happy and I undertook together, something we did once a month, was that of 'rations'. All our meat in camp, for both staff and traillists, was venison: impala, to be more exact. Not being a hunter, and Happy being an ex-hunter, meant that this was not our favourite chore, but we took it seriously. One of Happy's over-riding qualities was the respect and love he possessed for the animals of the bushveld. In the safari world, almost everyone loves and respects wild-life but Happy's appreciation for wild creatures was on a different level altogether. If you live in the bush fulltime, it does not take long before you start driving past the more common animals, such as impala, without even noticing them. Happy was different. He loved every creature in the bush equally. He would always stop the car and even sometimes greet, quite audibly, I might add, whatever creature was standing next to the road. If he was driving along and a herd of impala was split on either side of the road, he would patiently wait for the rest of the herd to cross before driving on. He behaved like this regardless of whether he was conducting a safari drive or rushing on his way to town to buy provisions or see a dentist.

Taking all this into account, you can well imagine that Happy did not enjoy having to shoot for the pot, but it was a part of our job and he handled it with professionalism and the utmost care. He would expertly load his own rounds, sitting in his hut and using a tiny scale to weigh the gunpowder down to the last gram. He would then make sure that his rifle's sights were perfectly calibrated. When he was satisfied, we would head out together and go in search of a herd of impala.

Once we found a herd, Happy drove past it. Only when we were completely out of both sight and earshot, did he switch the engine off. Then he jumped

out of the vehicle and disappeared into the bush, leaving me surrounded by a silence that can best be described as deafening. Our modus operandi was so that the impala never associated our safari truck with danger. Although this made Happy's job much more difficult, it was something he was adamant about. Stalking his subject with patience, and years of experience, he took his time.

Sitting, listening and waiting in anticipation for the bang, not being able to see or know what was going on, was like a mild form of torture for me. When I heard the rifle's blast echo through the valley, I quickly started the engine and followed the sound. If it had been a long stalk, I sometimes had to drive a couple of miles to the location, where we would then load the animal into the back. Unfortunately, the camp needed four impala per month and Happy chose to get it done in one go, which meant that we repeated this entire exercise four times. Driving around with the dead impala was my least favourite part. As rigor mortis set in, the carcasses on the truck's bed would kick vigorously between my legs, before finally stiffening. Remember, I was a city boy, who had grown up buying meat in styrofoam containers covered in clingfilm. I never quite got used to this kicking from the impala; I always thought they were still alive. But I had to put on a brave face and not allow myself to get a visible fright every time one kicked, as I did not want Happy to know what a wuss I was.

The next day, also very early, my own difficult task began: I was the camp butcher. Happy patiently taught me exactly how to dismantle, cut and pack an entire carcass and we utilised every part of the animal, setting aside even the bones for soup. The most dangerous part for me was using the big orange electric saw, the one all butchers have, with a long vibrating silver blade that cuts through bone like paper. Being a bit clumsy, I always feared accidentally adding a finger to the stew meat! Happy also made me grind the mince by hand. It was only after I had suffered suitably, having to manually remove the sinew that always caused a blockage, that he showed me the automatic mincing attachment that comes as a standard feature on the side of any electric saw. He also showed me how to expertly divide and separate the hindquarters into their respective muscle groups like topside and silverside. I always found that part difficult, though, and I never quite mastered it, often having

to call Happy to the butchery to help. I did, however, with practice, get so good at being a butcher that eventually I could complete the job of working four carcasses in a single day.

Happy made sure that we kept some meat aside, which we soaked in white wine and covered in salt before hanging it outside his hut to dry and become biltong. I was always glad that we hung the meat outside his hut – I wasn't too keen on attracting predators to mine. The camp had been there for 20 years and the bush had reclaimed it to a large degree and this, coupled with the fact that it was unfenced, meant that we regularly had big and dangerous game walking through. I would often lie awake on my bed listening to elephants munching so close to my hut that my bedroom was permeated by the behemoths' sweet smell. I learned to sit up in bed while half asleep to listen to lions roaring – and they roared often. Happy had taught me that if one is not upright in bed, it is impossible to tell the direction from which the roars are coming. Knowing that we would be walking the next day, the direction of lion calls was something we paid special and careful attention to.

The camp had some delightful smaller residents. My favourites were the large gang of dwarf mongooses. The tiny creatures would usually arrive while we were having breakfast and request a breakfast of their own. Happy was the only one allowed to feed them. He would fetch an egg from the kitchen and roll it in the direction of the motley crew, who would then feverishly roll it further themselves to the base of the closest tree, where, flicking it backwards through their hind legs, they would crack the shell against the trunk. The contents of the egg were relished and devoured in no time at all. They also loved cheese which, considering that they are carnivores from the order Carnivora, might seem a bit strange, but I guess they were just after protein of any kind. The strangest thing about these marvellous little creatures is that subordinate females can lactate without necessarily being pregnant, thereby assisting in the nursing of young. This is what is known as spontaneous lactation.

Speaking of marvellous creatures, we also had a couple of porcupines that came into camp. They knew exactly what time the kitchen staff knocked off and timed their visits accordingly to feed on the peelings that had been especially left for them in a green bucket below the kitchen

counter. We would often catch them gorging themselves when we were on our way back to our huts as we had to pass through the kitchen to get to the path that led out to the back of camp. Porcupines are much larger than one might realise, their quills reaching almost to waist height.

We had another camp 'pet' but this one I learned to loathe. Like the porcupines, our hyena, whom we called Klepto, would wait until the lanterns in the kitchen had been blown out before running through on a raiding party. Although no scraps were left out for him, he always had to make sure. While we were sitting at the fire with the traillists, still digesting our dinner, the clanging of pots and pans told us that Klepto was in the kitchen wreaking havoc. Being the GDB, I was duly sent forth to chase him off, a duty I performed with gusto, I might add. Somehow, though, Klepto always knew when I was coming and he would scamper out the other side ahead of me, before turning around and glancing back. His irritating whoops tormented me; it was as if he was laughing at me.

One night I decided that I was going to surprise him. Instead of sitting by the fire, I sat closer to the kitchen and in the pitch dark. As soon as I heard a pot fall, I sprinted into the kitchen only to find Klepto sprinting in the opposite direction – straight towards me! I was now blocking his way. Close up, a hyena is a lot bigger than you might think. Remembering how this one had once bent a stainless steel pot with his jaws, I turned and ran out of the kitchen with my bum thrust forward to avoid a bite and my arms pumping vigorously to maintain forward momentum, Klepto hot on my heels. As soon as we were both clear of the doorway, I peeled left and the beast peeled right. By this time my heart was beating considerably faster than the camp's old Lister diesel pump, which I had, very proudly, recently learned to start all on my own.

This same hyena would, once I was asleep, sneak into my shower and nick anything that I had left behind. One fateful night, after a day of fixing more roads, I took my bucket shower in the dark and left my favourite pair of leather boots behind. These were not just any boots. They were my special 'buffalo boots' and made to last a lifetime because they were constructed from real buffalo leather. The hyena must have been partial to the taste of buffalo because he stole not one, but both. The bold delinquent even started stealing things straight out of my hut, including my

beloved maroon rucksack. For some reason, Klepto favoured my hut, probably because it was at the end of the line and the furthest into the bush. In the mornings I would often wake to find something missing. When I trudged into breakfast moaning about the kleptomaniac hyena, Happy sat sipping his tea, legs characteristically crossed, quietly chuckling away to himself. He reckoned that the hyena was stealing items from my hut for his own abode, where he sat tanning during the day, in my boots, reading a book and wearing my sunglasses, the latter being the most recent item to disappear.

I finally decided to try and outsmart Klepto. I took a drive to Hoedspruit, which was our closest town, where I managed to track down a packet of party balloons. With a look of glee upon my face, I returned to camp. Later that night I found some congealed cooking fat in the bottom of a pot. It was thick and white, perfect for my plan. Back in my hut while everyone else fell asleep I stayed up, blowing up balloons until my cheeks ached. I tied the balloons, one at a time, to the supporting poles of my hut. There were a few left over, which I placed in my shower and tied around the surrounding trees. I then dipped my fingers into the cold white fat at the bottom of the pot and smeared each balloon liberally with grease before jumping into bed.

Not long thereafter, I heard a loud pop!, followed by a high-pitched squeal that sounded as if it belonged more to a warthog than a hyena. The sound of paws slapping the earth in a rushed panic grew ever fainter as they disappeared into the night. To this most pleasing lullaby I closed my eyes and fell fast asleep. The next morning, after a good night's rest, I told the story of how I had outsmarted the beast and I relished every second of it. I was the one chuckling this time. Happy quietly sipped his tea, saying nothing.

The next night I smeared a fresh supply of fat onto more balloons and retired to bed for another peaceful night's rest. When I registered a loud bang in my half-asleep state, I just grinned to myself. I was about to roll over and make myself more comfortable in my bed when I heard another loud bang, followed by another, and another, and another, until it sounded like World War II outside my hut. *Bang! Bang! Bang! Bang!* Apparently deciding that one delicious lick was worth the bang that followed, my

rabid nemesis ran from one balloon to the next. *Bang!* I was furious. The next morning I could hear Happy's chuckling from around the corner before I even reached the mess area for morning tea.

Aside from having to deal with Klepto, for the most part living in a rustic trails camp so close to nature was wonderful. My hut was raised on stilts and, as I've mentioned, it had no windows. In the cold winter months of June and July all I could do to try and keep the cold out was roll the canvas blinds down. Our camp being in a valley and on the bank of the Timbavati River, the cold seeped in, or more correctly speaking, it seeped up and through the ample cracks between the floorboards. On one occasion, during a sleep-out, the water in the bottom of a hand-basin actually froze. Lying in my hut on those winter mornings, the first thing I did once I was awake was exhale deeply to check how cold it really was. If I saw steam escaping from my mouth, I would grab my clothes, which I had carefully placed beside my bed the night before, and yank them under the covers with me. They were so cold that at first they felt wet. I would wait for them to warm a bit, then leap out of bed and prance around on the cold floorboards, like some sort of clumsy gumboot dancer, trying to fit one new Trailbuster boot on at a time. These I made damn sure were right beside my bed every night, so that the balloon-popping klepto-mongrel wouldn't get to them. At least in winter there were no insects, and no scorpions, so there was no need to shake my boots out first, and this helped to not delay the getting dressed process.

One night I was lying in bed in my hut and, for some unknown reason, after I had switched my gas lamp out, I flashed my torch into the roof. I was more than a little surprised to see, in the apex of the grass-thatch roof, two large green snakes coiled up. I felt with my fingers for the snake guide book on my bedside table. Not wanting to take the beam off the serpents, but needing to read, I quickly flashed my torch into the book and turned a few pages, before pointing the torch back up at the roof, where the shiny green scales glistened in the light. The only large green snake matching the

size and shape of the two in my roof was a boomslang. In the book there was a skull and crossbones symbol adjacent to the name, only in a different colour – red – to the other skull and crossbones symbols beside deadly snakes I knew, like mambas.

Not being able to continue without knowing what exactly the red skull and crossbones meant, and not wanting to take the torch-beam off the snakes, my speech stutter transferred into my reading as I shone the torch to and fro between the roof and the book until I eventually found an explanation. While no one ever expects pleasant news from a pirate symbol, I was horrified to read that the boomslang has an especially potent and unique venom. Unique in that the haemotoxic blood-thinning venom requires its own special monovalent anti-venom which, my book also stated, 'is difficult to locate'. Not able to stop illuminating my book so as to read more about the serpents above me, I continued reading about how a single bite can cause bleeding from a person's gums and 'other orifices'. Shining back up at the snakes, I contemplated how many 'other orifices' I in fact had before I evacuated my hut by horizontally levitating off my bed and squeezing out the opening between the window blind and the wall, thereby not risking walking beneath the snakes.

'Happy!' I shouted in panic, standing outside his hut. Not even waiting for his reply, I yelled again. 'I have two boomslangs hibernating in my roof!'

There was a longer silence than I wanted, before Happy responded. 'Yeah, and so?' he said.

Perhaps he hadn't heard me properly, I thought. I yelled back, harder this time, and with more emphasis on the word 'boomslangs'.

Again there was silence and again not waiting, I blurted out, 'So can I shoot the BOOMSLANGS that are in my roof?'

'Not a chance in hell!' Happy yelled back, and this time there was no pause before he continued. 'They belong here more than you do!'

'What am I supposed to do?' I asked, fear catching in my throat.

'Go to bloody bed. Goodnight!'

And with that I was left outside standing in the dark, totally vexed.

I could not access the rifles in the safe because I didn't have a key and sleeping outside was not an option. Lions and leopards have a bite of their own, for which there is no anti-venom whatsoever. I had no option but to

return to my bed. Climbing back through the side opening with the stealth of the Pink Panther, I crept under my duvet and fell asleep on my back clasping my torch on my chest, its beam shining up at the two slithery bodies above me. I did this every night for the entire winter. The snake duo might have enjoyed the extra warmth from my flashlight's beam, but I just needed to know that they were still there, tucked away in my roof, until my eyelids grew heavy. What exacerbated the situation was that a tiny grey tree frog had decided to hibernate on the bookshelf next to my bed and rather close to my head. The frog had turned a cold white colour and sat permanently frozen there, like a paperweight. I had read that boomslangs eat tree frogs, amongst other things, and my major concern was that the two serpents would wake from their winter slumber and, obviously being hungry, slither down for a morsel, which happened to be positioned adjacent to my head.

I threw the little frog out of my hut numerous times but he was a stubborn little amphibian. When I woke in the morning there he was, back on his bookshelf perch. To make matters worse, my intense research on boomslangs indicated that they are what herpetologists call 'back fanged', which means that to successfully inject venom it is potentially easier for them to bite a person on a finger or ear tip. My ears were close to the frog and he simply refused to hibernate anywhere else. Finally, I started sleeping the other way around, with my head at the base of my bed. As winter came to an end, I crept my way ever more gingerly into bed, opting to cover my ears with my hands until I was prostrate, before shining my torch into the roof and bidding my serpentine roommates goodnight.

One night I was alarmed to discover that they had disappeared. I slept very fitfully that night, waking periodically to shine the torch around my hut and checking under my blankets every five minutes. Thankfully it seemed the snakes had left for good. A few nights later I was awoken by a cold wet kiss on my cheek. My tree frog friend had also woken from its slumber and decided to jump off the shelf using my face as a stepping-stone on his way out. Half asleep I grabbed the little amphibian and tried to pull his cold body away from my face, but the tiny toe-suckers clung on, pulling my cheek sideways before losing their grip. I tossed him out and the next morning, with all amphibians and reptiles gone, my hut was finally mine again.

Although at the time I thought Happy was possibly hoping that the venomous snakes would quietly get rid of me, as it turned out, he was correct in having me leave the snakes alone. Snakes are creatures that, just like any other, if left alone, will leave you alone. In Happy's camp the wildlife had the right of way. After the skull and crossbones incident, there was no doubting it ever again.

10

Buffalo, beards and barking kudu

A far more real threat than the two hibernating snakes were the two buf-falo bulls that had taken up residence in camp. Buffalo are among the most dangerous animals in Africa and indeed were the most feared animal to hunt by even the greatest of great white hunters. Surprisingly, though, when travelling in a herd they are almost as harmless as cattle; it is only when they get old and leave the herd that they become cantankerous and dangerous. Later in life the males give up moving with the herd altogether. Almost as if they get tired of the company, they break off into smaller bachelor herds. These herds usually frequent dense areas of undergrowth, where they carry out a sinister sedentary existence, respecting and fearing no one that crosses their path.

Like a retired gang of Hells Angels bikers, they have a look about them that just says 'don't mess with me' and no one does, except for maybe a hunter trying to prove his metal, or a coalition of big male lions who might be feeling particularly brave. We call these old cantankerous buffalo bulls 'dagha boys'. The word 'udaka' means 'mud' in Zulu, and because these old bulls love to wallow in mud, this seems an apt name for them. Dagha boys are almost always covered in a layer of dry, cracked earth. Happy liked to quote the hunter Robert Ruark who said, 'A buffalo looks at you as if you owe him money.' Unfortunately for us, our camp was built on the Timbavati River and the same tangled undergrowth that we called home, well, so did two old dagha boys.

These buffalo were a menace in that every night, after bidding the traillists goodnight, Happy and I would have to run the dagha boy gaunt-let. Our huts were on the other side of the camp, which was also where the dagha boys liked to hang out. The pathway we walked down passed through an alley of thick bushes, which made me feel a bit like Alice in Wonderland by day but more like Little Red Riding Hood at night. Happy

always had a good few whiskys inside of him to numb the danger; all I had was the knowledge that I was young and fleet of foot. On numerous occasions we would bump into our buffalo pair and have to reverse, with haste, back down the path, often bumping into each other and causing Happy's flashlight beam to momentarily point skywards. Sometimes the bovids were just off the pathway and we would decide to speedily race past them, like someone you see at a function who you know, but really don't want to talk to. Happy seemed to not mind this technique because once we had passed them, I was the one at the back, facing the business end of the buffalo, who by now had heard us squeeze past and had swung their giant horns around to look at who had had the audacity. Tucking my bum in, once Happy branched off to his hut, I speed-walked home.

Living in the bush, one becomes increasingly blasé to the dangers. Happy had spent the last 40 years in the bush, so he was more oblivious than blasé, to the point where sleeping with boomslangs and sidestepping buffalo were considered 'normal' or perhaps, at worst, only slight inconveniences. For me, however, having grown up in the city, I was petrified half the time, including when doing 'normal' things like commuting to work.

One of the apprentice's jobs at TWT was to take the safari trucks into town to get them serviced. Happy was more than capable of servicing the vehicles himself but for warranty purposes we had to drive to the small town of White River, where the Toyota dealership would do the routine 10 000 km service and stamp the service book. White River was almost a three-hour drive away and if I didn't get there first thing in the morning, I would have to spend all day in a one-horse town and without transport, which was not my idea of time well spent.

On one such vehicle service day, my alarm sounded at 5 am. I needed caffeine to wake up properly. Wearing non-khaki clothing for a change, and flip-flops instead of boots, I was plodding sleepily down the pathway to the kitchen when I heard the crack of a branch off to the side of the path. I had stupidly, in my half-asleep state, forgotten altogether about the dagha boys. At that moment one of them swung his large grey bovine bulk around and walked out of the bush, holding his head high and sniffing the air with flaring nostrils. His wet nose dripped snot and his beady black eyes looked sinister. Stepping backwards slowly, but also in

a hurry, the more steps I took back, the more the buffalo walked forward. Eventually, in an attempt to break the deadly waltz, I was doing a sort of moonwalk back in the direction of my hut when my right foot landed on a thorn, which pierced straight through the rubber sole of my flip-flop. Not wanting to halt my retreat, I continued going backwards, hopping on one foot and holding my bent leg in my hands, trying to pull the offending thorn out at the same time. Uttering profanities all the way, I hopped back past Happy's hut, who, upon hearing the commotion, was now awake and standing on his deck laughing at my predicament. Once the thorn was out, and I had composed myself, I took the long way round to the kitchen, using the road at the back of camp. Dispensing with coffee – I was damn well wide awake, absolutely no need for caffeine! – I started the bakkie and roared off into the bush, now 10 minutes later than planned. Thankfully, a few months later the dagha boys moved off and life returned to 'normal'.

At the start of a trail Happy always briefed the traillists on how they should behave in the bush and especially on what to do if they encountered a wild animal. He ended by reiterating that in the event of bumping into a predator, one should never ever, under any circumstances, run away. There was much emphasis put on the phrase 'never ever'. This principle is firmly entrenched by safari guides across the continent and the logic is sound. Quite simply, predators are wired to kill, and when you run from them you are behaving like their prey does. I had heard Happy drum this into traillists hundreds of times. I was convinced that should I ever bump into lions on foot, I would definitely not run. I was, after all, a game ranger in training. Running was for amateurs and wusses.

One fine summer's evening I was walking from my hut down the familiar pathway to the mess area, on my way to the campfire, when suddenly I heard a short, gruff growl emanate from the bushes directly adjacent to the pathway, and to my right. Turning my head in the direction of the sound, I saw two female lionesses leap to their feet; they seemed as shocked as I was. This was it, the big moment of truth. I could hear Happy's voice in my head. *Whatever you do, don't run.* The problem was that while my mind was being kept occupied by repeating this, the proverbial safari mantra, over and over, my feet seemed to have a mind of their own. They were carrying me off, and at quite a pace, in the opposite direction to the felines, down

to the river – which was swollen and flowing after the rains – where I jumped in with a plop. I emerged some way downstream like a drowned rat.

The phrase 'never ever' rang in my head. Never ever, under any circumstances, would I tell anyone about this incident. I badly wanted to lead my own walking trails one day and I had just failed the trail guide board exam. Feeling very disappointed with myself, I slunk back to my hut and sheepishly changed into dry clothes.

While it would be correct to say that living my boyhood dream of becoming a game ranger was not all smooth sailing, the hardest part, by far, was the loneliness. I was starved for young company. There was no cell signal in those days. The only radio station I could pick up was a local bush station called Radio Bundu, which seemed endlessly to replay a programme called 'The Wonders of the Marula Tree'. Our only communication with the outside world was snail mail, which we had to fetch from town. There was the HF radio, which was located in the camp kitchen, but this was strictly for business purposes. Sitting in the mess area we could hear the radio, and over the years we heard a few strange messages on the open-air microphone.

Once, while having lunch, we heard the radio crackle into life, followed by an even more lonely-sounding voice than my own, which simply said, 'Hello, hello.' It was the type of hello that had a question mark after it, as if the person was greeting the wider universe and wondering if extraterrestrial life existed, and hoping that, if it did, someone or something would answer. After a pause, the same voice came back and this time the question was more to the point. 'Anybody out there?' There was more silence before the lonely voice said, 'I need eggs and milk.' Yet more silence followed and then, finally, lonesomeness replaced by panic: 'And toilet paper!'

On another occasion we heard a more panicked and frantic voice burst onto the airwaves. 'I have been bitten by a scorpion – HELP!' After a long silence, a very soothing voice came on, saying, 'Okay, don't panic and repeat after me –' 'YES, YES?' came the panicked voice filled with pregnant

anticipation. As calm as a cucumber, the soothing voice said, 'Our Father ... which art in heaven ...' after which we heard a click, the equivalent of a phone being hung up. What happened to the hapless scorpion victim, no one knew, but Happy and I were in stitches. Timbavati is a large reserve with numerous safari camps and private houses. Who knew that some-one out there, in the bush beyond, was a comedian? Perhaps it was the same person who once sang 'Singing in the Rain' over the radio during a thunderstorm.

But back to my point about loneliness and limited communication. There were no young people around at all except when, from time to time, the head office sent us a student who was looking for some experiential training of sorts, usually for a few weeks while they were on a break from their studies. There was often not a hut spare and they would have to shack up with me. I was so lonely I didn't mind and, actually, I really enjoyed having someone my own age around. I met some interesting fellows and I especially enjoyed the fact that I was now the experienced bush man and the one who got to show someone else the ropes for a change.

One day a chap named Scott arrived in the camp. He had just finished high school and was spending his summer holidays in the camp, giving me a hand. This meant that I, the GDB, had an assistant! Happy soon gave Scott the nickname 'Senegal', after a particularly tall species of acacia tree. Senegal was indeed tall, 1.9 metres, to be exact, and he bragged about having a black belt in judo. He was a real character and, for such a large guy, I was surprised when he told me that he was a vegetarian, which in those days was pretty unusual. When he broke the news, however, I was immediately glad. Sharing the same hut, although very well ventilated, body odours were shared too, in close proximity. If I had entertained the thought that vegetarian farts probably wouldn't smell ... boy, was I wrong about that! Let's just say that Senegal's were a highly effective fumigation.

While Senegal was staying with us Happy received a radio call notifying him of an upcoming meeting for all the tourist camps and lodges in the reserve. He didn't want to go, so Senegal and I eagerly volunteered to be TWT's official representatives. It was a chance to get out of camp, and maybe, if we were super-lucky, to spot a different type of bird, one without feathers. The meeting was to be held at King's Camp, a smart lodge in the

north. Senegal and I duly set off in the bakkie, dressed in our Sunday best. I endured my companion's vegetarian farts the entire way. When we got to King's Camp, we were thrilled to hear that we were early and that we could go to the bar for a drink. We ordered a beer from a tall, slender hostess who, after many months in the bush, might as well have been an angel. Standing in the corner with my beer in my hand, I was about to witness an incident so bizarre that it would feel as if I had drunk not just one, but a whole case of beers.

A banded mongoose came running through the doorway of the bar area like he owned the place. The little critter continued to run through and around the human legs in his way, before coming to a halt at the size 12 feet of Senegal. Cocking its little head, it looked up and stared Senegal in the eye. Perhaps it took sudden exception to his now quite long beard, who knows, but in a trice the mongoose ran up his lanky frame and sank its teeth deep into his beard-covered cheek. Senegal let out a yelp and took off running around the bar, clutching the mongoose by its bushy tail, trying to pry it loose from his face. The folk in the bar were in a mixed state of horror and laughter. Poor Senegal, a black belt in judo, was getting his butt kicked by a tiny mongoose. Finally, the camp manager, Warren, came to the rescue. He yanked the mongoose loose and, apologising profusely, removed it from the bar.

Senegal stood slightly less tall now as he was bent over, clasping his bleeding cheek. Just as he was starting to recover, both physically and emotionally, from the incident and regaining some form of composure, the mongoose reappeared at the door. It had managed to shake itself free from its owner's grasp and had returned for round two of the fight. It was just like an old Western movie, you know the type, when a particularly dangerous bandit walks through the saloon door and everyone cowers in the corner. This time, aware of what was in store for him, Senegal ran out the side door with the mongoose hot on his tail. The small but devious creature chased his black belt behind all around the lodge gardens. Even our gracious hostess was laughing, holding her hand over her mouth in an attempt to disguise what the tears rolling down her cheeks were saying. I laughed through the entire meeting and all the way home. Retelling the story to Happy, whom I now called Hap, we laughed all over again. I went to bed with aching tummy

muscles while Senegal clutched his cheek, wondering whether to shave the beard he was so proud of, or whether to leave it with a chunk missing.

On another occasion we had a certain Wayne arrive to stay for a few weeks. He was busy completing a degree in the natural sciences and was an avid birder. His dream was to become an ornithologist. I seldom met a peer who could match my birding prowess, but I met my match in Wayne. Shortly after he arrived, we were driving through the bush when a bird flitted across the road in front of us. I decided to flex my birding muscles (and yes, birders can have muscles!). Clearing my throat, I asked in a rhetorical and casual way, 'Did you see that tchagra?' I then continued, this time with more authority in my voice. 'We get two species out here and that was either the brown-crowned or the black-crowned.' To really drive the point home that I was no trivial twitcher, I added, 'Judging by the habitat around us, I am led to believe that that bird, in all probability, was in fact a black-crowned tchagra.' I placed my foot a little harder on the accelerator, as if adding emphasis to my hypothesis. Wayne's confident response took me somewhat by surprise. 'You are quite correct, Greg,' he said. 'That was indeed a black-crowned tchagra. You can tell because it is considerably larger in size than the brown-crowned.'

What utter crap, I thought scornfully. How on earth can an already tiny bird be that much bigger than its closest cousin, so much so that someone notices it in the millisecond it took for the brown and black smudge of feathers to streak across the road? When we got back to camp I headed straight for my bird book where, blow me down, I read that the black-crowned tchagra is in fact two centimetres longer than its brown-crowned cousin (the then called three-streaked tchagra). Most kids my age wouldn't even have heard the word 'tchagra', let alone known that it was a type of bird. I knew two species, as well as their habitat preferences and calls. One sounds like a drunken whistler and the other like it is falling out of the tree. What I did not know was that there is a notable size difference. This new boy had taught me something. In the weeks that followed, Wayne and I became great pals as we tested our tchagra skills by slamming on the brakes every time we saw one, asking each other which species we thought it was. Wayne was never wrong. Neither of us ever left the camp without our binoculars.

In the late afternoons, once we had finished our work, we would sit on the deck of my hut and while I read a book, Wayne sat forward in his chair, poised like a heron fishing, with his watch in one hand and one finger of the other held above it. He was waiting for a pair of sandgrouse to fly past. When they did he inspected his watch and wrote down the exact time, right down to the second. I thought he was just a bit cuckoo – an apt phrase for a nutty birder perhaps? However, after a couple of weeks of data collecting from my hut's front porch, Wayne could predict the time, almost to the second, that the pair of sandgrouse would fly past my hut. It was incredible. He clearly had the makings of a fastidious scientist.

On one particular evening, while we were sitting on the deck and he was waiting for the sandgrouse to come speeding past like kamikaze pilots on their way to the waterhole behind camp, we heard a loud rasping bark. 'Booooh – Booooh – Booooh – ' The deep, gruff sounds, punctuated by silence, echoed down the river. I had never heard such a spectacularly booming sound before. Grabbing our binoculars, Wayne and I set off to investigate. We crossed the river and walked across a plain, towards the sound. The barking, although loud, was coming from a long way off. It was only when we were halfway across the plain that we spotted a herd of kudu in the far-distant tree-line. It was these antelope that were making the load barking sounds and their heads were all turned and facing in one direction. I told Wayne that I wanted to take a closer look. He told me, in a very matter-of-fact fashion, that I was bloody mad, before returning to the hut to wait for his sandgrouse. He was timing birds flying past my hut for no reason and he thought *I* was mad? Stalking closer on my own, it struck me that even though I was now getting close to the kudu, who are incredibly alert and shy creatures, they seemed to be stuck in one place and weren't paying me the slightest bit of attention. Going down on my hands and knees, I inched closer to the antelope, who were standing in amongst a dense grove of tamboti trees, until I was a mere 30 metres away from them.

Suddenly something tawny streaked through the grass less than 15 metres to the front and left of where I was crouched. My eyes did a double-take. Surely I was seeing things? I sat motionless in the khaki grass. Just then another tawny ghost-like shape slunk past me, this time to my right and

even closer. As the reality set in that I had diligently snuck my way into the middle of a lion hunt, my heart began to race. Behind me I saw a termite mound and, not knowing where the rest of the pride was, I decided to crawl to the mound. I propped myself against it so as to be safe from any attack from behind. Sitting there motionless, I barely dared to breathe. The next few minutes were plain terrifying. There was an eerie silence, which was deafening at the same time and only added to the tension. Both predator and prey were too scared to make a move, it seemed. I certainly wasn't moving. In the silence all I could hear was the blood rushing through my ears.

The kudu were facing left even though I knew that at least one lioness was stalking them from the right. It was as if I was watching a documentary, except that I was a part of it, which was admittedly a strange sensation. The kudu were too afraid to run as they might run into an ambush. I was too afraid to leave as I did not want to bump into any more lions, especially hungry ones. The lionesses were too afraid to make a move because if they did so too early, they would lose their prey to the bushes. Predator and prey were poised in silence. The kudu were no longer barking – it was too late for that. A seeming eternity passed while I sat propped up against a pile of termite dirt. As it turned out, the first lioness that I had seen, the one to my left, was the decoy runner, sent only to distract the prey. I was recalling how Happy had once talked about this strategy when suddenly all hell broke loose. One of the lionesses had made a break for it.

The rest of the pride attacked, with one lioness who, unbeknown to me, had been crouched in the grass not far from where I sat, running right past me. The silence literally shattered with the sound of thudding paws, frantic hooves and breaking branches, causing me to almost wet myself. The kudu ran off like giant rocking-horses with the lions hot on their tails. I took my leave in the opposite direction, running all the way home like a Forrest Gump version of Crocodile Dundee.

Arriving back at camp I was so grateful to be alive that Wayne's lecture about how one day something was going to eat me was like water off a duck's back. They say that the hard way is also often the best way to learn a lesson, and the lesson on this occasion, besides the fact that sandgrouse have surprisingly accurate mini-internal body-clocks, was that kudu, unlike some other more paranoid antelope, only bark for very good reason.

11

Dung beetles

Under the watchful guidance of Hap, my bush knowledge grew exponentially. Once a month he and I would go out on our own 'Birding Big Day', without tourists. The point of this was to complete a Birds in Reserves Project (BIRP) checklist, which was a project aimed at ascertaining which species of birds were found in protected reserves so that they could be mapped for a bird atlas. I relished these outings as we would stop for every bird burp (and fart!). It was birding on the next level. Even on winter mornings, we would identify dozens of bird species in a matter of hours. We also found a few rarities in our time, including a green sandpiper and Baillon's crake; the latter had only been recorded three times previously in the Kruger National Park.

In my spare time I was also learning to identify the different grass and tree species, using rhymes to try and remember their scientific names. Hap was a phenomenal help, especially in the grass department, where he was extremely knowledgeable. As previously mentioned, he used to advise cattle ranchers in the Zimbabwean lowveld on how many head of cattle they could run based on the species of grass that occurred on their land. Wild flower identification was more challenging, especially as there was no one definitive flower guide that covered our region. I would go out in the morning and collect a few species of wild flowers and then, with no fewer than five different flower books open, Hap would sit and watch as I tried to figure out which flower I was holding in my hand. He would eventually step in and help, and just occasionally he would jump straight in, which meant I had found a new flower, even for him.

I also developed a fetish for beetles. Before I expand on this, please understand that a beetle is not a bug. While I did not care much for bugs, beetles fascinated me. The essential difference between a beetle and a bug is that a beetle has hard outer wings whereas a bug is soft and

squishier. A good place to find certain beetles is in an animal's dung.

Rhino like to defecate in one place and pretty soon this one place becomes a massive pile of poop called a midden. Rhino middens are like mansions for dung beetles. During any spare time I had, I would drive from one rhino midden to the next, and sitting in each, like a child in a sandpit, I would scratch around for hours looking for dung beetles. My search was not limited to just rhino dung; given half a chance, I would enthusiastically explore the dung of any creature. Fresh elephant dung always yielded good results and was way less messy than buffalo dung. Herbivore dung smelled a hell of a lot better than lion dung, and even lion dung smelled better than wild dog dung.

Before you write me off as being a complete feral, please let me explain that dung beetles are in fact fascinating and very important creatures. Not only do you get thousands of species of dung beetle, but each species specialises in a particular kind of dung. You get beetles that specialise in non-ruminant dung, like rhino dung, and others that specialise in ruminant dung, like impala droppings. You even get beetles that specialise in predator dung and since this dung is harder to find, so are the long-legged variety of dung beetles that specialise in this predator department. To collect and bag these in my collection, and out of sheer desperation, I resorted to not using the long-drop toilet in camp. Instead I did my business in the bush to bait my beetle prey. It was incredible to witness long-legged beetles arriving at my dung in a matter of minutes, sometimes when my pants were still around my ankles! Apologies for the over-share but for thousands of years dung beetles took expert care of our business – you may not realise it, but the modern toilet is a relatively new invention.

Okay, so maybe I had become a bit feral, but I had also found 43 species of dung beetle in the Timbavati alone. My beetle collecting knew no boundaries; not even when we were walking with traillists. Halting the trail so that I could sort through a pile of dung with my hands, once I found a beetle I would clasp it between my index finger and my thumb, holding it up to the face of each traillist for them to behold the wonder that is the dung beetle. I would then offer these frowning faces the opportunity to feel the strength of a dung beetle by suggesting they make a fist with the beetle inside. Few ever took me up on the offer, which is a pity because they would

have been amazed: the beetle is so strong that it bores free by prying one's fingers loose. They are, pound for pound, the most powerful creatures on the planet.

I had a special talk that I gave on the wondrous dung beetle. Flipping the beetle over, I would point out the tiny white mites that keep the beetle's mouthparts clean. I would then recount the remarkable but true tale about how African dung beetles were exported to Australia to help with their dung problem, which was also the reason for their fly problem. At the time, however, the scientists did not yet know about the symbiotic relationship the beetles have with these mites, and so the exported beetles' mouthparts became clogged with dung and they died. It was then that the project started exporting live beetles as they already possessed the symbiotic mites. I would go on to talk about how some beetles roll balls while others bury the dung right beneath where it falls. I would tell of the special kleptocoprid variety, which do not roll their own ball of dung, but rather hijack someone else's. At this I would always get lots of nodding of heads from the South African traillists, who knew all about hijackings.

I would also be sure to remind the group that if it were not for dung beetles, there would be no large mammals like zebras and giraffe because the internal parasites that live in these mammals' stomachs actually breed in dung, the very same dung that the beetles remove, distribute and bury, thereby controlling the parasite load that the large mammals carry. I closed by concluding that dung beetles, unlike humans, are a cornerstone species and that if they were to be removed from the ecosystem, many other species would become extinct. If humans were removed, it would be quite the opposite. No wild animal would miss us. On the contrary, they would benefit!

After my dung beetle lesson, the trail would continue and, as per normal, we would stop somewhere pretty, usually along a river, for a tea break. On these breaks it was my job to lay out all the fruit juices and snacks and slice the cheese. Strangely enough, after my dung beetle show-and-tell, I found that I mostly had all the cheese to myself.

One of my duties was to fetch clients who flew in for their safari from the airstrip. I would be notified via radio when the pilot was on his way. We had a really ridiculous system for an air-sock. I would have to take the air-sock from camp and once on the airstrip, tie it to the end of a pole that we left lying in the bushes there. I would then tie the pole to the bull bar in the front of my truck. This worked okay in as far as it showed the pilot the wind direction, but it was a nightmare trying to ensure that no animals were on the strip when he landed. Usually in Africa you have to drive and chase animals off an airstrip, and oftentimes repeatedly, before a plane arrives. With our system, though, you could only drive at them once, because then you had to tie the sock to the truck and the truck had to be stationary. So then you would have to chase the animals off the airstrip on foot, which was hot work.

Herbivores love hanging out on airstrips. Not only is there plenty of grass, but the visibility is also good, making it easier for them to spot predators. There were always zebras on the southern end of the Timbavati airstrip and warthog on the northern end, who were especially partial to digging up the grass roots on that side. After running and chasing the zebra off first, I would then run to the top and chase the warthog off. By the time I had done this, the zebra were back on the southern side and grazing again. I ran up and down that airstrip like a blue-arsed fly until I was blue in the face myself. When the guests finally landed, I would be dripping in sweat and sticking out a clammy hand for them to shake. Making a good first impression was pretty much impossible.

One of the pilots who landed on our airstrip to drop clients was a butterfly collector. On one occasion, while his passengers were disembarking and before he took off again, he handed me a jar containing a mixture of rotten bananas and peanut butter, together with a special butterfly trap in the form of a net with strings. He requested that I hang the net high in a tree close to the river. As if this sort of request was perfectly normal, I followed his instructions. I climbed the big African ebony tree above Hap's hut. A few weeks later, upon inspecting the trap, I found no butterflies, but I did find the minutest green and shiny beetle. I had my leave coming up and I decided that I was going to take the beetle to the Natural History Museum in Tshwane – which I did.

At the museum I asked to meet with the scientist who headed up their coleoptera department. 'Dr Coleoptera', as I dubbed him, met me in the foyer and he seemed really pleased when I told him about my beetle collection. In no time at all he whooshed me along a series of high-ceilinged dark hallways, then down multiple staircases of the gloomy government building, and into the bowels of the museum. If it was not for his white coat he would have been hard to follow. He ushered me into a large dark room and flipped a switch. White fluorescent lights flickered into life, revealing a glint in the doc's eyes that made me feel like Marty McFly in *Back to the Future*. In a kind of 'show me yours and I'll show you mine' manner, the doc gestured for me to reveal. I pulled out the film canister I had in my pocket, flicked the black lid open and passed it to him. When he saw the tiny green beetle, a green speck not much bigger than a pinhead, in the bottom of the canister, he jumped up and down, screaming, 'It's a very rare chrysomelid!' His ecstatic demeanour then changed abruptly. He tilted his head forward so as to peer at me over the top of his glasses and, clutching the film canister to his heart, he asked, 'Can I keep it?'

'Of course,' I said casually. I was probably too scared to say no and besides, dung beetles were more my thing.

Wiggling his glasses back higher onto his nose, he asked if I wanted to see his life's work.

'Oh, yes,' I told him. I didn't feel this was an invitation I could refuse without awkwardness.

We descended yet another flight of stairs where, even deeper underground, there was a dark room full of large wooden drawers. The room had a musky smell to it and as the lazy lights flicked on and off, the doc stood beside a long line of drawers where he paused, either waiting for the lights to be fully on or simply adding dramatic suspense, kind of like an orchestra conductor before he begins conducting. Then the doc slid each drawer open, one by one, before standing back and gazing lovingly at the contents, as if basking in the glory of the sight he had just unveiled.

He motioned for me to step forward and I must admit that I saw some spectacular beetles in those drawers, the likes of which I had never seen, or even dreamed existed. There were gigantic jewel beetles, much larger than my hand, from Asia. Seeing the look of delight on my face the mad

scientist hurried me down another aisle of drawers and stopped. Sliding one drawer out particularly slowly and carefully, he spread his arms wide and announced: 'This is my life's work.'

Staring at the collection it contained, I tried my best to look impressed. If I'd been expecting it to be filled with colourful fruit chafer beetles, I was in for disappointment. All I saw was blister beetles, the likes of which I had seen many times before, all of them identical looking. Puffing his chest out, the doc exclaimed with pride, 'Each one of these is a different species, you know.'

'Blimey,' I said. 'How do you know? I mean, they look identical – even the black and yellow spots on their backs are identical.'

'Ah,' said the doc, 'I have studied their sexual organs under the electron microscope. Each male and female has uniquely matching genitalia that fit like a lock and key.'

At this point I made an excuse about how my parking meter must be running down and I'd best be off. Back on ground level, and back in the real world, I decided that I'd better get a grip on my beetle fetish before I, too, landed up in a dungeon somewhere studying their sexual organs.

Back in Timbavati, I had come a long way. I was now being seriously considered to lead my own wilderness trails. There were two camps – Happy was doing the trails in the Timbavati Camp but Mike was having to come in, all the way from Durban, to run any trails booked out of the second camp. Thankfully, Hap and I had also come a long way in terms of our working relationship. We were unlikely friends from the start. Not only was he triple my age, but we were also from different worlds. He had lived in the wild bush country of the lowveld for decades and I had grown up in the suburbs of a large city. We had absolutely nothing in common outside of the reserve, which meant I could not talk to him about sport, not even rugby – and we had just won the World Cup!

What made it harder was the fact that in such a tiny camp we lived in each other's pockets. There were no weekend breaks as we worked seven

days a week, week in and week out. Our huts didn't have their own kitchens and so we took all our meals together, even when the camp was empty. All we had in common was our love and appreciation for the bush, and luckily this shared passion provided us with endless hours of conversation and things to do. In the beginning, I used to dread the nights when we had no traillists in camp as Happy and I would have dinner in near silence. Later on, however, I really enjoyed our dinners together and cherished the time that we would sit at the old wooden table and bench in the mess area, under the grass thatch roof, with a lantern or two swinging from the beams. Dinner was always a simple affair, like fish and chips, and being young and still with some hollow bones, I would dig my hands deep into the black cast-iron pot and pile my plate, before adding salt and copious amounts of All Gold tomato sauce.

During dinner Hap would sometimes open up and share a bit of his past and when he did, I hung onto his every word. He would talk about his old days in Rhodesia and retell his big game hunting stories. He might have shot big game for years, but he was now a passionate game ranger and, dare I say, even a borderline 'tree-hugger'. I envied the fact that he had had a chance to test himself against big game and that he had emerged victorious. This was something I had not yet done and looking back, I think my photography became a way for me to test my bush knowledge and skill in this way, although it would still be a few years before I picked up a camera. I also envied the fact that Hap had grown up in an Africa and in a time when you could take off in any direction into the bush, without set plans and with only the very basic supplies to embark on a wild adventure. Hap had experienced the lost Africa and I wanted to do the same.

There were the times he went off camping by boat into the Okavango or on Lake Kariba for weeks on end. He described how he would paddle until he found an island on which to camp. There he would build a fire and barbecue the fish he had caught in the day. Back in those days he had not had the slightest interest in birds, he said ruefully. His hard face winced, the pain visible, when he thought now about how many incredible and rare birds he must have seen. He told me about the dogs he had owned and how much he had loved them. One of the few times I saw an emotional side to Hap was when he spoke about his hunting dogs, which he'd sadly had to

give away when he took the job of wilderness trails guide 20 years prior. No dogs were allowed in the Timbavati Game Reserve at the time for fear of spreading rabies and canine distemper to the Cape hunting dog population. Hap also told stories that in hindsight were funny but which, at the time, must have been harrowing. His dogs often ran ahead of him exploring the trail on bush walks and when they ran into trouble, in the form of a big elephant bull or a lion, for example, their first reaction was to run back to their owner and hide between his legs. The problem with this was that when the dogs retuned to Hap, they were often being followed by whatever creature they had angered and would lead the dangerous beast straight back to him. Sitting under the grass roof, Hap's stories were periodically interrupted by roaring lions, in the blackness beyond the comforting glow of the lanterns.

12

Bird cricket

The roar of a lion is not what one would typically expect from the king of the jungle and it is not at all a loud growl, as depicted by the MGM lion. In reality it is more a moan than a roar. It starts slowly – 'at the tail', as Hap used to say – builds to a crescendo and ends suddenly, finishing in a series of low groans and grunts. It has always been the rasping end of the roar that I enjoy the most and it remains the most primordial sound I know, and the ultimate reminder of all that is savage and wild.

One night we were sitting around the campfire after a typical day on safari and one of the traillists got up and shone his flashlight into the dark night, scanning the beam slowly from left to right. The beam came to an abrupt halt about halfway through its rotation, and even in the warm glow of the fire, I saw its operator turn pale. Seemingly rendered unable to speak, he gasped for air as if he was choking on a kebab stick from the braai. But instead of clasping his throat, he pointed into the night. Everyone leapt to their feet, some standing on tiptoe to see over others' heads. Lying in the sandy riverbed less than 30 metres away was not one but an entire pride of lions. We must have made for a peculiar sight to them, a bunch of pale apes in the dark night gawking with open mouths and eyes as wide as a bush baby's. Hastily retreating to the mess area, knocking over campfire chairs on our way, it was every man for himself. No one wanted to be caught at the back of the procession on the way to supposed safety.

I say 'supposed safety' because the place we were huddling, the mess area with its thatch roof, of course had no walls. At least there was a roof to climb into, for those who had not drunk too much. Like a human bait ball we circled each other; no one wanted to be caught on the outside. For some reason the ring of lanterns that hung from the support poles seemed to make everyone feel a little safer. It was moments like this, a dinner disturbed by lions, that made the Timbavati Camp so special. To this day,

whenever I arrive at a safari camp and see a big electric fence surrounding the lodge, I sigh and think back to my Timbavati days, and I remember how wonderful it was to live so close to nature.

My favourite time of year in the bush was early summer as this was when Hap and I played our 'bird cricket'. South Africa receives a large influx of migratory birds in our summer. Birds of differing variety and size, ranging from tiny warblers through to massive storks and eagles, arrive from other parts of Africa, and indeed from all over Eurasia. They come mostly to feed on the plethora of insect life that emerges after our first rains, with some birds coming from as far afield as eastern Asia. Hap and I kept score as to who could spot the first returning migrant of each species, although it must be said that he had the upper hand – he had been recording the arrival and departure dates of each species for years. In fact, his data would many years later form the basis for research providing matching evidence of global warming. He kept meticulous records for decades, documenting exactly when the birds arrived and departed the region. What made this even more astounding was that he did it for no other reason than the fact that he loved birds. He was not doing it as part of a scientific study, even though that is what scientists would use it for decades later.

What all his data collecting did do was give him a hugely unfair advantage in our bird cricket match. He could often predict the arrival of a certain species within a few days' accuracy, and I, not having the luxury of that knowledge, could only beat about the bush, eyes as wide as saucers, searching for any sign of the migrants. I was never without my binoculars and by the end of spring I had a tan that revealed two white binocular-sized rings around my eyes.

Hap and I were 20 apiece in our bird cricket tournament and things were looking good for me, for a change. With no TV and no football teams to bet on, this was all I had by way of sport, my very own birding premier league.

One fine day I was driving back after doing a shopping trip in Hoedspruit, looking forward to our lunch. It was a standard 'town treat' to buy pies from the Spar supermarket and after weeks of eating only impala for protein, a chicken or beef pie was nothing short of heaven on a plate. The pies were temptingly on the passenger seat next to me. I tried not to inhale their delightful aroma, while daydreaming about eating both and

telling Hap that Spar had been all sold out of pies. Unfortunately, I had the receipt, the same receipt with all the other grocery items on it and which Hap needed for accounting purposes. He was an absolute stickler for receipts was Hap. As I puzzled over this pastry conundrum, out the corner of my eye I thought I saw a bird fly in front of my bumper. Had I also heard a faint thud? I looked in my rear-view mirror.

Backing up and jumping out I was horrified to see a large pale blue bird lying on its back with its feet in the air. Upon closer inspection my worst fears were confirmed: it was indeed a European roller. This beautiful bird, which I have always described as an overgrown blue waxbill, due to its similar coloration, migrates all the way from southern Europe each year for its 'summer vacation'. While the stark fact that this particular individual's migratory journey had ended at my bumper really upset me, my competitive nature took over. As I drew close to camp I radioed Hap and told him the score was now 21 to 20, in my favour. He enquired as to what species I had seen and when I told him it was a European roller he mumbled that it was highly unlikely as they were only supposed to arrive in a couple of weeks' time. Back at camp I placed two delicious pies, which I had managed not to eat, and one dead bird on the lunch table.

A sad byproduct of living in the bush is that from time to time a person will inadvertently drive over a creature of some sort. This is unavoidable. It always pains the heart when it happens, but it is also a part of bush living.

The only live polecat, which is a type of African skunk, that I have ever seen in Southern Africa was when I was driving back from Maun in Botswana on a dark night. I spotted the striped skunk-like creature running out from under a bush next to the road. Hardly believing my eyes, it took me a few seconds to click. While my brain was busy identifying it as a polecat, it ran straight under my wheels. The only polecat I had ever seen I had also murdered! I swore and cursed for the next 700 miles, all the way back to Johannesburg.

On another occasion when driving back from Hoedspruit, I found a dead snake on the road. I was glad that I hadn't been the one to drive over it and, upon examination, and seeing that it was still very much intact, on impulse I tossed it into the back of the bakkie. Back in camp I decided to play a prank on our camp cooks. These two Shangaan women, Salamina

and Astania, were wonderful cooks (just the thought of their delicious homemade bread still makes my mouth water). They were fairly comfortable in the bush but there were two things they were petrified of, and one of these was snakes. The kitchen would knock off for three hours each day, from 3 pm to 6 pm, and so I waited until four o'clock before slipping into the kitchen where I placed the dead snake on the floor in front of the gas oven. I coiled it and even propped a twig under its head so that it looked more alive and menacing.

I then went off to enjoy a hot shower. Getting hot water was quite a process. First I would have to walk to the central gas geyser, an old Junker, which was located in the middle of camp, and coax it into life. By now I had learned every trick in the book to get it started. The best way, I'd worked out – and I had the singed eyebrows to prove it – was to leave the hot water running while pressing in the gas release button and then throwing a match onto the burners. It was sort of like hotwiring a car, except that this was a gas geyser and the sound it made was a fierce 'whoosh!' as all the burners lit up simultaneously. I would then have to carry the bucket of water all the way to my hut at the end of the camp, sloshing water over my feet as I trundled down the pathway. Once at my shower, I would then add cold water, which came from a water tank perched high on a stand, one that I had helped build and which in the building process had nearly come tumbling down, with me on the very top.

The most important part was to swirl the water around by thrusting your arm deep into the bucket. If you forgot to do this, then half your shower would be hot and the other half cold due to the differing densities of the cold versus hot water. This rookie mistake would mean that your shower ended on a cold note. Finally, you would have to hoist the bucket up on a pulley system and then secure the rope, before enjoying what was, undoubtedly, the best shower in the world because it was alfresco. I would stand under the running water listening to the bush sounds around me, my favourite being the trill of the woodland kingfisher. Depending on what time I was showering, looking up I stared at the giant ebony tree's boughs or at the stars. Those bush showers were glorious, unless I forgot my sandals. To get back to my hut meant running down a dirt path so by the time I got there my freshly clean feet were covered in a layer of dirt.

And if I had also forgotten my towel, which happened not infrequently – well, you can imagine.

On this particular evening, I was standing under the shower enjoying the blissful warm water, when I heard a blood-curdling scream coming from the direction of the kitchen. I glanced at my watch – 6 pm, the exact time the cooks started their evening shift. By the time I was finished showering and dressing in clean clothes, the screams had subsided but when I walked into the kitchen at 7 pm they started again – only this time they were directed, and rightly so, at me. My dinner portion was unusually small that night.

At this time I was busy studying towards a National Diploma in Nature Conservation and so it was extra important that I hone all of my bush skills in preparation for examinations.

Our bird cricket rules allowed for birds to be identified by their calls and to hone my skills in this department, I took up the practice of early morning bird yoga. This simple exercise entailed trying to identify every bird by its song while lying in bed, in the early morning, when the dawn chorus rang loudly. If you have ever heard Africa's cacophony of a dawn chorus, you will know that isolating calls is no simple feat. At breakfast each morning Hap would quiz me on how many birds I had been able to identify.

For some reason one or two calls always remained tricky for me. Even though these birds themselves were not uncommon, not possessing a musical ear (or even the minutest musical talent), the calls remained a challenge for me. The grey-headed bushshrike, for example, has a few different calls, which I eventually got to know, but most commonly it gives a long drawn-out 'woooooh', giving rise to its Afrikaans name of spookvoël, or 'ghost bird'. In time I mastered the subtle differences in the calls between the bleating of camaroptera and that of a prinia; one sounds like the bird is knocking two stones together and the other like the bird is knocking two slightly smaller stones together. I could differentiate between the cackling of the babbler and the raucous laughter of the

wood-hoopoe and just as I thought I was becoming the bird wizard, the simple trilling of the brown-hooded kingfisher would trip me up.

I think the tipping point to me finally being able to lead my own trails was when Mike quizzed me on the calls of the LBJs. Being able to identify the sounds of the long-billed crombec, yellow-breasted apalis and Stierling's wren-warbler seemed to signal to Mike that I was ready. One would have thought that being able to shoot a lion in full charge would have qualified me, but the skills required to lead wilderness trails were far more nuanced. In fact, in the more than 20 years that Happy had led trails, he had not once had to shoot a dangerous animal. It was all about being alert, understanding animal behaviour and being able to interpret the signs of the bush. Being so immersed in the environment yourself that you are able to immerse others seems to be the art of the safari guide, and one I was learning from my master sensei, Happy. Except, instead of teaching me to wax on and wax off like in *Karate Kid*, he was teaching me bird calls – and, of course, to not get lost in the bush.

Finally, it was decided that I was going to start to lead my own trails out of the Sesetse Camp. Leading a trail did not just entail walking with guests in the bush; it also included all the pre-trail preparation. Of all my tasks, this was the most daunting, as I was responsible for all the catering for a group of up to eight guests, and if we ran out of anything, I would have egg on my face. Hap would help supervise the trail prep when he could, but he had his own trails to run and so it was time for me to fledge, so to speak.

Those early days of leading my own trails remain vividly etched in my memory. I would stand waiting in the parking area, wiping my sweaty hands repeatedly on my khaki shorts, watching for the dust that signalled the approaching convoy of cars. I remember feeling very awkward. As the vehicles pulled into camp, I would give a sheepish wave. It seemed like an eternity before everyone was out of their cars so that I could introduce myself. I was so nervous I nearly always forgot the guests' names immediately after they gave them to me. Many of our guests in those days were top business executives wanting to get away from the corporate rat-race for a few days. I was just 21 years of age, and still had acne. I would need to take charge of the group and instruct them about the daily

camp routine and the 'do's and don'ts' of bush living. I would then have to get these top business execs to walk behind me in single file when on trail, and I would have to tell them to shut up, if need be. As if this was not enough pressure, I had to host them at meals with many a corporate wife casting a beady eye over my hosting and culinary skills. If we ran out of pork sausages, which was the one item I always seemed to run out of, there was no one else to blame. I feared pork sausages in those days more than I did lions or elephants!

In the morning we would assemble for a quick coffee and a rusk, after which we would all gather in the parking area where my already packed rucksack and rifle had been carefully propped up against an old warthog skull mounted on the wall, the tusks of which made for perfect hooks on which to hang my binoculars and hat. I would then give the group the usual brief, reiterating the point that they should not run, and of course not mentioning to them how I had once run for my life when I encountered those two lionesses in camp. I ended my walking brief by asking the group if they knew what to do if we encountered a lion.

'Don't run!' would come the almost unanimous reply.

'Yes, you are quite correct,' I would say before asking, 'but then what do you do?'

'Aaah ... not sure ...' someone would say hesitantly.

Casually I would explain, 'Well, you see, lions absolutely hate dung. So if you bend down and grab a fistful of dung and throw it in their face, they are sure to stop.'

This statement would generally be followed by a long silence before, hopefully, someone would ask the question that would allow me to deliver my punchline: 'What if there is no dung?'

'Don't worry, there will be!' And with that I grabbed my rifle, secured my cap on my head and walked off to start the trail, with everyone chortling away behind me and rushing to catch up.

From that moment on there was often much talk about dung. If the group had particularly enjoyed the joke, then later that night around the fire I expanded on it. First I explained that in all seriousness, once a person has not run and stood their ground in the face of a lion charge, one then of course does need to slowly back away. Jumping up and in the light

of the campfire, I demonstrated how: take a giant step sideways – so as not to step in the dung! – and then one step backwards.

One of our regular repeat guests, or 'repeat offenders', as we like to call them in the tourism industry, was a guy called Andy. He used to be a wilderness trails guide himself, down in the iMfolozi Game Reserve, before starting his own safari company. I enjoyed taking Andy on walks because he was so knowledgeable and enthusiastic. He could talk about the buffalo thorn tree for half an hour. This is the most important tree to the Zulu nation, and having worked at iMfolozi, which used to be the private hunting ground of King Shaka himself, Andy knew all the Zulu beliefs and traditions around the tree. Every guide has his own style and quirkiness, and over the years I have heard many guides talk about the buffalo thorn tree (or the anthill, for that matter); it is always interesting to me to see how guides choose to convey their knowledge.

When out leading a trail, two things played constantly on my mind. The first was the possibility of a serious run-in with big game, something I tried to avoid. The second was that I must not get lost. Both Hap and Mike had given me the same advice about the latter: if I should get lost and happened to come across a road of any sort, I should walk down the road until I figured out where I was. This was the golden rule. Under no circumstances should I cross the road and continue walking. And if the traillists started to complain about the length of the walk, Hap said, I should tell them that I was just making sure they were getting their money's worth. Fortunately, I only got really lost once. This was when I crossed a narrow two-track road that separates Timbavati from the Kruger National Park. The problem was that I crossed the road at a right angle and therefore didn't even notice it. Unbeknown to guide and traillists alike, we took an illegal jaunt into Kruger. By some miracle I found my way back to camp without having to confess that, actually, I'd got horribly lost. The exhausted traillists did, however, comment later that night, when slumped in their chairs around the fire, about how much longer the walk had seemed compared to the previous days.

As the weeks rolled into months, I became more confident and with this surge in confidence, my repertoire of safari jokes increased proportionately, albeit admittedly more in number than in quality. There always seemed to be much joking around the topic of urine and faeces when on walks,

and while the people came on a wilderness trail to learn more about animals, I was learning more about the human animal. It turns out that the average human being has a morbid fascination for dung. While my personal love for dung related specifically to its beetle inhabitants, most people just seem plain enamoured by dung itself. I found different ways to play on this. A favourite trick I'd learned from Hap was to find a fresh buffalo patty and stick my finger deep into it. Pressing my finger deeper into the dung I explained to the traillists what I was doing: you can assess the freshness of the dung by the degree of acidity, I said, which you could test with your tongue. Quickly, and without warning, I would pull my finger out of the steaming pat and suck on it. Swirling my tongue around I would exclaim, 'Gee, this is fresh, we'd better get out of here!' It was a sleight of hand trick as I would swap the dirty finger with a clean one.

Hap had perfected the buffalo dung tasting, and he owned this trick, which perhaps was why I was having only mild success with it. Then one day when I was in the supermarket in Hoedspruit, I saw a packet of chocolate-coated raisins on the counter beside the till ... On my next trail I kept a couple of these chocolate raisins in my pocket and early into the bush walk, before they could melt, I stopped at an impala midden where I gave my usual spiel on the dung. At the end of my talk, I grabbed a handful of the impala pellets with my left hand and, pretending that I was passing the pellets into my right hand, which actually contained the chocolate-coated candies, I popped a few into my mouth. Before I clamped my teeth down I stuck my tongue out to show the evidence – small round pellets – before chewing them with relish and swallowing them. I think many a tourist thought they were on a trail with a Neanderthal!

It might alarm you to know that your average safari guide in Africa, instead of wondering how to keep you out of harm's way, is often pre-occupied with how exactly they can use their safari joke repertoire. When anyone needs the loo, every tree in the bushveld becomes a 'lavor-tree' and every meal starts with the phrase, 'Baboon up a tree!' (Bon appetit). The best thing was that because a trail only lasted five days, I never ran out of jokes. In the bush we have to entertain ourselves!

I had music for my personal entertainment in my Walkman, but its single stretched TDK tape of a Counting Crows album, which my cousin Ryan

had dubbed for me, wore thin on my ears. Besides that I had the music of bird calls. There is one bird that is very aptly named: the monotonous lark. Mercifully, these birds migrate, but when they are passing through they call incessantly, throughout the day and night. The sweet little birds never bothered me much until one morning I caught Hap in a sinister mood. He asked me if I had heard the monotonous larks calling during the night.

'Yes,' I said.

'But do you know what they are saying?'

I should have stopped him right there, but my curiosity got the better of me.

'No, what are they saying, Hap?' I asked.

'Purple jeep,' came his reply.

How silly, I thought. That does not even make sense.

But later that night I found myself lying in bed wide awake, repeating over and over in my mind, in unison with the larks, the words 'purple jeep, purple jeep, purple jeep'. Hap had executed a masterful form of torture on me, I realised, and forever more I would hear that same refrain whenever the larks came for the summer. At last the 'purple jeeps' (or the 'purple cheeps', as I called them) moved on, which was more than could be said for the black cuckoo, whose favourite perch was in the African ebony tree above my hut. From this high vantage point his mournful cry, which sounds like the bird is saying, 'I'm so saaaad', would go on for hours. Another eternally depressed species is the emerald-spotted wood dove, which sings the following lyrics, usually from deep inside a dark bush: 'My mother is dead, my father is dead, my whole family is dead. I am so sad. Boo hoo hoo hoo hoo hoo.'

There are, of course, other more cheerful birds, like the Coqui francolin, which shouts, 'Be quick, be quick, be quick', warning you in the late afternoon that it is time to get back to camp. Living in the bush you learn to love bird songs because if you don't, then you will surely hate a few; they are loud and they are everywhere. Each part of the day has different calls. I personally love the 'Three Blind Mice' call of the little chinspot batis, which I used to hear foraging in the tree above my hut around siesta time. This tiny bird has the humongous Afrikaans name of witliesbosbontrokkie, the meaning of which no one has ever been able

to adequately explain to me. Birds are also really clever with their calls. Take the Cape turtle dove, for example, who says 'Work harder, work harder, work harder' on weekdays. On weekends the same bird sings, 'Drink lager, drink lager, drink lager.'

I told you we have to make our own entertainment in the bush.

13

Who planted all these trees?

It was a standard part of my morning brief to the traillists, after I had gotten through the 'whatever you do, don't run' bit, to give a geographical explanation about the ecosystem in which we would be walking. I'd explain that the park was in excess of 20 000 square kilometres (7 722 square miles) and that we were a part of the Greater Kruger and, as such, it was a wilderness par excellence. On one particular trail, a mother and her 16-year-old son were along; they were from a small town somewhere in the backwaters of Kentucky. After my pre-trail brief, we set off into the bush for our morning walk. We'd not gone very far when the mom asked from the back: 'Greg, who planted all these trees?'

Thinking this was some sort of a joke, I turned around and said, 'I beg your pardon?'

But she wasn't joking. She repeated the question, enunciating more clearly, and loudly, in her strong southern twang. 'Say, Greg, who *planted* all these *trees*?' The words seemed to echo amongst the marula trees. The others on the trail seemed as dumbfounded as I was. Deciding to rise to the challenge, I explained that the wild trees produce fruit and the fruit contains seeds. In the case of the marula tree, the fruit gets eaten by an elephant, whose bad digestion ensures that the seeds are passed in a whole state, so that when they land they find themselves encased in their own personal hothouse of steaming manure, perfect for germination. I went on to explain that other trees' flowers are pollinated by bats, insects or even giraffe, and that seed dispersal takes many forms, including dispersal by wind. Thinking how proud Hap would be of my impeccable answer, the wind was somewhat taken out of my sails at the lady from Kentucky's next question: 'Oh, but then who cuts the grass?'

'No one cuts the grass – except for the rhino, ma'am!' I said, trying to sound as genuine as possible and ignoring the sniggering of the others

behind me.

After this interlude we carried on walking. A habit I had learned from Hap was to regularly check that my traillists were in tow and not stretched out through the bush behind me in a broken line, as that was dangerous. Turning and glancing back to check that my walkers were following, I was more than a little alarmed to see that the 16-year-old boy had vanished. Backtracking a considerable way, we found him up a marula tree where it appeared he'd decided to take a nap. With his arms and legs wrapped around a thick branch, not unlike a leopard, he was trying to get some shut-eye. His mother, quite unembarrassed, simply smiled. 'Tobby enjoys climbing 'em trees!' she said.

Walking with people who don't grasp the concept of wild Africa is pretty dangerous. The next morning I managed to convince the group to take a safari drive instead. We had a great morning with many enjoyable sightings and as a result we were running late. I had instructed the camp cooks to have breakfast ready at 10 am but when that time came, I was still a few clicks from camp. To make us even later, the road leading down towards camp was blocked by a breeding herd of elephant. In those days the Kruger had only recently stopped culling elephants and this meant that they were still incredibly grumpy and temperamental. To be blunt, they were mad as hell!

It is indeed true that an elephant never forgets and with the horrors of culling still fresh in their minds, we needed to be super-wary of any elephants at the time, and especially breeding herds, which contained tiny babies and paranoid mothers. Hap had taught me expertly to drive around elephants but there were a few golden rules, one of which was never to approach a big bull from behind. But the best advice Hap gave me when it came to elephants I have always retained and practised: 'The only time your engine is running when you are around elephants is if you are driving towards or away from them.' To this day I am so grateful that I was taught how to drive with elephants. Many safari guides all over Africa rev their engines loudly at elephants in an attempt to ward them off or get them to move. The trouble with this is that an elephant interprets a roaring engine as a threat. Hap taught me to never idle or rev when in an elephant sighting, but to rather make a decisive decision to stay or go; and if the latter, well, then put foot and get the hell out of there.

With this in mind, I turned to the tourists on the back of the truck and, not wanting to get into trouble with the camp cooks, who were still not totally over my puffadder surprise, I explained that I was going to put foot through the breeding herd of elephant, and that everyone should hold onto their hats. My moment came when the heffalumps peeled to the left and to the right of the road, leaving a neat gap for me to accelerate through. I was halfway through the herd when Tobby, the tree-climbing reprobate from Kentucky, gave us all a heart attack by yelling at the top of his lungs, 'MOM, I dropped my pullover!' He was sitting on the back row of seats and the sweater had fallen out onto the ground.

Slamming on brakes, I leaned out of the safari truck and reversed as fast as possible back down the road. My plan was to back up to where the sweater lay, lean out and grab it, then continue without further incident. The elephants were already trumpeting in protest at seeing the truck lunge back into their personal space but the bush was thick so I couldn't tell exactly where the trumpeting was coming from. This added significant tension to the scenario. Whipping my head back around to ask the kid if he could see his sweater I was positively horrified to see that the seat next to me was empty. The mother, who had been sitting in the front next to me, was gone!

Perplexed, I put my foot on the brake and jumped out. What I saw I will never forget. The woman was running through a breeding herd of elephant like she was a quarterback for whatever football team hails from Kentucky. Scooping up the sweater, she made it back to the truck, where she leapt back into her seat and said brightly, 'Okay, we can go now!'

Over the years I have witnessed tourists do and say the funniest and dumbest things, some more serious than others. Many incidents were completely innocuous, while others ranked on the dangerous scale – but that mother from Kentucky beat them all. Driving back to camp, not even the smell of frying bacon could put a smile on my face.

Timbavati is perhaps most famous for its white lions. This recessive gene lingers and pops up every few decades, whereby lions are born snow white in colour, looking like little polar bear cubs. The white lion fame came from a book titled *The White Lions of Timbavati*, authored by Chris McBride, who lived in the reserve long before my time there. I once had a

corporate group on a trail and sitting around the fire one night one of the men asked, 'Greg, do you still get white lion here?' I explained that you do, but that currently there were none in the reserve. Then, without thinking and in front of everyone around the fire, the same man asked, 'Greg, what colour are the white lions of Timbavati?'

There was a pregnant pause around the campfire, followed by raucous laughter from the whole group, including me!

With me now leading my own trails, I was not getting to all my GDB jobs and so the company decided to hire a new apprentice. I felt pity for whoever this new guy was going to be as the roads had been neglected and there was a lot of fixing to be done. The woodpile was also at an all-time low. When the newbie arrived, it was my job to show him the ropes. On his first afternoon I took him out for a drive, to break him in gently. He was not interested in birds, at all, and when I showed him a big herd of buffalo, he was as nonchalant about them as one would be about seeing a herd of cows. He certainly was not interested when I stopped and sifted through a rhino midden, looking for new dung beetles. The impression I got was that he was expecting a job where you wore khaki clothes and leather bangles, where you smoked Camel cigarettes, drank beer and chatted up foreign female safari guests who instantly succumbed to a case of the khaki fever. He had most certainly come to the wrong place!

The next morning, I woke him early at dawn and we fixed roads all day. The next day we did the same and on the third day, when we were back in camp for lunch, on a short break from fixing roads, I was in my hut when I heard his car roar out of camp. When work resumed, Carlos, one of the camp hands, brought me a note that had been scribbled on the back of a cigarette carton. The note simply read: 'Sorry, I think this is not for me. Bye.' Hap was livid, mostly because the kid had borrowed his Maglite flashlight and driven off with it.

Starting from scratch again, Mike searched for a new apprentice but it was not easy to find a youngster willing to work in the sticks. Finally, he

sent a new guy down by the name of Neil. It did not take me long to give him the nickname Tazz. He was wild looking, like the cartoon version of a Tasmanian devil, with long frizzy brown hair, freckles and a naughty grin that revealed a chipped front tooth. He didn't walk forward to meet me – it would be more accurate to say he bounced up into my face like Winnie the Pooh's friend Tigger. While he certainly did not have any kind of bush Zen or calm about him, I could see he was tough. Assuming that, like me, he had come to the bush because he was interested in birds or mammals or predators or beetles or dung, or a combination of all of these things, my first words to him were 'How did you land up here?'

Grinning and rocking from side to side in his bush boots, as if he was going to take off at any moment, his reply went something like this: 'Well you see my bru, I was shacked up in Cape Town and jeez bru, I was dealing for a crazy Leb syndicate. It got hectic my bru and I was like needing to get out of there, if you know what I mean hey my bru? I tuned my boss that I like wanted out and he promised me that if I walked away, he would like kill me cuz. Jeeez bru, I skeemed I better make like Tom and cruise and so I started looking for work in the bundu bro. This jol right here is banging sweet my bru, no phones or nothing. No comms nor nothing bru. Those Lebs won't find me here ek sê!'

His answer was difficult to comprehend but I got the gist. Hiding from a druglord was, I guess, as good a reason as any to be in the bush. While I was grateful to have someone my age around, Hap did not take a liking to the new apprentice, which came as no surprise.

Tazz seemed indifferent, however, and he had boundless energy. He was always up for any sort of mischief. Besides hiding from druglords, he was also weaning himself off of drugs. I tried to help by introducing a programme of doing a lot of bush gym together to try and take his mind off his cravings. Using anything for weights, from fire hydrants to buckets of water, we helped each other with sit-ups and pull-ups. His mother sent us a manual – *Gym At Home* – authored by none other than Arnold Schwarzenegger. It was amazing how we could gym using the most mundane objects. Arnie's guide taught us that just standing in the doorway and pressing your arms out against the sides could give your shoulders a good workout.

Tazz was one of those people who, despite having a big and generous heart, also had an enormous propensity for getting into trouble. He was trying to clean himself up and with him no longer getting his narcotic fix, his new drug of choice, and one that was giving both of us major highs, was stalking big game. We soon started competing as to who could get the closest to rhino on foot. It was huge fun and a little dangerous but whenever we had a free evening we would go off in search of rhino to stalk. It got so bad in fact that if we were driving anywhere in the reserve in the bakkie together, and we saw a rhino, we would stop, have a quick stalk and then carry on.

One afternoon we spotted a rhino mom and calf out on Sesetse plain. With a simultaneous fist-bump it was 'Game on!' Assessing the wind direction independently, we both landed up approaching the rhino mother and calf from the north, which was of course also downwind. Usually there were trees and bushes to hide behind, but out on the grassy plain we were simply crawling forward on our bellies. With our bums in the air, we resembled a pair of caterpillars inching forward and ever closer to the rhino mother and her calf. White rhino are gentle creatures and not as moody as their black counterparts, although legend has it that when they get upset, they are far worse than their black cousins. Besides this fact, which always lingered in the back of our minds, the white rhino is also the second largest mammal on earth, after the elephant. And then of course there is the fact that they possess a long horn, like a sword. In this particular instance there was also a baby involved. Most intelligent people know that any wild animal with a baby is dangerous.

As we got still closer our modus operandi changed. We stopped our synchronous caterpillar wiggles and replaced them with a stealthier type of solo advancement. One of us would crawl a few feet forward, thereby being the closest to the rhino and potentially the winner of the game, but at the same time also daring the other to get closer. While we played this dangerous game of leapfrog, the rhino mother and calf were oblivious to our presence. Although this was a good thing, it also kept the game going to dangerous heights of stupidity. Mother and calf were walking away from us, grazing slowly, which made us feel comfortable enough to crawl even closer. The thing with wild animals is that they do not move like humans

do. They have nowhere to get to specifically, well, most of the time any-way. If a human is going in a certain direction, then one can assume that human has somewhere to go, like to their car or to buy milk. The person generally continues to move in that direction. Not so with a wild animal – and we were about to learn this fact first hand.

With only three suburban house swimming pool lengths separating us from the rhinos, they slowly started turning, and, somewhat alarmingly, began grazing their way back towards us. In fact, they were coming straight towards our position! Usually, at this point in the game Tazz and I would flee up a tree or hide behind a bush, but this time we were out in the middle of an open plain, not a convenient tree in sight. Lying in the grass, frozen, like a couple of stiff cadavers, we held our breath. Rhino do not generally see well, although baby rhinos have considerably better eyesight than their mothers. The calf was going to blow the whistle on us sooner or later, and we had nowhere to run to and nowhere to hide. The rhino pair kept chomping grass, getting closer and closer. They were now so close to us that the sound of the grass pulling through their lips was audible, like a piece of paper being periodically torn in half.

We were getting ourselves deeper and deeper into trouble. By now they were grazing mere metres away and were closing in. Tazz and I lay in the grass and stared at each other like a couple of new parents when the baby starts crying again. Neither of us wanted to move but we knew we had to overcome our fear. If we stayed where we were, lying flat down in their path, one of us was going to land up on the end of a horn. Every fibre in our beings was against moving – how we wished the earth would swallow us! – but slowly, and together, we rose out of the grass. It was no longer a game. It was a matter of life and death. And our only hope of getting out of there alive was to work together.

The rhinos, who up until this point had no idea that we were there, suddenly saw two human shapes rise out of the grass in front of them. They jerked their heads up and sideways, the mother getting such a fright that her giant jaw literally dropped. That was when things started to go in slow motion. I remember staring at the long grass that was protruding from her bottom lip, still fresh and green, and covered in a white paste of saliva. We had given the poor mother such a fright she had stopped

chewing her food. Standing there, stock-still, we waited for what seemed like an eternity while the mother decided whether to turn us into a human kebab or make other arrangements. The calf, which resembled a beer barrel with legs, simply spun around on its heels and shot off, with its little bum tucked in and its head held high.

After a tense few seconds, thankfully the mother decided to follow her calf. As the two beasts moved off in the opposite direction, running with a buoyant, bouncing gait, Tazz and I stood immobile in the middle of the plain, like a couple of mannequins in a shop window. It took some time for the adrenalin to wear off and for oxygen to return to our lungs and blood to our limbs. It was as if the fear needed to thaw and as it did, our knees began to knock. Neither of us talking, we made our way down to a rockpool in the Sesetse River, where we had a dip, allowing the rest of the tension to dissolve in the muddy water. Then, dripping wet and happy to be alive, we drove back to camp.

14

Every dog has his day

We decided not to tell Happy about the rhino incident. Tazz didn't really fit the mould of a trainee game ranger to begin with so from the start Hap was not particularly enamoured with him and Tazz was always in trouble. Tazz being a first-class rebel and Happy a bush-hardened, hard-nosed, old-school boss made the two men an unfortunate mix, like oil and water, or leopard and impala. Keeping quiet about our recent reckless brush with death seemed the wiser option. And Hap had the upper hand: no matter how difficult he made day-to-day life, Tazz could go nowhere for fear of the Lebanese druglords.

One day when Tazz was moaning to me about how hard Happy was coming down on him, in an attempt to make him feel better I made an offhand remark. I said I wished we had some Brooklax to put in Hap's whisky. I didn't give the comment another thought, and life carried on, but after the next shopping trip into town, Tazz had an extra bounce in his bounce, if you know what I mean. He called me to his hut and slipped a brown and yellow box out of a packet. Brooklax. For acute constipation, the instructions on the pamphlet read, two tablets were recommended. Tazz, with a look of absolute glee on his face, popped an entire strip of pills out on the table. With some vigour, and displaying the skills from his previous life, he turned them into powder while I watched, half in admiration and half in alarm.

Hap was a big Bell's whisky drinker and a good few stiff whiskies, drunk from an enamel mug with ice, was how every night ended. His clunking mug of whisky and ice was a standard ambient background sound at the campfire. Indeed, many of the traillists used to join Hap in drinking whisky from the enamel mugs; and a whisky or two in the bush, around a campfire, went down so well that they in fact often went down too well. One clever traillist blamed his hangover the next day on 'enamel poisoning', and the

phrase stuck. From that day on you could drink as much whisky as you liked as long as it was out of an enamel mug. You could blame any ill consequences on the dreaded 'enamel poisoning'.

Obviously, the best way to get the powerful laxative into Hap's system was to lace his whisky. I pleaded with Tazz to only use a small amount of powder but he took no notice, repeating the phrase 'Happy is going to shit for a week!' over and over. His usually wicked grin had turned somewhat sinister. While Hap was out on a safari drive, we dropped the powder into his whisky bottle. As hard as we tried to shake the bottle, the brown powder refused to dissolve and there was considerable sediment left at the bottom. Be that as it may, we eventually stopped shaking the bottle and hoped that Hap just would not notice. The camp had no electricity and we reasoned that the powder would be hard to pick up in the light of lanterns.

That night as Hap poured his usual few whiskies, Tazz sat at the fire grinning from ear to ear. I sat sweating and blamed it on the hot flames. I didn't sleep a wink that night, convinced we'd killed our boss. The package insert had said two pills and we had put five times that amount in the bottle.

The next morning Hap did not arrive for breakfast. Tazz was giggling uncontrollably but I was pretty worried. I finally walked over to his hut with Tazz some way behind me, by now laughing so much he was crossing his legs in fear of wetting himself.

'Hap?' I shouted. 'Can we take the bakkie and carry on with work?' I just wanted to ask him something, anything really, to check that he was alive. When the words 'Yeah, sure!' rang out in a strained but forceful tone, we looked at each other. Hap's voice was not coming from his hut but from his long-drop in the adjacent bushes. We rushed off like two schoolboys and collapsed in a heap of laughter as soon as we were out of earshot. Then we climbed into the bakkie and went off to do our bush work. As the saying goes, 'every dog has his day' and that was Tazz's day. He had a real spring in his step all day long.

But Hap also had his fun at others' expense – including his apprentices'. Quite often, instead of walking the traillists straight out of camp, we would first drive to a different location in the reserve, park the vehicle and walk from there. This allowed us the opportunity to walk in different parts of the park, or in search of a specific bird species. On such days, the plan

was to walk in a big circle, and to of course always finish back at the safari truck. The nifty trick I learned from Hap came at the end of the walk, when the truck was still out of sight and hidden behind bushes. He would turn around and with a concerned look on his face, explain to the group how embarrassed he was to admit it, but in fact he was lost. It was always an interesting psychological observation to witness the reactions of the various individuals who made up the walking party on any given day and I enjoyed playing the prank.

There would usually be one cool and calm customer with a built-in compass who knew the exact direction we should walk to get back to the camp. There was almost always someone who thought they knew the direction of the camp and, pointing in the exact opposite direction, would proclaim with certainty: 'It is THAT way!' Then there were those who would immediately start panicking. Some would even ask, 'How many bullets do you have?' to which my deadpan reply was 'Only four, and there are six of us.' This would get them even more worried! Just before the panicked guests began to really stress, I would walk the group around the corner and there, lo and behold, the safari truck would appear.

Some guests would slap me on the back, complimenting me on the joke while others would climb silently on board, furious or simply not sharing my sense of humour. I had pulled this prank off enough times to feel confident about it and one day I found myself again acting out the familiar drama of being supposedly lost. The group I was with were taking it hook, line and sinker. This is perfect, I thought. They are totally panicking. I decided to continue walking to the truck before the group decided to lynch their incompetent guide. We rounded a large gardenia bush, behind which I had parked the truck, and when I turned to see the usual look of surprise and relief on my traillists' faces, I got a bit of a shock. They gazed at me blankly. Swinging back around, I realised why. There *was* no truck. Playing my own game of 'Ring a ring o' roses', I ran around the gardenia like a chicken inspecting the ground for seed. I even knelt down and felt the ground. Then I looked up at the heavens, bewildered, feeling like Marty McFly when the good doc disappeared in the DeLorean.

Instead of my traillists being the nervous ones, I was now suffering from a mild panic attack, although doing my utmost not to let them see

it. I checked behind all the surrounding bushes, trying to reassure myself that I was not losing my marbles. But the truck was gone, completely gone! To buy time, I led the group down the road that we had driven up while I pondered my predicament. We rounded a bend in the road and there, right out in the open, was my safari truck – to the traillists' relief and my complete bewilderment. As I drove back to camp for brunch, my thoughts raced along various preposterous lines. Had poachers moved my car? Did I not drink enough coffee this morning? Is enamel poisoning a real thing?

Every morning after brunch, Hap and I would normally get on the radio to swap information about the morning's sightings and the movements and whereabouts of the game. We also swapped bird numbers and sightings. These radio calls usually ended with me asking to borrow a few more eggs or a packet of pork sausages. On this particluar morning the conversation went something like this:

Greg: '93, 93, Hap come in for Greg.'

Radio silence.

Hap: 'Roger Greg, standing by.'

Radio crackle.

Greg: 'Hi, Hap, how is everything?'

Hap: 'No, yeah, fine, thanks, Greg. How did you go this morning, over?'

Greg: 'Went well, Hap. Did a walk up in the Pompi Spruit this morning. Good birds up that way but not much in the way of big game.'

Hap: 'Yeah, I was out on the gabbro section this morning and found some nice rhino. Let me guess – you need pork sausages?'

Long silence as I put the microphone down to count the number of guests vs pork sausages vs the number of mornings left on the trail.

Greg: 'I think, um, please send a pack, or wait, make it two.'

Hap: 'I will send Tazz over this afternoon. Talk tomorrow again, over?'

Greg: 'Thanks, Hap. 93, Greg over and out.'

Hap: 'Greg, before you go, one last thing.'

Radio crackle. More crackle. Pregnant pause.

Hap: 'Glad you found your truck, lad. 93 Hap OVER AND OUT!'

Click. Silence.

Tazz had invited a girl he fancied for a visit. In the days leading up to her arrival, he looked decidedly nervous. Finally the big day came for him to drive to town and meet her bus. He had tidied up quite considerably. His usually wild bushy hair was tied back and his face even looked like it had stood relatively close to a very blunt shaver. When they arrived back in camp, I was introduced to his lady friend but it was not long before Tazz whisked her off to his hut. After a few hours, he reappeared in the kitchen, where he set to work meticulously cutting a big block of cheese into neat little blocks. I watched without comment as he placed the cheese blocks on a platter, and then arranged a neat ring of salted biscuits around them interspersed with gherkins. This was far too refined for the Tazz I knew. He was clearly trying to woo this woman. Once his cheese and biscuit platter was complete, he pulled out a bottle of red wine that had been left behind by the previous guests on a trail. Two wine glasses were placed carefully between the cheese and biscuits.

Leaving him to search for a bottle opener, I decided it was time for my bush siesta. I headed off down the path towards my hut but I only got about halfway before I caught a glimpse of a massive grey shape, off the path and to the immediate left. I swung around just in time to register the elephant bull lunging forward in my direction. These big old bulls would sometimes come into camp and while they were potentially very dangerous, they were not in any way paranoid like the breeding herds were. Although they would often charge, they seldom meant any harm.

Elephants are highly intelligent creatures – they have a brain 15 times the size of our own – and they knew where both our trail camps were located and they knew that people lived in them. When they came into a camp they knew they might bump into us, but this didn't mean they liked us. They would often give a mock charge – a way of telling you they simply wanted you to move out of their personal space. While the colossal mammoth chased me and I sprinted towards the closest trail hut, I tried to remind myself that it was only a mock charge. Fortunately, all the huts were built on stilts and I slid under one just in time, like a professional

baseball player sliding into base. The elephant locked his front legs and slid along too. His gigantic toes stopped within inches of my face, covering me in dust and sending my heart over maximum. This type of unexpected adrenalin rush was a part of my daily life in the bush and lying under the hut I watched as the elephant continued to pretend to be browsing on a Terminalia bush, while keeping a beady eye on me.

Soon Tazz would be coming down the exact same path, and I had an altogether delightful and equally awful thought, which presented itself as something of a conundrum. Should I shout out to him and warn him about the elephant? A little angel descended and landed on one shoulder telling me that I really ought to warn Tazz. I was about to call out when a little devil flew onto the other shoulder and protested vehemently, advising that I should keep my mouth shut. While the little angel and the devil argued, I saw Tazz appear on the pathway. He was walking with the tray beautifully balanced above his head. I saw it all so clearly: the bottle of red wine opened to breathe, two glasses, the platter of exquisitely arranged cheese, biscuits and gherkins. He seemed to be floating along. Perhaps he'd been a waiter at some point or perhaps he was just that in love. Anyway, lying under the hut on my belly, with bent elbows and my head resting in my hands, I watched Tazz float down the path to where the elephant bull was now again well hidden, still browsing on some bushes. There was basically going to be a bush version of a slapstick movie and I had a front-row seat. Neither the elephant nor Tazz disappointed. Just when Tazz was almost adjacent to the bush behind which the heffalump was feeding, it let out an almighty trumpet. Tazz leapt at least a metre into the air, kicking one foot forwards and one backwards, like I had seen in Laurel and Hardy cartoons growing up. And if Tazz leapt a metre into the air, then the bottle of wine leapt two metres, while the two wine glasses shot off in different directions. Cheese and gherkins rained from the heavens. Tazz started running while still airborne, thereby completing the cartoon analogy. When his feet hit the dirt, he had the same idea as me. Salticrax deflecting off his head, he came hurtling towards the hut and dived under it, landing alongside me, where he lay panting, uttering profanities aimed at the elephant and me, but mostly at me.

That same big bull elephant stuck around camp for the next couple of months and Tazz was to get an opportunity to execute a degree of revenge.

After months of playing 'stalk the rhino', which we even attempted to do on full-moon nights, both Tazz and I rated ourselves pretty high in the stealth department. When our heads got too big, Hap was always there to put us in our place. In the wild, a mature elephant bull often has a couple of younger bulls that he roams with, and these young bulls, known as 'askaris', not only learn from the older bull but are also kept in check by the big bull. Our situation in camp was much the same, whereby Hap would keep our work and our egos in check.

When it became evident to Hap that we were getting too big for our bush boots, he would tell us about his younger days in Rhodesia. He would mention how he, as a part of the standard game ranger initiation, needed to present the hair plucked from the tail of an elephant to his examiners. While we rated ourselves as first-class stalkers (which I agree can be interpreted in disturbing ways), who had stalked rhinos to within an inch of our lives, neither Tazz nor I owned an elephant's tail hair. This didn't bother me as much as it bothered Tazz – when it came to Tazz and Hap it was like trying to get two wag-'n-bietjie trees to shake hands.

One fine night Tazz and I had stayed up sitting around the fire drinking port, courtesy of the large corporate group that were on a trail (we could never afford to buy our own booze). Apparently Tazz consumed considerably more than me that night because when we heard the crash of a branch in the bush behind camp, his eyes lit up. 'Greg, my bru, tonight is the night!' he said, with such a big glint in his eye it was even visible in the firelight.

We stood in the dark behind the kitchen, listening to the gigantic creature crash about the brush as it enjoyed its dinner of leaves and bark. Tazz was rocking in his bush boots, shifting his weight from one leg to the other, like a boxer standing in the corner of a ring preparing for a fight. If Tazz was the boxer, then I was his trainer, egging him on and slapping him on the back. All that was missing was a white towel and a gum-guard, although a gum-guard would have been useless to protect him from what he was about to do.

'Now remember, Tazz, you got to get in, and you got to get out, you hear?' I said, taking a swig of port from my enamel mug. 'If you lose your nerve, then get the hell out of there before he tramples you like grapes.'

'Sure, bru, I got it,' said Tazz. He raised his fists into the air and gave an imaginary punch like Rocky Balboa.

The next 15 minutes felt like 15 hours. I stood alone staring into the African night, listening, waiting and straining my eyes to try and differentiate between the outline of bushes and the outline of the elephant. Knowing that my colleague was stalking an enormous animal that could kill him with the greatest of ease was a concern – and then of course there was Natalie, his new girlfriend who, despite missing out on her cheese platter, had fallen for Tazz. They were now an item. Standing beneath the stars feeling decidedly lonely, I asked Orion the hunter, twinkling upside down above as he does in the southern hemisphere, to go with Tazz.

I heard an almighty trumpet followed by an almighty crash. In the pale moonlight I saw large black blobs of trees being pushed flat. Poised to run like an Olympic sprinter in a relay race, I saw Tazz emerge from the treeline and two large white tusks not far behind him. It then became just as if we were really running a relay race because I waited for Tazz to reach me before joining him in his great escape. We made it back to the safety of the kitchen, leaving an extremely grumpy elephant standing at the door. Tazz was bent over, resting on his knees and breathing heavily, when I asked, 'And so?' Not saying a word, he flashed me his usual grin and opening his fist, he revealed a strand of thick wiry black elephant hair.

15

Never stand in front of a warthog hole

Soon after plucking up the courage to pluck a hair from an elephant's tail, Tazz left the bush. He figured that if he could take care of a big elephant bull, then he could surely survive back in the city and he hoped that the druglord who'd been looking for him had moved on to other concerns. I was sad to see Tazz go as he was the only other young person around and we had enjoyed each other's company.

During my years at the Wilderness Trails, I only had three friends visit, the first being a family friend from our church back home, who went by the name of AJ. AJ was just 16. When I collected him from the gate, I had to promise his mother that I would take good care of him. Little did I know what lay ahead!

A short two-day trail was about to start and this time I wasn't standing alone in the parking area waiting for the traillists to arrive – I had little AJ right by my side. We were only expecting two guests – a husband and wife couple – and they were quite a surprise, not our usual type of safari guests. Firstly, they didn't have a pair of binoculars between them (this is the equivalent of arriving naked) and secondly, they were not what you might call khaki clad. They both wore bright psychedelic clothing, which did little to cover their tattoos, and which reminded me of my clothing growing up in the 80s. I doubted that they were going to be keen on seeking out any new lifers, or that they even kept a life-list.

We went through into the mess area where I gave my welcome speech and learned that the couple had come to celebrate the wife's 40th birthday. When I was done explaining to them that we had no electricity and that the pot under their bed was really a potty, the husband sat forward and gestured with his hand, indicating that he wanted to say something in earnest. 'Greg, my wife and I are adrenalin junkies,' he said. 'We love skydiving, bungee jumping and bridge swinging. We are also petrol heads and we love

racing boats, motorbikes and quads. I booked this trip because I heard that you could give us a near-death experience, so please don't hold back.'

I was a little taken aback by this full and frank disclosure. Normally, after the briefing anything guests said was related more to a food allergy they might have, or a bird they really wanted to see.

'Um, er, sure ... you have come to the right place,' I said. 'It's always possible that we'll bump into a wild animal on a walk.'

Looking a bit anxious that I was not quite getting his point, the husband leaned further forward and reiterated: 'Greg, we don't just want to *bump* into dangerous animals, we want to *pursue* them.'

While this was a highly irregular request, once they had signed the indemnity form, I assured them that they had indeed come to the right place.

That afternoon I gave my rifle a good clean, and the next morning I slipped a few additional .416 rounds into my ammunition belt. We set off, with young AJ carrying the backpack and bringing up the rear. Not far into the walk, I stumbled across fresh elephant tracks belonging to a breeding herd. I explained to the two self-professed adrenalin junkies that a breeding herd of elephant was far too dangerous to actively pursue on foot. Immediately the husband protested, saying that this was the very reason they had come. Oh well, AJ's mother is going to kill me, I thought, as we turned and followed the herd's tracks. Two hours later, the tracks had landed us all the way east, to the confluence of the Sesetse and the Timbavati rivers, and then all the way west again, back along the northern bank of the Timbavati River to the crocodile pool, where we stopped for a rest.

This was the same crocodile pool that had been Tazz and my swimming pool. We used to take turns. One of us swam while the other kept tabs on the sunbathing crocodile after which the pool was named. If it slid into the water, then whoever was swimming slid out the other side. Feeling rather sheepish about not having been able to locate the elephants, I told the two guests that I had tried my best but that the elephant herd had eluded me. The husband seemed content that we had at least tried. Although I didn't think of it then, I should have just told them to go for a dip – that would maybe have gotten their adrenalin flowing to sufficient levels.

While I was peeling an orange, AJ picked up my binoculars and glanced down the river. 'Lion!' he exclaimed and sure enough, lying in the sand

way off in the distance were two lionesses. I asked the couple if they were keen to get closer. The look of delight on their faces is hard to describe. Quickly assessing the wind and drawing a map in the sand illustrating how I planned to stalk the felines, I told them that once we started moving, there would be no talking whatsoever. I got a couple of keen nods to show that my modus operandi was well understood and we set off to stalk the lion. Let me take this opportunity to say that it is never a good idea to stalk an animal that stalks for a living and, unlike rhino, lions have excellent eyesight.

A line of white berry bushes growing on the northern bank of the river provided cover initially, but it soon ran out. I motioned for the group behind me to get down. We continued on our hands and knees, like prisoners escaping from Shawshank. The lionesses, fast asleep in the sand and enjoying the sun, were now less than 30 yards in front of us. I flattened out onto my belly and the others followed suit. Now only about 20 yards away and the lionesses still sleeping, I began to wonder how this was going to end. Lionesses are apex predators. I was more concerned about little AJ than the adrenalin-crazed husband and wife who, being prepared to jump out of perfectly good aeroplanes, must have possessed a death wish anyway. But AJ was a child and he had a very protective mother.

Coming to my senses and only a mere 15 yards or less from the sleeping lionesses, I quietly and gently stood up. The couple behind me wanted to follow my lead but their legs only allowed them to stand up halfway, making them look like they were sitting on an imaginary loo, before one of the lionesses spotted us. Leaping to her feet, she uttered a gruff grunt in protest at our presence. The other lioness leapt up too. As had happened during the encounter with the rhino and her calf, everything went into slow motion. In a matter of less than a second, however, the two lionesses bounded off down the river. I turned to face my two guests. The wife might have just turned 40, but judging by the look on her face, in those few seconds she had aged a good few years more. There was much backslapping and nervous laughter as we made our way back to camp and in a straight line, as the brown-headed parrot flies, so to speak. The adrenalin junkies were full of adrenalin. AJ was alive. As far as I was concerned, at the time, my job was done. Later that night however, lying in bed and reflecting on

the day's events, I realised that in the future I would need to learn to say no to any safari requests that resulted in animals being disturbed, including for special birthday requests.

When Hap took his leave, he would drive a few kilometres east, where he would camp in the Kruger National Park. I always thought it was a bit strange to go from living in the bush permanently to camping in the bush on your holiday. For him, though, the bush a few kilometres east was a completely different place. When you know the bush like he does, I mean really KNOW the bush, you notice even a difference in the species of grass. I had noticed that whenever Hap went camping, he seemed to take everything but the kitchen sink with him. This surprised me somewhat. Having been a bush bachelor his whole life, I thought he would take the bare necessities only. But when I say that he packed everything, I mean everything. He even packed a doormat saying 'WELCOME' to place in front of his tent.

One day, as he was about to drive out of camp in his fully laden bakkie, I saw my opportunity to have a dig. 'Hap, you taking everything along on this trip, hey, except the kitchen sink?'

There was no reply as he continued meticulously checking the ropes that were holding all his luxuries in place. I wondered if he had heard me or if he was perhaps just ignoring me. Climbing into his bakkie, he started the engine. He drove up to where I was standing and gently rolled his window down. 'Remember, any fool can be uncomfortable,' he said. Before I could think of a retort, his laden bakkie was rocking from side to side up the marula-clad hill, leaving me standing speechless in the dust. Hap was like that; he was quiet but wise and I learned a great deal from him. Many years later, camping alone in Kenya in a most rudimentary way and eating my two-minute instant noodles, I would remember his comment and chuckle to myself.

While Happy was off camping, I took the opportunity of inviting an old school friend to visit. Duncan brought his girlfriend along and, as were all

of Dunc's girlfriends, she was pretty and likeable. It would have been nice to converse with her but I had been in the bush for a few years and I had completely lost the ability to talk to girls my own age. It was great to see Duncs, though; since Tazz had left, I had not had much youthful company. This is the life of an African safari guide. You mostly spend your time with people your parents' age because younger people are largely not in a position financially to afford an African safari.

Duncan and his girlfriend were keen to go on a walk and I was keen to take them. In the crisp light of dawn the next day, strolling along the Timbavati River, we came across a fresh warthog hole. Ignoring one of Hap's 'never ever' rules, despite his words echoing in my brain, I stood right in front of the hole. It was a clear-sky day and any self-respecting warthog would surely already be up and out of its hole, looking for grass roots, or whatever else warthogs do. I started explaining to Duncs and his girlfriend how a warthog and a hyena will sometimes share the same hole. The hyena, being nocturnal, uses the hole in the daytime while the warthog uses the hole at night (something I have actually seen happen in the Okavango). As I was about to elaborate and get to the part about how warthogs always go into their hole backwards so that they can come out with their tusk-end first, I heard a thrashing from deep within the hole and the words dried on my lips. Next a plume of fine powdery dust erupted from the hole's entrance, like the smoke you see at a rock concert before the band comes on stage, followed by an angry-looking boar thrashing the walls of the hole like a pig possessed. I turned and ran, with Duncan hot on my heels. His girlfriend had better reflexes than both of us. She also had strong, hockey-player legs that propelled her to a position way ahead of us. The pig shot out of the hole with such pace that it was completely airborne. Looking over my shoulder, I saw it land and run off, its tail held high in indignation.

I was so embarrassed. I had made a classic rookie error of note. We stood and caught our breath under the shade of an albida tree. It was then that Dunc's girlfriend noticed that a ring she had been wearing on her finger was gone. She had gotten such a fright when the dust erupted from the hole that she had flung her hands into the air and with such vigour that her ring had been launched clean off her finger and into the heavens.

'No, Greg, please no, forget about the ring, I am just happy to be alive,' was her response to me crawling around on my knees in the vicinity of the warthog abode looking for the ring. For weeks after that I went back to look for the ring but I never found it. Perhaps it landed on the warthog's tusk! Suffice to say that in those early years of guiding, despite Hap's input, I learned many lessons the hard way, such as never ever, no matter what the time of day, stand in front of a warthog's burrow!

'Clunk, clunk, clunk' came the sound. I climbed out of bed, walked onto the deck of my little hut and peered around the corner to discover the source of the noise that was disturbing my rest. It was a francolin, which is a type of wild partridge, and it was slamming its beak into the shiny silver rims of my bright yellow VW Beetle. I had acquired a set of my very own wheels in the form of a VW buggy. It looked like a dung beetle on wheels, which meant that I absolutely loved it. The problem, however, was that the shiny bulging convex hubcaps not only reflected whatever stared into them, but they also projected a larger, more distorted version of that reflection. The birds in camp hated my wheels with a passion, or more specifically, they hated my hubcaps. Each species took turns at head-butting the hubcaps. Not even the fine German-engineered metal could withstand the pockmarking that a large, robust hornbill beak can inflict. The worst part about it was that even on days when we didn't have any traillists, I still could not sneak in an extra half hour of sleep: the hubcaps became my new alarm clock.

Perhaps it was just as well as I needed every spare minute to study as my exams were coming up. To complete my Nature Conservation studies, I had to attend lectures in Pretoria at the same time as carry on with my practical assignments in Timbavati. My little Beetle had to ferry me 500 kilometres back and forth at regular intervals, often overheating under the pressure. Attending lectures was strange for me as I was not used to being surrounded by so many people my own age. Most of the other students had come straight out of school and treated their tertiary education with

the same nonchalance that they had their high school education. I was different in that I had work experience in the field, and I had found my niche in the world, so to speak. As a result of this, I attended ALL my lectures, asked ALL the questions, aced ALL of my exams and sat right in the front of the class. I was the first to raise my hand to answer any question, which was not exactly the 'cool' thing to do. I did not care about being cool though. I just wanted to glean as much information as possible before returning to Timbavati. I soaked up the lectures in ecology, botany and zoology, but my favourite subject of all was conservation development, which addressed the latest trends in the relatively new and emerging science of nature conservation.

Despite my uncool approach to my studies, I managed to make some interesting friends. On the very first day of lectures, a sheepish-looking chap called Dave came up to me and tapped me on the shoulder. He was slightly plump, had a beard and wore his spectacles on the end of his nose. He requested my help with his car. I assumed it would not start or had some other minor mechanical fault, but that wasn't it. His vehicle was neatly parked on a traffic island, with all four wheels in the air. Dave explained that he had tried to park on the island because the parking bays were all full, but he had overshot it and landed in a precarious predicament, which, as it turned out, took 20 students to rectify, by physically lifting his car off the island.

Dave couldn't seem to get a lot right. As a part of our studies, we went on regular practical excursions. On our first one, a casual bush walk, Dave managed to brush past a bush that was covered in hairy caterpillars, to which he instantly and dramatically had a horrendous allergic reaction. By the time we returned to base camp, his skin was one gigantic raised rash. One of the students thankfully carried antihistamine tablets, which worked quickly and effectively, so much so that from that day on I always travel to the bush with antihistamine. It was Dave's second attempt at tertiary education, and his dad refused to pay his tuition for a second time, so Dave needed money. He took up a job as a bank teller and on his very first day the bank was robbed!

I felt rather sorry for 'Dangerous Dave,' as he became known, who, despite having the worst luck in the world, almost always had a smile on

his face. He was a very gentle fellow. Sadly, I lost touch with him but, long after we'd finished our studies, I did visit a safari lodge I knew he'd once worked at and I asked after him. The camp manager explained to me that they had had to let Dave go. He had spotted a tortoise in the bush and, excited to show it to his safari clients, had leapt out of the vehicle to fetch it. The only problem was that his Land Rover was parked at the top of a hill when he leapt out of it and he forgot to lift the handbrake. The vehicle went careering down the hill and into the bush with a group of wailing tourists screaming, 'Oh my Gooood!' Dave, who by then must have been quite used to his bad fortune, went running down the hill after them, waving the tortoise in the air.

A further part of our studies involved studying fire ecology. Fires have always held a fascination for me so this was one of the courses I relished. Fires are also an integral part of the African ecosystem. As a part of our practical application we were taught how and when to light back-burns. A back-burn is basically a fire that you light to put another, out of control fire, out. As part of our studies we travelled to the Drakensberg Mountains and watched how the expert fire teams burned fire-breaks there. We also had to conduct our own 'burn'. In a reserve in the dry North West Province, I watched as our fire jumped a road for the first time. It was both exhilarating and scary to witness how the intense heat from the fire ignited the bush on the other side of the road before the flames did!

I aced fire ecology and had learned how to use the biomass of the grass and the wind direction to achieve different results with fire. Sadly, though, back in Timabavati I missed my chance to start my very own back-burn. It must be said, and in my defence, that I slept particularly well at night in my little hut in Timbavati, which was right at one end of the camp. One fine morning I was trundling along the 'green mile' from my hut to the kitchen to grab a cup of coffee. Placing one sleepy foot in front of the other, I was very surprised to see Hap and all our staff and traillists sitting in the mess area, wide awake and covered in black soot. Apparently, the camp had almost burned down in the night and while everyone was fighting fires, I was fast asleep in my bed. More embarrassingly, walking from my hut to the kitchen I had not even noticed that the entire camp was charred, not helped by Hap asking if, during my fire ecology studies, my lecturers had

mentioned that in order to light a back-burn a person actually needed to be awake. I tried to argue that they should have woken me but in the frenzied panic of the fire-fighting, no one had thought to do so, and I had missed my opportunity to put my fire ecology lectures to the test. I was embarrassed and disappointed, although years later I would get my chance to save a camp from fire.

16

Operation 'Fetch the Liver'

To finish my practical studies, I spent three months working at the Timbavati Game Reserve headquarters, or HQ. It was a little bit like going to the army. The warden at the time was an ex-Special Forces captain, famed for his outstanding anti-poaching operations. I had to wear a uniform and on Saturdays we even did drill marches on the airstrip. Lying in my bed at night, I could hear the warden practise fighting with his punching bag late into the night. To say I was petrified of him is a complete understatement. He had never decompressed completely after his war days on the Angolan border, and he carried a firearm on his hip – permanently.

On one occasion we were walking through the camp at the HQ in the evening and an owl flew out of a tree, snapping a branch as it alighted. The warden instantaneously drew his revolver and spun around in the direction of the sound. On another occasion – it was after hours and he was in the swimming pool – I walked up from behind to ask him a question. I must have given him a fright because he spun around in the water and assumed a karate-like stance, like Rambo coming out of a swamp somewhere in Vietnam. He had one of those gym appliances, the ones comprised of a pair of handles and a spring that you squeeze in your hand, which he squeezed continually, whether sitting at his desk or driving his pick-up around the reserve. This resulted in him having the largest forearms in the lowveld. When he raised his arm and shook a fist to make a point, a shadow quite literally passed over me.

Once a month we had to drive into town to deposit the reserve's money that had been collected in the form of entrance fees. At the time there was a crew of armed robbers hitting banks in the area. The anti-poaching team assembled in the strong-room for a meeting to discuss 'Operation Make The Drop.' It was just like I was in the Special Forces. We had a map and a plan of who would drive in which vehicle, and who would stand where. I

was given the duty of manning the bank's back door. I was handed a large semi-automatic rifle, plus a sidearm. Standing on the back of a pick-up with the anti-poaching team, all of us armed to the teeth, we rolled into town like we were a posse of vigilantes in the Wild West.

We pulled up in front of the bank, coming to an abrupt halt, and all deployed to our designated positions. Standing at the back door holding the semi-automatic in front of me and with another bulging weapon on my hip, I truly did feel like I was in a movie. 'Operation Make The Drop' went down without a hint of trouble and before long we were racing out of town back to our camp.

During my three months at HQ, there were two incidences of trouble, however.

One came when the warden got a tip-off about an illegal rhino hunt happening in our area, which he promptly reported to the police in town. Minutes later the phone rang in the warden's office. It was the owner of the land on which the rhino was going to be hunted. He threatened the warden, telling him that he would 'take care of him' if he went to the police again. Being young and naive, I needed some help in connecting the dots. The warden had to explain to me that it was the police who must have tipped the caller off. My time at the HQ was a rude awakening to the reality of what lay beyond the veneer of the wilderness trails, where collecting dung beetles and stalking rhino for fun was the order of the day.

Not wanting to get involved in any more combat operations, I volunteered to oversee the alien plant control programme and specifically a project called 'Operation Prickly Pear'. This meant travelling across the reserve looking for, and treating, prickly pear infestations. It was hard work. I had a large team of workers and the food rations were meagre. I shared a small dome tent with the corporal assigned for our protection. The trails camp felt a million miles away.

But it wasn't long before I was called out again to assist on an anti-poaching patrol. This was over the full-moon period. I had slept out in the bush many times before with a fire, cozy blankets and a warm plate of food, but this was an altogether different exercise. Each member of the anti-poaching unit was deployed in different spots in the reserve and I was dropped off way down in the south. My job on 'Operation Sit Tight' was simply to

sit on my own and to listen, for the entire night. No fire, no eating, no drinking, no singing and no smoking (not that I smoked). Poachers make noise and sound travels, so all that was needed was to listen. With just my rifle and the moon for company, I sat in the bush alone for the night. The next morning the corporal picked me up in a hurry. We raced off to an area where poachers had been heard and soon we were tracking them. I thought I had learned a thing or two about tracking when out on a walking trail, but the guys in the anti-poaching unit were crackerjack trackers. Not only had they been trained by the warden, who with his war experience had taught them how to differentiate between people walking wearing hooves on their soles versus a real animal, but they were also from the Shangaan tribe. These are the local people from the area and their recent ancestors had tracked in order to hunt and survive. Suddenly Corporal Frans shot off. When I finally caught up with him, he shouted, 'We are close!'

We ran and ran until our army boots felt like dead weights tied to our ankles, but it was to no avail. The poachers had seemingly slipped through our grasp. Eventually, when we returned the same way we had come, I asked the corporal how he knew that they were running. He pointed to saliva on a grass stalk. The poachers were running, he assured me, and one of them had coughed up some phlegm.

Once the full moon had passed, 'Operation Count The Grass' began and I was sent out with an ecologist to perform grass transects all over the reserve. I thought it would be great to get out and walk in the various parts of the reserve, but boy was I wrong! It was not at all like walking when on a wilderness trail as we only took one step at a time, and every single time our foot hit terra firma, we needed to record the grass species closest to our big toe. I had studied grasses and learned all their scientific names by using word associations. I had also learned which grasses were good and which were bad, or in more correct scientific terms, which ones were 'increasers' and which ones were 'decreasers'. So, for example, the unpalatable grass genus *Sporobolus*, I remembered as Spor-horribleness. This word rhyming had worked as I had aced my grassland science subject and I could identify almost every kind of grass in the veld by its seed structure.

The problem was that if the grasses didn't have seeds, I was stuck. Theresa, the reserve's ecologist, could, however, identify every grass by its

leaves. She carried a tape recorder with her as she walked along. She also had abbreviations for every species, which she said aloud as each foot hit the ground. She knew her grasses so well in fact that she was almost walking at a normal pace. I scurried behind her, doing a chimpanzee-type walk, trying not just to crack her code of abbreviations but also to learn the leaf structure of each grass. When I got back to the trails camp, I would need to, as the very last part of my studies, complete my own grass transects. Not having a tape recorder, I was scribbling down notes and drawing pictures in my notebook, all of which, after days of counting grass, made absolutely no sense whatsoever. I decided to just wait until summer, when all the grass would have seeds, to do my own transects.

Soon enough my three months of practical work, or more accurately my army basic training, was up. I had written assignments on each and every project and exercise I had taken part in. These included 'Operation Make The Drop', 'Operation Prickly Pear', 'Operation Sit Tight' and 'Operation Count The Grass'. All my assignments had been signed off by the warden, my bags were packed and I was desperate to get back to my little hut on the river. As I was about to take my bags and load them into my Beetle, the radio on my bedside table crackled my name. I had that feeling you get when you know it's an ex-girlfriend calling and you really don't want to answer, but technically I was still on duty. I was duly summoned to the warden's office.

'Greg, I have one more assignment for you,' said the warden. 'I am calling it "Operation Fetch The Liver". The assistant warden will talk you through it.'

With that I was loaded into a bakkie and the assistant warden drove me deep into the reserve to where a dead waterbuck lay. In fact, it was so dead that it was completely bloated, lying in the blazing hot African sun. The assistant warden explained that the waterbuck had died mysteriously and that they needed a sample of the liver to send to the veterinary department at Skukuza for an anthrax test. Did he just say anthrax? Before I had time

to process this, I was handed a pair of rubber gloves. He gestured to me to walk over to the bloated carcass. When he said the word again, I could not believe my ears. Having studied wildlife diseases recently as a part of my studies, I knew how serious anthrax was. I also knew that, if the animal had indeed died from anthrax, and this seemed to be a possibility as there was no evidence that predators had killed it, when I opened the carcass I would be releasing the spores. It was also the end of winter, which is when anthrax outbreaks typically occur.

But this was par for the course. Me being the 'laaitie', or youngster, the warden was making sure I was paying my dues and that I understood the pecking order of life before I rode off into the sunset and back to my cushy world at the trails camp. Walking closer to the waterbuck carcass, I winced at the stench. When I looked back at the assistant warden and the bakkie, they seemed a million miles away. Wanting to block my nose because of the smell, and also not wanting to inhale anthrax spores, I took my shirt off and tied it around my mouth and nose as I inched closer to the bloated belly of the beast. When I was beside it I drew my pocket knife and ever so gently pierced the skin of the extended stomach.

A putrid plume of green gas promptly escaped and sprayed straight into my face, causing me to rip my shirt off and gag violently. After composing myself and retying my shirt, I psyched myself up and thrust a hand deep into the rotting bowels of the animal. I felt around for the liver, cut a piece off and hurried back to the bakkie.

'Nope,' said the assistant warden. 'This is a piece of a kidney.' He pointed me back to the carcass.

As I got closer, the smell seemed worse. I battled to control my gag reflex as I worked my way through the swollen internal organs of the waterbuck, while large blue flies with red eyes swarmed in from all directions. For the life of me I could not find the liver. While I was the official camp butcher, I was not responsible for the skinning of the animals and, as such, I was not familiar with the internal organs of an antelope. Feeling a round organ of blob, which I hoped might be the liver, I cut a piece and headed back.

'Nope,' said the assistant warden. 'That's a piece of spleen.'

After all my churning inside the belly of the beast, the organs were now more than a little topsy-turvy and the latex gloves were covered in

green slime, which extended past the gloves and up to my elbows. It was a messy, stinking, foul job but I eventually found the liver and presented it with as much triumph as I could muster in my nauseous state. Mission accomplished!

Driving back home to Timbavati Camp, I dangled my right arm out the window the whole way and when I got there I promptly plunged both hands into a bleach solution. I wished I could do the same to my brain and disinfect the memory. 'Operation Fetch The Liver' was my second-last student assignment. The only thing left to do was my own grass transects, after which I could submit my papers and I would be a qualified nature conservationist. After that I planned to live in the sticks for the rest of my life and lead wilderness trails. After my three months at HQ I now had a brand-new appreciation for how awesome my real job and life was. All I wanted to do now was carry on with 'Operation Live The Dream'!

I soon noticed that something seemed to be troubling Hap, but I didn't feel free to ask. He was the kind of person that you could not force to speak. Having spent his life in isolation in the bush, communicating his feelings was not something he was particularly partial to, but finally one day, when standing beside the bakkie, he decided to get it off of his chest.

'Greg, there is trouble with the owner of the land,' he said, 'and it looks like we will lose our trails concession at the end of this year.'

Shocked, I asked, 'So what will happen to the Wilderness Trails?'

'Sorry to say but it's over, lad,' came his reply.

My memory of the rest of that conversation is blank. All I know is that my world shattered.

While I was concerned about my livelihood, I was far more concerned for Hap. He had been living in his little wooden hut on the Timbavati River for 20 years and he was now heading into his mid-60s.

In my last week in Timbavati a huge and very old male lion took up almost permanent residence in the clearing behind camp. We would hear his mournful roars during the night and during the day he lay up under some

gwarrie bushes, staring down towards camp with a look of melancholy. He was a lion we had never seen before and still, to this day, he is the biggest lion I have ever seen. The logo of the Timbavati Wilderness Trails was the head of a big male lion and the presence of the lonely beast, out at the back of camp, became a symbol of the ending of a chapter.

Before I left the Timbavati, there was some unfinished business that I had to take care of. You get a large brown spider in the bush called a bark spider. It looks just like a piece of bark, except that it has two protruding knobs on its back. I knew where one of these spiders lived as I had seen its web across the road at night. Unfortunately for the spider, it is very palatable to birds, so each and every evening it has to construct its massive circular web, where it spends its nights waiting for insects to fall prey to its intricate orb design. Then every morning, at the first sign of daybreak, the spider has to take its web down, consuming the silk, which it recycles, before retiring to a branch where it blends in and spends the day sleeping. One question had always plagued my mind: how does the bark spider get its web across the road each night?

I came up with a plan to solve this mystery once and for all – 'Operation Bark Spider'. To execute it I would need a full gas bottle and a full cooler of beers. In those days we used to fill our own gas bottles from a larger gas bottle that we placed upside down in a contraption that Hap had welded together. I have to say that I never felt very comfortable with this set-up. The gas from the big bottle would pour into the small one at a rate of knots. Shell Refinery was a regular corporate client of ours and many of their staff members came to do the four-day trail. One of these guests asked for a tour of the camp one day. When he saw how we had inverted a massive 48 kg gas cylinder, he covered his head with his arms and ran off into the bush.

Ever since that day I said a prayer before filling the camp's smaller gas bottles, which was one of my GDB chores. Having not yet been blown up, I loaded the gas lamp and beers into the bakkie and drove to the place where the bark spider lived. It seemed a little random, even to me, to be sitting on the back of a bakkie with a gas lamp in the middle of the bush. But it was nothing a cold beer could not fix. Before I opened one, I lit the gas lamp and dialled the brightness right down so the spider didn't think

it was still daytime. Sitting on the back of the bakkie, listening to the last whistles of the white-browed scrub robins and watching the stars pop out from their hiding places, I knew that a wonderful and epic chapter of my life and youth was about to end.

In the twilight, and the glow of the lamp, I watched in wonder and awe as the bark spider let a thread of silk loose from her abdomen. She floated the thread ever so gently with the wind, like a kite, until it landed on a tree on the opposite side of the road. She then clambered her way along that single thread a few times, thereby reinforcing it. By the time I was on my second beer, she had secured a few more strands, like tent poles. She began walking in perfect circles and I watched, absolutely mesmerised, as slowly her web began to resemble Charlotte's. And when she was done, she took up residence right in the middle of her beautiful handiwork. She was finished, and so was my night's entertainment.

My last few days at Timbavati were spent completing my grass transects. Hap came out to see how I was progressing. Our entire friendship revolved around the bush and the transects were a good excuse for the two of us to hang out together. Along one of my grass transects we found a ground hornbill nest inside the trunk of a marula tree. Climbing onto Hap's shoulders, I peered into the nest where two chicks lay side by side. That is the last bush memory I have of Hap.

The next day I went back to packing my Beetle.

I had been asked to take a few bones home for a family friend who was a biology teacher. She had asked for a bone or two to put on display in her high school laboratory. Luckily for her, the lions had killed a giraffe a couple of weeks prior. I decided to forget her request for just a bone or two – she was going to get an entire giraffe skeleton! The bones still stank a little, but I figured this would be okay as I would be driving back with the passenger window open anyway, as that was the only way to fit the long leg bones in. And besides, after the great green stench of the waterbuck, I was fairly impervious to bad smells.

My little yellow Beetle was soon packed to the gills, complete with giraffe bones sticking out the window and an impressive collection of dung beetles on the passenger seat, all neatly pinned. I was in the habit of playing cassette tapes when driving and my music of choice was none other than

'South African Bird Calls' by Len Gillard and Guy Gibbon. The cassette was half sticking out of the cassette player and ready to be popped in.

Before I knew it, it was my last evening in the Timbavati and, as I had done on so many other evenings, I went for a stroll through the bush. Not far from my hut I saw some fresh elephant tracks and it suddenly dawned on me that I didn't know when again, if ever, I would have the opportunity to track a wild elephant on my own. I set off with determination to stalk my last creature in the Timbavati. Tracking skills are one aspect of the bush that a person cannot learn from a book; you have to practise them. I was by no means an expert tracker but that evening I did manage successfully to track down the large elephant bull. The feeling of accomplishment, when having successfully tracked a wild animal down from scratch, is quite something – even if my particular quarry happened to be the largest land mammal on earth.

Once I caught up with the elephant, I thought about going for a tail hair, but I was in a far too melancholic state, and I decided to rather walk behind the animal, remaining out of sight and undetected. Trailing the magnificent beast, I picked up the stalks of vegetation that he had just minutes before been chewing on. Feeling his wet saliva on the branches and walking west towards the Transvaal Drakensberg Mountains, the sun set on what had been an incredible few years.

There was no emotional goodbye between Hap and me. In fact the morning of my departure, my car would not start, which helped relieve the awkwardness of a long goodbye. Hap gave me a tow before shouting out the window 'Good luck, lad!' and that was that.

I was going to need all the luck in the world for the next chapters of my life but I did not know that then. As I pulled out of camp, I drove past the sad-looking lion, who was lying right next to the road. Applying brakes, I came to a halt right in front of the lonely beast and with my VW sitting low in the rutted tracks, I met his gaze head-on. In his glassy eyes I saw the same loneliness and sadness that I was feeling. Years later I would learn from Hap that the lion got shot by a hunter and was the second-biggest lion on record.

Remembering that I had a car full of giraffe bones, for the first time in days I snapped out of my melancholic state and pressed the accelerator to

the floor. My Beetle was so low to the ground that it felt like a Porsche. I wound my way through the marula-filled valleys and out of the reserve, where a 500 km journey lay ahead of me.

The smell of the wet giraffe bones was something I had gravely under-estimated. I had to refuel halfway in a town called Ohrigstad, but I had a tough time finding a petrol attendant willing to serve me. In most African cultures, traditional healers or sangomas (they are sometimes still called witch doctors) are feared and revered, and they throw bones to diagnose illnesses and to predict the future. When I pulled into the small rural gas station in Ohrigstad, the local petrol attendants saw my gigantic bones protruding from the window and thought that I was the wizard of all witch doctors. To make matters worse, my bug of a car was emitting peculiar bird calls. The cacophony of sounds coming from within must have reinforced their suspicions of my supernatural powers, and they scattered like ner-vous impala, all in different directions and shouting the words 'Eish!' and 'Aikona!' and 'Hoah!' Finally, the owner walked over and even he seemed a little on edge, especially when he saw the pile of dung beetles on my passenger seat. But he did help me with fuel, even if somewhat reluctantly.

17

Birdwatching nearly killed me

I had not been back home for long when I got a call from an old friend, Paul.

'Hey, Greg, I hear you're back?'

'Yeah, howzit, Paul?'

'All good. Hey, man, I got a wildlife filming gig with a new company and I need a filming partner. Salary is good, R7 000 ($400) per month. You in?'

'Sure, I'm in!'

'Pack your bags and I'll collect you on Friday morning 7 am.'

The details were not important and before I knew it, I was heading down to Zululand to live and work as a wildlife filmer. Paul and I were going to be working for an incredibly exciting new company, one that was way ahead of its time. The concept behind it was to use the internet, a brand-new invention at the time, to bring an African safari to the world. The company had started out by placing cameras in the bush at various waterholes. Every 30 seconds the camera would capture a still image of the waterhole. Sitting in your home, anywhere in the world, your computer screen would refresh every 30 seconds and you would see almost live images from the waterhole in the African bush.

The concept was a novel one and it became insanely popular, with almost a million hits daily, and coming in from all over the world. It was still a young company and they wanted to take it to the next level. This was where Paul and I came in. We were hired to drive a Land Rover with a camera on board and conduct a 'virtual safari'. The concept was the same as for the waterhole cams, except that we were mobile, and the camera could therefore be aimed at a specific subject and panned or zoomed in and out. Paul had to explain this new technology to me very slowly. I had spent the last few years living in the Timbavati without electricity and showering from a bucket. Now I was to be at the forefront of the inter-web!

Hluhluwe Game Reserve, with its rolling hills and deep valleys sliced down the middle by lazy meandering rivers, teeming with wildlife and birds, was a welcome sight. I have always said that if time travel was possible, and I could go back in time and explore any one part of Africa, I would go to Zululand – back to the days long before colonial rule and the white man set foot there. On my voyage I would journey to the fortress-like Drakensberg Mountains, then across the ample savannahs filled with their umbrella-shaped acacia trees. I would bird my way through the fig and fever tree forests searching for elusive avian endemics and one of my favourite birds, the very aptly named gorgeous bushshrike. I would search warm tropical dune forests for leopard and canoe down the rivers, just like my childhood hero the late Dr Ian Player did. Into the estuaries, through the lagoons and out onto the Indian Ocean, Natal was not a province but a wild kingdom second to none. It was here, in the heart of Zululand that King Shaka himself reserved his own private hunting ground.

I have always wrestled with the distinct feeling that I was born a couple of centuries too late. By this I mean to say I was born too late to see the real wild Africa of my boyhood dreams. After hearing Ian Player talk when I was 16 years old, I had vowed to not rest until I found my lost Africa. Living in the Hluhluwe-iMfolozi Park, right where Dr Player had had his bushveld home for many years, seemed like a very good omen and so, arriving in Zululand nothing could dampen my spirits – not even our accommodation.

Pointing at a sorry-looking caravan with a tattered canvas tarpaulin that could extend out to provide us with a veranda of sorts, Paul explained that this would be our home for the next six months. The caravan looked a bit small and smelled like damp socks, but it had a big view and was perched right on top of a hill inside the reserve. Despite the humble-looking abode, I could take my morning coffee gazing out over the green hills and valleys of Zululand. On our first night we placed stones in front of the caravan's wheels, just to be certain our home would not roll away in the night, then sat outside with bowls of two-minute instant noodles for dinner. One small thin flat mattress in the caravan, just left of the

entrance, was to be both my bed and bedroom. With the door open, the fresh night air carried with it the scent of grass and adventure. I think I fell asleep with a smile on my face.

Our job for the next six months was to be inside the Land Rover filming each day, starting every morning at 9 am exactly. We had an international cyber audience and our mandate was to conduct an eight-hour, uninterrupted safari drive and to do this every day of the week. Our directive was simply to explore and film whatever we saw. Driving out of the camp, with the Land Rover's turbo still warming up, Paul and I looked at each other and together we exclaimed, 'What a joke job!' The phrase stuck and we began every morning with this mantra, just to remind ourselves how lucky we were. We raced down the hill on which we lived each morning simply to explore the bushveld below. I was being paid to go on safari!

When we saw something interesting we stopped to film it, and people all over the world sitting at their computers would receive a 30-second refresh of whatever we were pointing the camera at. Back in the Timabavati I had relished sharing the awesomeness of the African bush with my walking guests and this was no different; except that my audience was sitting thousands of miles away and strewn across the planet. The technology was new, however, and as such there were significant technological challenges, like having elephants push the telephone poles over. Often we would film vigorously all day, only to return to camp to discover that our signal was not going out because the phone lines were down – and all because an elephant had had an itchy bum and had used a pole to scratch it! We then had to do a ping to see where the phone line was down and report it. Satellite technology was not yet mainstream and while our set-up was rudimentary, when it worked it was exciting to be taking Africa to the world. With only a 30-second delay, it was almost live and this seemed incredible. Until now people had only ever seen documentaries from Africa that were filmed long before the audience got to see them.

In my eyes, however, the product had one flaw in that there was no audio stream and therefore no way to share our insights with our viewers. To get around this, Paul and I decided to introduce a new element in the form of a small whiteboard. While one of us filmed our subject, the other scribbled a few interesting facts about it on the whiteboard. After the 30-second

refresh had captured our frame of the animal in question, we then filmed the whiteboard and waited for the next refresh. People at home could read about whatever we had just shown them. The concept took off and our safari drives became known as the 'Paul and Greg Show'.

We would spend all day driving slowly through the bush looking for filming subjects, which ranged from rhino and elephants through to dung beetles (of course) and dragonflies. Every subject was thoroughly researched so that we could have interesting information to place on our whiteboard. While we were having the time of our lives, we were also unknowingly attending the finest 'field university' in the world, studying and learning about the African bush around every literal twist and bend in the road. And we did this for eight hours every day, seven days a week.

Each morning I slipped out of the caravan in the dark and, since preparation for filming only began at 8 am, I enjoyed at least two hours of birding before work began. Our caravan was parked close to remnant yet virgin montane forests, and these, combined with the open glades on the mountain flanks made for some exceptional birdwatching. I have never really been what I would classify a true-blue twitcher, someone obsessed with notching lifers and growing their life-list. More than ticking birds, I just love seeing them, and I especially enjoy listening to them. Their voices are to me as pretty as their plumage. There is nothing cheerier than a bird – I have yet to see a depressed one.

I had also not yet seen the very rare, or to put it more accurately, a rarely seen bird, called the Narina trogon. The trogon is a forest dweller of note and although possessing a brilliant ruby breast and vent (bird talk for 'bum'), its head and back are an emerald green colour. Being incredibly shy, when this bird sees you coming, it turns its back so that the shimmering emerald feathers melt into the shiny green canopy of the forest. I knew that the trogons were present in Hluhluwe, I had heard them calling, but I had yet to actually see one. Every morning I set out with my binoculars and high trogon hopes, and every morning I returned to the caravan with what Paul called 'the trogon blues'. The Narina trogon is, after all, a bona fide megatick. Interestingly, the bird was given its name by none other than the noted early nineteenth century ornithologist François Levaillant himself. Being French, he could not pronounce the name of his Khoikhoi lover, but

he could pronounce the word Narina, which was 'flower' in her language. Or so the story goes. One thing for sure is that Monsieur Levaillant was one of the few Western naturalists who named native birds after those who were native to the territory. One Klaas, for example, who assisted Levaillant, duly got a cuckoo named in his honour.

One particularly fine morning, the kind when the sunlight sparkles in the dew of the fresh green grass and your lungs get filled with fresh oxygen-laden air as you draw in the clean earthy scent of Africa, I left our caravan and set out into the forest with my binoculars. I searched for the trogon and, as usual, having no success and deciding to cut my losses, I walked along the edge of one of the forest glades. At the time this seemed like a good idea; I could view both forest and grassland birds. As I walked out of the forest, however, I spooked a herd of dagha boys, each looking about as grumpy as Donald Trump himself. They are the most dangerous and feared animal in Africa and this I knew all too well from my run-ins with buffalo in the Timbavati. Thankfully, though, these dagha boys gave me little more than a disdainful snort as they ran off and disappeared from view.

I continued my foray along the forest verge, looking for birds and just generally enjoying life. After a while I caught up with the same buffalo herd which, upon realising that I was following them, abandoned their grassy breakfast and veered off, retreating into the forest. Not many minutes later I was surprised to hear a rustle from within the dark interior, adjacent to me. My eyes were accustomed to the brightly lit grassland and as my pupils dilated slowly, I strained, peering into the gloomy forest from whence had come the rustle. Once my vision adjusted, I made out the dark sadistic shape of a large dagha boy. And he was staring straight at me.

The bull walked forward and the familiar sensation of someone, maybe God himself, having hit the slow motion button again, kicked in. Everything slowed down. My thoughts became clearer. In fact they became crystal clear as I realised that I was in quite a predicament. The buffalo walked forward towards me with his head held high. Illuminated by a shaft of sunlight, I could see his wet dripping nose covered in bumpy black and shiny skin. I had not realised that the forest was so thick that it was in fact an impermeable wall of vegetation. This meant that I had inadvertently

cornered one of Africa's most dangerous animals. Having worked as a trails guide, I knew that I was not to run, and that now was the time to shoot the animal, before its head came down. Instinctively, the muscle memory from my trail ranger days kicked in and I raised my arm, as if raising a rifle.

The only problem was that all that I held in my hand was a tiny pair of 9x35 mm binoculars. Without a rifle I might need to run, I thought, as the bull continued slowly walking towards me. His massive sweeping horns were shiny and deeply grooved. He was a formidable foe, a heaving mass of pure muscle. Hunters have always feared buffalo because once their horns go down a bullet cannot penetrate the thick horny boss easily. To make matters worse once a buffalo has his head down and is running straight towards you, a heart shot is almost impossible. It is for this reason that many of Africa's most famous hunters have admitted to always remaining nervous when hunting buffalo, despite having lost this nervousness when hunting other big game. Buffalo are also fiercely tough creatures – more hunters in Africa have been killed by a buffalo they thought was dead than by any other animal.

I was not even a hunter! I was just a birder and with all this buffalo trivia racing through my head, I watched with alarm as the bull dropped his head and charged. This was no mock charge; it was the real thing and the beast had his sights locked on me. He was one seriously pissed-off bovid, who had not appreciated his breakfast being disturbed, twice! Finding himself cornered between the forest and a bipedal creature, he was now taking matters into his own hands. As mentioned, ad nauseam, the theory in Africa is to never run, and this is all fine and well, but I live by another motto too. This one says 'common sense must always prevail'. And common sense was telling me to get the hell out of there – and fast!

One of Hap's hunting stories was about a hunter who had leapt into a tree to escape a charging animal. Once the danger had passed, his fellow hunters measured the distance from the ground to the branch he had jumped onto: to do so, the man had to stand on the bonnet of a Land Rover. The conclusion to be reached is that with adrenalin coursing through one's veins, a person is capable of the impossible. With this story in the back of my mind, and with no trees to climb, I turned and ran down the hill. I will outrun this bastard were my last thoughts before I face-planted into

the side of the hill. Clumps of tufted perennial grass had tripped me up. Still clinging to my binoculars, I leapt to my feet again and, like a slower, shorter version of Usain Bolt coming out the blocks, I shot off again, now with the buffalo extremely close behind me. I ran another few metres, then tripped on another tussock of grass and, with a loud and audible thud, hit the ground for a second time. The only difference was that this time my beloved Bushnell binoculars took the brunt of the fall and they snapped in half, leaving me with a monocular in my hand.

I had time to think just one more thought, other than perhaps that it would be my last. The thought was: Jeez, so much for adrenalin! This notion was scarcely cold when the thundering of hooves and the snorting of my foe were upon me. Covering my head with my hands, I was surprised that there was still time for one more thought: I am going to die without having seen a Narina trogon. The scuffle of hooves descended upon me and I instinctively tensed every muscle I owned, waiting to be gored.

Quite suddenly and bizarrely, all fell silent. So silent in fact I even heard the familiar meowing calls of a yellow-throated longclaw. Was I in heaven? And if I was, I would have expected to be greeted by a singing Narina trogon, not a bloody longclaw! I got to my feet and patted my body just to confirm that I was still alive, and indeed I was. My head was banged up with a big graze along my forehead and one knee was bleeding, but I was alive, and the buffalo was gone. Shaking with adrenalin, and still clinging to my monocular, I made my way back to the caravan. Walking back I could have seen a flock of Narina trogons doing a mating dance and I would not have stopped. I was in shock. When I arrived back at the caravan Paul could see that I had not had my usual morning of birding.

Retelling the story to the section ranger, I realised just how fortunate I had been to only come away with a few bumps and bruises. The ranger told me that if I had not tripped, and therefore not immediately disappeared from the buffalo's sight, and if the hill was not sloped downwards so steeply, the outcome would have been very different. From the buffalo's perspective, it was charging at a perceived threat, one which then literally just disappeared out of its sight. When that happened the bull felt no need to stick around. Nevertheless I was very lucky that none of its hooves had trampled me.

I was happy to be alive but the incident really unnerved me. I no longer went birding in the mornings, and for the first time since I was 13 years old I was without binoculars. With a large chunk of my life missing I was also too embarrassed about how scared I had become of the forest to tell anyone. I now had some spare time on my hands and a thought landed on my brain, like a dandelion seed deposited by the wind. This thought was: why not buy a camera to share your experiences with family and friends? I had never ever before been interested in still photography, but Paul was a keen photographer and he helped to water this seed.

As a young 13 year old I attended Pretoria Boys High School.

A family portrait on a bush break to Kruger.

As young boys sitting on a wood pile at N'wanetsi picnic site in Kruger (me in the yellow T-shirt).

Pouring a bucket shower in the Timbavati camp. Nothing beats an al fresco wash!

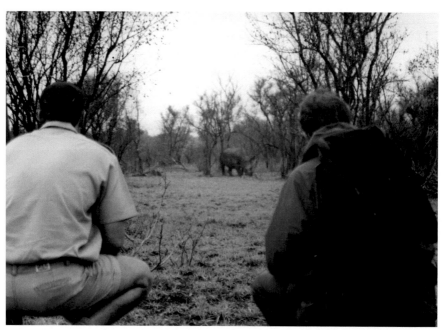

Getting close to rhinos on foot, a great privilege, and something that I shared with others when leading wilderness trails.

Young and free, Tazz and me taking a dip in croc pool.

My hut in the Timbavati. Home to me, two boomslangs and a tree frog.

My yellow Beetle. I loved this car! She purred like a dream and resembled a dung beetle.

Paul and me sitting outside our caravan on a hilltop in Zululand.

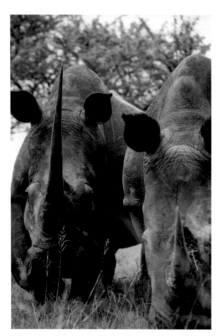

The day I learned the hard way about MFD (minimum focusing distance).

Our first job, a young Claire and I, managers at Mashatu Game Reserve.

Proudly preparing to fix a leak at Tented Camp.

The actual fixing of the leak. My plumbing operations never were a simple affair.

Sleep-outs at the Kgotla, nothing better – except when you hear 'the crunching of leaves'.

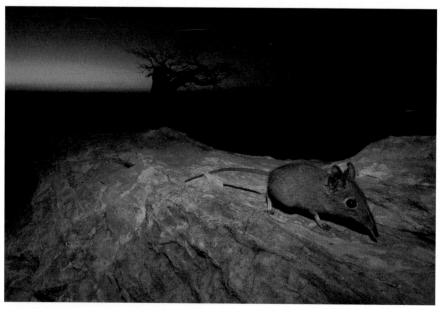

It took me many years to get this photo of a small shrew that lived on a sandstone koppie in my favourite corner of Mashatu.

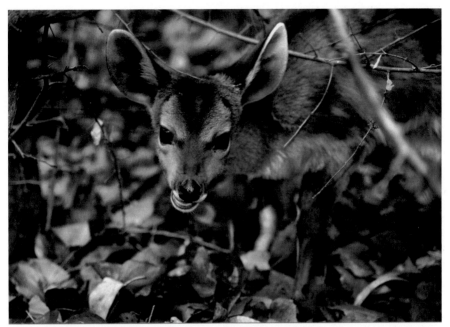

It was while working as a safari camp manager that I cut my teeth as a wildlife photographer. My two oldest published photos, taken in the gardens of Mashatu's main camp, both have dead mopane leaves for backgrounds.

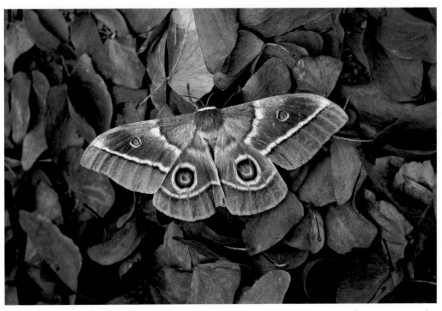

This photo of a mopane moth, from our Mashatu camp manager days, appears in my *AWE* coffee-table book.

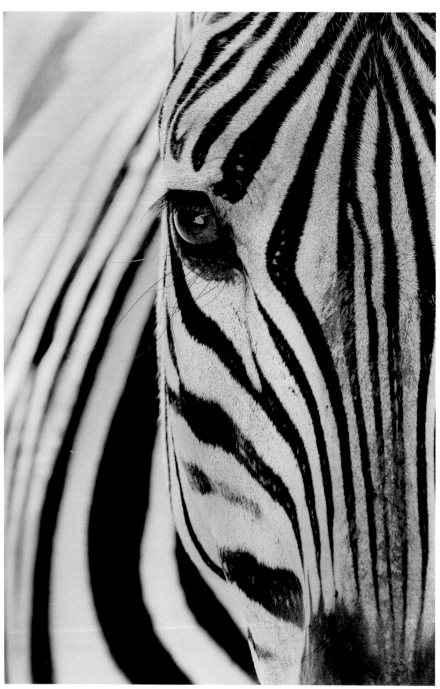

Zebra Soul – the very first photo I ever sold was for 'the story of horses told by horses'.

PART TWO:

NOT WITHOUT MY CAMERA

18

Unplanned and altogether stupid

We had a week's leave coming up and we would be returning to the 'big smoke', mostly to catch up on pizzas and milkshakes. The thought of buying a camera had not dissipated, although all I really wanted it for was to record some of the incredible wildlife encounters I was experiencing so that I could share that part of my life with my family and friends. On the eight-hour drive home, Paul and I chatted about it a bit and he suggested that I buy an SLR camera. 'What the heck is an SLR camera?' I asked, which shows how much I knew about cameras. A single-lens reflex camera, Paul explained, is a camera that can take a detachable lens.

There was a store in Hatfield, Pretoria, called Radio Lens, which I knew sold second-hand cameras. Walking into the tiny, stuffy space, I saw a cabinet of SLR cameras. I might as well have been looking at lingerie I was that clueless, and a camera salesman sniffed out my naivety, much like that hyena in Timbavati had sniffed out my balloons smeared with cooking fat. Before I knew it, I was the proud owner of a Pentax MZ30 camera body and a Sigma lens kit. Over the moon with my purchase, I raced home in my yellow Beetle. This was the first big camera purchase of my life! I was so excited to get back to Hluhluwe I almost forgot to buy film. Not only that, but I had no idea what film to buy, so I settled for the only pack of colour negative film that I could find. I could not wait to capture literal 'Kodak moments' of my life in the bush.

I told Paul that since we'd used his car the last time we drove to Hluhluwe, I would pick him up this time.

'Um, Greg, you mean in your Beetle?'

'Yeah, sure, Paul, she purrs like a dream,' I said.

I loved that car but Paul, after placing his bags in the bonnet and climbing in, seemed a little less affectionate towards my wheels. I had forgotten that the internal heater levers were stuck in the up position.

In wintertime this had been quite pleasant but we were into the height of summer. I tried to convince Paul that the tiny triangular windows in the front, if positioned just right, were better than any air-conditioner, but he wasn't buying it. What we did buy was lots of fluids, to counteract the heat and potential dehydration, which meant frequent stops along the way. As a result we were not making the best of time and the stuck heaters blowing hot engine air straight into the interior of the car wasn't improving Paul's mood. The heat was one thing, but the hot air also resurrected the smell of rotting giraffe bones, elevating the air quality to an almost putrid level. It felt like we were in an oven, one that was baking giraffe bones. I thought the smell had long gone but hours of heat on the open road brought it back, with a vengeance! In between sweating and gagging, Paul had to answer all of my beginner photographer questions. Despite leaving early, it was now dark and, while we should have been safely ensconced in our caravan by this time, we were only driving through Mkuze village. The journey should have taken us eight hours but it had taken us 10 – and we were not yet even in sight of Hluhluwe town, let alone the reserve.

Suddenly, as if things could not get any worse, in the black of the night my engine lit up behind us like a Catherine wheel at Guy Fawkes. My Beetle sounded like one of those monster trucks that you see on TV driving over other, smaller trucks. And it had started raining, hard. The windscreen wipers – I think they were still the original ones – were doing absolutely nothing to dissuade the pelting raindrops. Actually, I was very glad it was raining since my engine seemed to be on fire. Despite a considerable lack in engine power, I kept my foot flat and we eventually limped into camp later that night. We were very surprised to find the researchers and rangers all awaiting our arrival. They said that they had heard a god-awful unpleasant sound coming closer for the last 30 minutes and they just had to come and have a look and see what the din was all about. It turned out that one of the spark plugs had completely shot out of its socket and the arching spark had bored a hole clean through the engine block. The Beetle was running on three cylinders. When the Hluhluwe mechanic saw the mess, he exclaimed, 'Well, I'll be damned, I've never seen this before!'

Lying in our caravan with sweat-soaked clothes and our hair smelling like rotten giraffe bones, Paul finally broke the silence. 'So she purrs like a dream, does she, Greg?'

The next morning I awoke at my usual early hour but beaming with excitement. I had a new toy to play with. Attaching what I thought was a really big lens, but which was actually just a stock-standard 70-300 mm kit lens, to the front of my shiny silver camera body, I began stalking through the camp grounds. When Paul surfaced he could not help but laugh. I was holding the camera all wrong, a fact that he was not shy to point out. When he'd stopped laughing he showed me how to cradle my lens with my left hand.

I chose to drive that day. When we stopped to film content, I wanted Paul to do the filming so that I could practise with my new camera. We drove down the hill and around a bend where, close to the gate of Hilltop Camp, we spotted a nyala bull. Although they are abundantly common in the reserve, I put on the brakes and lifted my camera. It was as if I was seeing the antelope species for the first time. I was captivated by the chocolate-brown body interrupted by white stripes, and the bright orange fur that made his legs look like he was wearing stockings. A white bridge of fur between the eyes looked a lot like a pair of spectacles. Forgetting to zoom the lens I pressed the only button my finger could find. I heard a heavenly 'clunk' as the mirror flipped up. In a literal split-second I had created my very first exposure. I had taken my first photograph!

I could not have realised the significance of the moment or that the pursuit of photography would completely alter the course of my life but I remember being filled with an incredible sense of exuberance. I can safely say that from the very first frame, I was hooked. From that moment on, both my work and my life took on a different dimension. I was already passionate about Africa and searching for the 'lost' Africa of my dreams, inspired by Ian Player when I was still a schoolboy. I had subsequently carefully studied under the guidance of my bush mentor, Hap. Now fate had brought me right to where my childhood hero had written his *Zululand Wilderness* memoir. With the purchase of a camera I had not only found a way to harness my knowledge about animal behaviour and my passion for Africa, but I had also found a way to somehow contain, record and collect

my wild experiences. I had found a way to bottle Africa's light and energy and to share it. Photography instantaneously became, and has remained, an extension of my soul. The camera is the tool I use to share the awe I feel for Africa's wild places and her wild creatures.

Unfortunately, something else that picking up a camera did, and something I did not need any encouragement to do more of, was renew my enthusiasm for stalking big game. The camera helped heal me of the dagha boy incident. Already equipped with the critical knowledge of how African animals behave, I photographed everything that moved, the more dangerous the better.

Hluhluwe is the true home of the white rhinoceros. One late afternoon – Paul was driving and I was manning the filming camera – we rounded a corner and saw two rhinos grazing off in the distance. One of them had the longest horn I had ever seen. Paul parked the Landy and without a further thought, after locking the filming camera on its tripod and pointing it out into the bush, I reached for my Pentax. I climbed out and began stalking closer on foot. Soon I was on my belly, slowly wriggling my way through the grass towards the prehistoric-looking beasts.

Nature is full of surprises. One can never be quite sure how wild animals will react in any given situation. This is in essence what makes them wild. My two dinosaur-like subjects had heard a rustling in the grass and instead of fleeing, the strange sound had piqued their inquisitive natures. So inquisitive were they that they started walking closer, towards the rustling. I knew that rhino have very poor eyesight so I sat up to clear my lens of obstructing grass stalks. Before I knew it, my finger was pressing my shutter button down. The rhinos halted at the sound of the clicking. For a moment they looked like they might turn and run. I then did something completely unplanned and altogether stupid. I used my left hand to swirl the grass beside me. It worked. The rhinos began moving again, in my direction.

Looking through my viewfinder, my heart began to pound with excitement. To be so close to such big powerful animals and to have such a low angle was a total adrenalin rush. The rhinos kept walking closer ... and closer, seemingly straining their tiny eyes to see what type of creature had made the strange rustling noise. I might mention at this time that I was in

a national game reserve where it is totally forbidden to be out of the vehicle. Should a ranger have come around the corner I would have been kicked out of the reserve. Suppressing this thought, I kept clicking away, when all of a sudden my lens seemed to malfunction. 'Zzziiiiiit' was the sound it made as it zoomed in and out at a furious pace, and for no apparent reason. I was about to learn a very valuable lesson in wildlife photography. This is that the viewfinder of a camera makes your subject look further away than it actually is.

I was now unable to photograph because I could no longer focus through my lens. Sitting on my bum, staring up at the two rhinos, one of which had a horn that seemed to reach to the heavens, I found myself in a rather surreal position as the now all-too-familiar feeling of having the world turn to slow motion set in. To stand up would be dangerous as the rhinos would get the fright of their lives and no one wants to give the second-largest land mammal on the planet a fright. To stay sitting meant that if they took a swipe, even if just out of curiosity, I could land up on the end of a horn.

Baaaaaaap. The sound came from the Land Rover where Paul, thankfully, had been watching the entire episode. Recognising that I was in trouble, he cleverly hit the hooter. The rhino duo looked up in fright and this gave me a gap to half-crawl half-run back to safety. I jumped into the cab, exclaiming that my lens was broken. Paul patiently explained that every lens has a point from which it can focus. Anything closer than this point, which is known as the MFD or 'minimum focusing distance', cannot be focused on. On my lens this was about one metre, which meant that I had been within one metre of the rhinos, and perhaps even closer to their protruding horns. I learned two valuable lessons that day: the first being that animals appear further in the viewfinder than they actually are; the second that there is no circumventing the MFD.

It was December. The year was winding down and what a year it had been. I had survived a buffalo charge, bought my first camera and almost been turned into a human kebab by a rhino. Paul and I were working, filming

as usual, over the Christmas period. Working in the bush, as I had mostly done since I was 18 years of age, one tends to work throughout the year and forego the luxury of holidays. This meant that I worked most Christmases and this one was no different.

The two of us had been invited to the Hluhluwe Game Reserve's annual Christmas party for all the game rangers and other reserve staff and we joined the others after our shift. I found myself seated next to the reserve's resident wildlife veterinarian, who had arrived late because he was performing an autopsy on a crocodile.

'Why did it die? Was it sick?' I asked.

'No, we shot it. It ate a honeymooner,' he said. 'Pass the butter, please, Greg.'

Apparently, as he went on to explain while buttering his bread roll, the honeymooners had gone for a midnight dip in the St Lucia estuary, which is not far from Hluhluwe. The husband had simply vanished, presumed taken by a croc.

'But how could you know which crocodile took him?' I asked, fascinated.

'Oh, it's quite easy,' he told me. 'We just fly over the area and shoot the biggest crocodile. Usually he is the culprit.'

'You mean you've done this before?' I'm sure my face must have registered my shock.

'Heck ja. It was the very first job I performed as a Natal Parks Board vet over 30 years ago.'

Someone else at the dinner table asked the question I hadn't been able to bring myself to ask.

'How do you know for sure the remains you found were the husband in question?'

'Oh, the crocs in that estuary are so big the head gets swallowed whole,' said the vet. 'I'm starving. Is that roast warthog down there?'

In Africa a person can get desensitised quite easily. While I was becoming seriously desensitised to messing around with my camera and big game, the wildlife vet thought it perfectly normal to do an autopsy on a man-eating crocodile before heading off to enjoy his Christmas dinner.

After dinner we were taken to the rhino capture bomas. This is where rhino are kept before being released back into the wild or shipped off to

another reserve. The Hluhluwe-iMfolozi ecosystem was the place where the rhino had been brought back from the brink of extinction during the poaching pandemic of the 1950s and the place where Ian Player had worked and launched 'Operation Rhino'. That night for the first time, through the boma walls, I got to feel the lips of a rhinoceros – and I can testify that they are as soft and as smooth as butter.

The new year would bring about some changes for Paul and I. We were going to be moving filming locations away from Hluhluwe and into the South African lowveld. As was usual with our company, we were given little warning, and by now we were accustomed to living the ultimate nomadic lifestyle. We were just about to hitch the caravan when we were told that we could leave it behind.

All too soon the Hluhluwe chapter was ending but I had one last thing that I had to do. I needed to revisit the site of the buffalo incident. Strangely, I had been too nervous to go back to the scene of the crime, but I felt that I had to.

Walking through the forest for the last time, I took in every smell and sound. I turned onto the open glade as I had done on the near-fatal day of the buffalo charge, and retraced my steps. This time, though, I walked away from the forest verge as that was what had nearly got me killed the first time. I stuck to the grassy side of the hill, but still managed to retrace my steps to where that unreal scene had played out. I lay down in the now tall grass blowing whimsically in the wind and looked up at the blue sky. Beside me in the grass I spotted the empty white shell of a giant land snail. I picked it up and decided I would take it home, a memento to remind me how fortunate I had been on that day to come out relatively unscathed. As I write this memoir, that shell is on the shelf above me and occasionally it catches my eye, and I find myself daydreaming about the cool remnant forests and steamy valleys of a Zululand I once knew. Standing on the side of the hill, watching the sun set as I gazed over the green hills of Africa, I realised that Zululand had stolen a piece of my heart.

19

Young, ambitious and a little crazy

This time it was in Paul's blue Toyota that we drove down to the lowveld, both of us relieved to not be sweating nor inhaling the stench of giraffe bones. Our destination for the next filming stint was a game reserve called Djuma in the Sabi Sands, which borders the Kruger, forming part of the Greater Kruger National Park. This entire ecosystem stretches through to Mozambique and is in excess of 30 000 square kilometres (over 11 500 square miles), although we would only be filming in about 40 square kilometres (15 square miles) of it.

Arriving at our destination, we were pleased to hear that we would not be staying in a caravan, although our relief was short-lived. Our new quarters consisted of one small room made from hollow Shangaan-made sand bricks, with a rickety tin roof and a bathroom whose drains were so blocked that my first shower flooded our floor.

We had also traded our luxury turbo-diesel Land Rover filming vehicle for a much older – like from World War II older – short-wheel-base Land Rover that came from a production line long before turbo engines were invented. Our new baby was bright green in colour, so we called her Peppermint. She had no roof – which in fact was perfect for us because our filming style had changed. One of us drove while the other sat in the 'playpen' on the back, which was where we filmed from. We had to be careful that we didn't spill out, as the short wheel base offered a pretty wild ride. Our filming hours had also changed; we now did a four-hour morning safari drive and a four-hour afternoon drive. This was great as it meant we could siesta in the mid-afternoon heat, which is a habit I am ashamedly still rather partial to.

The filming strategy was much the same, however, in that we would bumble through the bush filming anything that moved. In my spare time I researched every subject that we could possibly come across so that we

could scribble interesting facts about it on our whiteboard. I learned, for example, that a particular beetle called a blister beetle contains a chemical called cantharidin, which is the active ingredient in the aphrodisiac 'Spanish fly'. When we scribbled that on our whiteboard, both the little beetle's status and the subsequent number of website hits we got shot up dramatically. The 'Paul and Greg Show' gained much popularity and we received letters from fans all over the world. The website had become a huge sensation in the USA but it was still strange for me to think that what we were filming every day was being seen almost live by millions of people around the world. My head just could not get around the miracle of the new technology.

Paul and I took turns filming. When I was on driving duty I was also taking my own still images of our subjects with my Pentax. To help me along on my photographic journey, *Africa Geographic* was running a series of articles titled 'Getting it Right'. Written by professional wildlife photographer Daryl Balfour, each segment highlighted and tackled one photographic subject at a time. I tore each article out of the magazine and filed it, so that eventually I had my own 'how to photograph wildlife' guide. It was never far from me. My own imagery looked nothing like what I was seeing in the magazine, but at least I was learning.

Although my photography knowledge was growing exponentially, my knowledge of the opposite sex was still pretty much non-existent. Most of my life I had been surrounded by boys. I came from a family of only boys and I attended an all-boys high school. Straight from school I went to the bush, where I worked predominantly with men, and while I was quite capable of stalking a rhino or an elephant, when it came to approaching someone of the opposite sex I was thoroughly petrified. Just when I thought that I might be a bush bachelor for the rest of my life, a new and rare type of bird, one without feathers, descended onto the scene. To extend the metaphor further, this beautiful bird would at first be a 'rare vagrant' in my life and, although displaying peculiar mysterious behaviour, she was no doubt a

'megatick' in the 'lifer' department and would take up permanent resident status in my heart.

Paul had told me that a student who was studying tourism at the University of Pretoria was going to be hitching a ride down to Sabi Sands with us after our next leave break. For her degree she needed to complete a practical stint in the eco-tourism sector, and so she would be helping out in the Djuma safari lodge, which operated on the same land we were filming on. Paul refused point-blank to do any more trips in my Beetle, so it was in his Toyota and with our bags packed for another long filming stint that we swung by 526 Mississippi Street in a leafy suburb of Pretoria. Standing outside was a tall pale-skinned young woman. She had short blonde hair and was wearing three-quarter-length trousers (which apparently were the fashion at the time, but which I had never before seen). I introduced myself and got a casual 'Hi' in reply. I was scratching my brain, trying to think what to say next, when a woman came bursting through the gate accompanied by a torrent of words. Her accent was so broad that I could not understand a word she said, although I was sure she was Scottish as I had scenes from the movie *Braveheart* appear in my thought bubble. She, my future mother-in-law, shook her head at our boot, saying, 'Nope, this winnae do.'

After repacking our car, Paul was quite flustered that his camera kit had now landed on the bottom, but before we knew it, we were making familiar turns and twists down to the lowveld. The only difference this time was that we had a passenger in the back seat, and a talkative one at that. I didn't mind one bit. She had the sweetest voice I had ever heard.

On our first day back, I decided to go for a walk. On my way out of camp I passed the camp workshop and there – lo and behold – was Claire, the Scottish lass, perched on top of the scrapheap beneath the overhead telephone wires.

'Um, what you doing?' I enquired.

'Ah, nothing, just watching the sunset,' she said.

'I am all for sunsets,' I said, 'but let me take you to a better spot!'

Clearly, I was dealing with an amateur in the sundowner department and so I took it upon myself to show her how a sundowner was done. Fetching Peppermint, I drove Claire to the top of a rise where, under a marula tree,

we could gaze over the bush and onto the setting sun beyond. I had seen many sunsets in the bush but the mysterious, beautiful creature beside me was far more fascinating.

Claire was not especially enjoying the lodge work and Paul cleverly invited her to join us on our filming expeditions whenever she had time off. When I told my first safari joke she threw her head back and gave a laugh that, much like a lion's roar, originated deep within her belly. With the first joke going down so well, I shared my next safari joke and got a similar reaction. I had found someone who actually laughed at my jokes! Paul seemed less amused by my jokes or, more specifically, the reaction they were getting. We were two bush blokes, who had been living together in a caravan and were now sharing a single room. Now we had a green-eyed, fair-skinned passenger in our office – and she was wreaking havoc with our minds. It must be said that Paul was far more experienced than me with the ladies, so I was taking notes in between scribbling down camera settings and writing fun facts on the whiteboard.

All too soon Claire's stint with us was over and, just like that, both Paul's and my life returned to normal. Except that for the very first time I was feeling that the ultimate bush bachelor lifestyle that I had been living perhaps needed rethinking. That's just crazy talk, I told myself as I focused on my filming, photography and research.

Something I have always enjoyed about living in the bush is how one gets to obtain wild pets. Although they are not the type of pet that you pat and play ball with, they are none the less a form of aloof companionship, and can greatly enrich your life. Outside our room there was a marula tree and living inside a hole in the trunk was a lesser bushbaby. The name for this little primate comes from its minute size: it weighs about the same as a large lemon. Bushbabies have huge eyes, so big in fact that they cannot even move them in their sockets. But the really fascinating thing about bushbabies is their propensity for routine. Being nocturnal creatures, they emerge from their holes in the evening and, quite remarkably, at the exact

same time every day – to the minute! We made it a habit to watch our bushbaby, whom we named Miquel, emerge each evening; it was as if it was sitting in its hole with a watch, just waiting for the exact time to poke its head out and clamber up the marula tree before going off to forage.

Miquel wasn't our only pet. We also had a civet called Ronny, who was the recipient of our leftovers at night. Every evening Ronny came to our fence at about 8 pm and we threw him scraps. Civets are striking creatures, not too dissimilar from the American raccoon, I guess, but much larger. We also had a resident pair of hornbills that we fed our lunchtime scraps to. They made me wonder what had happened to Zazu 1 and Zazu 2, the baby hornbills I had raised all those years ago not far from where we were filming. We learned that hornbills, like mongooses, also love cheese.

The cooking was largely left up to me and I had grown tired of two-minute instant noodles. The packets might have promised six great flavour varieties but if you ask me they only ever delivered one not-so-great taste. I had found a suitable substitute in the form of fish fingers. These consisted, according to the box at least, of minced fish meat that had been rolled in breadcrumbs. They were easy to fry, quick to eat and tasted great with a boiled potato and mayonnaise. Paul and I pretty much lived off fish fingers. Once, though, we made the mistake of purchasing a box from the local town of Acornhoek, a small town that supports a vast surrounding rural area. In the middle of the town was a building with a large sign outside that had been divided into two; on the left side it read 'Tintswalu Hospital' and on the right side 'Elite Funeral Parlour'. Perhaps we should have taken that as a warning.

After buying our emergency supply of fish fingers in Acornhoek we returned to base. When I opened the box, to my astonishment the fish fingers were bright green in colour. With hungry eyes Paul and I gazed upon them, wondering, firstly, how on earth they could turn so psychedelic and, secondly, whether or not they would kill us. We decided not to risk it, settling for boiled potatoes on their own. Later that night when Ronny pitched for his usual treats, sadly our plates were bare – no scraps for the civet today. The only thing we had to toss his way were the psychedelic fish fingers. We doubted that he would eat them, but we tossed them over the fence anyway. To our surprise, he scoffed them down before trotting

off into the bush. Sensibly, after that Ronny must have chosen to give our culinary skills a wide berth because he never stopped by again. He was still collecting scraps from the camp's kitchen, so at least we knew we hadn't killed him.

Our company had come up with a new concept, something called 'The Trailer Cam', which was a new way of filming. We now towed a trailer through the bush, which we parked and set up when we found something interesting. The camera on the trailer would roll around the clock so that our internet viewers would get a live refresh of whatever the camera was trained on. It sounds simple enough, right? But in reality it was a mission of note. To set the rig up in the right location – and especially when working with wild animals – was not as straightforward as it sounds. For a start there was an almighty long antenna that we would have to erect so that we could relay the signal back to our little office at base. And the trailer itself weighed a ton.

One night we were radioed by a safari guide and informed that lions had killed a zebra close to the Djuma bush lodge. They had heard the kill going down during the night. Paul and I duly set out extra early and by the time the sun rose we had the entire rig all set up. The trailer cam was beaming images of lions feeding on a kill, out to the world and in real time. Not only were we chuffed to be a part of this groundbreaking technology, but there was lots of meat left on the zebra and we figured that the lions would feed all day. This meant that all day we could sit on our arses and get paid for it. But just as we were starting to stretch out in Peppermint and soak in some of the beautiful winter rays, a big lioness began tugging on the carcass. She possessed power enough to actually pull the zebra carcass, which ordinarily would have been fascinating to witness (and a fact worth noting on our whiteboard) but this presented an immediate problem. She seemed to be moving towards a shady tree about 30 metres away. Eventually she succeeded and the kill, and all the other members of the pride, were now not only in the shade but were completely out of the camera's view.

Paul and I had made a schoolboy error. Anyone who knows lions knows that when the sun is up they drag their prey under a tree to hide it from vultures. It was made obviously clear to me that day that the ability of a successful photographer lies in their ability to predict animal behaviour.

While this lesson was sinking in, our internet audience was staring at a bare patch of African dirt.

I am not sure how it happened but Paul and I both, to this day, swear that we were 100 per cent sober. Perhaps we were not of sober mind, however, because we decided that we were going to fetch the zebra kill and drag the carcass back to the open patch where our trailer cam was parked. I have always suffered from an impulsive condition, one which causes me to do the craziest things around wild animals, and then one day looking back, or writing a memoir like this, I scratch my head and ask myself, What were you thinking?

To be honest, I have no idea what I was thinking on that day except that moving the entire trailer was not an option. We had pegged the long antenna's support ropes into the ground, and this at great risk, while the lions had their heads down feeding. We also always wanted to deliver a fine show. Initially, Paul and I drew straws to decide which of us would go and fetch the zebra, but after doing the arithmetic, we soon realised that if we both went, our survival chances increased – twofold, to be exact.

We climbed carefully, tentatively, out of Peppermint and began walking towards the lions as they fed on their stripy breakfast. We knew that the pride contained no cubs and we hoped that they had already eaten a fair amount of meat, just enough to not want to eat us. We knew that walking quietly up to the kill scene would have spelled more trouble for us than if we made a considerable noise and so, with raucous screams and clapping our hands, we made a synchronous advance on the feeding lions. We couldn't know for sure what the outcome was going to be, but we egged each other on in our stupidity.

Our behaviour might well have qualified us for a Darwin Award, had it not been for the fact that during the daytime human beings are actually the apex predators in Africa. While we are physically completely inferior to a predator, especially a lion, it is the large organ between our ears that has allowed us to fashion weapons that are able to kill anything. Neither Paul nor I had a rifle, or any weapon of any kind, but the lions didn't know this – we were calling their bluff. Bearing in mind that a lion can cover 100 metres in just six seconds from a standing start, Paul and I were not banking on the fact that we could outrun the cats. We were banking on the

fact that our hunting ancestors had done such a good job in defending and hunting that their legacy would allow us to ward the lions off.

Either way, there was no room for doubt. Turning and running would have meant our end, and so we continued walking towards the lions, screaming, shouting and clapping our hands above our heads. The felines gave us a snarl or two before slinking away into the bush beyond the carcass, where they lay low in the grass and kept a steady eye on our every move. Full of adrenalin, we grabbed the half-eaten stinking carcass and gave it a tug. It didn't move an inch! A single lioness had dragged the carcass to where it lay, and two fit young men were unable to move it at all. And just like that I learned my second lesson of the day: lionesses are far more powerful than they look. Tugging at the lion's breakfast was to no avail and only made us feel even more vulnerable. A plan B was needed.

This entailed using Peppermint and a rope tied around one of the zebra's legs, which met with better success. We dragged the carcass back to its position in front of the trailer cam, and this time we secured the carcass in place by tying it to our bull bar. Every few seconds while setting up, we glanced back to check that the lionesses were still sedentary in the grass. Paul, thank goodness, had remembered to turn the camera off while we did all this. With the zebra securely in place, we jumped back inside Peppermint and the trailer cam started rolling again. The still wary lionesses made their way back to their kill and continued feeding to the delight of thousands of people watching, and of course to us too. Our show received record hits while we sat in Peppermint, sweating in the hot African sun, tied to a zebra carcass (but out of frame of course). Although it had worked out, we had displayed senseless bravado. My only defence, all these years later, is that we were young, ambitious and a little crazy.

20

Inch by inch

On my next leave stint in Pretoria Claire and I met for coffee every single night. She also invited me over to her parents' place for dinner. Her mother greeted me at the door wearing a Braveheart hat made from red tartan with long orange tassels of fake hair hanging out the back. I thought it was funny, but perhaps a little scary; I contemplated heading for the trees like Braveheart did but decided not to. Claire's parents were not bush people and while I answered their questions and told them tales from the bush, at Claire's prompting, they nodded and smiled politely. I wondered what they made of this man their daughter had brought home. I had more or less just crawled out of the bush and, rather embarrassingly, I was so relieved to not be eating two-minute noodles or fish fingers that I wolfed my lasagna down practically before anyone else had started eating. Licking a finger, I could not remember if I had used my fingers to push the food onto the fork as I was not used to eating with cutlery.

'Would you like some more, dear?' asked Claire's mum.

'Absolutely!'

It was the best lasagna I had tasted and the accompanying garlic bread was from heaven.

After dinner Claire walked me out to the street where my yellow VW Beetle was parked. The car was suffering from a flat battery but the atmosphere between Claire and I was electric. Although we had spent the last seven nights having coffee and talking, we had not run out of things to say. It felt as if we would never run out of things to say. At this point we were just friends but I definitely wanted to make a move. My car, however, didn't, so instead of a romantic kiss goodnight Claire had to give me a push start! The car gained momentum down the small hill outside her house and I leapt onto the side railing. Hanging onto the steering wheel with one hand and waving goodbye with the other, I pulled myself into the Beetle

in the nick of time. A second later and I would have crashed over the kerb and into a wall. Driving home, my heart beating fast, I felt quite strange. Either I had a case of heartburn from too much lasagna or ... I was in love.

After our 10 days leave, Paul and I were sent to a new filming location, the famous MalaMala Game Reserve. We picked up a state-of-the-art filming vehicle along the way and were travelling on the dirt road between Hazyview and the western border of the Kruger National Park, air rushing past our faces under a big blue African sky. We rounded a bend and turned east down a straight road that cut its way deeper into the bush. The wind now carried the scent of burned grass. Our new camp comprised an old farmhouse and a number of smaller outhouses. In the middle of a large patch of green grass a beautiful fig tree stood tall.

We arrived late in the afternoon and got to work offloading large batteries and much high-tech equipment that I had no idea how to use. A man with a very dark tan, no shoes and wearing the green overalls of a mechanic walked past and greeted us. He jumped into a Land Rover that had special metal plates welded around and beneath it and a large tripod on the back. As he disappeared in a cloud of dust, it dawned on me who we had just met.

'That was Kim Wo-wo-wolhuter,' I stammered, feeling a little starstruck.

'Yeah' said Paul. 'He lives here, and we are sharing the camp with him.'

Kim Wolhuter is the grandson of Harry Wolhuter, one of the Kruger National Park's founding rangers. In 1904 a lion had pulled Harry off his horse and dragged him through the bush to the base of a tree. He took out his pocketknife and stabbed the beast through the heart. Bleeding profusely and worrying about a second lion, he managed to climb a tree and secure one of his limbs to a branch with a piece of clothing, to prevent him from falling down if he passed out. But he survived the ordeal, and both the lion skin and his pocket knife can be seen today in the museum at Skukuza. Kim's dad had also lived and worked as a ranger in the Kruger Park. Having grown up in the bush, Kim was the proverbial 'Crocodile Dundee' of Africa. He was currently based at MalaMala where he was filming a documentary on leopards for National Geographic.

Our new home felt like the Ritz. Not only did I have my own bedroom, but I had a bedspread with matching curtains. It was a far cry from sharing a caravan and a tiny room with a rusty roof with Paul. Could life get any

better, I thought, as I unpacked my things. I am getting paid to live in a camp with a National Geographic filmmaker.

Sitting in the kitchen that night, I was brought up to speed as to what exactly I would be doing in MalaMala. Our initial concept of taking 30-second refreshes and streaming them onto the internet had evolved into a fully virtual game drive. This meant we were to drive around the reserve streaming not just live running footage from the African bush to the world, but streaming audio to accompany the visuals. Our audience would see real-time footage of wild animals and hear our commentary, something unheard of at the time. There was no longer any need for a whiteboard. While the technology itself was still a bit of a mystery to me, if I was getting paid to drive around the bush, film and talk about animals, I was happy. We agreed to work in 12-hour shifts that were rostered so that we were beaming footage almost 24 hours per day.

MalaMala was the largest portion of the Sabi Sands Game Reserve at the time and it shared its eastern boundary with the Kruger National Park. The late Michael Rattray had bought one chunk of land after the next, and he owned all of it. He had realised some 40 years earlier that wildernesses teeming with wild animals would become a precious commodity and, being a businessman, he knew that if you owned anything that was in short supply, you were bound to make money. What made him extra smart was that he did not just buy land in random big chunks; he purchased land along the Sand River. The river flows directly through the length of the property, acting as a gigantic magnet in the dry season, drawing wildlife to its lush banks. This beautiful and gently flowing river has cool, clean water that slides just a few centimetres above the white granular sand and is enough to supply water to an ample gallery forest growing along its course.

MalaMala has the most exquisite trees. The beautiful African ebony tree (locally known as jackalberry) grows in abundance there, their massive boughs covered in dark chocolate-brown bark. Then there are the sausage trees, with their huge sausage-like fruit hanging on the end of long tendrils. Although this tree is somewhat stocky and squat, it possesses the very elegant scientific name of *Kigelia africana*. It also produces the most exquisite burgundy sprays of flowers. Pollinated mostly by bats, the flowers

blossom overnight and fall to the ground a mere 48 hours later, much to the delight of the impala and bushbuck. Elegant apple-leaf trees also grow out of the banks, their smooth trunks contorted ever upwards towards the heavens. Ancient leadwood trees with their thick crocodile-bark trunks are dotted about like giant chess pieces. Their gnarled branches, twisted and bent by time, often have holes in them; these are home to squirrels, birds, lizards and of course the infamous and deadly black mamba.

I was driving and Paul was on the back filming. I was still getting used to the concept of a cyber audience and the reality of whatever the two of us were saying the rest of the world was hearing. As we wound our way through the woodland and down into a dip in the late afternoon, my nostrils filled with the delectable smell of cooked potatoes. This aroma comes from a bush aptly called the potato bush and in the cool of the evening its aroma floats through the still, dense air, permeating the bush with its scent. We crossed a bridge known to the MalaMala rangers as West Street Bridge, the air cool and fresh next to the river where the trees grew in dense stands, towering above us.

We came across a breeding herd of elephants just as the last rays of the sun were managing to find their way through the foliage of the trees. Switching the engine off, I picked up my camera while Paul filmed. Because Kruger Park had stopped culling, the elephants that surrounded us were very relaxed in our presence. One young bull, however, did come closer, to flex his muscles, so to speak. With his head high and his ears out, he steadily walked in. Most of the time this would be enough to get a person to start the engine, but Paul and I had seen plenty of elephant action together and as the young bull approached to within a few metres, I focused my camera on his eye just as one last shaft of light penetrated the trees. One does not usually see much colour in an elephant's eye but the light was so perfect that through my lens I saw a large bulging hazel eye with red veins peering back at me. It was huge. I thought it looked like a whale's eye. The colour and texture reminded me of peanut brittle rimmed in white. Looking up,

I was able to peer beneath the long eyelashes, which usually hide all this splendour. I took the shot – and felt invigorated.

Through my camera I was able to see detail that I otherwise would not have noticed, and in this instance, I was able to capture the exact moment when the last rays of the day pierced through and into an elephant's sentient being. Something clicked – excuse the pun – as I began to appreciate that my camera was a powerful tool to take me deeper and further into the wilderness, illuminating my subjects, homing in on their beauty. Just like a magnifying glass, my camera magnifies beauty and reveals detail that otherwise would go unnoticed.

Once the sun had set, the elephants turned into grey ghosts and slid silently into the bush. We crossed the bridge and drove further east where tall, slender knobthorn trees, with their neat tiny round leaves, were sentinels on the high bank, silhouetted against an indigo twilight sky as the first stars revealed themselves. Paul and I were on the night shift. This meant that we had dinner at about 4 pm each day before leaving the camp. Our job was simply to drive all night and to find interesting subjects for our international cyber audience.

Exploring the eastern side of the river I learned what a remarkable property MalaMala really was. Over 90 per cent of the land that belonged to MalaMala lay on the eastern side of the river and there were few man-made structures on that side. This meant that over 90 per cent of MalaMala was a wilderness area set aside just for the wildlife. The only man-made structures on this vast portion of land were the few neat narrow dirt tracks that passed through the bush, an old windmill and a couple of waterholes. All this was ours to explore. The only difficulty with this was that at any given moment in time, we didn't know where we were.

Usually this wasn't a problem as there was wildlife everywhere to film but MalaMala bordered directly onto the state-owned land of the Kruger National Park. There was no fence on this boundary and if we unknowingly crossed over into Kruger we could get lost for months or, worse, be arrested as poachers. The real challenge came at 4 am, when it was time to head back to camp. We often had no idea where we were. At that time of the morning all the rangers were still fast asleep so if we got stuck for some reason, there was no one to call. All we knew was that our camp was in the

very deep south of the property, so 'If in doubt, head south' became our familiar and firm mantra.

One fateful night we saw the familiar yellow and green reflections in our spotlight of a pride of lion (it is a myth that all predators' eyes glow red). The problem was that the lions were lying on a sandbank in the river. We had not filmed anything for a couple of hours, time was drawing out like a sword and we were getting desperate for material. And so we inched our Land Cruiser down the steep bank of the river and onto the sand. In low gear we were making slow but steady progress – or so we thought – until the back wheels sank into the sand and stayed there. The more we tried to reverse backwards and forwards, the more the sand mixed with water. The wheels churned and turned but to no avail.

'Damn it, we're stuck and it's 1 am!' I yelled.

We decided that we would take turns trying to jack the vehicle up, which was the first step to getting ourselves out of the mess we were in. One of us needed to keep an eye on the pride of lions, who were now staring our way, the movement around the vehicle having piqued their interest. I was glad at that point to be the one on spotlight duty while Paul got the Hi-Lift jack in position. Much cursing came from the back of the vehicle when he discovered that we only had one plank. The problem with being stuck in slush is that you need a plank to put the Hi-Lift jack onto; without it, you just jack your way deeper into the sand. Under normal conditions, once the plank was under the jack and the vehicle lifted, you'd walk into the bush to fetch logs to place under the tyres, which would enable you to get purchase and, inch by inch, start moving. We thought about playing 'rock, paper, scissors' to see who would go fetch logs, but only for a minute. The proximity of lions made this way too risky. If we'd had more planks in the vehicle, we could have used those.

Then it was my turn to work the back, while Paul watched the lions on the sandbank. I kept peering around the sides every couple of minutes to make sure that there were always seven lions staring back at me. There had been seven when we had arrived and it was of critical importance that this number did not change.

Our strategy was to jack the car up, then floor the accelerator in reverse gear, causing the vehicle to collapse backwards, off the jack. If we kept

repeating this exercise, each time the Land Cruiser would land a few inches closer to the river bank. Painful inch by painful inch, the plan seemed to be working, but it wasn't ideal. Every time the jack collapsed it shot out, eliciting a creative array of swear words from Paul and I. By 3 am we admitted defeat. After muttering many more venomous expletives at our own stupidity, and at the pride of lions, we finally gave up. Sitting in the front seats with our feet up in the air beneath the Milky Way, we began spit-balling about our options. We soon digressed. Paul was almost always involved in a deep and intense relationship or friendship with a woman. This made for fascinating conversation during the quiet times. You could say this was one of those times. While he described his latest crush's beauty in the 'inch by inch' manner in which we had tried, and failed, to make our way to dry ground, I suddenly remembered something. 'The sound!' I blurted out.

Ironically, Paul shouted a few more choice expletives as he leapt over the front seat and killed the sound, which had been on the entire time we were stuck. Sitting very upright, we both frantically tried to remember what exactly we had said and how many swear words we had in fact screamed at the jack or the lions, or each other. On the other side of the world, it was daytime. Children might be watching. Picturing their enchanting virtual safari drive turned suddenly into a screaming match of profanities before deteriorating into a detailed description of Paul's latest romance was too awful to contemplate. We could not agree on exactly when or what we had said but the one thing we did both agree on was that we were both certainly going to be fired. We had just stuffed up – royally.

Meanwhile, Pippa, the owner of Djuma, happened to be watching our ordeal online and was doing her best to try to get us help, not because she feared for our lives, but because she realised we had forgotten about the sound. She was phoning the camp, but the day shift team were all asleep in the outhouses. It was only when Kim arrived back at camp and heard the phone that he answered and woke the day crew, who groggily drove out to look for us. They had no idea where we were and had to search every crossing, but eventually they found us. Towing us to firmer ground was not a problem as the lions had finally decided to take their leave. We drove back to camp, the adrenalin now wearing off fast, with the sound back on,

just in case we saw an aardvark or something. Paul and I were silent, too scared to utter a word. Back in the tiny kitchen in camp over a cup of coffee we retold our story to our colleagues until the francolins screeched.

It was not long before the phone rang. It was Andy, our boss. While Paul answered, I felt like going to pack my bags, but the conversation was short. All Andy wanted to check was that the 'show' was back up and on track. He didn't even mention the sound issue. We phoned Pippa. Apparently, we had put on quite a show trying to get unstuck and the ratings were up. She told us that while it was obvious that we had forgotten the sound was on, most of the swearing took place at the back where the jack was slipping. Our conversation in the front, she reassured us, had broadcast as nothing more than mumblings, but there was suppressed laughter in her voice. Just before she hung up Pippa giggled and said, 'Glad to know you boys find Rachel hotter than Monica.' In our meandering conversation Paul and I had touched on the popular sitcom *Friends* so we got the reference right away – but then ... that meant that Pippa and the rest of the world might well have heard ... It didn't bear thinking about. We collapsed into bed at 7 am and slept like dead men.

21

MalaMala

I enjoyed working the night shift as it meant that I had the day to sleep and relax in camp. Kim was sometimes around and I took advantage of this whenever I could. It is not every day that one gets to enjoy social banter with a National Geographic filmmaker. Kim would sit on the wall of the veranda, dangling his bare feet over the edge, and we would talk kak until the cows came home. He had got permission to microchip a young leopard called the Rock Drift Male but which Kim called Tjololo – 'the one that stands alone'. He was able to track Tjololo and that is exactly what he did, all night, every night. Eventually Kim got Tjololo to accept him and be so relaxed around him that Kim was able to get out of the vehicle and film him on foot.

Leopards are shy creatures and they need their personal space, but Kim had grown up in the bush and had the necessary bush skills to placate even the most introverted of cats. He also had amazing camera skills and was one of Africa's best wildlife photographers. He was not in camp much as he spent almost all his time in the bush and when he was in camp, he was usually horizontal, fixing the undercarriage of his filming truck. When filming a sequence Kim would have to follow in Tjololo's footsteps. The hardwood trees in the area meant that branches still found a way to the truck's unguarded parts, piercing them and wreaking havoc, despite the large metal plates welded beneath his vehicle. Watching Kim operate, one thing became very apparent to me: this was that the life of a filmmaker is not glamorous. It was hard work for him and I used to wonder if the audience sitting at home watching the documentary he made would be able to fathom the amount of time and effort that went into the filming.

Kim had two daughters and they came to visit him often. One afternoon, just as the golden rays of the sun were caressing the green grass in camp, he decided to take a portrait of them. I had been photographing long enough

to also feel a twitch in my right index finger whenever the light was good. Placing his two girls on the lawn, he was about to take the picture but then changed his shooting angle. I was never fortunate enough to join Kim in the bush as we worked seven days per week but watching him photograph his two little girls, I gleaned as much as possible. When he pulled the sprinkler closer and incorporated the tiny flying backlit droplets into his composition, I realised that he was both a perfectionist and an artist. His two precious girls entertained their dad by simply standing and smiling, while he set the perfect scene. They were just tiny tots, but they seemed to know the drill. As the last rays fell on their cute faces Kim finally tripped his shutter, shooting through the hundreds of shimmering water droplets. It was a family portrait on another level.

Paul and I were very fortunate one evening to find Tjololo on the Kruger boundary. Meeting and spending some time with Tjololo, who was a star in his own right, was as exciting as hanging out with Kim. We followed the tomcat down the fire-break where he was being a typical inquisitive cat, stopping to investigate every sound and potential prey, regardless of its size, and climbing and hiding behind termite mounds. Tjololo was not easy to follow. As we clumsily manoeuvred our big Land Cruiser, our respect for Kim increased dramatically knowing that he kept tabs on Tjololo's every movement. I picked up my camera and began photographing, but this time I did it with more purpose; I was, after all, photographing a Nat Geo star in Tjololo, and in my dreaming mind, this made me a Nat Geo photographer. Switching my camera from a horizontal orientation to a vertical one, I cradled my lens like a pro to capture a portrait of Tjololo for the *National Geographic* cover. This was just my fantasy of course but I was beginning to dream of a fulltime career as a wildlife photographer. Time seemed to vanish when I picked up my camera. My wildlife photography had become more than just a hobby and a need to merely record what I was seeing. Pandora's box had been opened.

MalaMala is possibly the best place in Africa to see leopards and we were filming them almost every night. The best was when they had a kill. We would lock the camera on our subject and its dangling prey, then sit back and enjoy the show ourselves. One night Paul and I had filmed a leopard dragging its impala prey through the bush, and then up a marula

tree. Very proud of ourselves for finding a kill that had just been made and knowing we could relax for a good couple of hours, we parked beneath the leopard and its prize. As I locked the camera in a vertical position, I noticed the impala's lifeless limp tongue dangling out the side of its mouth. Paul and I had the exact same thought: what a perfect time for a cup of coffee.

While we poured our coffee, the leopard plucked the fur from its prey, which fell around us like orange snowflakes. Our international cyber audience was being entertained by the leopard and it was too bad that they could not smell the delicious aroma of our coffee, I thought, as I lifted the mug for my first sip. We should have heeded the warning signs of falling fur because the next thing to fall on us was the full stomach of the impala. The gigantic grey blob hit the dashboard, the rumen bursting and spraying forth its putrid green contents, which went all over us and into our coffee. A vile-smelling liquid of half-fermented grass and gastric juices flowed over the dashboard and onto our laps. Miraculously, this time we remembered not to swear. The delectable aroma of coffee had been replaced by the sweet smell of grassy rumen contents, now soaking into our clothes – and we still had a night's worth of filming to do! Driving around in an open truck and smelling like impala innards, we were like moving bait. We learned the hard way to never park directly beneath the action.

On another night a leopard had dragged its kill into an ebony tree that grew horizontally out of the river bank. This meant that when I was on the back filming, the leopard and its prize were within arm's length of me. Being that close to a wild leopard I concluded that surely I must have the best job in the world.

MalaMala is such a beautiful property that words cannot ever do it justice. An area in the north called Marthley consists of a series of dry seasonal riverbeds that meander their way through a series of koppies where large granite boulders look like giant macarons. The koppies were covered in candelabra trees, Africa's version of a cactus, which grew amongst the rocks, giving the area a distinctly sculptured feel. In fact, a MalaMala ranger was once asked by an American tourist, 'Who does your landscaping?' Tall trees line the riverbeds, including beautiful mahogany trees with their dense crowns of dark, shiny green leaves. The rocks, trees and dry

sandy riverbeds all seem ancient, and exploring them, for me, was like being a kid in a candy store. It is even rumoured that Kruger's millions are buried there somewhere.

Whenever we got close to a series of boulders we would look very carefully for a leopard. One of the MalaMala rangers had recently taken a photograph of a leopard on a rock with the full moon in the background and had won the BBC Wildlife Photographer of the Year competition. It is the most prestigious prize in the world and the ranger was the first South African ever to win it. Little did I know that I would be the second South African to win it some 14 years later. We never did find a leopard with a moon, but we did manage to film a klipspringer silhouetted against a full moon. These tiny antelope pair for life and spend their entire lives on the rocks where, with rubbery hooves and hollow fibrous fur in case they slip and need to be cushioned, they are well suited to their rocky environment.

I often forgot that I was working and that we needed to find content for our cyber audience. As far as I was concerned, I was exploring the wilderness and the rest of the world just happened to be along for the ride. My favourite place in all of MalaMala is on the top of Campbell Koppies. We could only go up if the lions were not there. This must have been one of their favourite places too – we would see evidence in the fur they left behind. The Styx pride could often be seen lying on top of the rocks and looking out as if surveying their kingdom. Perhaps it was the view of the undulating bushlands that stretched all the way to the Drakensberg Mountains in the west, or perhaps it was simply knowing that I was enjoying the same view as a wild lion, but whatever the reason, the top of Campbell Koppies is one of my two favourite places in the entire world. The other is a baobab on a sandstone hill in Botswana, but more on that later.

MalaMala was not just good for leopards; we were filming lots of lions too. The filming vehicle had no seats on the back, so we used to stand to film. Around lions this made one feel especially vulnerable. The lions were used to the MalaMala game viewing trucks, but our filming vehicle looked different. The movement on the back would on occasion evoke a charge, especially from one of the ageing males in the West Street coalition, who was especially cranky. Standing on the back once I remember him charging

so close that I could actually smell his bad breath! Most of his teeth were broken. Filming him made me think about how hard and cruel life is for lions. Most people see male lions as lazy kings, just lying about while the females do all the work. But male lions have a terribly tough time in the bush. First they need to secure a territory and a pride. Then, once they have a territory of their own, they need constantly to patrol and ward off other, rival males. Their reign only lasts about three or four years before they are ousted by new males. They have to flee for their lives, and they scrounge a meagre living as nomads. Of all the creatures in the bush, I would least like to come back as a male lion, excluding dung beetles and oxpeckers, of course.

One night we were driving down the eastern bank of the Sand River and had turned onto my favourite road, Sabuyo Drive. This two-track hugs the bank of the river and passes through beautiful bush country where the trees grow over the road, giving the feeling of driving down a tunnel. There was no moon, it was extra dark, and we had a flat tyre. We used to get flats regularly and we knew the drill pretty well. Standing at the back of the Land Cruiser, Paul and I had just gotten the spare wheel out when we heard the distant groans of lions. Smiling at one another, there was nothing to say. We both knew what the other was thinking: There is no better sound in the world!

Another series of roars bellowed forth from the same direction.

'It sounds much closer this time,' said Paul as we continued our tyre-changing routine. We had just gotten the Hi-Lift jack out when there came yet another series of roars, this time much closer. 'Jeez, those sound like the West Street boys and they must be coming this way,' said Paul. We started working like Formula 1 mechanics, the Hi-Lift jack's handle being pumped up and down at such a speed that it reminded me of watching one of those old black and white movies. Barely two minutes later, yet another series of roars broke forth and this time they sounded like they were literally around the corner. Jumping onto the jacked-up, now lopsided vehicle, I grabbed the spotlight and shone it down the road behind us.

Four of the West Street boys came bounding over the horizon. They seemed to be running straight for us. When they got to about 30 yards away, we heard a rustle in the bushes directly next to where we had been

changing the tyre. Swinging the spotlight around, I was utterly shocked to see a female lioness leap up out of the bush and run towards the males, followed by three tiny cubs. Anaemic with fright, Paul and I gasped in disbelief. We had been changing a tyre within 20 or so yards of a lioness and her cubs. The mother must have felt comfortable in the dark of the moonless night and she would have been watching our every move, but because we had stayed close to the vehicle, she had not felt the need to attack. There are few things more dangerous in the bush than a lioness with tiny cubs. I was just so glad that neither Paul nor I had felt the need to answer the call of nature. The closest bush would have been the one that had a lioness and her cubs in it!

Back in camp a couple of weeks later I was feeling decidedly ill. I managed to film for another two days before I realised that I might have malaria again. Packing in haste, I very sadly forgot my Roberts bird book behind, the one with an inscription inside and gifted to me as a child by my dad, who has since passed. I knew that the sooner I got to the doctor the better because malaria is a parasite, so basically you kill it before it kills you. I raced my way up to the highveld and into my local GP's consulting rooms, where I picked up a letter to go and have blood tests done. The call came through early the next morning to say that yes, I did have malaria. Now too ill to drive myself, I was taken to Pretoria East Hospital where a quinine drip was promptly stuck into my arm. The quinine causes one's ears to ring. My doctor called it 'the sound of freedom' but to me it was just plain irritating. My body was so full of quinine that I had its bitter taste in the back of my mouth. I lay in hospital waiting for the parasite to die. Whenever I have malaria it always astounds me that a parasite so tiny that it lives in the saliva of a mosquito can make a grown person so ill.

As I went from hot to cold, and tossing and turning in my fever, the low ceiling of the modern hospital started really bugging me. I needed air. I needed to see the big African sky. Claire was busy with her final exams at university and it felt like an eternity had passed before she was finally at

my bedside. I told her about the plummeting impala rumen, which was not an altogether wise thing to do since I was already feeling decidedly nauseous from the quinine. I also gave her a bunch of film to go and get developed. When the specialist did his rounds later that evening, I suggested to him that he discharge me. The ceiling was really bugging me. I felt I would go insane if I stayed any longer. The doctor, who I have to say had the bedside manner of a dagha boy, was indignant and insisted that I didn't understand the severity of malaria. He was clearly irritated when he wrote down an instruction for me to have a sonar.

The cold jelly on my tummy was tingly. Lying there, watching my internal organs on the monitor, I saw that my spleen was horribly swollen. The doctor had made his point: malaria is a serious disease, and it is seriously bad for a person's internal organs!

Claire arrived the following afternoon carrying a white envelope of photographs. I sat up in bed and opened it. Pulling the photos out, I was so chuffed to see that I had a photo of Tjololo. Maybe I was just still delirious from the fever but I was sure it could be a *National Geographic* cover. With Claire lying next to me, her head propped on her elbow and photos spread everywhere, I recounted to her the memories of each. Feeling better and thinking that soon I would be back in MalaMala and photographing like a National Geographic photographer again, what came next was a shock.

My cell phone rang. It was Paul and he was not in a talkative mood.

'The company is bankrupt,' he said.

Although he said something else after that, I cannot recall hearing anything past those words. The team at MalaMala had been told to simply pack up and go home. There had been no warning. Suddenly I was not just sick and in hospital; I was sick, unemployed and in hospital. To add insult to injury, on being discharged I was handed a bill for the sonar, which apparently the medical aid did not cover (for malaria). As I walked out the sliding hospital doors, it dawned on me that I had no money whatsoever.

I drove straight to the Keg, the pub one of my old school friends and fellow wildlife society member managed. Grant 'Flintstone' Burton was one of those friends who was closer than a brother. We had met as 16 year old boys in veldskool and bonded during a pillow fight. Being teenage boys, it was not long before all manner of objects were being shoved into the pillow cases, including hard hiking boots. The pillows now took on a much more sinister meaning and what had started out as a simple pillow fight became a war of attrition. If no one had your back, you were potentially a dead man. That was how I met Flintstone. He and I teamed up as back to back we wielded our pillows together. From that moment on we were firm friends and of course we had also shared that memorable full moon night, up a bushveld tree at a waterhole, as schoolboys.

Flintstone and I had a lot to catch up on. We enjoyed a beer together and then got into reminiscing about the good old days. We remembered how we had once decided on a whim to climb to the top of the Drakensberg mountain range. It was December and we were ill-prepared, but with the vigour – and the stupidity – of youth, we climbed a series of chain ladders and pitched camp on the high berg. Grant had said he would bring the tent and unpacking it I could not help but notice that it was not one of the more modern dome-type tents. The green A-frame structure did not strike me as a mountaineer's accommodation of choice; it looked more like a tent that Christopher Robin would use!

Soon we were jammed into it like sardines and precariously perched on the edge of the mountain. That night an almighty thunderstorm raged on the top of the berg; the wind swept down the mountain from Lesotho with an anger and an intensity that I still to this day have never experienced again. Lightning struck and thunder boomed all around us. The green tent lost its rigid structure as the top was blown horizontal.

By some miracle both we and the tent survived the storm. The next morning found us sitting with our legs dangling over the edge of the Tugela gorge. The air was clear and clean after the storm and the valley stretched out below us in what has to be one of the finest views in Africa. As if it could not get any better, we heard the sound of rushing wind and a bearded vulture flew past at eye level. It was only when we pitched the same tent the next night on the coast and a gentle onshore breeze blew,

splitting the tent in half, that we realised what a close call we had had in the mountains.

Having another beer, which wasn't doing my battered liver any favours, Grant and I talked late into the evening, reminiscing and remembering good times. The night ended with him offering me a job as a barman. When I got back to my Beetle, I noticed a parking ticket on my window. I had parked on a yellow line. Placing the ticket next to the hospital's sonar bill, I was grateful I at least had a job.

22

Urban woes

I was not a very good barman. Having to continuously go to the back to look in the cocktail book meant that my service was pretty slow. My worst day of the week was on Saturday afternoon when there was a big rugby game on. The place became manic. Running between the bar fridges and the bar counter with people yelling their orders at me was pretty much the furthest thing from the tranquillity of the bushveld. The week days, however, were slow, dead slow in fact, as we had just a handful of regular customers come in.

You get to meet some really strange people in a bar. One gentleman arrived each day at 12 pm sharp and ordered a triple cane and water. We were only allowed to serve a double, so the third tot would be placed on the bar separately. The gentleman in question would add it to the water himself before glugging the clear mix down in a long narrow glass, and then promptly returning to his business offices across the road. The alcohol would not be detected on his breath and the pain of the proverbial urban grind had been numbed.

Every day told me that I needed to get out of civilisation – fast. I scoured the local newspapers for jobs and it was there that I saw that the Natural History Museum in downtown Pretoria was looking to fill the position of ornithologist. This was the same museum whose bowels I had visited when dropping off that tiny green beetle I found in the Timbavati. Now I was driving back to the museum in my Beetle wearing a half-baked suit, one which I had thrown together by pairing a white-collared shirt with chinos and a borrowed tie. I was interviewing to become an ornithologist and I was beyond excited. I mean, what could be better than researching birds for a living?

My interview was at 10 am and I was asked to wait in the foyer of the museum, where a life-size statue of an elephant loomed over me, strangely

making me feel quite at home. The building was dark and gloomy and very intimidating, with thick stone walls and a high ceiling. I was not an ornithologist by any definition, but I was desperate for work by every definition. I had studied nature conservation but ornithology had not even been a stand-alone subject. Sitting in the foyer I reminded myself that I had been obsessed with birds from a young age, and that I had never gone anywhere without my binoculars. The time I'd spent at the Austin Roberts Bird Sanctuary was worth more than a degree in ornithology, or so I tried to convince myself.

I had prepared very well for the interview. Working on the assumption that they would ask me what my dream avian hypothesis would be to prove, I'd composed an essay about a tiny bird called a village indigobird (then called the steelblue widowfinch), which lays its eggs in the nests of unsuspecting hosts, as an example of the ongoing arms race that exists between brood parasites and their hosts. I began with a broader background, using cuckoos as my starting point. At first, cuckoos were recorded laying any colour eggs in their host bird's nest. The poor host would incubate the egg just as if it was one of her own, even though it was a totally different colour. But, over time, lots of time, the host birds learned to differentiate the eggs that were a colour mismatch, and these were expelled from the nest. More time passed and the cuckoos started laying eggs that matched the colour of the host bird's eggs. This worked for some time but the host then realised that her eggs were speckled and that the cuckoo's were not, so over the edge the cuckoo's eggs went.

The cuckoos then developed a new strategy. They started matching the colour and the markings of the host bird's eggs. It worked and the host again incubated the foreign eggs like they were their own. But the plot thickens. When the chicks begged for food, the host birds noticed that their own offspring had markings on the top of their palates, which helped them favour their own offspring at feeding time. Now here's where things get really interesting – and this was where I wanted to come in with my hypothesis. The village indigobirds, which, like cuckoos, are also brood parasites, now have their young develop palatal markings that match those of the host chicks! I was going to propose, in my interview, that I continue this fascinating research into this evolutionary arms race and in my home country of South Africa, where the village indigobird is fairly common.

While I was busy going through my essay in my head and imagining the questions I would have to field, I heard someone clear his throat right beside me. I looked up to see a tall, black-haired man in a grey suit and thick spectacles, the kind that make one look abundantly intelligent. The manner in which he had cleared his throat implied that he had been standing there, trying to get my attention, for quite some time. I hoped that I had not been practising my interview out loud, although I was pretty sure that I had been gesticulating with my hands. He showed me into the lift and we descended into the bowels of the museum where I was told to wait in a smaller foyer. Sweating under my armpits and having no jacket to hide it, all I could do was fidget nervously. A secretary then motioned for me to enter through a large closed door.

The door was heavy, the kind of door that was built before rainforests were endangered. I grabbed at it with a sweaty palm and it creaked open. I walked into a large room with an intimidatingly high ceiling. The air was thick and musty. I rubbed my hands on my thighs to try and get rid of the sweat on my palms. On the far side of the chamber was a long table with a panel of interviewers sitting behind it. On the very left of the table was the gentleman with the thick spectacles and in front of the table was a single lonesome chair. Walking towards the chair seemed to take ages and the creaking floorboards made the journey to the table feel even longer. Finally I made it to the chair and sat down. The man with the glasses stood up and introduced me to the panel. All I can recall is that everyone on that panel had PhDs in various fields of natural science.

'Mr du Toit.' The voice, which came from about halfway up the panel, echoed in the large room.

'Um, er, yes,' I confirmed.

'Please, Mr du Toit, tell us how you would improve the current avian exhibit at the museum?'

A long pause followed as I tried to figure out an answer. I knew the museum well and I had been to the bird exhibit many times as a kid with my dad, which consisted of stuffed birds with little buttons that you pressed to get their call. How on earth do you improve a stuffed exhibit? I went totally blank. All I could hear was the thumping of my heart as I felt my face going red.

'Um, er, it is a wonderful exhibit and I am not, um, er, really sure ... um ... how I could improve it?'

'Okay, Mr du Toit,' said the bespectacled man, who now looked like he belonged in a movie playing the role of a CIA assassin. He might be masking his deadly powers with his pair of spectacles but he was unable to hide his steely, cold and merciless nature. 'In one word, what will you do for this museum?'

How do I sum up my dream hypothesis about the evolutionary arms race between brood parasites and their hosts in one word, I wondered to myself.

'Um, er ...' I stammered, trying to buy time.

'Mr du Toit. In one word.'

'Okay, well, in one word I ...'

'Mr du Toit? When I say one word, I mean one word.'

'Okay then, I would—'

'One word, Mr du Toit, one literal singular word, please!'

'Okay, in one word then—'

'Mr du Toit! Which part of ONE WORD do you not understand?'

I wished the creaking floorboards would collapse, right there and then, and that the room would swallow me whole. With singular words racing through my mind I clutched my thighs and stared up at the high ceiling. The sweat was now not just pouring out of my armpits but from my temples too. The sound of a throat being cleared snapped me back to reality. Sitting before this panel of accomplished scientists, I was a deer in the headlights. My pause seemed to have created a great degree of expectation, the kind you get in rugby when a penalty is about to be kicked.

'Love,' I said. 'LOVE.'

A long and awkward silence followed. Trying to console myself, I thought, Yes, that's what this museum needs. It's what the world needs. More love!

At this point more than one of the interviewing panel had lowered their glasses and were peering at me, as if to confirm that the answer I had given was indeed my final bid.

'Love. Mr du Toit, did you say love?'

'Yes,' I replied.

'You mean to say that you will, um, er, love this museum?'

Now even the interviewer was stammering and at a loss for words. I looked

down at my nicely and rarely polished brown Bronx shoes, the ones I wore each day in the bar.

'Thank you, Mr du Toit, you can go now. We will notify you if we need to see you for a second interview.'

I got to my feet and shuffled to the door, trying not to make the floor-boards creak too much as I went, grasped the door handle and pulled.

'Push, Mr du Toit, PUSH!'

That was the last thing I remember of that interview. The next thing I knew I was sitting in my Beetle, banging the steering wheel with my head and feeling like a real idiot. Did you really say LOVE? I asked myself. Repeatedly. I knew already that a second interview was never going to be on the cards.

The Natural History Museum was around the corner from a major police station. I still had a parking ticket outstanding and I thought I may as well settle it while I was in the vicinity. I parked in front of the police station and walked inside. I told the officer behind the counter that, although I did not have it with me, I had an outstanding ticket, and I wanted to settle it.

'Sir, the registration number of your plates?'

'LCL 391T,' I said.

Rapid typing on a keyboard followed, then more rapid typing. I waited patiently. It hadn't been an especially good day so far and I wanted this part to be over. The police officer babbled something – police code, I guessed – into his radio, then instructed me sharply to 'Stay right there, sir!' I thought that was a bit puzzling but before I could say anything I felt a firm grip from behind on both my arms. With two police officers restraining me for no apparent reason and a third whipping his revolver out of its holster and pointing it at me, I wondered what on earth was going on. One moment I was standing at the counter being a good citizen and paying my parking fine, one which a 'peace officer' and not even a real policeman had given me, and the next I was being dragged, literally dragged, upstairs at gunpoint. To say I got the fright of my life would be underplaying it. I started trying to pull myself loose, but the officers gripped tighter. I then started pleading with them to let my arms loose.

'Loose!' scoffed the officer who had my left arm in his brawny right hand.

'We got you now and the only place you are going is to the cells!'

I protested vigorously but to no avail, and soon I was at the entrance of a holding cell. At that point something in me snapped as I realised that things were getting very serious. I grabbed onto the bars of the cell and held on with all my might. While the two officers tried to pull me loose I shouted, 'I drove myself here!'

'I don't care!' said the third cop who had holstered his firearm and grabbed me by the leg to tip me into the cell.

But a fourth cop, who was standing in the corridor, seemed intrigued. 'Did he really drive himself here?' he asked.

Capitalising on his puzzled expression, I yelled, 'Yes! I brought myself here, I can show you my car!'

The other three police officers had managed to get me all the way through the door when this 'good cop' told them to let me loose. They looked perplexed at his request, but I slowly felt their grips loosen. This cop, the nice one, told them that he would handle the matter further. He slapped some handcuffs on me before escorting me downstairs and out onto the street. He asked to see my car and I pointed at my yellow Beetle. He wrote down the registration number and then led me back into the station, to the original counter where my ordeal had begun. The officer behind the computer typed in my registration number again. Under the vehicle description it read 'white HiAce minivan', and the address of the owner was in Mamelodi, a township east of the city.

'Ah,' the cop exclaimed and with that he freed me and disappeared upstairs again. Pale and shaken but still none the wiser, I stood where he'd left me, until finally the officer behind the counter explained. It seemed that a person in Mamelodi, one with numerous arrest warrants out for him, had fake number plates and, unfortunately for me, he had chosen the exact numbers and letters of my Beetle's number plate. This was a very difficult issue to resolve, he added, and strongly suggested I contact a certain inspector in Pretoria West for assistance.

I looked at him blankly while the implication of his words sank in.

'In the meantime,' he went on, 'if you run into police be sure to tell them to check the vehicle description.

'Or—'

'Or you will be arrested,' he said. Then he told me I was free to go, which seemed to me rather ironic.

I paid the piddly little fine for having parked on a yellow line and walked unsteadily out of the police station. By now I was slightly late for my evening shift at the bar but as soon as I got there, I made sure my first drink order was the one I placed for myself!

The next order was from a bona fide customer who ordered a 'virgin daiq'. I had no idea what drink this was. This day just wasn't getting any better. I ran to the back and began desperately paging through a copy of the 'Bartender's Bible', which listed all the ingredients for every cocktail ever invented.

It had been a long day and by the end of it I had learned three things; that a career in ornithology was out of the question; that traffic fines are to be paid online only; and that a virgin daiq has no alcohol in it.

The next day I got in touch with an employment agency. My brief to them was short: 'Get me a job in the bush. Any job, anywhere. Salary is not important.' Within a week I had an interview at a safari camp in Botswana, for a managerial position. The agent told me that the camp was ideally looking for a couple, and that if I applied as a 'couple', the chances of getting the job were that much higher.

Claire was close to finishing her degree in tourism. I bought a couple of milkshakes and went to pick her up in my car with suspect number plates. We drove to the Union Buildings where there is a beautiful view of the city (and a chance of being mugged) and sat on the wall of the state gardens. Gazing down on the city lights, I allowed her to make me feel better about the horrible week I'd had. I could talk to Claire about anything and she always saw the humour in my experiences. She had a way of throwing her head back and roaring with laughter, a good belly laugh. I loved hearing her laugh. Then, taking a slurp of my milkshake, I told her that I had an interview lined up. She looked at me enquiringly. I took another slurp.

'It's a management position,' I said. 'At a lodge in Botswana.'

'Botswana?' she said.

'Yes ... and they're actually looking for a couple ...'

She said yes immediately.

On the drive to the Botswana border, I answered Claire's questions as best I could. Although we had met in the bush, she had had very little bush experience. Growing up, her family had always gone to the seaside on holiday. Her folks had emigrated to South Africa from Scotland just before she was born, which meant that sunshine and surf won every time over grass and animals when it came to making decisions about holidays.

'Is it dangerous?' she asked.

'Not at all,' said I. 'Animals are as scared of us as we are of them.'

'What about snakes and scorpions?'

'Oh those. They stay out of our way.'

'How will we communicate with our families?'

'Um, other people live and work there so there must be a way,' I said, not really sure myself.

Mashatu Game Reserve's then flagship and very unoriginally named 'Main Camp' was looking for an administration assistant and an operations manager. The interview went very well, so well in fact that we were offered the job right there and then. The only catch was that we would need to wait three months for our work permits to come through.

Back it was to the Keg. The next couple of months were pure torture. I phoned Pete le Roux, the reserve director, who had an office at the border between South Africa and Botswana, almost daily to check on the status of our work permits. Our entire lives depended on the stamped approval of Botswana's Immigration Department. Without work permits we could not work in Botswana. My body was behind the bar but my mind was in the bush. I took my photo albums to work every day and anyone who ordered a drink also got a private showing of my wildlife gallery.

One fine day, excusing myself for a break, I walked outside and called Pete yet again.

'Greg, your work permit status has not changed since yesterday,' he said patiently. 'But you seem to be champing at the bit, so why don't you just come up and I am sure your permits will come through soon enough.'

Within two days, Claire and I were packed and on the open road heading to Botswana.

23

Just a little scorpion

The road narrowed into a single lane as we passed through the one-horse towns of Vivo and Dendron. Slowly the bush was getting wilder and I was wilderness dreaming again. We had received a message from a chap called Grant Hall, the resident archaeologist at Mashatu, asking us to pick up post for him and the other camp staff in Alldays. It was not hard to find the little post office; nothing can be hard to find in Alldays. This tiny town was once a one-horse town – that was, until the horse died.

The strange name comes from the tale of an old missionary who lived in the town and was particularly partial to marula mampoer. This moonshine has the dubious hallmark of being distilled so many times that it can be used as car fuel, should the need arise. The missionary in question used to enjoy a mampoer with his lunch, and with his dessert, and with his tea later in the afternoon. He passed out before the sun set and woke up the next morning after the sun had risen. So as far as he was concerned the sun in this part of Africa never set. So he named the town Alldays and the name stuck. How much truth there is to this story I do not know, but it is the only satisfactory explanation I have heard. Driving through, or past, the town, both pretty much the same thing, I managed to glimpse a few large Toyota pick-up trucks with gun racks on the back and a sign for Att se Gat, the local watering hole.

Pont Drift border post was a more welcome sign. We parked our car under a shady tree and were soon heading across Kipling's 'great, grey-green greasy Limpopo' – by cable car.

I had the privilege of having Claire as my companion on this exciting new adventure. Well, for me at least it was an exciting new chapter. For Claire leaving the city behind for good was a more daunting prospect and I was determined to help her settle in to her new environment. The Tuli Block, where Mashatu was situated, not only had its fair share of dangerous

animals but, in the height of summer, there would be smaller but no less deadly creatures to look out for – spiders, scorpions and snakes too.

We had been allocated a rondavel each and, after I'd finished unpacking, I strolled over to Claire's to collect her and take her to dinner. Mashatu's Main Camp could sleep about 36 tourists and each night these guests, usually from overseas, were wined and dined by the various Mashatu managers. Although it was our first night, we had been asked to help host dinner. We were just exiting her doorway when I spotted a large black scorpion on the path. I threw my arm out to stop her from taking another step in her summer sandals. Everything about the bush was new to Claire and she was already apprehensive and nervous, so I was relieved to have seen the scorpion in time, even though she would not have known what I knew. I had noted the arachnid's incredibly thick tail and instantly recognised it as belonging to Africa's most dubious and deadly genus, the *Parabuthus* variety. That Claire's very first night in the wilds of Africa could have borne out her worst fears would not have made for a great start.

Grabbing two sticks, I quickly began shuffling the deadly insect away and into the bush.

Claire looked at me, her eyes wide and enquiring.

'Just a little scorpion,' I said.

Dinners at Mashatu, like in most safari camps, were grand affairs. There were pre-dinner drinks offered in the bar, appropriately called the Gin Trap, with impala kebabs on offer as a snack. Mashatu's main clientele were American tourists enjoying an African safari. Claire and I were in the deep end, having to answer question upon question about ourselves and about Mashatu. I at least had bush experience, but Claire was not just new to Mashatu, she was new to the whole experience. It didn't take the American women, most of whom were about the same age as our mothers, long to get to the bottom of who exactly we were and where we were from, and that this was in fact our very first night. As a result, it felt more like we were being hosted than the other way around.

The next day I was sitting in my office scratching my head as I tried to work out how many guests needed to be collected from the border post, and how many were leaving camp, and how many were staying, and who

was currently on safari drive, and how many vehicles and rangers I had at my disposal. It was a process far more complicated than having to pack the backpack for Happy or drive around filming wildlife. Just as smoke was beginning to rise from the crown of my head, the gardener burst through the door – well, he looked like a gardener because he was wearing green overalls and he had a rake in his hand. 'Come quickly!' he said.

I followed him down the pathway and was surprised when he made a turn towards Claire's rondavel. I was even more surprised when he pointed at a large Mozambique spitting cobra less than 10 metres away from Claire's front door. Before I could gather my thoughts, the man in green overalls lunged forward and whacked the snake on the back of the head. Turning to me with a big grin, he said, 'That snake is very bad!'

'Um, what's your name?' I asked.

'I am Jack, Jack Rama-da-banana,' came his emphatic reply.

'Jack, what do you do here?'

'I am the garden technician,' he said.

'Okay, Jack, please move the snake away and don't tell anybody, especially not the lady living in this room, okay?'

Walking back to my office, I was so relieved that Claire had not been around to see the snake. She had been in the bush less than 24 hours and we had already found a deadly scorpion and a cobra within spitting distance of her new home (pun intended).

Although my job at Mashatu lay mainly in overseeing the logistics and activities of the safari guides and trackers, when the camp manager, Lloyd, was on leave I would fill in for him. With this came bigger responsibility, as the entire camp, with a staff contingent of over 60 people, fell into my hands. There was a silver lining, however, in that when I was the camp manager I had to direct camp maintenance, which meant that I interacted with Jack on a daily basis. His description of being the 'garden technician' was not altogether inaccurate, for he was the gardener, but he was also the general handyman.

Every camp has one and every camp desperately needs one. We call them 'bush mechanics' and they are the MacGyvers of the bush, able to fix anything with anything. Bush mechanics always have one distinctly strong discipline and one distinctly not so strong discipline. I soon learned that Jack's distinctly strong skill was plumbing, with using grand vocabulary coming a close second. He liked to use big words and had a turn of phrase second to none. One day I found him fast asleep in the fork of the mopane tree that grew behind the camp reception. I ran to fetch my camera as I had seen plenty of leopards make a tree look as comfortable as a sofa, but I had never before seen a human do it. Jack had wedged himself in the fork and with a leg dangling either side, much like a leopard does, he was leaning back against the trunk, with his mouth open and his thoughts in a distant lala-land. After I took my photo, I cleared my throat.

'Jack Rama-da-banana, what are you doing, sir?'

'I am resting my eyeballs,' came his quick retort.

Jack enjoyed using big words but his favourite word was 'referring'. He used it in almost any given sentence. No matter what I seemed to be looking for in the toolshed, I almost always could not find it and I would have to go and ask Jack. Our conversations took on a pattern, with only the tool I was looking for varying.

'Jack, where are the pliers?'

'Greg, are you referring to the pliers that we used to fix the fence?'

'Yes, Jack, I believe we only have that pair.'

'Yes, but are you referring to the pliers with the blue plastic handles?'

'Yes, Jack!'

'Are you referring to the very same pliers with the very same blue handles that we used to fix the very same fence the other day?'

'YES, JACK!'

'Okay, I know the ones you are referring to, I will go and fetch them.'

I worked out that Jack had learned that by using the word 'referring' he could buy time while he racked his brains as to where the particular item you were referring to could be. Although he was a good plumber, he was an electrician in training only. After rewiring the camp's swimming pool motor he very nearly electrocuted Lloyd when he went to turn the pump off one evening.

Mashatu in those days was very remote. There were no towns nearby and our water supply was pumped a considerable distance from a borehole along the Limpopo River. The landscape around Mashatu is rugged and covered in rocks, which gives one the feeling of being in a truly ancient environment. Large baobab trees stud the landscape, adding to the African ambience. Mashatu is perhaps most famous for its abundance of elephants and the reserve serves as a safe haven for hundreds upon hundreds of pachyderms, who, if they were to venture south into South Africa, would encounter angry orange farmers. If they ventured north in Botswana, they encountered villages. Having elephants frequent the waterhole in front of camp was a delight and especially for me as I would oftentimes go many days without ever leaving the camp.

As South African citizens, to work in Botswana, apart from the special work permits required, the only way we could get any position was if we were filling a post that could not be readily occupied by a Motswana. As a result, I was not allowed to guide at all, but I was able to fill a management position as the universities of Botswana were not yet offering nature conservation or tourism degrees. This proved to be a very difficult position to be in for me. I was living in a wonderfully remote and rugged piece of Africa, but I was forever camp bound. This was extra frustrating for me because my dream of becoming a wildlife photographer had only grown stronger. Fortunately, there were some photographic opportunities in and around the camp and since the camp had been there for 20 years, there was even some wildlife that frequented it.

Bushbuck ewes had learned to come and give birth in the camp as their offspring would be safer in camp than in the bush. This meant that at any given time we had at least one baby bushbuck in camp and I would spend hours photographing them. One day I was photographing a tiny little bushbuck when suddenly the camp's sprinklers came on. The poor little thing must have thought it was raining because it stood motionless getting wet when all it needed to do was walk a few metres away to be out of the reach of the spray.

My favourite time of the day was 4 pm when all the guests and the guides left on their safari drive and the rest of the staff knocked off for a break. The camp became my own personal photographic oasis. I would wander around

photographing just about anything, including the beautiful butterfly-shaped mopane leaves. In autumn mopane leaves covered the dry ground like an orange carpet. One such autumn day, I spotted a baby bushbuck standing in amongst this carpet of leaves. Camera in hand, I crept closer, keeping low to the ground. The photograph I took, slap-bang in the middle of the safari camp, would be my first ever published photograph as it would later feature in a calendar depicting baby wildlife. The onset of winter saw the mopane moths pass. I photographed one of these moths lying on the carpet of mopane leaves in the camp. When I published my first coffee-table book, some 11 years into the future, the image of the moth on the leaves would be the oldest image in the book.

Sadly, these two images were the silver lining to dozens upon dozens of rubbish photographs. Although the learning curve was steep, I was photographing in every spare minute. Slowly but surely, while working as a safari camp manager and hosting hundreds of tourists over dinner and lunch, I was paying my photographic school fees.

24

The story of horses

Food is a really big part of any African safari and tourists are forever complaining about eating too much. Mashatu was no different. Every day at around 11 am there was a huge brunch on offer. By that time the guests were all back from their early morning game drives and they were ravenous. And, as I can personally testify, so were the camp managers, who had been waiting patiently for the last safari truck to arrive back, and who, having been in camp all morning, had endured the tempting aromas wafting from the kitchen. It is safari tradition to host guests over meals and every day each one of us managers was assigned a table to host. This meant that Claire and I always ate apart, yet we were often answering the exact same questions. Hosting brunches we soon learned that Americans are not shy when it comes to asking questions and that the more questions you answer, the more they ask. As the guests in camp departed for their next safari destination, a new lot arrived and asked us the exact same questions, all over again.

I remember hosting a large group of Italians and halfway through brunch they erupted into an argument. I didn't understand a word of it but there was much screaming and shouting, accompanied by vigorous gesticulations and waving of protesting arms and hands. I didn't know where to look. I wanted to slink away like a leopard whose prey has spotted it. Then, like a flock of babbler birds, their argument reached a crescendo and just when I thought fists were about to fly, one of the gentlemen leaned over and in a perfectly calm tone said, 'Grego, can you-a pass-a me the butta, please.'

And just like that things were back to normal. I remember thinking what a peculiar and strange tribe the Italians were!

It seemed my chief role at Mashatu quickly became that of host and I found myself spending many hours each day talking to guests in camp. This was perceived to add tremendous value to the Mashatu 'guest experience'.

One particular day I was waiting for a new guest to arrive from the border post. It is customary in safari camps for a camp manager to meet you upon arrival and to give you a briefing about the camp. A tall, thin and very pale gentlemen, with white, hairy, bony knees, climbed off the safari truck and greeted me with a twang.

'Bim, the name's Bim. Bim Levin.'

'Pleased to meet you, Bim,' I said. 'Welcome to Botswana.'

Bim followed me into the reception room where he promptly burst into tears and ran outside into the camp's garden. Perplexed and shocked, I followed him to where he was standing under a mopane tree blubbering like a school kid.

'Mr Levin, is everything okay?' I enquired.

In between some shaky inhaling and exhaling, he stammered out an explanation for his distress. He explained that his purpose for coming to Africa was to write 'the story of horses told by horses' and that the zebra skin hanging on the wall in the reception area was highly insulting, not just to him but to all the horses of the world.

'Um ... er ... not a problem, Mr Levin,' I said. 'Let us do your check-in right here, in the garden, and I will then show you to your room.'

After an awkward check-in and with the tears having eventually subsided, as we walked to the room, Mr Levin told me how he had travelled all the way from Ethiopia, where he had spoken to the wild asses there about horses. His purpose for being in Botswana now was to talk to the zebra, after which he would be travelling to South Africa to speak to the mountain zebras there. As soon as he walked into his room Bim began laughing and smiling, almost in delirium. It was hard to believe that minutes earlier he had been crying. Pointing to a picture of a zebra on the wall, he exclaimed, 'You see, the zebra knew I was coming!'

I did the quickest room orientation ever, finishing up by pointing out that the can of Doom insect spray was not to be applied to the body. I then went and reported the rather bizarre series of events to Lloyd, my manager. When it was time for high tea I found I was assigned to host Mr Levin's table. There were other guests at our table and everything was going fine. That was until Bim, after hearing that I enjoyed photographing wildlife, had a question for me.

'Do you speak to the animals you photograph, Greg?' he asked.

Giving a nervous laugh, I replied, 'Ah, I wish I could. That would make my photography so much easier.'

There was a long pause while Bim fixed his gaze firmly on me. Then he leaned across the table and said, his tone very serious, 'Greg, but you can.'

One of the other guests saved me from trying to think of a response, by arriving at the table and informing me that she had no water in her room. This was a conversation I could have and it gave me a perfect excuse to leave.

Water issues were very common in Mashatu as the elephants had learned to remove the rocks that covered the waterline to camp and they had also learned to kick the pipes until they uncoupled. I walked around camp trying to find Jack but no matter where I looked and no matter how many people I asked, I could not locate him. I searched high and low, checked every room, checked the staff quarters and everywhere in between. Walking into the rangers' room, I noticed that the manhole in the roof was ajar. I stood below the square hole in the ceiling and yelled, 'Jack! Jack, are you up there?' I was not expecting a reply when a voice from above said, 'Are you referring to me, Jack Rama-da-banana?'

Looking up, I snapped back, 'Jack, what the heck are you doing up there?'

There was a very long pause and silence, then this reply: 'I am hiding like Bin Laden.'

It was just impossible to be angry with Jack (even if he was partial to stealing forty winks on the job).

Later that night I was in the Gin Trap bush bar waiting for the guests to arrive for pre-dinner drinks. The first to arrive was a British family and I asked the standard question that all safari camp managers ask every day across Africa. 'How was your safari drive this afternoon and what did you see?' The dad immediately went red in the face with anger and told me that they had stopped for a herd of zebra when the radio call came through from another safari truck, saying that lions had been spotted and that they were on a kill. The guide turned to relay the message to his guests and to tell them to hold on tight as they were going to rush over to the lions. 'But then, this American idiot on the truck with us, he refused to let the guide leave the zebra herd. He insisted that he was in the middle of a very important conversation with the zebra about horses!'

I excused myself as quickly as possible and went to check if we had another vehicle and guide spare. Bim Levin needed to be on his own private safari truck. I assigned a ranger named Godfrey to Bim and advised him that they would be going out all alone the next day.

The following morning I was in my office, busy working on the guide roster, when the door was flung open and in walked Godfrey. He was furious.

'Why does that man's mother let him out of his village?' he demanded.

I didn't have to be told who he was talking about, but I asked him to explain what had happened.

'We were driving in the east close to the Zimbabwe border and we stopped to look at a herd of zebra. Mr Levin then insisted that I speak.'

'What did you say?' I just had to ask.

'He insisted that I talk to the zebra!' yelled Godfrey, who was normally a very placid chap.

'But what did you say?' I asked again.

Looking suddenly rather sheepish, Godfrey mumbled, 'I asked them why they don't go to Zimbabwe?'

'Aah,' I said. 'And did they reply?'

'Yes,' said Godfrey, 'but not directly to me. They spoke only to Mr Levin. They said that they don't go to Zimbabwe because the government is mad.'

'Oh-h-h, I see,' I said, although I didn't.

'That's not all,' Godfrey went on. 'We then found a cheetah and Mr Levin asked me what their favourite food is. I told him it is impala. But after discussing the matter with the cheetah, he told me that I was wrong and the favourite food of the cheetah is in fact the steenbuck.'

Godfrey was so annoyed he was actually shaking. Not only had he been made to converse with animals and then seemingly been corrected by the animal itself, but to have it all translated through an American tourist was too much. Bim would need a very special guide, I decided. I thought I knew the man for the job – Bashi, who is one of the best guides in Africa. I told Godfrey that he was relieved of having to drive Mr Levin again and he calmed down right away. As he walked out of the door I heard him mutter, 'His mother should never ever let him out of his village.'

I subsequently briefed Bashi about his new safari guest. He was not at all amused. When I finished he just shook his head, staring down at the

ground. But there was nothing for it. Bashi was my last option and so Bashi it had to be. We still had three nights to go with Bim.

Later that afternoon there was a safari truck spare. I had been camp bound for a couple of weeks and was desperate to get out and photograph anything with claws and jaws. Slipping out of the back gate of the camp in the truck, I set off with the wind in my face and sun on my back. It was autumn and the bush was turning, displaying a beauty that is hard to describe. The lumps of volcanic surface rock looked like chunky bits of Swiss Toblerone, interspersed by beautiful swathes of khaki grass. The purple pods of the Terminalia bushes dangled everywhere, like earrings adorning a beautiful woman. The endless sky was a deep blue, punctuated here and there by wispy clouds and flapping hornbills, in their characteristically undulating flight. Driving pretty fast to get to a lion sighting in the good light, I drove past a herd of eland which seemed to disappear before my eyes, as if melting into the landscape. As mentioned, they are my favourite antelope.

Just as the last of the sun's rays were caressing the veld, turning the khaki grass into a golden shimmer of refracted light, I found the two male lions I had been looking for. Although it was cooling down, the beasts were still lying in the shade of the Terminalia bushes. Picking one of the lions as my subject, I lay across the front two seats and poised my camera, hoping the lion would wake from his slumber before the sun vanished. The vehicles at Mashatu had no doors, which was ideal for photography. While I remained poised for action, I heard another safari truck arrive. Not wanting to look away from my camera's viewfinder, I kept my focus on the lion. A few minutes went by and then I heard a loud, 'Psssst!'

I looked up, startled, and there, parked opposite me, were Bashi and Bim.

'Try telling the lion that you will use the photo you take to advance the good of his own kind,' said Bim.

I just smiled and waved and placed my eye back on my camera's eyepiece. At that exact moment the lion got up, walked and lay down again, this time in the golden sunshine. He turned to face me, and I let off a series of shots. By the time I was finished photographing there were no vehicles around and I beat a hasty retreat back across the Majale River and home to camp.

It was one of the rare nights of the week when neither Claire nor I were hosting dinner. I was in my pajama boxers and we were chilling inside Claire's rondavel, reading and listening to music, when I heard a knock on the door. Before I could respond, the door creaked open and in walked Bim Levin, with a crazed, excited look on his face. It was a most peculiar situation. Guests never ever came to the back of house. Before I could think what to do, like put some pants on, Bim looked me square in the eyes and said, 'You spoke to that lion, didn't you?' I was so uncomfortable and embarrassed that I nodded yes, sheepishly. 'I knew it!' exclaimed Bim excitedly, wrapping his arms around me and giving me a hug. 'I knew you had the gift!'

As I ushered him to the door, I feared the worst – Bim and I were now kindred spirits.

From that awkward moment of man-love while standing in my boxers, Bim never left me alone. I hosted the remainder of his meals, during which he – at length – told me the story of horses, told, of course, by horses. Time drew out like a sword and finally on his last morning I was standing in the parking area to welcome him back from his morning safari and to notify him of his departure plans. Bashi rolled into camp with a plume of dust trailing him; he was obviously in a hurry to get back. Bim was in the front passenger seat and I saw at a glance that he had tears streaming down his cheeks. Less perturbed than I'd been the first time, I asked him if he was okay and why he was crying.

After a few gulping sobs, he told me they had found a herd of zebra not far from camp and that he had stopped to explain to them that he needed to carry on with his journey and head to the Cape, to talk to the mountain zebra. Then, not before sobbing some more, he went on to explain that the zebra all shook their heads from side to side, saying, 'NO, we don't want you to go!'

I will never forget Bim, not just because he taught me to speak to animals but because I sold my very first photograph to him. It was a photograph of a zebra for the cover of his book and one which, to this day, I call 'Zebra Soul'.

25

Bone throwing

Part of Claire and my duties was to perform relief camp management at Mashatu's tented camp. This camp, affectionately known as TK, was an absolutely delightful little canvas safari camp, located in a deep valley close to the Zimbabwe border, and not far from the Tuli Circle. Running TK was a breeze compared to working at Main Camp. The camp was a quarter of the size, tucked away on a rivulet, and the bush had completely reclaimed it. This meant that wildlife abounded in camp and there were more photographic opportunities for me.

I would sit under the thatch roof hosting high tea with the guests and my index finger would be literally twitching, knowing that as soon as they left, I would bust out my camera and begin photographing. 'My my ... look at the time!' I would say. 'You guys better hit the road. The animals wait for no one!' As soon as the last safari truck roared out of camp, I began photographing. There was a large euphorbia tree in the middle of the camp which flowered in the wintertime; each branch of the cactus-like tree bore tiny yellow flowers. These flowers attracted a plethora of insects, including bugs I had never before seen. I spent hours around that tree, photographing to my heart's content. Bees were regular visitors and I wanted to get a bee in flight, which, in hindsight, might have been a tad optimistic. But the important thing was that I was contributing to the ten thousand hour rule (more on this later).

Bees were actually a big problem in TK, especially during winter and the accompanying lack of moisture, and they plagued the poor kitchen staff. One day Claire was walking towards the kitchen and immediately panicked when she saw that it was filled with smoke. Fires in the bush are a camp manager's biggest fear. Running into the kitchen to see what was on fire, Claire discovered the cooks going about their business as per usual. The only thing out of place was a smouldering ball of elephant dung

in the middle of the floor. In fact the smoke from the dung proved to be a wonderful bee deterrent and it was not long before we had similar smouldering balls of elephant dung in the dining room too. TK was a very relaxed and informal camp compared to Main Camp. The dining room consisted of a wooden table and a few rickety chairs, all set under a large thatch roof with an exquisite boer bean tree towering overhead.

Claire and I ate all our meals at TK together and with the guests. Safari camps are interesting places – you get people from all walks of life. Tourists from different countries and cultures, each with their own peculiar quirks and mannerisms, are essentially all lumped together in the middle of nowhere when on a safari. We learned the hard way in Mashatu about Italians and their culinary preferences when a large group arrived and the hot English breakfast we served made them disgruntled. Apparently, it was the toast. Their tour leader was irate and let me know she was irate in no uncertain terms, her hands doing as much talking as her mouth. Calling me aside, she said: 'Grego, don't you know-a, we are-a Italianos. We-a take-a our bread-a *before-a* our-a hot-a BREAKFAST!' On another occasion, years later, we would be running the remotest camp in East Africa and we would deal with another irate Italian, who would get terribly upset if his pasta was not al dente. I would have to try to explain to a very rural cook that he would need to cook the pasta so that it was soft but still firm.

For the most part, though, everyone in a safari camp gets along and sometimes surprisingly well, given the challenges of different cultural norms and language barriers. Working in the safari industry was like having a ticket to visit the nations of the world.

With food being such a big part of the safari culture, over the course of our time in the industry we shared many a meal, and delightful conversation, with people who arrived as strangers and became friends. Most would leave after only a few days, either going back home or on to another camp somewhere else. It isn't easy to keep up friendships where time and distance, combined with remote settings, make it difficult to stay in touch. The lifestyle of a safari guide or camp manager is unusual in this respect, even bizarre. It's sociable, entertaining and gregarious. You meet and interact with wonderful people and share your life and incredible experiences with them. Then that group is whisked away and replaced

by a new one, new strangers who become friends. And then the process starts all over again. You may be surrounded by people, but you can also feel very alone.

Having Claire with me at Mashatu was so important to me. I enjoyed her company enormously, the more so when I compared the richness of companionship to my lonely days as a wilderness trail guide. I loved sharing my love of the bush with her and seeing things through her eyes. She developed a special love for the small creatures in and around camp, and TK had many. There was a pair of francolin that we used to feed muesli to, and there was a warthog family that would mow the lawn for us. We also had a genet, which, although it looks like a cat, is more closely related to a mongoose. Our genet pet was particularly partial to the homemade crisps that we served as a bar snack. As soon as we had all moved through to the boma for dinner, he would climb down the boer bean tree and devour any remaining crisps. The old barman, Richard, would stand quietly watching the genet from behind his bar counter.

During our time managing TK we lived in the pilot's room, which had shade cloth for walls and an old thatch roof. The bathroom was alfresco and although it was delightful to shower beneath a leadwood tree and under the starry sky, in wintertime we absolutely froze. It didn't help that we had squirrels which seemed to have a fetish for soap, so every shower began by first trying to locate the bar of soap, which, when you found it, had toothmarks around its edges.

While Claire loved all these camp 'pets', Mashatu is most famous for its elephants and I wanted her to experience seeing the world's largest land mammal, on foot. One afternoon, after the guests had left camp, I took her for a walk upstream from camp. I knew of a remaining pool of water that the elephants were drinking from and, as luck would have it, there was a breeding herd drinking when we got there. Spotting them from a distance I briefed Claire on what we were going to do, explaining that I was going to lead her to the edge of the stream where we were going to sit on the rocks and watch the elephants. 'There is just one very important thing. We must not say anything, not a single word or whisper, okay?' She looked nervous but before she could chicken out, I took her hand and led her down towards the rockpool. We crept closer, hunched over to hide our

human shape, and trying to avoid any dead twigs or leaves so as not to alert the elephants to our presence.

It worked brilliantly and soon we were sitting on a rock less than 20 yards away from a wild breeding herd of elephant, who did not know we were there. I was especially chuffed as Claire was enjoying a wonderful elephant experience. As the minutes passed, Claire slowly eased her grip on my hand and started to relax. Unfortunately, she relaxed a bit too much and, leaning over, she whispered to me, 'Tuskless.' The Tuli Block is well known for its tuskless gene but the problem with Claire's utterance is that even whispering this word, it sounds loud. As soon as the fateful syllables left her mouth, the elephant herd went into a panicked frenzy. They had heard a human, but didn't know exactly where. The females trumpeted and swirled the babies into the middle, lifting their heads and extending their ears forward. They were on high alert. We were right under their noses. Too close to move off.

Claire jumped up to run but, grabbing her arm tightly, I kept her firmly at my side. Gently raising my finger to my mouth, I motioned for her to keep silent. She squeezed my hand again. I was a little bit concerned when, looking down, I noticed that my fingers were going red. The next few minutes were utterly terrifying as three elephant mothers approached us in the twilight, their heads held high, their enormous ears out, making them look menacing in the extreme. Their eyes bulged in anger as we sat there, quiet as two mice, held our breath and waited. Slowly the three grey masses before us turned, on stiff legs, and their wrinkled bodies became indistinguishable grey blobs as they followed the rest of the herd back into the mopane bushes.

One of the TK guides was Dan, truly a one-of-a-kind safari guide. One day he had a particularly gullible group of tourists on the back of his safari truck when the radio call came through that lions had been found on a wildebeest kill. The message came to Dan in Setswana via a sneaky ear-piece that he had in one ear. Giving nothing away, he continued driving,

winding his way along the dirt tracks. After a sufficiently long period of time and when all the other safari trucks had cycled through the lion sighting, Dan pulled over next to a pile of old giraffe bones. In a voice of utter frustration, he exclaimed to the tourists on the back, 'Eish, today I am having no luck and we are seeing nothing! But in my culture we communicate with our ancestors through the bone throwing ceremony. My great-uncle came from these parts – he can tell me where to find animals.'

Squatting on his haunches above a giraffe femur, Dan began chanting. Grabbing any bones that were within reach, he threw them about like a man possessed. After a sufficiently long period of bone throwing, he paused, then listened, and said, 'The lions ... the lions are hungry ... my uncle says they are feeding close by!' After some more bone tossing, more leg stomping and more pregnant pauses, he leapt back into the driver's seat and yelled, 'My great-uncle says the lions have killed a wildebeest!' A couple of minutes later, he rounded the corner and, sure enough, there the lions were, eating a wildebeest.

Dan was no amateur, mind you. He was a master prankster, able to keep such a straight face that he once even tricked a very astute South African photographer by the name of Shem Compion. Shem and Dan were on a safari drive and they stopped for sundowners on top of a hill. Shem noticed distant lights on the South African side of the border and asked Dan what they were.

'Eish, Shem,' came Dan's concerned reply. 'Those lights are from the diamond mine and they are causing a big problem, man.'

'How so?' asked Shem.

'Well, the lights stay on day and night, and at night they attract all the mopane moths. They fly across the border and die there. Now my people have nothing to eat!'

The caterpillars of these moths are an important source of protein to the local people in the area. Knowing this, when he got back to Pretoria, Shem took the matter up with the ecologist of the diamond mine, who happened to be a good friend of his. It was only when he saw the expression on the ecologist's face that he realised he'd been pranked. Dan even got me once when he told me that there was a project on the go in Botswana to crossbreed eland with cows. He was so convincing as to the merits of this

project, which he listed as being an increased meat yield, better milk production and higher resistance to disease that I was slowly convinced. When I asked how they do this he went into great detail about how they pen an on-heat eland cow with a mature bull. Once Dan saw that I had bought his story he then asked me, 'Do you know what we are calling the offspring?'

'No Dan, tell me?' I enquired.

'E-cows,' he said with a straight face. He had got me!

One night I was sitting around the fire with Dan and his guests after their day on safari. After a lull in conversation one of the guests broke the silence.

'It is just so awesome how the animals work together,' he said.

'How so?' I asked.

'Well, you know, Greg, today we found an impala in a tree and Dan was explaining to us how the giraffe helps the leopard out, how it puts its kill in the tree.'

'Um, er, yes ... incredible, isn't it?' I murmured, my eyes seeking out Dan, who sat in the dark in silence, his grin betrayed by the flickering of the campfire.

26

The crunching of leaves

Another role of mine when relieving at TK was to oversee the camp maintenance. Since this was not my strong point, I would usually just report any problems to headquarters, who would then send Dennis up, who was the general maintenance guy and mechanic for the reserve. But sometimes the nature conservationist in me would insist on fixing a leak immediately, without waiting. The reason for this was because Dennis knew each camp's menu off by heart, and he was particularly partial to chicken pie. It was uncanny how he would arrive in camp to fix things on a Sunday at around about lunchtime, just when the chicken pie was coming out of the oven. We would always make the most of the opportunity to get things fixed and we made sure he always got his piece of the pie, so to speak.

A jack of all trades is indeed the master of the bush. Dennis was worth his weight in gold, and he knew it. Always with his blue overalls on, sporting a patchy beard that looked like it had been partly fed on by a mouse, and dirty glasses, he was a tall man who carried his pot belly proudly before him.

One day when walking along a pathway in camp, I spotted a patch of wet earth. This indicated a leaking pipe, but it was only Monday. 'By Sunday we will have wasted too much water,' I muttered to myself, knowing that only a chicken pie would get Dennis to come up for a little leak. I turned back, went to the shed and grabbed a spade and a hacksaw. Digging around the pipe, I soon had it exposed, but as soon as I began sawing into it with the hacksaw blade, I realised that I was dealing with no ordinary plastic pipe. This pipe was high-grade, industrial-strength. It was too late, my blade pierced through the pipe's wall and a fountain of water spurted forth. I sprinted back to the storeroom to look for an industrial-strength coupler but there wasn't one.

I dashed back to the leaking pipe, where the fountain was now squirting almost eight metres into the air. I calculated that the leak would drain the camp of all its water in a matter of hours and we had a full camp of guests. Stripping down to my boxer shorts, I leapt into the fountain and began wrestling with the piece of pipe, probably looking not unlike Steve Irwin with a poisonous snake. So engrossed was I in desperately trying to get a regular hose clamp to work a miracle that I had not heard Pete le Roux pull into camp. It was only when I heard someone clear their throat behind me that I saw him standing there. Pete was the operations director of Mashatu and my very big boss.

Slowly I released my grip on the pipe. I could feel my wet, now half-see-through boxer shorts clinging to my thighs.

'Um, hi, Pete,' I said, as casually as possible, wiping the water from my face. 'Got a bit of a leak here.'

'You've got a hell of a lot more than a leak there and you're draining all the water from the tanks. We're going to need to courier a coupling in, all the way from Polokwane!' said Pete.

The camp had no water for two days, although blaming it all on the elephants seemed to make the guests slightly less grumpy. That Sunday, long after the leak had been fixed, Dennis arrived. Damn him and his chicken pie radar, I thought, as I walked up to his beat-up old Land Cruiser. I told him the camp was in tip-top shape and that there was no need for him to even get out of the truck.

Plumbing was really not my strong point. On another occasion, yet another pipe sprang a small leak and this time right where it passed beneath the electrified elephant-proof fence. I walked to the other end of camp to fetch a hacksaw, clamps and a screwdriver, then returned to the leak, tools in hand. Crucially, I realised I had forgotten to switch the energiser box off, which was supplying about 8 000 volts to the fence. I stood looking at the leak, understanding that I would be dangerously close to a live wire when fixing it. I contemplated walking all the way back to the storeroom to switch the fence off but decided against it. Come on, Greg – just be careful, I told myself as I began sawing through the pipe. When I cut into the pipe, I got thoroughly soaked. Now dripping wet, the danger stakes had been raised and I still needed to replace

the leaking section. I managed to insert the new length of pipe and, feeling chuffed at not having electrocuted myself, I was tightening the last hose clamp when my wet screwdriver slipped out of the groove and I fell face forward into the fence. With wet skin, much thinner than an elephant's, I got a jolt that threw my body into a contorted spasm and launched the screwdriver into orbit. I had learned the lesson that every electrician only learns once: always switch off the power supply! I never did find that screwdriver.

Tent Camp was less busy than Main Camp and this meant that I could spend more time photographing, but my longest lens was a 300 mm, which made it really difficult to photograph birds. I came up with a way to get closer. This involved a stepladder and, although cumbersome, it worked quite well. There was a fever tree in camp where a pair of red-headed weavers were feverishly building an untidy nest. The male was in full breeding plumage and with his bright red face set against and juxtaposing the Africa-blue sky, there were the makings of an epic photograph.

Placing the stepladder under the tree and climbing to the top rung, I eventually got my shot of the weaver. Whenever I walked around camp with a ladder, everyone thought I was a very diligent camp manager, looking for things to fix, but I was in fact just being a diligent wildlife photographer looking for subjects. There was a little waterhole in front of TK with a hide but it was too far from the water for my lens, so I resorted to standing, not moving for hours on end, inside a mopane bush that grew on the water's edge. Pied kingfishers would land sometimes only a few feet away, and my 300 mm was then enough.

Claire and I were due our leave. We drove down to the Pont Drift border post and across the Limpopo River to where Claire's little blue Ford was parked. We noticed immediately that there was a massive dent in the driver's door. In fact it was concave. Feeling pretty miffed that someone had reversed into our car, we walked to the South African border police station and reported the incident. The officer who accompanied us back

to the car was quite excited. Waving a finger in the air, he exclaimed, 'This was a hit and run, okay, lady, but not an ordinary one. No, no, no siree. This here damn damage is from an elephant.'

'Um, an elephant?' we asked.

'You, sir, why did you park here, on this spot, exactly why, sir?' the officer enquired of me.

'For the shade of the big tree,' I said, rather annoyed. It had seemed like an obvious place to park.

'Yes, sir, this tree is lovely, big and green, is it not? But it gets even lovelier big bright orange flowers and elephants, sir, they like them. No, no, no, in fact, they love them!' said the officer.

As the truth sank in that an elephant, in its attempt to eat the flowers, had casually leant into our car and buckled the driver's door, we drove back to Pretoria wondering if the insurance company would buy the story.

The next day, early in the morning, I drove to Prolab, my local camera store. I was anxious to get my film developed. I noticed a promotional poster in the big glass windows advertising a special for a Nikon N65 and a 70-300 mm lens, with a Nikon camera bag thrown in. Standing at the shop's window much like Wayne in the movie *Wayne's World*, I exclaimed, 'She will be mine, yes, she will be mine.' But I had only enough money to get my film developed. After I had dropped off the film I spent the rest of the day dreaming about the Nikon special.

Later I collected the developed film and studied the results carefully. They were good but I had become a lot more fussy than when I had begun photographing in Hluhluwe. I paged through the sheets of slide film until I got to a series of a lioness in golden light that I had photographed not far from camp. I was hugely disappointed to discover that the images were not sharp, at least not to professional standards. I was especially disappointed because I knew that I had done everything right in camera. This was the first time I realised that camera equipment is an important part of the photography equation and pivotal to success. I now not only desired the Nikon that was on special – I needed it.

In a fortunate turn of events, the insurance company paid out for the elephant damage and I promptly placed an advertisement in the newspaper offering my Pentax MZ30 for sale, together with my Sigma lens kit.

I sold it pretty fast and handing it over to its new owner I knew it would be a camera I would never forget; it was my first, after all. After that it was easy. Deciding to spend the rest of my salary, I drove back to Prolab where I bought my very first Nikon. I also wanted to shoot only professional slide film and at R100 per roll, I could only buy three. I would need to choose my frames carefully. But the main thing was that I had a Nikon and there was a definite spring in my step when Claire and I arrived back at Mashatu for our next stint.

Cycling had become a very popular activity at Mashatu – we referred to it as 'Meals on Wheels', which wasn't a statement too far from the truth as cyclists would sometimes get chased by elephant. We enjoyed it when a cycle group was in camp because they would spend one night sleeping out in the bush in a remote part of Mashatu on the Motloutse River. Our job would be to go ahead of the cyclists and set up a temporary camp. We would have to not just pack the kitchen sink, but the cooks too! The area where we set up camp was called the Kgotla and driving there was an absolute delight. The sky was invariably blue, as it is in Africa, and warm gusts caressed our cheeks as we drove far west in an open-air safari truck. The feeling of freedom was simply glorious, especially after being cooped up in camp for weeks on end. Before we could cross the veterinary fence we would all have to get out and dip our feet in pesticide to prevent the spread of foot-and-mouth disease, before continuing west.

The bush is different on that side of the reserve and it feels wilder. The topography also changes. Huge sandstone koppies rise out of the sandy soil. On top of one of these koppies is an ancient baobab tree, one that had none other than Cecil John Rhodes' signature carved on it. Standing beneath this baobab at sunset, the Botswana hinterland stretches out before you, a canvas of unfathomable beauty and mystery. Under the large boulders on the same rocky outcrop you will find a very special and peculiar little creature, the rock elephant shrew. These tiny rodents, which weigh only a few grams, have a long trunk-like nose that's forever twitching. They have such a fast metabolism that they dash about like greased lightning, causing you to wonder if what you just saw was perhaps a figment of your imagination.

A large tomcat called those same rocky hills his home and I once spotted

this leopard running on top of the cliffs, hunting another peculiar creature. This was the rock hyrax or dassie, as they are commonly known. Although this animal looks like an overgrown guinea pig, it is in fact one of the closest terrestrial relatives of the elephant. Neither has a gall bladder and both have internal testicles and modified incisors, which in elephants we call tusks. In amongst the sandstone cliffs there are also ancient relics and artefacts of early human settlements and, if you look carefully, you can even find old beads made from ostrich egg shells.

Turning off the main road, we would travel across plains filled with the delightful scent of wild sage, pausing for herds of kudu, impala, wildebeest and eland. Jackal and warthog seemed to love the area too, as did the elephants. As it winds its way towards the river, the road enters a flood plain where the deep soils and an abundance of subterranean water give rise to the most incredible woodland. Most noticeable here are the gigantic mashatu trees. They are about 150 years old and always called to mind for me Enid Blyton's Faraway Tree. The road finally ends at one such gigantic mashatu tree and this was the location of the Kgotla – a traditional boma for court hearings in Botswana and made from leadwood stumps placed in a circle. We plonked stretcher beds beneath the tree and made sure the donkey-boilers were lit, so that the 'Meals on Wheels' brigade would have hot water when they arrived. I would start a fire and the cooks would get busy making an oxtail potjie. Once the camp was taking shape, me and my camera would head off into the bush for a walk.

Wandering from one mashatu tree to the next, I picked up a small green berry the size of a large peanut. I pondered the mystery of how such a small fruit could produce such a gigantic tree. Termites have something to do with it because almost every mashatu tree grows on top of a termite mound. The termites that live in these mounds lack pigment in their skins and for this reason they only come out at night to forage for dead grass. They collect more grass than is consumed by all the other animals combined, and take it down to their mounds, where they use it as a fertiliser to grow mushrooms. These mounds reach all the way to the water table as the termites fetch water to irrigate their fungus gardens. They also keep the mounds at a constant temperature and humidity – the perfect environment for a mashatu seed to germinate.

A mashatu tree is the ultimate mansion for a leopard and I often found the remains of a kill in their arched boughs. Following the Motloutse River, I would pause at the drying river pools to investigate tracks. Lions loved the area too and this made walking through the dense bush a little bit more exciting. The western side of the river was home to a pair of black eagles. These majestic and regal birds would soar close by overhead as I walked along the ridge, using the updraft created by wind rushing up the cliff face. I once peered down at the nest and to my delight it had a chick in it. Raising a chick successfully for this pair of eagles was a really tough challenge as the resident troop of baboons frequented the same cliffs and relished the taste of eagle eggs. The black eagle, now called the Verreaux's eagle, is the eagle of eagles!

Sneaking up on an elephant mother and calf one afternoon proved a little too nerve-racking so I continued north to an area called the Amphitheatre, which consists of a small piece of bush encircled by sandstone. Although the rock is as hard as cement, ancient elephant pathways can be discerned here, like weathered veins of time, running over the top of the rock. I spooked a warthog boar once and the clippety-clop of his retreating hooves echoed in the amphitheatre. The mood in the Amphitheatre was enchanting, as were the nights spent at the Kgotla.

After a hot day, once the cyclists were all finished dinner and in bed, I would take an alfresco shower beneath a tall apple-leaf tree, whose slender crooked trunk seemed to reach all the way up to the Milky Way. Hot water washing the dust off made me realise that the greatest joys in life often come from the simplest pleasures. Camping in the bush is always a good reminder of this. With no tent and not even a mosquito net separating us from wild Africa, I lay on my back looking up into the boughs of the ancient mashatu tree, gently illuminated by the flickering flames of the campfire.

Lions often roared in the area and on more than one occasion these roars came from both sides of the camp as the resident lions communicated (or argued) with one another. The sawing sound of a leopard's cough was also often heard, as well as the persistent 'prrrrp' call of the small African scops owl. Stars twinkled from behind the delicate leafy veil of the mashatu tree. In the fresh air I usually slept really well – except for the time I heard the crunching of leaves underfoot. At first it was distant, but

then the crunching got closer and closer; so close in fact that I simply froze up, stiff as a corpse.

It was when the crunching of leaves stopped that I realised the beast, whatever it was, was standing right behind my head. I heard it sniff the air, taking in my scent, and the hairs on the back of my neck stood up. It was too late to reach for the rifle which was standing against the trunk of the mashatu tree a few metres away. For a few deathly silent moments I waited, wanting to scream but not able to out of sheer fear. The beast sniffed again, then again, and after what seemed like ages, I thankfully heard the crunching of leaves again.

The next morning, after shaking out my vellies, I snuck past the sleeping bodies of weary cyclists and stoked the still-glowing mopane coals of the campfire. Rummaging in the dark for bits of leaves and twigs to place on top of the coals, I gently blew over them until flames burst into life. I then made a cup of coffee and spent the last hour of darkness alone with my thoughts. There is no finer hour to be spent alone anywhere in the world than the hour before dawn breaks in the African bush. With the twinkling winter constellation of Scorpio now on its way to bed, the inky black night sky slowly turned a rich pre-dawn blue. The last nocturnal sounds of crying jackal could be heard on the distant plain and the snorting of impala meant that a leopard was slinking off somewhere. The coarse grunts that occur at the end of a lion's roar were barely audible and the piercing whistles of pearl-spotted owlets, and the deep grumpy moans of the Verreaux's eagle-owls gradually gave way to the gentle cooing of doves and the whistle of the Kurrichane thrush.

The warmth of the campfire, the aroma of coffee and the glowing dawn of another bushveld day made me feel very grateful to be alive. As soon as there was enough light I went to inspect for tracks, to see exactly what type of creature had sniffed me, but the carpet of leaves was too thick. There were no tracks that I could discern. And still to this day I have no idea what sort of beast stood above me that night.

27

Disappointment Koppie

The word 'work' is an interesting one for a safari camp manager as work can mean quite literally anything. On one occasion a young elephant bull had taken advantage of TK being empty and when we were all sleeping out at the Kgotla, he enjoyed a night of feasting on the succulent trees there. Arriving back from the sleep-out, it looked like a bomb had gone off. It seemed the elephant had had quite a party – there were broken tree branches strewn all over the place. Thankfully, the camp's water supply was still intact. The elephant bull was, however, still in residence and it was my job to get him out of camp before another night of destruction ensued. But how does one remove an animal that weighs a few tons?

First I tried talking, then I tried talking and clapping my hands, but I was simply ignored. A new strategy needed to be devised. I summoned a few other staff members and we walked together in a line, talking, clapping and waving our arms in an attempt to herd the elephant towards the gate at the back of the camp. I stationed Claire at this gate. It sounded like a simple plan but an elephant is an incredibly intelligent animal, and this one saw through our plan in no time. He allowed us to move him towards the gate but just as we felt like we were getting the upper hand, he would trumpet past us and back into the lush camp. Of all the many experiences I have had with elephants this one stands out as a prime example of how intelligent and stubborn elephants can be.

Finally, just as it was getting dark, and with the help of the cooks banging on frying pans, the elephant decided that the treats in camp were not worth the harassment and he slunk through the gate where Claire had been patiently standing all this time. He tiptoed past her like a naughty child and she shut the gate behind him.

The older staff members at TK told a frightening story of some camp invaders that had happened a few years back. A couple of guests enjoying

an afternoon siesta in their tent were rudely disturbed by a zebra charging straight inside it. They were even more disturbed when the zebra was followed by the lions that were chasing it. To be more specific, the zebra ran through their tent and into the bathroom at the back. With lions circling and the zebra hiding in the loo, the guests lay in bed stiff with fright. Fortunately, my worst days at TK didn't involve lions but I did need to remove a Mozambique spitting cobra or two. Trying to coax one of these snakes out of the dining room one afternoon, I learned the hard way that these cobras can spit without rearing up, and through only partially open lips.

Back at Main Camp we had a different kind of camp problem in a stubborn visitor who declined to leave. This occasion saw me ordering a boxload of fireworks from a supplier in town. The supplier asked if we were sure we needed fireworks – it was nowhere near Guy Fawkes night and there was a question of availability – but I told her it was a matter of urgency. The fact was we had a rogue baboon on our hands. Mr Baboon, as we called him, was a specimen of monstrous proportions and he was proving to be a serious problem. His favourite trick was raiding the dustbins behind the kitchen. Standing behind a door with a cracker in one hand and a lighter in the other, I waited for him to show. The kitchen had knocked off and so had the staff, so the camp was eerily silent as I stood doing the 'work' of a safari camp manager: standing behind a door with explosives in hand waiting for a baboon. An interesting line to add to my résumé, I thought.

One Sunday Claire and I decided to go for a safari drive. Driving out of camp, I turned immediately right, where a small two-track road wound its way down the rocky hillside and into the Majale River, with its characteristic black basalt sand. The river had stopped flowing and was now a series of drying pools. There were a couple of hyena around one pool and the light was getting good. Shooting on slide film had taught me the single greatest lesson in photography and that is that it is all about the light!

After photographing the hyena, we continued driving along the riverbed, meandering through beautiful bush country and cliffs adorned with candelabra trees.

The track climbed out of the riverbed and took us beneath ancient leadwoods and tall apple-leafs, the woodland towering above us, before opening up again onto plains dotted about with shepherd trees. A herd of eland disappeared over the ridge ahead of us as we found our way back into the river and past an incredible specimen of a rock fig, its pale green roots cascading down the rockface. Passing another pool at Hamerkop Crossing, we saw a pair of gigantic saddle-billed storks pacing up and down, scouring the pool for fish. I have always felt that these birds belonged on a cereal box, what with their gigantic red and black banded beaks, and long legs with pink 'knees'. A hamerkop stood patiently on the edge. This peculiar bird has a head the shape of a hammer as is suggested by its Afrikaans name. Not having an English name to go by, the hamerkop is in a family all of its own and quite a birding conundrum in general. It builds a bizarrely massive nest that can take the weight of a human standing on its roof. In Zulu traditional culture this bird is considered an bad omen.

A little three-banded plover dashed up and down in the shallows, running forward as if trying to balance its round body on top of its little toothpick legs. The light was getting better and better, and so my foot began to rest more heavily on the throttle. I desperately wanted to find a suitable photographic opportunity. We passed by a couple of large mashatu trees where the smell of baboons signalled that this was what was referred to as 'the baboon's bedroom', a clump of trees where a large troop of baboons chose to sleep each night. Meandering through a Croton forest, we were looking for leopard but there were no monkeys chattering and a large flock of guineafowl or 'government chickens', as one ranger called them, also seemed relaxed. Both were signs of there being no leopard in the area. Slowing down at every huge mashatu tree, we scanned the boughs in search of a lazy cat, but without any luck.

The road followed the eastern bank of the river and we passed another mashatu tree, called Church Tree on account of the Sunday morning services the local people held there. The water had cut into the river bank at this point and, looking down into the river below, there was a pool

where, even in the bitter dry season, water could be found. This pool was the ultimate waterhole, providing water for creatures as big as elephants and as small as mongooses. The water also gave life to a beautiful grove of albida trees. These trees are unique in that they do everything in reverse: they lose their leaves in summer and in winter they stand out like tall green umbrellas. In South Africa we call them 'Ana trees', derived from the word 'ander' meaning 'different' in Afrikaans. In Zimbabwe they are known as 'winterthorns' or 'apple-ring'. Their seedpods look like the peels of skinned apples when they drop down at the end of winter. These pods are rich in carbohydrates and provide a vital source of food to all animals, and at a time when they need it most.

We then passed a breeding colony of white-fronted bee-eaters, their excavated holes consisting of long tunnels with a chamber at the end where the egg is laid. The chamber has a lip to stop the egg from rolling out. The birds sat perched on tree roots growing out of the river bank and cocked their little heads skywards as they scanned for bees. Leaping off the branch, they fly high into the air, a flash of dazzling blues and greens before landing back on the branch. These little birds remove the sting of the bees before swallowing them, and bee-eater chicks need to be taught by their parents to remove the sting. Claire and I sat beneath the bee-eater colony listening to their strange plaintive nasal calls, bedazzled by their blue, green and russet coloration, all offset again by a bright, brilliant blue African sky. The light was crisp, but my 300 mm lens was way too short to shoot bee-eaters.

The Majale Island pride were next on the list of potential photographic subjects. As we drove onto the island, the wild sorghum grass towered around us, giving us the feeling of being in an Indiana Jones movie. Their ranks offered excellent cover so this was the favourite place for the lionesses of the pride to give birth to their cubs. The area had an abundance of general game. In years to come when the pride was moved out of the area by the arrival of two new male lions from Zimbabwe, the females would still return to the island to give birth as this was where they themselves had been born. Having had no luck with lions, we turned around, passing through dusty plains where impala jostled and rollers perched on dead stumps. Our sojourn took us back into the narrow riverbed that is the Matabole River.

Following the river upstream we passed through more dense woodland. A brown-hooded kingfisher alighted from its perch and the drumming of a woodpecker was audible, even over the engine noise. Not quite sure where I was, I was relieved to pop out of the bush just to the south of Disappointment Koppie, a hill I recognised. This grassy knoll had been given its depressing name by Pete. As a young student doing leopard research, he had witnessed leopards mating on top of the koppie and took photographs of this unusual sighting. It was only when he was back at camp that he realised he had no film in his camera. Thirty years later the hill was still called Disappointment Koppie.

Finally, on the southern side of Disappointment Koppie we found a large herd of elephant and just in time, for the sun was about to set. The scene was magical. Dust lingered in the air and the world about us had turned the colour of golden honey. The matriarch and her herd were all enjoying the leaves of Salvadora bushes and the young baby elephant, not yet able to use their trunks to pluck leaves, were wandering between the legs of their mothers, clumsily swaying from side to side, not quite sure exactly where to find the milk. The last rays of the day caressed the dusty landscape that is the Tuli Block of Botswana (the word 'tuli' means dust). Wanting to photograph the scene in front of me, I felt a surge of calm adrenalin.

Out of the corner of my eye, I saw a young elephant, about one to two years of age, walking away from the herd. I knew what he was up to. He was going to spread his little ears out wide and mock charge our vehicle, to try and show us how big and scary he was. Without thinking about it, and without consulting Claire, who would have tried to talk me out of it, I slipped out of the driver's seat and crept around to the front of the car, where I sat with my back against the bull bar. Sure enough, the little elephant raised his head, stretched his ears as wide as he could and ran forward to within a few metres of where I was sitting. Bringing his charge to a halt just a few yards in front of me, a small plume of dust rose as he lifted one little leg into the air. He reversed back again to have another go, and I poised my camera, ready to capture his next charge. He came running in just like before and I hit the shutter button. But – there was no click! My camera was silent.

Looking down in panic, I saw the flat battery warning light flashing.

As the little elephant reversed again, I slipped back around the car to fetch new batteries from my camera bag, but by the time I had loaded the fresh ones, the sun had dropped below the horizon and the elephants had moved off. The moment was gone! An eye-level shot of a baby elephant charging, in golden light with pixie dust sprinkled in the air is the kind of shot photographers dream about. And to make matters worse, at Mashatu I hardly ever got out of camp.

I had just blown my shot, a potential award-winning shot at that.

I slumped back into the driver's seat. Claire felt sorry for me but there was nothing she could say to lift my spirits. It seemed fitting that we drive up to the top of Disappointment Koppie for a sundowner, before heading back to camp. I had suffered my first photographic defeat. It seemed like a cruel blow but, as I would learn, such defeats are very much part and parcel of the life of a professional wildlife photographer – a career I wanted now more than ever.

28

Have you seen the president?

There is almost never a dull moment in Africa and the saying 'only in Africa' is an expression used often, and for good reason. The Tuli Block was at the time famous for its horse riding trails. Billy Colesky was the horse guide and he was a cowboy, in the old Wild West sense of that word. He was tall and lean, with squinty eyes, long brown hair and a thick beard. With a handkerchief always around his neck, long trousers and cowboy boots, he could have fitted perfectly into any Western movie. Billy would pop into Main Camp from time to time (actually quite often) to buy booze, which he always claimed was for his horse safari clients. If that was the case, then they must have been riding inebriated most of the time.

Horse riding in the Tuli was only for experienced riders as the horses would often get spooked by elephants and bolt off in all directions. If you could not withstand a wild gallop over logs and under thorn bushes, you would inevitably fall off and the consequences would be too dire even to contemplate. Billy's biggest nightmare wasn't the elephants, however. The lions had taken an interest in the horses and had begun stalking them, with the riders on their backs. To solve this issue Billy carried a large bullwhip when he rode, and when he saw the lions starting to get into a hunting formation, he would crack his whip loudly. That would at least keep the lions in a crouching position, buying the riders valuable time to put some distance between their own horses and the cats. Once the riders were sufficiently far enough away Billy would gallop off, often with the lions now in hot pursuit of his horse.

The horse trails were in many ways an accident waiting to happen. One evening we got a radio call at camp to say that Billy had a party of inter-national riders, and that neither he, nor any of the riders, had returned from the day's riding. We promptly sent out every spare ranger and truck that we had, but we had no idea where to begin looking. After driving

around for four hours without any trace of the riders, the radio was abuzz with talk, everyone trying to predict where the riders and their horses could be. The hour was approaching midnight. Little did we know that the riders had accidentally crossed the border into Zimbabwe and were thoroughly lost. Billy and his riders were now in a world of trouble for it was a moonless night and they were huddled in a tight circle in the dark, somewhere in Zimbabwe.

With lions on the prowl, this was a potentially life-threatening predicament. Billy's idea of a solution was to leave his foreign guests alone, leaving his rifle with them, and rely on his horse's sense of direction. Letting go of the reins, he told the animal to go home. Sure enough, the horse found its way through the black of the night and took its rider all the way home. Billy had not wanted to risk taking the group through the bush at night as the chances of bumping into lion were greater than if they stayed put in one place – or so went his thinking. This, however, culminated in a very embarrassing situation as the guide was now safely back in camp and his guests were, well, lost. And not just lost but lost in another country!

Finally, in the wee hours of the morning, one of the search vehicles heard a rifle shot from the Zimbabwe side and driving into the bush, the guide found the riders, off of their horses and cowering together in the dark. Fearing for their lives, they had fired the rifle into the air for help and luckily for them, it had worked. With the frightened foreigners on their way back to camp in the back of a safari truck we all masked our profound relief by joking about how awkward breakfast would be in the horse trails camp later that morning.

Most days things in Mashatu ran smoothly enough, but even just sitting at one's desk doing paperwork, which I tried to avoid at all cost, anything could happen. One afternoon I was planning the ranger roster for the next day when an owl of the pearl-spotted variety swooped down and killed a lizard on my desk. Spatters of blood landed on the roster sheet. Fortunately, my camera was never far from me; living and working in the bush a photo opportunity can arise at any given time – even when doing paperwork. On another occasion I was at my desk when a large rock monitor sauntered in, walking through the door like he owned the place.

Brunch times in camp were always a very good way to chat to the safari guests and to find out if everything was okay with their stay, in general. Over the course of the meal I would enquire casually as to how their safari drives were going and if everything was okay in their rooms. I had learned that it was better to fix any problems rather than wait for a complaint to arrive in the guest feedback form. On one occasion the reply I got from asking these simple questions had me somewhat flummoxed.

I asked a Canadian woman who was leading a tour group if everything was all right in her room. She replied in the affirmative, but then went on to say that a strange man in a trench coat had slipped into the bed beside her in the night. She screamed and the man calmly got up, apologised and left. Not thinking any more of it, astonishingly, she went back to bed.

Nevertheless, I needed to investigate this strange story. We learned that the night watchman, a very old fellow called Johannes, had developed a habit of sneaking into room 16, which was reserved for pilots and guides, for some shut-eye. We had no keys at Mashatu as there was no need for them but, unluckily for Johannes, and for the Canadian woman staying in room 16, he had read the occupancy board wrong and had jumped into what he believed was an unoccupied bed. Poor old Johannes had been at Mashatu so long we joked that he had planted the baobabs in the Tuli Block. It was impossible to be angry with him as he was quite the character. He was fluent in Afrikaans and wore his long trench coat and thick heavy army boots even in the height of summer. With a beanie on his head pulled low and a walking stick in his hand, he would patrol his territory, muttering to himself. Rather like a piece of familiar furniture, he was old, worn and loved. His job was simply to be around at night should an emergency arise.

When on safari and asked how you slept, it was a standard safari joke to reply, 'Excellently, like a night watchman!' It was not that Johannes did not take his job seriously, though. Camp legend had it that one night when bushfires were raging down closer to the border and their orange glow became visible on the horizon, he ran through camp screaming for everyone to take cover because 'die boere, hulle kom!' The Boers fought their last war in 1899 so Johannes's outburst got everyone wondering just how old he in fact really was.

Lloyd was going on annual leave and so I was to be the acting camp manager for the month. It was an important month, too, as not only were the shareholders holding their AGM at Mashatu but the vice-president of Botswana, General Khama, would also be visiting. Going through the booking sheet we noticed that a guest by the name of Paul Purcell had been flagged as a VIP. Investigating further, the booking office told us that Mr Purcell was booked in as a VIP US military general. This seemed like a strange thing to place on a booking sheet, especially for someone going on a safari holiday, and when the general arrived in camp, we were all relieved. He was about 70 years of age and did not mention anything about being a general in the US army.

Mr Purcell seemed pleasant enough and behaved much like a normal tourist. I hosted him for lunch on his first day and everything was going smoothly. But on his second night in camp things took a very strange turn. I was standing in the Gin Trap hosting pre-dinner cocktails, everyone chatting away, when I spotted Mr Purcell walking down the stairs that led into the bar. I could not believe my eyes. He was wearing a business suit, complete with a striped blue and white tie and a little American flag pinned to his chest. His entire demeanour had changed. He strode into the bar with a confident swagger and accosted Percy the barman: 'Has anybody seen the president?' Percy, not understanding, thought he was asking for a cocktail called 'the president' and rushed to the back to search the index of the Bartender's Bible. While he was doing this, I approached Mr Purcell and asked if everything was okay. 'Yes, thank you, Greg,' came his very formal reply. 'I am just waiting on the president of Botswana. Has he arrived yet?'

Scrambling in my head to put the pieces together, I remembered that General Khama was arriving the next day and that Mr Purcell had booked in as a VIP military general.

'Um, Mr Purcell, the vice-president arrives tomorrow,' I stalled, aware of sounding unsure of myself. 'Do you ... um ... have an appointment with him?'

I was certainly not prepared for his answer.

'Of course I have an appointment with him, boy!' he exclaimed loudly in his broad American twang. 'Why the hell do you think I am here?' Before I could begin to process, he went on, 'I'll tell you why, sonny! I am HERE to discuss the assassination of the president of Zimbabwe with the president of Botswana.'

Mashatu shares a border with Zimbabwe and General Khama was the vice-president of Botswana at the time and head of the military. He also travelled with a small army and he was arriving the next day. I was in a state of semi-shock; this situation was way above my pay grade. Realising that Mr Purcell was indeed a VIP, I hosted his table for dinner that night. He was like a different person; his entire persona had changed, along with his accent, as well as his preferred topic of conversation. He no longer spoke about the animals he had seen. All he wanted to talk about was military weapons. After dinner he rose to retire to bed and I rose alongside him, bidding him a good night. As he turned to walk out, he said, 'Greg, please take care of business tonight because I don't want my bodyguards waking me up again in the middle of the night.'

Bodyguards? I had not seen him arrive with any bodyguards. Stuttering slightly, I queried, 'Wawawhat bodyguards, Mr Purcell?'

'Bashi and that other little man who lost his arm in the war. They woke me last night to say that there were black men running around the woods,' came his stern reply. Then he turned on his heel and marched out of the boma, leaving me standing next to the fire utterly puzzled. Bashi was his guide and Ben was his tracker; the latter had lost his arm working on the mines, many years before coming to Mashatu.

The next day we contacted the vice-president's office via Pete le Roux to say that Mr Purcell was waiting for him. His office didn't know what we were talking about. After Pete explained the situation in detail, the brief from the vice-president's office was that General Khama was simply coming on holiday and that we were to keep 'that nut job' well away from him. Pete briefed us accordingly, emphasising that under no circumstances were the two to ever meet. In addition we consulted with Mr Purcell's family, from whom we learned that he suffered from acute schizophrenia and that his false persona was that of a VIP military general. When he made the booking, Mr Purcell was not taking medication. For the first

couple of days of his safari he was back on his meds, but now it seemed he'd stopped taking them again.

I called an emergency staff meeting. I drew a map of the camp on the whiteboard and, with Claire's logistical input, we devised a plan to keep Mr Purcell from ever encountering General Khama. This meant that both parties would regularly enjoy surprise bush breakfasts and dinners, so as to avoid dining in camp. The next few days were stressful to say the least as Mr Purcell marched around camp demanding from random staff members to see the president. One afternoon I was in the ranger room having a meeting with all the trackers when the door was flung open and in walked Mr Purcell. He slapped his hands on the table and, staring intently at us all, he bellowed forth, 'Right, where is the president? He is late. I am an important man. I don't wait around for anyone!'

Assuring him that the president was around somewhere, when I knew full well that General Khama was out of camp on a full-day drive, we watched as Mr Purcell marched back out the door. He spent the entire day searching for the president as if he was playing a game of hide-and-seek with him. His standard question to everyone he saw was, 'Have you seen the president?' He opened every door in the back of house, walked into the storerooms, checked under tables, opened cupboards, interrogated the kitchen staff. He even asked Jack, who said, 'Are you referring to the president of Botswana?'

Hosting Mr Purcell at mealtimes was more than a little bit interesting. He gave me a full history lesson on the art of modern warfare as well as detailed explanations of how to operate every weapon under the sun. At one point during brunch and with tables of other safari guests all around us, he pulled out a knife which he promptly flicked open to reveal a gigantic blade, before yelling, 'I am trained to kill, man!' Fortunately, he was an older person and not in peak physical condition, so if push came to shove ... I managed to persuade him to put the knife down and asked him to tell me about the protracted trajectory of the latest heat-seeking missile – again.

General Khama was only with us for a few nights and when he left we all breathed a sigh of relief. In hindsight, perhaps we should have slipped Mr Purcell's medication into his drink but spiking a guest's drink and stealing

medication out of their room can hardly be considered normal hospitality practice, although it must be said that this was hardly a normal situation! Standing in the office after Mr Purcell left, we were all very relieved that we had survived the week. Just then the office radio crackled, and we heard Mr Purcell calling Pete le Roux from the airstrip. A guest never ever spoke on the radio but Bashi told us later that Mr Purcell had simply grabbed the handset out of his hands. We were rather intrigued to see if Pete, being our big boss, would answer. Sure enough the radio crackled back and Pete's voice came on air.

'Go ahead for Pete.'

Mr Purcell got straight to the point. 'Where the hell is my airplane, man?' he demanded.

Pete explained that it was a scheduled flight and that it would touch down in half an hour.

'Listen here, sonny,' boomed Mr Purcell, 'I don't wait for planes, planes wait for me!'

Shortly after Mr Purcell left, the board of directors arrived and everyone was frantically running around like headless chickens trying to please Mr and Mrs Rattray, who were the owners at the time.

By the time Lloyd got back from leave Claire and I were finished – both literally and figuratively. For the entire month I had not picked up my camera. Realising that my role at Mashatu was more that of hotelier than being out in the bush, and that my dream of becoming a wildlife photographer was stagnating, we handed in our resignation. I loved the area though and I knew that I would one day return, which I in fact did and finally managed, some 10 years later, to take an award-winning picture of an elephant at Mashatu – a blue elephant at that! This picture would tour the world and hang in both the London and Sydney Natural History Museums many years later but of course there was no way of knowing any of this at the time of leaving. If I had, it would have buoyed my hopes. My real dream was to return to live in the Tuli Block one day

as a professional wildlife photographer and to do a coffee-table book on the area because it is my version of paradise on earth.

At the time of leaving I suspected I had picked up malaria again and was by then feeling decidedly sick. Back in Pretoria I was admitted to the Zuid-Afrikaans Hospital. The infectious disease specialist treating me literally skipped into my ward.

'You have a parasite I have never seen before!' he exclaimed with glee.

'Oh really,' I said unenthusiastically.

'Yes, you have the rare reoccurring vivax strain.'

If I'd been feeling any better, I would have punched his lights out.

29

Somewhere in Kenya

I recovered from malaria in time for our wedding. Claire and I wanted to keep it a simple affair. There is a park in Pretoria that is absolutely beautiful, full of indigenous trees and with a large expanse of lawn. Getting married in a park posed an interesting problem in that in order for a marriage in South Africa to be legally binding, there needs to be both a foundation and a door. The only way around this problem was to get legally married the day before and hold our wedding reception in the park.

We chose Claire's parents' house for the official ceremony, with just both sets of parents, Claire's bridesmaid and my best man in attendance. In preparation for the next day Claire had had her eyelashes tinted. Standing with the pastor inside the house – which had both a foundation and a door, so we were about to get legally married – I suddenly noticed Claire's eyes. 'Your eyelashes, love,' I exclaimed, 'they look like a giraffe's!' My best man looked down at his shoes as if to say, Please tell me you did not just say that and Claire's bridesmaid glared at her as if to say, It's not too late, you know! Claire had seen enough giraffe to recognise the compliment – she just gave me one of her beautiful smiles.

Our wedding photographer said that he had never before experienced such a wonderful wedding. Perhaps this was because I made his job very easy by buying the film and handing it to him. When he was done, I took it back and told him that his job was done; I wanted to develop the film myself. Although he was free to go, he stayed on and enjoyed the festivities like a guest.

We needed to find work. I called a job agent I knew who specialised in bush placements.

'Hi, Jill, any exciting bush jobs going?'

'Not really, Greg. It is quiet. Oh wait, there is an interview for work somewhere in Kenya.'

'Oh, Kenya, you say?'

'Yes. I don't have details but they are holding interviews this evening at the hotel across from Jan Smuts Airport. Ask to speak to a Neil.'

I called Claire and told her that I had no details whatsoever, but we were going for an interview to work somewhere in Kenya. A couple of hours later we were sitting in the hotel lobby.

A tall bald man walked in, wearing glasses and a big grin. Sitting us down in the bar, Neil proceeded to explain that he worked for a company that built safari camps in East Africa and that they gave part ownership of these to the local communities. His manner was very laidback and his flowing white cotton clothing was not very South African in style. I asked him where he was from and was surprised when he seemed to not really be able to answer the question. He was an African nomad, a free spirit and vagabond, one currently residing in Kenya. He went on to explain that they had just finished building an incredible camp called Shompole in the heart of the remotest part of Maasai-land. They now needed professional camp managers and had come down to South Africa to scout for a management couple. The interview could not have gone better. It concluded with Neil inviting us up for a week to come and see the place.

Leaving the hotel and driving past the large jumbo jets parked on the runway at the airport, I felt excitement well up inside me. It was time for another African adventure and the best kind too – the kind that springs up out of the blue.

The company were in fact looking for two management couples, one to manage Shompole Lodge and another to manage a safari camp called Naibor, which was in a different part of Kenya. Both management couples were being flown up at the same time for round two of the interview process. Having been given the number for an Albie and Freda, I called to arrange a meeting point at the airport. When I told Albie that he would recognise me easily as I'd have a grey Pelican case, he apparently hung up the phone

and said to Freda, 'I am going to like this guy, he has a Pelican case.' Albie was an avid photographer himself and an even more avid birder, and we talked bush and birds all the way to Nairobi; our partners could not get a word in edgeways.

We were collected from the airport and driven past the soccer stadium and then along Langata Road, before turning left onto Ngong Road, where we collected a parcel. We then continued towards Ngong Town, at the base of the Ngong Hills. These are the hills that Karen Blixen wrote about in her book *Out of Africa*. The large sprawling town, streets now strewn with litter, that squats at the base of her beloved hills would be enough to make her turn in her grave. It was also enough to get Claire, Albie and Freda's eyes as big as saucers. Seeing the look of shock and horror on their faces, I realised that this was all new to them. They had never been out of Southern Africa before. South Africa was, especially back then, a more 'sanitised' version of Africa. Kenya was more like the real deal, full of dust and chaos, but also an undeniably African energy. When I was working for the filming company I had taken a sabbatical and had worked in northern Kenya for a couple of months helping to build a safari camp and, specifically, supervising the digging of a water well for the new camp. The camp was located in beautiful Samburu-land and was to be called Elephant Watch Safaris. I was therefore less shocked than my companions at Kenya's chaos.

Both Albie and Freda had grown up in a small Afrikaans town and weren't at all accustomed to things such as our driver expertly swerving for donkeys in the road, or the many makeshift roadside stalls we passed with signs like 'The Heavenly Hairdresser' and a bar called 'The Whitehouse'. I watched the changing expressions on Freda's face, which reflected a combination of shock, trepidation and fascination. Claire looked at me and words were not necessary. I knew exactly what she was saying: Where on earth are you taking me?

Leaving Ngong Town behind us, we wound our way up a long steep incline where Kenyan athletes were busy with high altitude training. It might be a cliché, but seeing them run was like watching poetry in motion. When we reached the top of the hill our driver shouted, 'Baridi Corner!' as cold air rushed in through the windows. Recalling the few Swahili words I knew, I remembered that 'baridi' means 'cold' and I hastily and proudly

translated the meaning for the rest of the crew in the car. Baridi Corner also marks the edge of the highlands and it is the last place where the sensation of being cold can be felt, before plummeting into the hot cauldron that is the Great Rift Valley. As we made our way down the escarpment, gradually the wide-spread, umbrella-like acacia trees gave way to straggly thorn bushes. The air rushing in the windows also became increasingly warmer and the surrounding bush turned into shades of creams and browns. It was very arid, and the engine was whining as if protesting the dry, hot air. We paused only momentarily to let a goat herder cross the road. 'Cannot hit a goat!' yelled our driver 'It will cost me 2000 bob!'

The distant hills seemed to melt in the heat haze. We were in a part of the Great Rift Valley that is officially called the Gregorian Rift in geography books, but affectionately known as the 'south rift' by Kenyans. The Rift Valley in its entirety is arguably Africa's greatest geological feature, stretching from northern Mozambique all the way through Africa and into the Middle East. Separating tectonic plates resulted in volcanic processes forming incredible features along its course. Mountains, volcanoes and both fresh and alkaline lakes all line the Rift Valley. The part that we were driving into had a particularly impressively high western wall.

The tarmac road ended at Magadi Town. As we approached a boom, the strangely beautiful Lake Magadi stretched out on our left and our right, and I could see a few flamingos dotted about. This lake has a distinctly pink tinge to it, the result of all the algae blooming in its caustic waters. Driving past the lake and the mining barracks everything looked otherworldly, with chunks of pockmarked volcanic rocks strewn about. It felt like we were entering Hades. We passed a golf course, of all things, whose 'fairways' were also littered with rocks and the greens, we were told, made from used engine oil! I was just thinking that it was definitely the ugliest town I had ever seen when our driver announced: 'Greg and Claire, this will be your nearest town from Shompole Camp.'

Somewhere in the middle of the small town we pulled up behind a parked safari truck with a long golden pheasant feather sticking out through the hatch in the roof. The man behind the steering wheel got out of the car, bending his head to avoid damaging the feather, which was perched on top of his crown. He was tall and thin, with sharp features. He wore a white

shuka – a loincloth worn as a body wrapping – large bright red beaded bangles and, on his feet, a pair of 'thousand milers'. These are shoes made from old car tyres. Recognising him as being a Samburu 'moran' or warrior, a flood of memories of my previous stint in Kenya came back to me. He exuded a cool calmness and returned my excited handshake with a softer one, before transferring our luggage to his car.

He told us his English name was James. To his great surprise, and mine, it turned out that I had been to his home village, some 500 kilometres away in the north of the country. Before long we were bouncing along, following the southern edge of the lake. Here the bush got even drier and more arid, punctuated by tall, slender acacia trees, the ends of their branches adorned with neat, round and skilfully woven nests. Other trees had more scraggly, grassier nests with a prominent spout on one end, which Albie and I recognised as the work of white-browed sparrow-weavers. The smaller, neater nests were the work of the grey-capped social weavers. On discovering that Kenya was full of birds not found in South Africa, Albie's face lit up. Freda, however, still looked somewhat pale.

James poked a casual finger towards the front windscreen and shouted above the noise of rattling vehicle parts, 'Ol Doinyo Shompole!' Not being able to see out of the front, we all stood on our seats and, with our heads poking out of the roof hatch, we gazed upon the beautiful sight that is Mount Shompole. The sun was beginning to set, the fierce equatorial rays subsiding and bathing the western flank of the mountain in golden rays. Mount Shompole is actually an extinct volcano. Rising out of the floor of the rift valley, it has flowing ridges which, after years of weathering, makes the mountain look like it has been handcrafted from soft molten wax. It is not a particularly tall or big mountain but with the afternoon rays highlighting the molten ridges, and throwing the recesses of each into dark shadows, it was a breath-taking sight. The further we drove, and the lower the sun sank, the more the mountain changed its expression.

As we neared the base of Shompole, the dry stony ground gave way to a swathe of grassland. Here the road became uneven and as the suspension creaked through each dip, we drove deeper into the grass until it was towering above us on both sides. 'It's called elephant grass because it's as tall as an elephant!' yelled James. The sun soon set behind the steep and

still distant rift valley wall. The now blue sea of grass brushed the sides of the car as we penetrated an utterly wonderful and little-known corner of Africa. Just getting to camp was an adventure. Albie and I both agreed that this was undoubtedly the most spectacular drive we had ever taken in Africa. Looking up, even the sky seemed bigger as the last rays of the day blasted heavenwards from behind the rift wall. Mount Shompole was now deep blue in colour. While we were admiring the canvas sprawled out before us, like a masterful work of art, I was surprised to hear the sloshing of water. Looking down, I saw we were now driving through deep, dark water and this in stark juxtaposition to the arid landscape. There was no road, only a small clearing through a wall of tall bulrushes. 'These are the Ng'iro Swamps,' James explained, shouting above the grinding of low gears.

I had done some research on the area before leaving home and I knew that the Southern Ewaso Ng'iro River spilled its watery contents into a large swamp, before trickling out and into the famous Lake Natron. As the water rose to the height of the bonnet, the air became more humid and flying insects emerged from the swamps, silhouetted against the evening sky. Once we'd crossed through the water the road became as smooth as a baby's bottom. We were now on the soda flats that lie to the north of Lake Natron. Extending his arm out of the window and pointing to the distant horizon, while driving at top speed, James yelled, 'There, up there, you see some lights? That is our camp!' Looking to where he was pointing, we noticed a faint twinkle of light halfway up the wall of the Great Rift Valley, which resembled nothing more than the flicker from a candle, making us realise how immense the vista before us really was.

As we sped across the valley floor, the warm African air caressed our faces and carried on it a new strange odour. This was the smell of soda from Lake Natron, which is the most alkaline lake in the world. The closer we got to the valley wall, the more it imposed itself, its deep volcanic creases and layered savannah steps towering above us. We drove through a small village and James yelled, 'This is the kijiji.' Kijiji is village in Swahili but the only sign of life we saw there was the flickering of a lantern and a round circle of white goats enclosed in a boma. Following the base of the rift wall, as the twilight faded into night, we turned up a steep road.

Engaging a low-range gear, James then proceeded to drive straight up the near-vertical wall of the rift valley. Right at the top, standing beside a lantern, was Neil. 'Karibuni Shompole!' he shouted.

30

Shompole

Neil led us down a pathway to the dining area. As he took us across a wooden bridge, he explained that all the furniture in the camp, including the bridge, was built from sycamore fig wood, harvested from dead trees along a river not far away from the camp. Traditionally in a safari camp the communal dining area is called 'the mess' but Shompole was no ordinary safari camp, as we would soon discover. For starters all the walls were painted white. The roof above us was made from papyrus, collected from the swamp we had just driven through. And flowing around the entire dining area was a waterway of clear sparkling water – 'from a spring in the mountains' said Neil. 'It helps keep the place cool.'

Continuing down a steep path to our room to freshen up for dinner, Claire and I crossed over another small wooden bridge and walked into tent number 5. Never has the word 'tent' been more misleading. It was more like our own private villa. There was not a single straight aspect to the room; it was free-flowing in every sense of the word, including having our own 'river' flowing through it. The walls were white and curvy and the front was completely open to the elements, with no wall or divide of any kind separating the bedroom from the outside. The bed consisted of a large slab of white cement on which was the largest mattress we had ever seen. An elegant mosquito net surrounded the bed, adding that quintessential 'Out of Africa' touch. Below the room was a beautiful curvaceous plunge pool; white and filled with clean, clear water that had just the slightest tinge of blue. The shower was another surprise. When I turned on the tap I was amazed to discover that the water cascaded over the top like a waterfall, plunging down onto my head and splashing over a large smooth white cement floor. There were no doors to the toilet or the shower. Everything screamed the words 'sensual freedom'. Tent number 5 was not a tent or a room. It was a work of art.

When we got back to the mess area for dinner there was a gentleman already there, sitting on a sofa. He had a goatee beard and long flowing brown shoulder-length hair. He was wearing a kikoi and a loose-fitting lightweight cotton shirt. Sitting next to him was a Jack Russell and Claire bent down to greet him. 'His name is Naju,' said the man on the sofa. 'It means "the hairy one" in Maa.' His voice was low in tone and he spoke as if he had just taken a draw from a marijuana pipe. 'I am Simon,' he said. Recalling that Neil had said the managing director of the company was called Simon, we assumed, correctly, that this was he.

We all sat down to dinner at a massive fig wood table and Simon told us the fascinating story of how Shompole came into being. He had designed the lodge himself. He spoke slowly and had a way about him that, much like the camp he had built, screamed 'cool'. In fact, Simon was the definition of cool; I was quite sure not even ice would melt on him. He was eccentric, as cool people tend to be. Gazing around at the incredible building in which we were dining – which also had no straight walls – there was no doubting that he was not your typical MD. Simon was more of an artist and visionary.

Over the course of dinner he explained to the four of us that he was a third generation Kenyan. His father had been a famous great white hunter and had brought him down to this area to hunt when he was a boy. The spectacularly rugged and remote environment had made an indelible impression on him, and returning to the area many years later, after his dad had passed away, he discovered the area to be just as he had left it. 'There is no one here except the Maasai,' he said. 'Most of the womenfolk here don't even speak Swahili and have never even been to Nairobi.'

Neil interjected to tell us an amusing story. When they started building the camp, he was racing along the floor of the rift valley in his Land Rover one day when he passed a few Maasai along the way. When he stopped to greet them, one of the men hastily climbed into the front passenger seat. Neil figured that the man wanted a lift somewhere and he carried on driving. He was only half-right. The Maasai gentleman wanted a lift all right, but to nowhere in particular. It turned out that he had never before driven in a 'gari' and when Neil had stopped, he quite literally jumped at the opportunity to do so. Riding in the car was a novelty but after having

had his curiosity satisfied, he wanted to get out. Neil was speeding across the Natron Flats when he heard the passenger door creak open, followed by a thud! Slamming on brakes and looking in his rear-view mirror, he saw the Maasai man rolling in the dust, head over shuka, so to speak. The car squealed to a halt. Neil, still in a state of shock, hadn't even got out of the car when the man came trotting up to the driver's window, dusting himself off. 'Asante, kwaheri!' he shouted, before turning around and walking back up the road in the direction they'd come from.

Most of the staff in the camp were from the local surrounding villages. At first this was problematic. Those hired as waiters had never before seen a knife and a fork, let alone set a table, so a good amount of training was required. This was one of the reasons the company had sent Neil to South Africa to recruit professional camp managers to train the staff, and to get the camp running more smoothly.

The dinner concluded with Simon describing how the entire camp had been built using raw materials sourced in the immediate surrounds. Large white rocks had been carried in from a stream up in the Loita Hills and used to create rapids in the rivers that flowed in and around the camp buildings. The open plan of both the tents and the mess area enhanced the feeling of being out on safari in Africa. Having no front walls impeding the view meant that one could smell the bush and feel the breeze inside.

'I bet there is a great view from up here,' I said, impatient to see it in the light of day.

Simon leaned back in his chair and gestured in the direction of the rift valley with a sweeping movement of his arm. 'Greg, bwana, down there you have it all,' he said. 'It's a boy's playground.'

The south rift of Kenya is quite possibly the most diverse place in all of Africa. There are forests on top of the escarpment where creatures like giant forest hog roam through tall *Podocarpus* (yellowwood) and cedar forests. Down in the valley there is acacia savannah, rivers, swamps, saline grasslands, mountains and soda lakes. Later, lying in bed contemplating

what must be out there in the dark valley below, I heard the honking sounds of thousands of flamingos, flying overhead en route to Lake Natron.

The dawn did not disappoint. The sun rose fast as we were just two degrees south of the Equator, and it lit up an incredible vista. Standing in our 'tent' enjoying the tea and coffee that had been delivered to us with a friendly 'Hodi' by our Swahili tent steward, Claire and I gazed out onto one of the finest pieces of Africa I had ever seen. The camp was quite literally perched on the very edge of the Great Rift Valley, which sprawled below as if someone had thrown down a vast green and yellow quilt. The patches of green were the forests and the swathes of browns, creams and beiges were the savannah grasslands. We could see clear across the valley all the way to the Meto Hills on the far side. Mount Shompole looked like a ship adrift on the open veld, every volcanic crease and crevice being caressed by the rising sun. I listened to the exotic-sounding dawn chorus of unfamiliar birds, and no doubt Albie was somewhere quivering with excitement.

Although it was only 7 am, it was already hot. Jumping into Neil's Landy, we drove down the hill and onto the rift valley floor. A small bush track passed through beautiful savannah, where tall umbrella-shaped trees were full of gently cooing doves. After that the bush grew thicker and soon we were in a huge fig forest. The bright sunlight filtered down, like it does in the ancient cathedrals of Europe, and the air was full of the ripe odour of figs. As I scanned the treetops I was sure that a trogon or two lived somewhere in the forest, and I wondered if I might be able to see the barred variety. It was cool in the forest. A river flowed through the middle of it and each tree sent out buttress roots, like thirsty fingers running deep into the sandy earth. The road wound its way out of the other side, where we found ourselves in rank swampy grassland.

Waterbuck grazed in the distance with Mount Shompole an ever-present backdrop. The grass was bright green here, indicating that the river we had crossed in the forest ended here, spilling forth onto the floor of the rift valley, giving life in its death. Crossing the moist grassland we found ourselves in arid bush country again. I recognised the strangely familiar smell of Salvadora bushes and the mewing sounds of a flock of blue-naped mousebirds. In parts the dry grass grew rank and tall, towering above us and rustling as the Land Rover scraped past. Large puffy white clouds, like

clumps of cotton wool, passed overhead as if the sky was a movie set. Albie and I, sitting on the roof at the back, tried to process all we were seeing. Both of us had spent considerable time in the bush in southern Africa, but we agreed that we had never before lain eyes on such a splendidly rugged piece of Africa.

As we approached the base of Mount Shompole, the grassland gave way to dust, lots and lots of brown-grey volcanic dust as fine as talcum powder. It was arid. Dust devils whirled about the valley floor as if entangled in a dance with the blazing sun. The land was crisscrossed with deep worn game paths, made predominantly by zebra. These narrow furrows ran in the same direction we were going, towards Mount Shompole.

Tall termite mounds dotted the landscape, much taller in fact than our safari truck. Each of these castles of clay had its own unique shape, but all tilted slightly, ending in a long narrow point at the top. The termites had worked the fine volcanic soil into a smooth grey finish that had then been baked by the sun, like clay in a kiln. The photographer in Albie and I was jolted into life as each zebra track formed the perfect lead-in line, all pointing towards Mount Shompole and the big blue sky beyond. In fact, our conversation quickly turned to photography. When I confidently blurted out that I was going to become a professional wildlife photographer, Albie looked at me and my entry-level kit camera as if to say, Good luck with that!

On the smoother mud flats we raced along with the wind in our faces. Again the strange unfamiliar acrid smell of soda assaulted our nostrils. As we drove we scattered herds of wildebeest and looking back from where we had come, lines of zebra walking in our direction melted into a haze of stripy heat, as if they were walking on air. Distant acacias, termite mounds and swathes of khaki grass all merged together into a singular canvas, creating a picture that more typified Africa than any I had ever seen before. The earth became damp as we neared the mountain and soon we came to a large cool pool wide enough to contain the entire reflection of Mount Shompole and fringed by bright green bulrushes. This was where the Ewaso Ng'iro River emptied its contents onto the valley floor. Birds darted about, causing Albie and my brains to short-circuit. And just when we thought the morning could not get any more spectacular, a group of

Maasai mamas, adorned in brightly coloured shukas and white beadwork, arrived at the swamp to cross to the other side. As they waded through the water, their bright red and yellow dress reflected, mixing and dissolving with the reflection of the green reeds and blue sky. The water became a dissolving array of bright African colours.

31

We must be mad

When Simon offered to take us on a tour to the back of house we were in for a shock. It was so basic we could hardly believe our eyes. The kitchen had no electricity, which meant no cooking machines like microwaves or blenders. The cooks were baking bread in coal stoves and there were no windows. Inside the kitchen, where cooks sweated and sous-chefs in traditional Maasai regalia bustled around, it was punishingly hot. 'These guys have never had a conventional job before,' said Simon. 'There was no one here before we came so most of the staff in camp have zero experience and need training.'

If the kitchen was a shock, then walking around the back of it was even more astonishing. 'This is the storeroom,' said Simon, leading us into a large dark room with walls consisting of wire mesh, the kind used to build chicken coops. In between the mesh were large chunks of charcoal and a pipe running along the top dripped water onto the wall. A short and slight Swahili man greeted us and, breathing in after each sentence, introduced himself. His name was James Maingi and he was the storeman.

Claire and I were plain dumbstruck at the basic infrastructure or, to put it better, the lack of infrastructure that constituted the back of house. It was very apparent that all the money had been invested into building the lodge, but not much thought had gone into the engine of the camp.

Passing behind the kitchen, we saw the guide, James, who had fetched us at Magadi. He was with another Samburu man, also dressed in full traditional garb and a long feather on the top of his head. He introduced himself to us.

'My name is Inno,' he said.

'It's short for Innocent,' Simon interrupted with a sarcastic smile.

The men were brothers and both were guides at Shompole. Because they were still of the warrior age-set, they could not be seen eating in front of women – hence them sitting out back.

'You going to get fat, bwana!' said Simon, grabbing Inno by the hand and dragging him to the closest acacia tree. 'Jump! See if your head can touch this branch.'

Innocent sank down on his haunches, his feet splayed out like a chicken's, then shot up into the air like a rocket. Reaching the apex of his trajectory his head made contact with the acacia's leaves before gravity took hold again. He snapped his legs back together just in time for the landing. Having proven his point, he went back to his lasagne lunch.

Simon led us up to the 'office'. The room, also made from chicken-mesh, was hardly big enough to swing a kitten in, let alone a cat. Chicken-mesh seemed rather pivotal in the design and development of the back of house! Claire and I tried not to look horrified at what might become our official daytime quarters – if we got the job – which had paperwork lying all about the place and here and there, where we could discern a surface, dirty plates with old, congealed food. The office had the world's most inaccessible safe: set into the cement floor, accessing it required one to go down on all fours.

'Greg and Claire, this will be your office,' said Simon. 'And should you need help, we will be in Nairobi, on the other end of the line.' He pointed to the HF radio that was crackling in the background, its aerial on top of the papyrus roof. 'Now let me show you where you will be living.'

He took us around the corner and we followed him towards a large water tank that had been built from cement and then covered on top with wooden planks. Perched on top of the planks was a tent. This tent was the 'manager's house'. To reach it, we had to climb a wooden staircase. Talk about an unconventional home! But when we reached the top, the view took our breath away, making us forget that we would, if we accepted the job, be living on top of a water tank. From the bed we could see the very top of the rift valley's wall, where high up in the Loita forests tall cedar trees stood like ancient sentinels. If we looked south from our tent, we saw the rift's wall disappearing into the distance, where it seemed to end at a large pink blob – Lake Natron. 'On a clear day you can see Ol Doinyo Lengai,' said Simon. In doing my research before coming up, I had learned that Ol Doinyo Lengai was the only active volcano remaining in the eastern arm of the rift valley.

The 'house' had a toilet and a bathroom downstairs, and with the constant dripping sound of water I figured that the need to run down to the loo would be a regular occurrence. The loo itself was a long-drop. Not since my Timbavati days had I seen a long-drop. Hot water was supplied to the shower via a donkey-boiler which in East Africa is called a kuni-booster. I looked at Claire, trying to gauge her reaction. Perhaps it was the fierce heat or the climb up the stairs that had made her Scottish complexion paler than usual, but I feared it was the thought of living in a tent on a water tank.

Walking back down to the beautiful main lodge building, we passed the rudimentary kitchen again. The camp was an oxymoron: a luxury lodge you'd see gracing the covers of glamorous lifestyle or travel magazines, attracting the highest of high-end clientele, while behind the scenes, there was only basic infrastructure and untrained staff.

Traditional Maasai, some of whom could not even speak Swahili, let alone English, made up the bulk of the staff component. For most of them this was their first ever job. On top of this, there were cultural complications such as the Maasai women having to be back in their village before it got dark. As a result, the local women could only do daytime work. Cultural complications aside, the total lack of infrastructure was more of an issue. The cold-room was more of a dark-room. Sprouting potatoes were being peeled by a Maasai sitting on a rock outside the kitchen using a sword.

The external environment was also exceedingly tough; it was as hot as Africa gets and as dusty too. The lodge was snow-white in colour, to create a soothing, cooling effect, which it did very well, but with no walls and windows, and enough dust in the rift valley below to cover it all, one had to consider how practical or, more to the point, impractical it all was. The lodge was also in a remote location. There was no town close by and only an HF radio to link one with the outside world. There were no neighbours, no friends. And the camp manager's house was a tent on a water tank.

The four South Africans being interviewed were in full agreement when we were on our own: 'Anyone who signs up to run this camp must be mad!'

That afternoon I think Neil and Simon wanted to discuss the candidates privately with each other and needed to have us out of the way. We were told there was a trainee guide, by the name of Dennis, who needed

some practice, and that he would take us to visit Lake Natron. I was super excited. As mentioned, not only is Lake Natron the most alkaline lake in the world, but I had read that it had recently been heralded by NASA as the most dynamic landform on planet earth. NASA had been taking pictures of the lake from space. The caustic water was home to millions of algae, all blooming in random sequences, resulting in each satellite photograph looking different. We drove down the hill, crossed a river called the Pakasi, and then hugged the base of the Nguruman Hills until we reached the local kijiji.

We passed a group of Maasai leaning on sticks, one leg casually crossed over the other, twirling Salvadora twigs – they used these as toothbrushes – in their mouths. Children played next to the road and as we drove the Maasai we passed all waved at us, giving us friendly smiles. Once through the kijiji we branched off to the right, following the water that had been filtered through the swamps and was now en route to its caustic end in Lake Natron. At this point in its journey it was still very much fresh water and as a result it offered life to countless bird species on the dry floor of the valley. We passed a flock of grey crowned cranes and as we got closer, they alighted in sequence, rising and falling with the elegance of ballerinas. After following the snaking river still further, we stopped at the edge for a break and so that Albie and I could do some birding.

Wading into the cool water we could not believe our eyes; it was like stepping into an aviary. Birds called all about us, ducks and geese swam around the reed fringes and wading birds ran up and down the shore in short bursts. I had that weird feeling – did the sky in Kenya look strangely bigger? Drinking at the water's edge was an Egyptian vulture, a bird so rare in southern Africa that it had been declared extinct. Coming from South Africa, where wildlife is mostly fenced into reserves, it was almost impossible to comprehend that here, as we feasted our eyes on breath-taking scenery and so much wildlife, on the floor of the Great Rift Valley there wasn't a fence anywhere. Quite frankly, it was hard to believe all this could still exist, unspoiled.

Jumping back into the car with our muddy feet, Albie and I were relegated to the back, where we sat on the roof of the safari truck. Dennis drove straight towards the escarpment and past a couple of very small and

remote Maasai manyattas. The bomas were empty as the cattle and goats were still out grazing. The mud huts were the traditional kind and in this part of Africa, as Dennis went on to explain, the Maasai were still nomadic, following the rains and the good grazing for their cattle. Driving further south still, now really hugging the escarpment, we reached the northern shores of the lake where the other side of Mount Shompole reflected perfectly in the water, an enchanting sight.

'That mountain there, that is Ol Doinyo Sampu,' said Dennis, pointing up and out of the right side of the vehicle. 'Sampu means striped.' The escarpment now loomed above us like a giant fortress. It was so steep it was doubtful any human being had ever been on its slopes. Looking up in awe, we could see long vertical grooved gullies running down the mountain, eroded wrinkles on its ancient face. Despite us being in the shadow of the rift wall, the setting equatorial sun was still bright and intense, blasting its rays over the top of Sampu and into the evening sky, which was now a blue-purple colour. The mountain escarpment on the lake's edge was black, built from solid volcanic rock, yet on its surface greenery grew and in its crevices trees clung on for dear life. Desert roses added a splash of colour to the volcanic landscape. The lake and the escarpment seemed to meet at this point. We drove through mud, making our way around the lake as best we could. Chunks of igneous rock lay strewn all about the place, as if they'd just yesterday been blasted out of a volcano. The lake had an acrid smell and the black mud, black rocks and surrounding black hills gave everything a distinctly volcanic feel.

As we rounded another small bay nothing could have prepared us for the sight we were about to see. Off in the distance a large flock of bright pink flamingos was bathing in a spring on the water's edge. Although the flamingos feed on the algae that thrives in soda lakes, they need to drink and bathe in fresh water. These fresh hot-water springs on the edge of the lake are essential to the flamingos' survival and bring the birds daily to the shore. The pink plumes of the birds juxtaposed against the black volcanic landscape left us quite speechless. We drove to the springs where the birds had been bathing, but the flamingos had disappeared, as if they had simply melted into the water. Dennis shouted above the engine noise: 'The Maasai believe that the lake gives birth to the flamingos – that they hatch

straight from the water.' It seemed strangely feasible. All we could see of the flamingos now was a distant pink mirage out in the middle of the lake.

When Dennis switched off the engine the silence was deafening. We climbed down and walked further. Here, and to our amazement, the lake turned into a salt pan, with a salt crust five centimetres thick. The water in this part had evaporated, leaving behind the volcanic salts that now grew in large flat white wafers. The blue light of dusk mixed with the pink tinge of the soda left in the salt created an otherworldly environment. As we walked the salt crunched and cracked beneath our feet and when Dennis walked over to us wearing his blue shuka and white beads, the part of our brains that processes colour quite literally short-circuited. Feeling like I was on another planet or that I had taken psychedelic mind-altering drugs, I took pictures of Dennis on the salt pan. The light was blue, purple and pink all at the same time. Luckily, I had Fuji Velvia 50 emulsion film loaded, which was the best emulsion to capture the saturated colours of the surreal atmosphere.

Racing back along the escarpment to make it back to camp for dinner, we sat again on the roof but this time with Tusker beer bottles in hand as we watched the lake and the hills slowly melt into the night. Soon we were under a kaleidoscope of stars, twinkling above and reflecting in the water below. With hot air gusting in our faces we passed through the same manyattas where, this time, we could see circles of white where the corralled goats were asleep. Arriving back in camp, lanterns flickered and cast shadows on the white walls. The day had seemed like a dream.

Neil officially offered us the job the next day. Of course Claire and I had already discussed it between ourselves. Although we felt that we would be in way over our heads, we just could not pass up the photographic opportunity. Albie and Freda asked for more time to think about becoming the managers of the sister camp on the other side of the escarpment. Although their camp would be a twelve-hour drive away, we were delighted when they finally accepted as at least the four of us would be able to talk on the HF radio. Albie and I would go on to become firm friends for the years to come.

The south rift of Kenya presented the perfect environment for me to build a truly wonderful and unique photographic portfolio but it was a

huge sacrifice for Claire to make. She was not a photographer and the lodge was in a very remote location. There would be no town to visit, no friends nearby, and our only contact with the outside world would be via HF radio. We would be living in one of the hottest, driest and dustiest places in Africa. We would be hosting high-end international clientele but behind the scenes we would be training many staff who had zero hospitality experience, or in fact work experience of any kind – apart from herding goats and cattle. We would work seven days a week for months at a time and in a foreign country. We would also be living in a tent on a water tank.

On the other hand the south rift would give me access to the largest breeding ground for lesser flamingo in the world, as well as forests, rivers, wetlands, grasslands and savannahs. It was a wild, unspoiled piece of Africa and one that – very importantly – had not yet been photographed. It was photographic gold. Although the wildlife was shy, I could potentially fast-track my professional dream. Neil seemed delighted when we told him that we would accept.

Back home, I had roughly one month to prepare photographically for Kenya. I needed enough film to take with me and a professional camera and lens. With cap in hand I approached my dad and asked for a loan. Being a bank manager, this meant that I was talking his language and I was delighted when he agreed to loan me R15 000. My next stop was The Camera Guy photographic store, where I bought my first ever professional camera body, the Nikon F100. I also bought an 80-400 mm lens which could produce professional-quality photographs as well as give me an extra 100 mm on the 300 mm lens I already owned. This was, incidentally, the first lens to possess VR (vibration reduction), something I would very much need for what lay ahead.

On the way back from The Camera Guy, Claire popped in to do some shopping for toiletries as there would be no such luxuries to buy in Maasai-land. I stayed in the car to look after my new babies. I took the big gold boxes out of the bags and just stared at them. This was my first professional

camera set-up. I swear I heard angels sing as I opened each box. The camera seemed massive and so did the lens. There were additional buttons that gave me butterflies in my tummy. This was it. I had a professional camera in my hands for the very first time – and it was mine. All I now needed was enough film and then I was ready to take on the professional photography world. The only problem was that I had no money left for film! Knowing I had to make a plan, I contacted a good family friend who had two daughters needing to learn to drive and I sold him my yellow VW Beetle. Getting it cleaned, I thought I could still smell wet rotting giraffe bones but I hoped it was just in my head. To be safe I left a bag of pleasant-smelling fabric softener under one of the seats.

To say goodbye to my car was very sad indeed but my future was calling. New dreams and adventures beckoned and so it was time to do something drastic. I liked the thought of my Beetle being the first car for someone else and with a heavy heart I exchanged the yellow bug for R10 000 cash. I then went straight to Prolab and I bought 100 rolls of professional slide film, mostly consisting of Fuji Provia 100 and Velvia 50 film emulsions.

The south rift was a wilder part of Africa than any I had ever lived in and I would need to draw on every ounce of bush experience and wildlife knowledge that I possessed to build a photographic portfolio, but at least I now had the tools to do the job. With the leftover change from the film purchase I bought a few filters, including a polarising one. Walking out of the store with two brown bags, one in each hand, I paused momentarily in the doorway. Looking down at the bags, I realised that I had exchanged a whole car for just two brown bags of film and filters! I also realised that I now owned nothing except the shirt on my back, and of course a camera and lens. Stepping through the doorway felt almost symbolic of me stepping into the exciting unknown world of my future dreams.

32

Self-professing rednecks

Our home was now on top of a water tank, somewhere in the middle of nowhere, on the wall of the Great Rift Valley in Kenya. Claire and I had no time to settle in because when we arrived, Neil, who had been finishing the last touches on the camp buildings while also acting as the camp manager, was now champing at the bit to get out of there. He handed us a massive wad of keys and the next thing we knew, his Land Rover was a trailing plume of dust across the floor of the valley.

Claire and I were now the camp managers of Shompole.

We spent our first afternoon with a staff roster, trying to learn the names of the staff so that we could in time put faces to them. Many of the staff had Maasai names: Ngatia was one, and we also saw there was a Ngatia Junior; there were a few 'mzees', like Mzee Patrick and Mzee Ole Simba – 'mzee', I knew, was a term of respect, usually for an older man. There was one staff member simply called Kibonge (meaning fat) and another called FM due to his long upright protruding earrings.

That night we tried to sleep and get used to the sound of dripping water coming from under our bed. The next morning when I woke to have my coffee, the ambient temperature was already too high for me to even want coffee. I walked down at 7 am to perform roll-call, and there in front of me were the 60 members of staff – all wide-eyed and most of them unable to speak English. I felt that as their new manager I should give a 'rah-rah' speech but to do this, I needed not just one but two translators. It was a most interesting speech, even for me. I would speak for two minutes before handing over to the Swahili translator who would then speak for one minute before handing over to the Maasai translator, who would speak in Maa for 10 seconds. Not having any idea of what exactly was being said or, more importantly, what was being lost in translation, I just kept on talking, trying to motivate and inspire. Eventually, my eloquent long

sentences were being reduced to just a word or two. Judging by the blank stares, the majority seemed to not have understood a word I had said, but in any event, they seemed like a pleasant enough bunch. After dismissing them, I retreated back up the hill to our little office.

I knew I had a mountain of work to do but wasn't at all sure where to begin. The radio crackled, offering me a welcome distraction, and I heard distant voices relaying messages from seemingly deep dark Africa. This got me wilderness dreaming and where better to indulge in wilderness dreaming than in Kenya? For me, and many others, the country had long held a safari charm to it. It had drawn romantics like Karen Blixen, after all, with the immortalising opening words of the famous *Out of Africa*: 'I had a farm in Africa.' I might not have had a farm, but I did have a safari camp to run.

Staring out of the window, still daydreaming about what lay in the valley below, I heard a small clunk. I pulled myself back to reality and saw that a weaver bird, in trying to get at the sugar bowl, had dislodged the teaspoon in the process. I pushed the rickety office door back, placing a grey rock in front to keep it open. Then I threw some sugar on the ground under a wag-'n-bietjie tree (in Kenya this tree is called by its English name, wait-a-bit bush). The weavers descended onto the sugar like bees to honey. The male birds were in full breeding plumage, each with a thin and barely noticeable feather protruding out the back of their heads.

I ran back to the house to fetch my Pelican case. Placing it on a bench in the office, I unlatched it and the smell of new sponge-foam filled the room. I lifted my brand-new Nikon F100 out of the case and attached the pleasantly weighty 80-400 mm lens. I then grabbed a roll of film. I popped the black cap off the plastic container and loaded the film into the back of my camera, a whiff of fresh emulsion lingering in the air.

Kneeling down, I began photographing the weavers at the same time as an elderly gentleman was making his way up the stairs with a thorn branch, which he was sweeping from side to side, creating a small cloud of backlit dust with every sweep. Mzee Tingo was the camp gardener. It struck me as a bit odd to have a camp gardener in the absence of a garden. The camp was built into the side of the escarpment, which consisted of dry thorn scrub growing on stony ground. As Mzee Tingo made his way up the stairs he greeted me enthusiastically – 'Claire, MORNING!' – with the emphasis

on the second word. I realised that our English names were so foreign in the south rift of Kenya that the names themselves wouldn't automatically distinguish gender. Claire wasn't yet down from our house but the Mzee couldn't be faulted for trying his best to get off on the right foot. When she came walking down the path he called out just as enthusiastically: 'Greg, MORNING!'

Claire and I sat in the tiny office, not quite sure where to begin. You could say we were in the proverbial deep end. Trying to figure out when guests were going to be arriving was a challenge, as we received emails via HF radio, which was not what you might call instant communication. And then there was the safe. Why anyone had seen fit to sink it into the cement floor was a mystery but it was extremely inconvenient. Not only did you have to bend down on all fours but then, against gravity, you had to pull the heavy door towards yourself to open it.

We'd hardly begun to get ourselves acquainted with these basics when a young Swahili man came running up the steps.

'Mister Greg, the Maasai are at the bottom requesting to speak,' he said.

We took the camp roster with us as we walked down the hill together, with Claire studying it closely, trying to identify the young man who had delivered the message. At the bottom of the hill we found two Maasai gentlemen waiting for us. They had a cow's head strapped to the back of their bicycle with some old tyre tubing. The head was upside down, its blue-black tongue hanging out to one side. The men seemed most agitated and were yelling at us in Maa. Claire and I stared at each other, hoping that not every day in Shompole started in this peculiar way. Needless to say, we couldn't understand a word of what they were saying. Out of the corner of my eye, I noticed a staff member walking up the pathway to the camp. I called out to him – 'Kuja hapa tafadhali!' – and he came over. We learned that he was our head waiter, Bernard. We asked him to translate the message from the two Maasai men, who by this time were extremely irate. Bernard shrugged his shoulders and gave a sheepish laugh, followed by a wide grin. He was from the coast, he said, and didn't understand Maa. Sending him off to find a staff member who could speak both Maa and English, Claire and I stood there in awkward silence with the two Maasai gentlemen, who had by now grown tired of screaming and pointing at the

cow's head but showed no signs of leaving. Finally we saw Innocent walking down the hill, his tall golden pheasant feather aloft.

Inno had the classic disinterested aloofness of most morans or warriors. I was familiar with this because of the time I had spent time camping alongside the Samburu in northern Kenya. This laidback attitude was in sharp contrast to that of the two Maasai men, who began yelling again, furiously, and pointing at the cow's head.

'You see, Greg, we have this problem,' said Inno. 'This cow was killed by your lions and these two gentlemen need you to pay them.'

As he was speaking, the two Maasai pointed more specifically and very vigorously at two dubious-looking puncture wounds on the neck of the cow. They are no doubt trying to make a quick buck off the new camp managers, I thought to myself. How convenient for a lion to have eaten a cow on our very first day. I asked Inno to relay the message that we were not going to pay for the cow, which news caused some explosive, vitriolic protests from the two aggrieved Maasai. The Maa language was very foreign on my ear; I could not distinguish individual words or even sentences. Full of 'A' and 'O' vowels, it was the language equivalent of a runaway train.

Inno turned to us and said, 'I think it best if you radio the office in Nairobi.'

As Claire and I trudged back up the hill the screaming of the two Maasai faded into the background and was thankfully replaced with the gentle cooing of emerald-spotted wood doves – a welcome and soothing relief.

The radio crackled back from Nairobi.

'Greg, bwana, how the hell are you guys doing down there?'

'Um, we're fine, thanks, Simon, we just have some Maasai with a cow's head here, wanting compensation for a lion killing.'

'No worries, bwana, just take some money and pay them.'

Claire rolled her eyes.

'Roger that,' I said.

'Greg, I am bringing the investors down on the weekend and we will have a talk then, bwana, okay? Over and out.'

After grappling with the safe door, Claire and I walked back down the hill where we handed the two Maasai men some cash. They immediately began jumping up and down again. The Maasai are famous for jumping and

Claire and I were fast figuring out why! Inno turned to us and explained that the cow that the lion had killed was pregnant, so they in fact wanted double compensation. Back up the steep hill we plodded. The south rift is a relentlessly hot part of Africa and by this time beads of sweat were running down our faces. For a second time, Claire had to get down on her knees and open the safe. She passed me more cash to count. This time, instead of walking down the hill again, I hopped into one of the safari trucks and drove down. I handed the Maasai gentlemen their second instalment. They promptly got on their bicycle and pedalled away. Inno and I watched as the cow's tongue bounced from side to side over every bump and twist, until they were out of sight.

Since I was at the bottom of the hill I thought I would poke my head into the bush that surrounded the base of the camp to do a bit of exploring. The track passed through beautiful acacia woodland, filled with the cooing of mourning doves. I spooked a herd of zebra who ran across the khaki veld and beside us a pair of yellow-necked spurfowl croaked raucously. I could see the camp from the bottom of the hill and despite having lots of white walls, it blended in very well as the makuti roofs were all built below the peak of the escarpment. Seeing the camp in context made me realise that Claire and I were really living in the middle of nowhere! Soon I passed the camp's airstrip. This consisted of a large flat patch of soda-bleached mud with a few white-painted rocks along one side and a windsock – and that was pretty much it. The road then led me back to the base of the escarpment, where I found a tiny waterhole. Jumping out of the car, I startled a pair of Egyptian geese as I walked around the edge looking for tracks.

I was surprised to see, imprinted very clearly in the fine volcanic dust, the pugmarks of a lion. I say I was surprised because the waterhole was not in the middle of the rift valley floor but on the edge and only a few kilometres from the kijiji. Continuing to walk around the waterhole but now checking the surrounding bush carefully, just in case the lions were about, I desperately wanted to linger. But I knew that we had guests arriving later in the day and that the camp would need to be ready and that Claire was probably drowning in it all. Seeing the lion tracks did alter my perception of the morning's 'cow head' incident though.

I drove back up the hill and parked, then walked through the kitchen to see how things were progressing there. I found the cook's assistant busy cleaning up after the lunch preparations, wiping down the counter tops. When I saw the implement he was using for this task I did a double-take. I could not believe my eyes. It was a cow's tail! – and these were the same counter tops the food was prepared on. Making a mental note to skip lunch, I asked to speak to the cook, whose name I remembered from the roll-call was Werre. He was a Luo from near Mount Elgon. I explained that using a cow's tail as a cleaning cloth was unhygienic and hoped that I was conveying shock and distaste with accompanying facial expressions. I used the word 'unhygienic' as many times as possible. For all I knew the cow's tail belonged to the same head that was no doubt still bouncing along the dusty dirt road somewhere on the back of a bicycle, across the floor of the Great Rift Valley.

When I stopped Werre looked confused.

'Bwana Greg,' he asked, 'what kind of a word is this UN-HY-GIE-NIC?'

'Werre, it's when you don't keep things clean and flies come and they bring disease.'

'Do flies bring disease, really?' exclaimed Werre, shaking his head from side to side, ending with a nervous giggle.

'Okay, Werre, it's the same reason that you wash your hands in the basin before cooking,' I said, thinking this explanation would satisfy him.

It didn't. He still looked confused. He looked at his hands and then at me.

I looked around the kitchen – not a hand-basin anywhere. We had guests shortly arriving from the US, the managing director and investors coming in a few days' time and, according to a random email Claire had found in the office, an international fashion shoot with *Marie Claire* magazine.

Wiping the counter tops with a cow's tail had to go – and soon – and knowing that the cooks had nowhere to wash their hands made me shudder. I walked up to the tiny office on top of the hill and checked the roll-call roster, recalling that I had seen a 'mason fundi' on the list. I got onto the radio and called the workshop, which was down below the hill somewhere.

'Workshop, workshop, come in for Greg.'

'Roger, roger,' came the reply.

'Who's talking, please?'

'Kihare!'

'Kihare who, please?'

'Kihare, the best mechanic in the world!'

'Okay, Kihare, glad to hear it. Please can you send Mathuku the fundi up here.'

After a short while a gentleman of stocky build duly arrived in the office. This was Mathuku, the 'master bush fundi' of Shompole. I walked him down to the kitchen where I asked him to build a small hand-basin at the back entrance, the one leading to the staff toilet facilities. I then walked back up to the office to make a note to order a soap dispenser.

Sitting on a rickety director's chair, so old it could have been used on the *Out of Africa* movie set, I was about to take my first delightful sip of Kenyan chai when a rumble from the heavens caused me to spill my tea and almost fall over backwards. Running outside and looking up, I ducked instinctively, getting the fright of my life. A Cessna airplane with bright yellow wings had flown so low over the office that it had nearly knocked the antenna off the roof. The pilot was buzzing us, for a second time just for good measure, to let us know that we must send a vehicle to the airstrip to collect our new guests.

Claire glanced at the booking sheet and read it out to me: 'American family, Kentucky, first safari, handle with care.'

I decided to drive down to the airstrip in the Land Cruiser with Inno, who was to be their guide. Jumping into the vehicle, I had to smile. Inno first opened the roof-hatch above the front cabin to allow for his pheasant feather to stick out. He was proudly dressed in full Samburu warrior regalia, a most impressive sight to behold. We roared down the hill and along the narrow windy road that led to the airstrip, displacing squawking spurfowls and whistling mousebirds on our way. Out of the corner of my eye something caught my attention and I instinctively yelled 'Stop!' Gazing far off onto the plains, I was surprised to see what I actually thought I had seen – a zebra and a donkey, grazing together. Actually no, to be more specific: they were both browsing on the leaves of the same Salvadora bush. This struck me as peculiar because zebras do not, or should not, browse. They are grazers, eating only grass. As if this was not strange enough, there was a Maasai elder standing right next to them, casually leaning on his walking stick and cleaning his teeth with a twig from the same bush.

And, as if this tableau wasn't odd enough on its own, above them hovered an eagle, flapping its wings but remaining in the same spot, staring down at the three where they stood around the Salvadora bush. Innocent looked surprised at my surprise. He pushed the accelerator down and casually commented, 'That is Christmas and Eddie.'

'Who and what?' I asked, nonplussed.

'Christmas is our pet zebra. We found him abandoned on Christmas Day and he now lives in camp with us. Eddie is an eagle that the Maasai brought to camp. It was a baby then too and now it lives in the mess. We had to buy a donkey to keep Christmas happy and his name is Merry. We were afraid that lions will catch Christmas, so that old mzee has been employed to look after them.'

At this point I had flashbacks to the roll-call roster and I recalled seeing the words 'Christmas Babysitter' on it. As we raced towards the airstrip, I meditated – not for the first nor the last time – on our new reality. We were living in a strange and remote corner of Maasai-land; on the edge of the Great Rift Valley; and in a place where no one spoke much English. Add to this that we employed a gardener with no garden and now, apparently, a full-time babysitter for Shompole's unusual pets – well, I was beginning to love this place.

Piling the American family into the safari truck, we waited for the Cessna with the yellow wings to take to the skies again. It seemed to be heading back to Nairobi. On our way back past the old mzee, Christmas, Merry and Eddie, I tried to make small talk with the American family. The family comprised a mother, a father, twin teenage girls and a 21-year-old son whose name was Chuck.

'So where are you guys from?' I asked and the mother, whose name I had already forgotten because I was so nervous I hadn't properly been paying attention at the airstrip, yelled out, 'Oh, we'all are from Kentucky and the folks back home, they call us rednecks. But we'all, we call ourselves self-professing rednecks. Where ya'all from?'

'Um, well, Innocent over here is your safari guide and he is from Samburu-land which is in the north of Kenya and the Samburu are like cousins to the Maasai. I am from South Africa and my wife, Claire, and I, we just started working here as the new camp managers.'

There was an awkward silence after this initial engagement and I was happy to arrive at camp where Claire and Bernard had rustled up welcome drinks in the form of lime and sodas. We ushered the family from Kentucky through to give them their 'camp brief'. It was a strange feeling as I felt like Claire and I needed a 'camp brief' ourselves! I began by explaining that the hot water came from a thing called a kuni-booster, which necessitates the making of a fire. I said that no ladies' underwear could be washed by the camp staff, for cultural reasons. I was just about to explain the camp's mealtimes and safari schedule when the mother pointed towards the roof and demanded, 'Greg, those little critters up there – are those bats?'

'Why, yes, they are,' I replied. 'Those are what we call epauletted fruit bats.' I was about to point out the tiny white patches of fur just below the ears, which resemble epaulettes, when I was interrupted by one of the teenage girls saying, 'Ma, can we climb up there and catch us one of 'em bats, please, Mommy, can we?'

I did a double-take. Most teenagers are scared of bats. The mother of the family must have sensed my puzzlement. 'Remember, Greg, we'all are –' and then the whole family chimed in, 'SELF-PROFESSING REDNECKS!'

'Yes, um, no, well, fine,' I said. 'I would prefer it if ya'all did not climb up to catch 'em bats.'

If you can't beat 'em you might as well join 'em'!

After the briefing, the Kentucky family went down to their tents to settle in. While Claire went up to the office to try and see if the painfully slow bushmail had managed to download a single email yet, I sat in the mess area waiting for the family to return for lunch.

Shompole was built in a most spectacular setting and looking out over the floor of the rift valley I now recognised the dark green patch below

as being the fig forest. Mount Shompole looked different every time I gazed at it; her deep volcanic creased walls fell in and out of shadows all day long, giving her many different expressions. Although benign looking from afar, the mountain is rated by the Kenyan Mountaineering Club as the most unpleasant mountain to climb in all of East Africa. Its walls are lined with wag-'n-bietjie bushes, sharp Sansevieria needle-like plants and climbing euphorbias, which are filled with toxic white latex. Neil had told us how a safari guest had wanted to climb the mountain and after getting halfway up had gotten milky latex in his eyes from all the slashing of the euphorbias and he went temporarily blind. Staring at the mountain and recalling this story, I decided that I would leave the mountain exactly where it was – a wonderful and distant backdrop. If I was to become a professional wildlife photographer I would need my eyes intact, thank you very much!

Down below I could also make out the tiny waterhole I had discovered earlier in the day. It seemed that a herd of zebra were drinking there. How I wished I was down there and not up in camp having to host the self-professing rednecks.

Chuck arrived first for lunch and took a seat on a sofa across from me. To avoid awkward silence, I did my level best to begin a conversation.

'Chuck, are you settled in okay?'

'Huh? Oh, yeah, yeah.'

'You been to Africa before, Chuck?'

'Huh? No, no.'

After a lull I tried again.

'So, Chuck, what do you do back home?'

'Huh? Um, I work on the farm.'

'Oh really? That's nice. What do you do on the farm?'

'Um, er, I cut the grass.'

His pronunciation of the word 'grass', long and drawn out with his southern twang, made the awkward silence that set in again seem even louder.

'Tell me, Chuck, what else do you do on the farm?'

'Um, well?' Chuck seemed puzzled. Placing a finger on his chin, he peered at the roof before exclaiming: 'Well, I guess I wait for the grass to grow ... and then I cut it again.'

At this point I had to excuse myself to check on lunch. What I really had to do was walk out of the mess area, and out of Chuck's sight, to avoid laughing in his face, which would have been most rude. I wondered what he'd make of the elephant grass ...

The remainder of the day was hectic, to say the least. Not only did we have Simon bringing the investors down soon, but we also had the fashion shoot coming in at much the same time, plus regular guests and 60 staff names to learn, as well as having to get to grips with the camp systems. We also had the pressure of being professional safari camp managers who had been brought up from South Africa, specifically to raise the standards of service. No pressure, as the saying goes!

PART THREE:

NOT WITHOUT MY LIONS

33

Africa of my dreams

Hot, dry and dusty are probably the best words to describe the south rift. Since the camp was built on top of a hill, just getting around the lodge was an exhausting workout – we were constantly sweating. Looking at the camp's accounting made us sweat even more because all the staff were in serious debt, having received advances on their salaries to the point where they were all three months behind in paying. Besides the heat and staff debt, something else that was making everything that much harder was the fact that only some of the Swahili staff could understand English, and those who could were having a really hard time understanding our South African accents. Most of the staff didn't understand us at all.

To make matters worse, Shompole had been branded and was marketed as an upmarket ultra-chic lodge which, on the outside, due to the clever use of white curvy walls and swimming pools, it was. But this was simply a veneer. Behind the scenes, it was a very rudimentary and basic safari camp. Claire and I were stuck in the middle of these polar opposite worlds. We were the foot-bridge between Africa and the first world. In our kitchen we had no electricity and a cow's tail.

It wasn't only the camp that had a deceptive veneer. I had my own deception. I was simply pretending to be a camp manager. I was really there to build my photographic portfolio so that I could become a professional wildlife photographer. As such, despite the ensuing chaos of those early days, I made a decision to drive out and photograph in the afternoons. This was a daunting task because not only were there hardly any roads to drive along on the floor of the valley, but the game was incredibly shy. Every animal I saw was always running away from me! The wildlife in the south rift was truly wild and very different to animals in established parks and reserves. Shompole was a new camp and the only tourist camp in the area. No one knew about this hidden corner of Kenya where the Nguruman

Hills petered off towards Lake Natron and where Maasai still lived such traditional pastoral lives and coexisted with wildlife.

The south rift was a place where both people and animals were not used to seeing cars, or wazungus, and if Simon had not gone hunting in the area as a young boy, it's possible that this corner of Kenya would probably still not be known to the outside world. While this was all fine and well, the whole reason that I had come to Kenya was to build a photographic portfolio. It was in part the sheer diversity of the area that had really appealed to me, on a photographic level. But what I had not factored in was that even though I had taken a loan to buy a new professional camera and lens, both were useless if I could not get close to an animal. Another challenge was the dust. I had never seen so much dust and dust so fine that it could seep in through any crack. I only had one camera and one lens, and trying to keep both safely tucked away in the sealed Pelican case as well as needing to shoot fast before the animals disappeared over the horizon was proving simply impossible.

I actually resorted to racing, like a rally car driver, across the valley floor and adjacent to a herd of galloping zebra. With no hands on the wheel and no road in sight, I pointed my camera out the window and shot while I drove. It was not a very effective way of photographing and it was dangerous. It also stressed the animals out, which in turn stressed me out. How on earth was I going to photograph here? This was the question that played constantly on my mind.

When I arrived back at camp and Claire asked me how it had gone, I put on a brave face. It was me who had brought her to a foreign faraway country, to live in a tent in one of the hottest parts of Kenya, in the middle of remotest Maasai-land, completely cut off from civilisation. I would just have to find a way to make my photography work.

Lying in bed one night, wide awake, my mind wrestled with finding a solution. I needed to solve this conundrum of the wildlife being too shy to shoot in the conventional fashion from a safari truck. As I churned this problem over and over I heard the distant groans of lions in the valley below. Their mournful, soulful bellows got closer and closer. Finally the lions sounded like they were right at the base of the hill, their roars now reverberating against the valley wall. Despite the roaring, my weary eyelids

finally got the better of me. I have always been an early riser, so at the first crack of dawn, and listening to the delightful song of a spotted morning thrush, I was awake. While Claire slept peacefully beside me, I heard a foreign sound emanating from behind our camp and across a small valley, deeper into the hills. It was a metallic sound – more like a chime, of sorts.

Listening intently to the random strangely melodic 'tinkle-tinkle-tinkle', I heard a goat bleat ever so softly. I took my binoculars and walked to the edge of our water tank tent to take a look. There on the other side of the small valley I saw black and white goats dotted about the mountainside. Interspersed among them, like the bright red pieces on a checkers board, were a few Maasai mamas attending to their flock.

At 16, after hearing Ian Player give that talk to our school's wildlife society about wild Zululand and how after his experiences in World War II he had disappeared into the wilderness where he had found healing, I began what I called 'wilderness dreaming'. Now, squatting on a small traditional Maasai stool in the dawn light, trying my best to enjoy my morning cup of coffee despite the temperature already being close to 30°C, I had an epiphany. I called it my 'wilderness awakening'.

Ever since that day as a schoolboy I had been searching for my own personal wild Africa. I thought of this as a 'lost Africa', feeling that I was born too late to find my own untouched corner of the continent. Despite this, at the age of 18 I had gone straight to the bush in search of this wild, lost Africa. My searching had not slowed down over the years; rather, it had intensified and now it had brought me here to the Great Rift Valley of Kenya, to Maasai-land. Up until this point in my life I had always assumed that a true wilderness, the purest kind even, would of course be devoid of humans. But, sitting there on my little stool, perched high up on the escarpment, listening to the tinkling of goat bells, and seeing the bright shukas of the Maasai mamas splashed against the khaki grass, my concept of what true wilderness is shifted – permanently.

Actually, perhaps it would be more accurate to say that there was a gargantuan cataclysmic altering in my thinking around the concept and term 'wilderness'. Pondering how I had fallen asleep listening to the roars of lion that roamed freely in the valley below, and beyond any formal park boundary, and woken up to the gentle clanging of goat bells, I realised

that there was no physical barrier whatsoever separating the lions from the goats, or from the Maasai mamas for that matter. The same was true of the Maasai cattle herders or morani who were out all day tending to their cattle in the veld.

Surely, I continued in my train of thought, if one was to try and define a true African wilderness, then one should not look at how Africa was a hundred or even two hundred years ago. One must rather look at how Africa was a thousand or two thousand years ago. The notion that a wilderness is a tract of land that excludes humans is a relatively modern one and invented by humans when we created parks with wilderness zones. If you look further back, to a time when human population growth had not yet meant the destroying of entire tracts of land and habitats, a truer definition of the word 'wilderness' is an area where wild animals and humans coexist. The south rift in Kenya is one such place and not only one of the few remaining places in Africa where this occurs, but indeed one of the last places in the world where man coexists alongside wild and dangerous animals. In this remote and ancient part of the planet, not far from the Leakeys' 'cradle of mankind', both man and beast not only co-inhabit the same space but they share the same resources. Maasai cattle drink from the same water sources that lions do and the plains' game, like zebra and wildebeest, eat the same grass that the cattle do.

During the daytime, the Maasai, with their good eyesight and long spears, are the top predator in the ecosystem. When darkness falls, however, humans become nearly blind and therefore the Maasai retreat into their huts and place their animals into their bomas. The predators, and especially the lions, being at the top of the food chain, now rule – but only until the sun rises and daylight returns. This perpetual switching of who is at the top of the food chain has been going on for thousands and thousands of years. Sitting in a posture on my stool similar to Rodin's 'Thinker', my world, and especially my concept of wilderness, was turned upside down.

My entire life had been about finding my Africa and all of my Africa wandering was a direct result of my wilderness dreaming. A dream sparked and ignited as a young boy had led me suddenly, as if miraculously and seemingly overnight, back in time. I had woken in the Africa of my dreams.

I had somehow found a piece of Africa so truly wild that lions, with fang and claw, ruled and roamed by night. The daylight belonged to Maasai herders, warriors of old – their silver spears glistening over their shoulders.

Finally, I realised, I had found my Africa.

It wasn't enough to just be here, though. The photographer in me wanted to collect some sort of proof that I had found the Africa of my dreams. I wanted evidence that I had found my lost Africa. I wanted this proof mostly for myself but also for future generations. Proof of an Africa that many considered gone forever. As the goat bells grew fainter and the light levels increased, I made a vow to myself there and then that if I had really found my Africa, then I would need to get a picture of one of the lions living in the valley below, one of the lions I had heard roaring in the night. This would be a symbol, my symbol, that I had found the 'lost' Africa of my childhood dreams. Even more than this, it would serve as evidence of my having discovered a true wilderness. I would cherish this photo forever.

I grabbed my camera, ran down the steps, and jumped into a safari truck. I tore off into the bush in search of the lions whose roars I had heard in the night. It did not take me long to find their tracks but after searching for them for a good couple of hours, I began to realise that these lions were not like the lions you get in more established reserves like the Kruger, or the Masai Mara. The free-ranging lions in the south rift were like ghosts, unaccustomed to vehicles and completely adept at avoiding human beings in the daytime. Their very survival had depended on it for thousands of years. They were strictly nocturnal so as to avoid the Maasai morani. My problem was, especially in those days of film photography, that I needed to find them in the daylight as my ISO was just 100. After no luck in locating the lions, I circled back around to the waterhole where I found their tracks at the water's edge.

Lions need to drink every day. As already mentioned, the south rift is an incredibly dry area, so I figured my best chance to get a photo of them would be at the waterhole.

I drove to the workshop, where I found Kibonge, one of our resident fundis, who helped me with a spade. I then returned to the waterhole and began digging a hole next to it. If the lions were not used to vehicles, then I would have to sit and hide. Once the hole was deep enough to conceal my

entire body, except for my head, I returned to fetch Kibonge. Carpentry being his special craft, I asked him to make me a flat roof with four short poles that I could place on top of the hole to help conceal myself, and to provide shade. Kibonge seemed confused as to why I wanted to sit in a hole but he understood the roof concept well enough. I had no time to explain to him that I had grown up in a city where all wildlife, except for the birds, had been decimated and that my soul had longed for true wilderness and because I had now found it, and that to prove that I had, I now needed a photo of a lion. If I had tried to explain all that to him, he would have thought I was more crazy than he already did.

Once my hole was dug, I returned to camp. I walked into the office covered in dust, which had turned to mud over my sweaty parts. Claire gave me her 'I am not impressed look' but when I explained the epiphany I had had, and what my plans were, she seemed more understanding. Perhaps she did not fully understand, or share in my longing for wilderness, which had now morphed into a longing for a photo of lions, but I think she could see that my destiny had been written, and that she would need to let me pursue it.

34

Livingstone lions

While Claire was busy getting to grips with all the camp's administration, I was managing the staff and hosting the guests. Contrite that I had not seen any guests because I had been out tracking lions and digging a hole, I walked into the mess area where a British family was having brunch.

'Good morning, how are you all today?' I asked.

'Well, we're okay, thank you, Greg,' said the father with a hint of uncertainty.

Having run a few camps before and knowing that guests are mainly in Africa for the wildlife experience, I cut straight to the chase. 'How was your safari drive this morning?' I asked.

'Well, um, we have had better, you know.'

'Yes, I know,' I sympathised. 'This is a wild area so you don't see quite as much as in the Masai Mara.'

'Um, no, that is not really the issue, Greg.'

The British are a fascinating tribe, I'd decided long ago. Even when they are about to complain, they do it in an awfully polite manner. Although I knew that a complaint was about to be aired, nothing, and I do mean nothing, could have prepared me for what I was about to hear.

'Our guide killed a buffalo!' said the father.

There was an awkward silence. I wanted to crawl and hide in a bush or under a rock.

'Excuse me? Did you say that your guide killed a buffalo?' I asked.

'Yes. And we are a little bit upset as we were under the impression that this is an eco-lodge?'

Shompole was indeed marketed as an eco-lodge, which had struck me as strange considering the ridiculously lavish plunge pools dotted all about, but killing wildlife – really?

I politely excused myself to investigate the matter further. As I walked

out of the mess I realised that I had left too soon, and that I should have given the British family more time to explain the story. I was just so shocked that my flight response had kicked in. As I walked past the parking garage I was even more perplexed. The guides in Kenya don't even carry rifles, so how did a guide kill a buffalo? Walking round the corner I saw Inno sitting outside, also eating his brunch. Not only was his warrior age-set not permitted to eat in front of women, warriors are supposed to be so tough they don't even need to eat often. They are sort of like demi-gods. So Inno was hiding out back when I walked up to him and blurted out, 'Your wageni (strangers in Swahili) tell me that you killed a buffalo?'

Unperturbed by the accusation, he replied matter-of-factly, 'Yes, I did,' before taking another mouthful of food.

A moment of awkward silence followed. Come to think of it, there seemed to have been a lot of these moments since we had arrived at Shompole. I couldn't believe that Inno didn't seem to feel the slightest need to explain. Trying to calm myself down, I asked politely, and with more than a hint of sarcasm, 'Why don't you tell me all about it, Inno?'

'Well, you see, Greg, there is this buffalo and he is very, very naughty. The other day he charged James's vehicle. He is very disobedient. So this morning I was out by the swamp and we found him there. He came running at the safari truck and I decided to teach him a lesson. I drove straight towards him and bashed him in the horns with the bull bar.'

Inno must have seen my flabbergasted face because he then uncharacteristically and quickly added, 'I knew he would die and so I quickly drove away but told my wageni that buffalo are very tough animals indeed, and that he would be fine.'

After a long silence during which Inno took a few more mouthfuls, my brain felt like it was hanging in the same way that our bushmail email system did. I felt quite slow and unresponsive, and when I came around I pointed out: 'But you killed the buffalo!'

I was trying to process the cold reality that a lovely British family, with two young girls, had flown all the way to Africa for a family safari to see and enjoy the bounty of wildlife, and that their guide had just killed a buffalo on their safari drive. Innocent must have seen my confusion, or my disgust, or possibly a combination of both because he stated in an

unapologetic tone, 'That buffalo was very naughty.'

Walking back into the mess, I immediately began apologising profusely. Then I gave the family a long explanation about how the Maasai believe that God created three types of people on the planet: the first type to hunt wild animals and the second type to grow crops. The Maasai believe that they are the third type and were given cattle, all the cattle in the world, in fact, and this is why, even today, they will steal other tribes' cattle. They believe that all cattle, even those belonging to your British Queen, are theirs. In fact, any cow not in their care must have at some stage been stolen from them. I was conscious of getting off point, that I was just trying to talk for the sake of talking, the way one does when one is nervous. Finally, I brought the conversation back full circle when I explained that because the Maasai were given all the cattle in the world, and since buffalo are so closely related, Inno had become infuriated that the bovid was not subject to his authority and so he had seen fit to teach the beast a lesson. Admittedly, I had made this last point up, on the spot. Nevertheless I was quite chuffed with myself for coming up with any, never mind a semi-plausible explanation as to why their guide had killed a buffalo.

I went and sat down with Inno again, this time to reinforce that Shompole was an eco-lodge and that our guests came here to see and enjoy animals in their natural habitat, and that, as such, we should not be killing them. He listened attentively and nodded. Then, as I was walking away he shouted after me, 'Hey, Greg, I got a message from James, who drove out to see if the buffalo was dead. I was right. He is indeed very dead.'

Innocent being not in the least bit remorseful made me think that my on-the-spot, made-up explanation to the English family was not that far off. As a Samburu Inno had felt it his duty to put the buffalo back in its place, which as it turned out was to send the poor animal to Ngai (God). I was still scratching my head about this as I walked up the stairs to the office.

Claire looked up. 'How are the guests?' she asked.

'Oh, they are fine,' I replied, 'considering their guide killed a buffalo this morning.'

That afternoon, after ushering the guests out of the mess and onto their afternoon safari drive, after having had their very colonial and traditional serving of tea, I tried to make light of the morning's safari incident. As

Inno drove off I yelled, 'Don't kill anything!' Only once the car was down the hill did it sink in that my comment could well be interpreted as inappropriate and callous. Perhaps if it had been the family from Kentucky I would have gotten away with it.

As soon as they were out of sight I ran up to the office where my grey Pelican case was at the ready. There were no safari trucks available because all the guides were out on game drives, so I would just have to walk to my waterhole. At the base of the hill a barely visible two-track road snaked its way through the dense bush. The turtle doves were harmonising in the umbrella-shaped trees and from under Salvadora bushes I could hear the faint whistles of rufous chatterers. Closer to the waterhole it got dustier. I was wearing flip-flops and with each foot placement a small puff of fine grey-brown volcanic dust ejected from beneath my rubber soles. Nearing the water, I spooked the pair of Egyptian geese, who ran a few paces, hissing and honking in protest, before flying off. My homemade hide was situated right on the edge of the water, with the escarpment behind and the small body of water in front of it. The waterhole itself was barely the size of a domestic swimming pool but, unlike a swimming pool, it was muddied – dark brown in colour, with a tinge of green.

Kibonge had done a fine job with the roof of my hide. He had not only built a roof, but had also installed a small trapdoor, allowing me to jump inside with ease. Once down in the hole my head was eye-level with the water. By resting my camera on a bean-bag on the side of the hole, I was able to shoot anything that came to drink. I desperately wanted a photograph of one of the free-ranging lion I had heard calling in the night. I strongly felt that getting such a photograph would be the only suitable evidence of me having found my Africa.

I had recently read a book titled *The Truth Behind the Legend* by Rob Mackenzie about David Livingstone's life, which included fascinating excerpts from the missionary explorer's journals. Standing in my hole, thinking about the Africa that Livingstone had seen, I decided to call the lions, the ones I wanted a picture of, 'Livingstone lions'. Although not geographically correct, this was an apt description, I felt. Livingstone had been mauled by a wild free-ranging lion close to one of his mission stations. So far there was not much happening at the waterhole, so I started wilderness

dreaming about what Livingstone might have seen on his incredible journeys. The most fascinating journey he took, however, might well have been when he was dead! After his passing, his trusty porters emptied his corpse of its insides before salting him, much like the locals salt and dry fish on the great lakes of Africa. They then carried his desiccated corpse over 1 000 miles to the Tanzanian coast, so that he could be sent home and his soul laid to rest with his ancestors. There were chiefs along the way who were superstitious and would not let any dead body pass through their territory, so at times the porters folded him in half to disguise the shape of his torso.

Livingstone is a controversial figure in history. Many say that he was just another explorer seeking the ultimate fame of discovering the source of the Nile and, although he was a missionary, it is said that he only had one true convert. Despite all this, Livingstone must have been held in high regard by some for his porters to carry him over 1 000 miles. After independence, many African countries went about changing the names of streets, cities and buildings that had been named for colonial occupiers or reverted these to their original ones. But Livingstone still has a town named after him in Zambia, while the capital city of Malawi is named after his Scottish birthplace, Blantyre. The stories abound. Many of the local peoples believed that he had magical powers, and apparently certain cannibalistic tribe members, after shown their reflection in his mirror (an invention they had not seen before), resisted the desire to 'taste a white one'.

During the course of his travels Livingstone assembled a boat which to the locals was sheer madness as it was made of metal and therefore, of course, would sink – metal being heavier than water. When the boat floated, the tribes attributed Livingstone as having 'powerful medicine'. His famous Livingstone pill was powerful medicine indeed. I can attest to this myself, having enjoyed the 'ringing sound of freedom' on more than one occasion strapped to a quinine drip in hospital while receiving treatment for malaria. African tribes were always curious to know who Livingstone's chief was and they were very surprised that she was a woman. When they enquired as to how wealthy she was and he replied that Queen Victoria was indeed very wealthy, they wanted to know how many cows she had.

There was no sign of anything at the waterhole, and certainly no Livingstone lions. As the doves cooed and the afternoon drew on, I found myself

feeling sorry for Livingstone for he seemed to be no one's hero; neither the Christians' nor the seculars'. Having never found the source of the Nile, he died a failure in his own eyes. Livingstone had thought that fame from discovering the Nile's source was how he would put an end to the slave trade and in fact after his death, his detailed journals helped to do just that. Pondering all this, I adopted Livingstone as another of my heroes. Not only had he been mauled by a lion and lived to write about it, but he had also discovered a rare bird, duly named the Livingstone's flycatcher. Interestingly, by the time Livingstone's body arrived in England it resembled nothing of the person himself, having been bent and preserved. But upon finding the scapula with the toothmarks of a lion in it, they knew it was indeed Livingstone. Now, all these years later, not just in a new century but rather in a new millennium, I was trying to glimpse a wild lion, a free-ranging lion, like the one that had attacked Livingstone. Standing in my hole my legs ached and the tsetse flies bit. It was then that I thought of my favourite Livingstone quote: 'It's not all pleasure, this exploration.'

It might have been hot in my hole and some might have viewed it as a sort of solitary confinement, or perhaps suitable punishment for a crime, but over the next few months my hole beside the waterhole became my reason for living. It was from this hole that I hoped I would see and photograph a Livingstone lion and so my hide became my portal to a lost Africa. A wormhole, if you like; one through which I hoped to put to rest the constant nagging feeling that I was born too late. It was from my hole that I hoped to attain proof that I had found an Africa as wild and untamed as when Livingstone had journeyed across the continent.

The only problem was that I needed the lions to come and drink at this specific waterhole and at a very specific time; in the daylight, and preferably in good light too. Staring at the quiet body of water, not only were there no lions but there was absolutely nothing else. A waterhole is actually a very poor place to build a temporary hide because the animals that visit the water every day notice if anything is out of place. In fact their very survival depends on this ability for they need to notice an ear twitch or the tail flick of a lion to avoid being eaten. Animals are therefore extra cautious when approaching a waterhole. They will have to drop weary heads to quench long thirsts, exposing their posteriors to the bush country behind.

Although I felt pretty invisible in my hole in the ground, in reality I stuck out like a sore thumb. The only way to win was to visit my waterhole every day, day in and day out, week in and week out, month in and month out – until the hole, with me in it, became a part of the animals' environment.

Managing a camp and working as if I was a full-time wildlife photographer could possibly work, or so I was trying to convince myself, as I rehearsed the speech I would later give to Claire. Photography is all about light and so I decided to spend the early hours of the morning at the waterhole, and also the late hours of the afternoon. At these times of day the safari guests in camp all went out on their safari drives, so this was potentially a suitable modus operandi. With my camera still showing that I had 36 frames available on my roll of film (or more specifically 37), it was discouraging to say the least, but walking back to the camp up the steep hill in the twilight, I vowed to myself to not rest until I had successfully captured a Livingstone lion on camera.

35

Kubwa shida maji

'Bwana Greg ... Bwana Greg ... kubwa shida maji ... Bwana Greg ... Bwana Greg ... kubwa shida maji ... Bwana Greg ... Bwana Greg ... kubwa shida maji.' I thought I was dreaming but I was now awake and all I could hear was someone calling my name – generally pronounced 'Grig', but I was getting used to that; at least the night watchman wasn't calling me 'Claire' – outside our tent.

My Swahili was still rudimentary and at 2 am it was taking me longer than usual to translate the words in my mind. As I slipped my feet into my sandals, Claire stirred and asked what the problem was. I told her I had no idea but that the night watchman, who went by the name of Nairobi, was outside saying that there was 'kubwa shida maji'.

'What does that mean?' she asked.

'Big trouble water,' I told her, having finally worked it out.

I stepped out into the moonlight, where Nairobi was waiting for me. He motioned for me to follow him down the hill. He was dressed in traditional Maasai garb and clutching a small silver torch in one hand, the kind that is made in China and comes with a little red button, and which necessitates two giant size batteries without offering much more light than that of a candle.

I asked him, 'Nairobi, what's going on?' but his English was about as good as my Swahili.

'Come ... come ... come,' he urged me.

He led me past the mess area and down to the swimming pool. This was no ordinary pool; it was the heart and soul of the camp. It was a massive body of water, with curvy walls of course, and built on the side of the mountain facing Mount Shompole. It was deep too and had about the same volume of water as an Olympic swimming pool. Basically it was a typical Simon creation – grand on every scale. Nairobi walked me to the

edge and flicked his torch downwards. I was shocked to see that the pool was empty, completely empty! He was right. This certainly qualified as 'kubwa shida maji'. I snatched the silver torch out of his hand and shone it down the hill in disbelief. The torch might have been no good but I saw the moonlight glistening off a large river of water flowing straight into tent number 5. I was extremely puzzled and still sleepy, but when I remembered the imminent arrival of the investors and the *Marie Claire* team for the fashion shoot, I suddenly felt very awake.

Nairobi pointed to the pumphouse. I was shocked to see that the roof above it had collapsed, and that the main pipe connecting the pool and the pump was snapped in half. Grasping my wrist firmly, Nairobi pulled me back towards the mess saying, 'Come, Greg ... come ... come ... come.' There in the mess I found Chuck, the 21-year-old grass-cutting, self-professing redneck from Kentucky watching a movie on his laptop. Nairobi stood at the entrance, motioning for me to go inside and speak to Chuck. It was a kind of nervous motioning, like encouraging a single person to go speak to a beautiful lady sitting at the bar.

I approached Chuck from behind. Still completely bewildered about what was going on, I said, 'Hey there, Chuck, what you up to?'

Chuck, without looking away from his computer, replied, 'Oh hey, just watching a movie.'

'What movie?' I asked, quite unable to think of an appropriate response.

'*Spaceballs*,' came his reply.

'Um, Chuck, is everything all right?'

'Yip, just fine.'

The by-now familiar lull in conversation that accompanied any dialogue with Chuck followed.

'Um, Chuck. I notice the pool is empty?'

'Oh yeah, sorry about that.'

Silence.

Chuck didn't appear to feel the need to explain further and he kept his eyes on his screen. Perhaps I was just semi-dazed or perhaps too stressed to draw it out of him, but whatever the reason, I decided to move on. I asked Nairobi to go and fetch the plumbing fundi, who came up and plugged the pool so that we could start filling it again. One very good thing about

Kenya was that we seemed to have a fundi for everything, especially since one of the main driving forces behind the community-based eco-camp was to provide jobs. The guests in tent 5 had thankfully thought that the river flowing through their room was just a part of the biomimicry cooling system. Each room in Shompole had a small stream of water flowing through it and into their plunge pool so the extra water had not ruined their night, although it did turn their pool brown.

Walking back up the hill, I was still thoroughly confused by the night's events. It was only the following morning at breakfast that Chuck's mom offered us an explanation for the empty swimming pool, which at first made less sense to me than the non-conversation I'd had with him at two in the morning.

'Greg, I am so sorry about my boy. I have told him to quit smoking so many times!'

'Um, huh?'

'Well, last night, he was unable to sleep because the frogs at the pool were making such a racket so he got up for a smoke and while he was having a smoke he had another bright idea. He decided to use the insect spray in his room combined with his cigarette lighter, to create a flamethrower. He tried to torch the frogs, to get them to keep quiet, you know? But as he was making his way around the edge of the pool he lost his balance and fell through the pumphouse.'

Although my brain was trying to process what the woman from Kentucky was telling me, this story was just so bizarre on so many levels I didn't know where to begin.

'You know we are an eco-lodge?' was the best I could come up with.

'Oh no, I know, Greg and I am so sorry,' said Chuck's mother, glaring across the table at her son, who seemed impervious. 'But this is nothing, Greg,' she went on, before proceeding to explain how Chuck had single-handedly almost destroyed their farm on many occasions – by getting heavy machinery stuck, driving through walls, playing with dynamite ... the list went on.

'Please pass the butter' was about as much conversation as I could muster for the rest of breakfast.

The pool had been filling for six hours and it still looked empty. As if

this was not bad enough, the hosepipe leading into it ran dry. All the cars were out on safari drive and the only vehicle available was the tractor. I radioed for Simon, who was listed on the roll-call sheet as 'Tractor Driver', to come to the office. He spoke Swahili and a bit of English too.

'Right, Simon,' I said, in the distinct tone of a panicked manager. 'Please drive up to the water tanks and inspect them as there seems to be a problem.'

'No,' said Simon.

'Please drive up to the water tanks and inspect them as there seems to be a problem,' I repeated, assuming that he had misheard me or that I had possibly misunderstood his reply, although it was pretty emphatic.

'No,' said Simon.

Does this man know I am his manager, I thought. These super-short conversations were really starting to grind my gears, first with Chuck and now with Simon our tractor driver.

We always had a constant stream of staff waiting outside the office, all wanting to ask something. Requests ranged from wanting advances on salaries to needing to go home to find a lost cow. There were actually lots of requests to go and find lost cows. Their cattle are everything to the Maasai, and so we got very used to granting leave for lost cows. One day the dishwasher came into the office requesting some time off to go find his lost wife!

Because there were so many staff always wanting to speak to us, Claire and I would often tell them to 'wait here', pointing out the door. Whenever we did that, whoever was standing in our office would turn around and run out the door, down the steps, never to return. It was infuriating. It took us months to figure out that when we spoke fast, like many South Africans do, the words 'wait here' had the same ring as 'iache' which means 'leave it' in Swahili.

This morning it was Kibonge, the wood fundi, who was standing outside the office waiting to ask for something or other. Since so much was getting lost in translation, I assumed that Simon had misinterpreted my instruction, which was more like a command under the pressured circumstances, so I asked Kibonge to repeat it for Simon in Swahili. Simon's reply was the same, a definite, unmistakable 'No.'

At this point I felt the need to take a seat. I politely asked Kibonge to tell Simon that I was the camp manager and I was giving him a direct order to drive his blue tractor up to the blasted hill to inspect the water tanks. At this Simon began shaking terribly and a torrent of words came out. Kibonge explained his distress: 'Simon says that even if you fire him he refuses to go to the water tanks because the last time he did a crazy German mzungu tried to kill him.'

'What do you mean, tried to kill him?' I asked, more shocked now than exasperated.

'He put a gun against his head,' said Kibonge.

The water tanks, he informed me, were actually built on land belonging to our German neighbour, who was a complete recluse. No one knew what he did up there. He owned a large tract of land between us and the high escarpment. We knew very little about him other than that he was wealthy and his name was Stein, but he was rumoured to have dubious business interests (smuggling gemstones in from Tanzania, some said) and friends in high places in the Kenyan government. He had a house in Nairobi, a grand mansion that was equally mysterious and not even his son's friends were allowed to visit to play. Not exactly the kind of neighbour we would pop over to borrow some sugar from. Sometimes we heard the sound of large airplanes landing in the hills behind camp, which seemed more than a little odd and fitted nicely with the smuggling story.

Be that as it may, we still had a major dilemma. The pool was the soul of the camp and with the investors coming, plus the fashion shoot contingent, we had to get it filled. Eventually, Simon capitulated. He agreed to go to the water tanks but only if I accompanied him. Soon I found myself seated on the wheel arch of the blue tractor bouncing my way up the Nguruman escarpment, on the look-out not for lifers this time but for a crazy German wielding a Luger pistol. We managed to repair a crack in the tank without getting arrested for trespassing, or shot, but the jolting from the tractor had, I was sure of it, shaken my tooth fillings loose.

With the pool finally filling again, I walked down to my waterhole. My body was still reverberating from the jolting ride up the escarpment, which reminded me to make sure that the vibration reduction on my lens was switched on. I jumped into my hole and stood waiting for my Livingstone

lions. The same pair of Egyptian geese were there but flew off as soon as it appeared I was going to stick around. It was deadly quiet but after the day I had had, standing in a hole in the ground, in perfect serene silence, was preferable to being anywhere else.

36

Aim two feet lower

The big day arrived when the advance crew for the *Marie Claire* fashion shoot landed, via private charter from Nairobi. The crew consisted of a photographer, a lighting expert, a make-up artist and the magazine's fashion editor – straight out of New York. The supermodel would only be flown in for the actual shoot. Shompole's chic design, with its white walls and azure blue infinity pool, and being located in the middle of remote Maasai-land, was an idyllic location for a fashion shoot. The photographer in me was already ogling the camera gear, which was a film camera but with a Hasselblad digital back. Digital was something completely foreign to me then.

For the shoot, the fashion editor had brought no fewer than 48 pairs of shoes and these were all lined up along a long wall in the mess area. They were colourful, shiny and sparkly, and news soon spread throughout Maasai-land. Before long we had a steady stream of Maasai mamas walking from God knew where to come and see the shoes. I think it was the biggest news to hit Maasai-land since the rinderpest! The mamas, all dressed in white beadwork and bright shukas, walked along the line of shoes, talking like a flock of babblers, and when they got to the end they started at the beginning again.

The fashion editor addressed Claire. 'Right, guys!' he said expectantly. 'All I need to do now is iron the garments ... ?'

Claire and I looked at each other in dismay. The only iron we had was the kind you filled with coals from a fire. There was no 'on' or 'off' switch and no way to control the temperature. Claire suggested that we show him the 'ironing room' so he could judge for himself. The laundry was all the way down the dusty driveway at the bottom of the hill and we trudged down together. To be honest, the laundry wasn't exactly state of the art. It stood under a clump of Salvadora bushes and consisted of a large tub and a slab of cement, the latter being the ironing board.

When we arrived a Maasai mama was bent over the cement slab with an ancient cast-iron iron, giving it serious elbow grease as she pushed it to and fro across a king-size white sheet. The editor handed Claire a glitzy-looking dress which Claire held in two fingers as if it was a black mamba. Too scared to use the iron on it, she suggested that the fashion editor try first, and perhaps just on the belt, which was made of the same ruby-coloured chiffon material. The instant the iron touched the belt, it singed it. Holding it up to the sun, the damage was well and truly confirmed: the part the iron had touched was now see-through.

The editor immediately succumbed to a panic attack. We sent Pat, who was head of laundry, scurrying up the hill to fetch a brown paper bag from the kitchen, while Claire did her best to console the man, who was now sitting hunched over on the cement slab in our open-air laundrette. By the time the brown bag arrived there was no need for it. The fashion editor had found his second wind, literally. Leaping to his feet and throwing his arms into the air with much pizzazz, he exclaimed, 'Right, team! I once had this problem in Paris where we forgot the steamer. All we did was we closed all the windows and ran the hot tub. The steam takes the creases right out!'

I could see Claire looking uneasy. There was not a single closed room in all of the lodge. There were no windows anywhere, and no hot tubs either. This unwelcome news took the second wind right out his sails and he collapsed back onto the cement slab. This time we had the brown paper bag ready.

To cut a long and stressful story short, we organised a few large sufurias, or cooking pots, to be filled with boiling water in the kitchen. Sweating profusely, and not just from the steam, the fashion editor bent over them, holding the designer gowns above the steam. All that this really achieved was the fashion maestro needing a rehydrate sachet. The garments remained creased. Finally he accepted defeat.

'Oh well,' he sighed. 'We shall just airbrush the creases out.' And throwing one hand into the air, he floated out of the kitchen amidst a cloud of steam, leaving me with the photographer, who looked super bleak, no doubt realising that he would be spending the next week deleting creases. On a Hasselblad medium format camera every crease would be visible!

With the fashion crew setting up shop, I took the afternoon to go to my waterhole, where the fresh tracks of Livingstone lion were visible in the dust. The Egyptian geese pair flew off, as per usual, when I got there. If I stood motionless, after about an hour or so they would tentatively walk back to the edge of the waterhole where they would stand dead still, peering suspiciously in my direction. They were the only living thing in sight though and so I was grateful for their company. Standing motionless made my legs ache, so I'd asked Kibonge to build me a bench to sit on. The staff were still baffled by this mzungu who went down to the waterhole to sit in a hole in the ground every day. I can't say I blamed them.

The model hit the ground running and the first shoot was under way in Little Shompole tent number 2, the honeymoon suite – a room that was as big as a house, with a long flowing deck and a massive bed so big that it needed custom-made sheets. I was standing to the side watching the photographer work and I was drooling all right, but not at the model – at the Hasselblad! When Claire finished her day's admin, she popped past and when she saw that the model did her wardrobe changes out in the open, she insisted that I leave. With her arms folded and the tapping of one of her feet, I decided to leave without argument.

Later that night Claire returned to our tent in tears. I asked her what had happened. She explained that at dinner she had placed the first course on the table and the fashion editor had slid his plate across the table, demanding to know what she had dared to place in front of him. When Claire told him it was tuna mousse on melba toast, in front of all the crew at the dinner table he threw a tantrum. 'How dare you serve me tinned tuna!' he said in disgust. Claire had been terribly embarrassed.

Being a camp manager is tough work and at Shompole we were really up against it. We had fashion editors expecting fresh tuna when we could not even get fresh tilapia!

I once had the most bizarre conversation with a German guest who was checking out and this was long before the days of internet via satellite.

'Greg, why can't I pay with a credit card?' he demanded.

'Um, Ulrich, you see, we don't have phone lines.'

'Well, why the hell not?' he said.

I have to say this left me speechless. I could only presume that the Kenyan government had not seen the need to put a few hundred kilometres of telephone lines in just for our camp – but of course I didn't say that.

There was a Kenyan mzungu called Simon, who Simon, our big boss, had hired to set up a fly-camp down on the river, a couple of hours' drive away from the lodge. This Simon was affectionately known by the Maasai as Simon 2. He was like someone out of a storybook, or perhaps, more aptly, someone out of a Hollywood movie. He was short but well-built and deeply tanned. One knew this because he never wore a shirt, or pants for that matter, only a kikoi. He had long wavy blond hair. Ice would not melt on him, not even in the hot rift valley. I never saw him break a sweat. In fact we didn't see all that much of Simon 2. He spent three months of the year doing security work in Iraq; for the rest of the year all he wanted to do was camp in the bush and live like a Maasai. We only saw him when he popped into the camp to get his Pilates ball inflated. He kept himself busy trying to clear the logjams in the river so that when the fly-camp was in place, we could offer canoeing. He was not being paid but was a friend of Simon number 1. He had no abode and would sleep on couches in Nairobi when he was not on the river. Anita, the general manager of Shompole, was trying to get him a work permit and had to drive him to get a passport photo as he had no transport. When he arrived at her door to leave, he was wearing the tiniest, shortest shorts ever, and he had no shoes on. His upper body was, however, all dressed up in a jacket and tie, and his hair neatly combed, appropriately so, because only his upper body would appear in the photograph.

Much like the bush telegraph spread through Maasai-land about the line of glitzy, sparkling shoes, Simon 2 got wind of the fact that there was a supermodel staying in camp and out of the blue he swaggered into the office. He always spoke with a drawl, as if he was high on weed, and stretching himself prostrate on the office couch, he volunteered his general services to help around camp. Claire, being the ever-pragmatic one, pointed out that we had no bed for him as Simon 1 and the investors

were arriving the next day. Simon 2 was unfazed. He always slept outside anyway, he said, and a pool lounger would do.

The fashion brigade took the model out onto the plains, where she was draped over a curvy acacia branch and told to 'work the tree' while she purred like a cheetah. (Talking of purring: it's an interesting fact about the big cats that lions and leopards can't purr; only cheetahs can. The rigid bones in the throat structure of lions and leopards that allow them to roar do not allow them to purr, and vice versa in the cheetah, which does not roar but chirps like a bird.)

The model shoot on the plains was not my cup of tea. I was far more interested in my Livingstone lions, so I went back to my waterhole. Again, with no cars available, I had to walk down. It was a steep descent and at 3 pm it was still ridiculously hot. Walking under the large acacia trees that grew at the base of the escarpment did at least provide partial shade along my journey. Hefty white puffy clouds hung in the sky and although I was sweating, carrying my grey Pelican case in one hand and a rifle in the other, I didn't mind. I just wanted to bag my shot of a Livingstone lion.

Sitting in my hole, there was nothing stirring at the waterhole and I was a little more fidgety than usual. Our managing director and the investors were all arriving the next day so perhaps my nerves were just on edge. I decided to leave my camera in the hole and take a walk around the edge of the water. The fine volcanic dust had hundreds of tracks imprinted in it. There were definitely lots of animals in the area and the sand had been heavily trampled on one end by a herd of zebra. I saw the tracks of a couple of dagha boys too, who no doubt were hanging out in the fig forest and using the waterhole as their main water source. I then decided to follow a game trail that led away from the waterhole, following it out and onto the wide plains. It was a zebras' track I was on and, as such, it was narrow and windy. Zebras all walk in single file, and on the same track, day in and day out, so that eventually a deep rut forms in the earth. They are also what we call 'water-dependent animals', meaning that they need to drink every day. There are quite a few antelope in Africa and especially in Kenya, which, being a very arid country, are 'water independent', never needing to drink and deriving all their moisture from the food they eat. The dik-dik is one such creature. I walked past a dik-dik midden and noticed how even the

fresh pellets come out brown and dry, evidence of all the moisture having being extracted.

Following a winding game trail, not knowing where it will take you, is one of my favourite pastimes. Perhaps it is the thought and realisation that the path I am walking on has been created solely by the hooves and paws of wild animals, enough of them to create a pathway and yet so shy that one hardly ever sees them. The volcanic dust was so fine in the south rift that I could see the thin faint lines where a porcupine had dragged its quills. The trail wound its way through tall khaki grass and past giant castles of clay. I soon found myself wilderness exploring again. In the distance I saw the windsock of the airstrip. I decided to make my way over to it, recalling how a ranger in MalaMala was once asked by his safari tourists if the bright orange thing was the giraffe feeder.

Inspecting the runway for the investors' landing the next day I noticed a Coke bottle glistening in the sun, possibly tossed by a pilot. Feeling a bit like I was in *The Gods Must Be Crazy*, I picked it up. Since I had gotten to Shompole I hadn't tested Simon's rifle yet. I decided now was as good a time as any to see if the sights were in and, propping the bottle on a termite mound, I took aim and squeezed the trigger. The Coke bottle stayed standing. I moved closer and took another shot but got the same result. I moved closer still and tried a third time. The Coke bottle stayed perched in its exact position on top of the termite mound. Deciding that the rifle was more useful as a club than a gun, I scooped up the bottle and headed back to camp.

The same plane with yellow wings buzzed the camp the next day. It was Simon our MD with the Weders, who were the money behind Shompole. I raced down to the airstrip. Simon climbed out first. He had his shades on and was wearing jeans, sandals and a white loose-fitting cotton shirt. In his typical deep and mellow tone, he greeted me, 'Greg, bwana, how are you, man?' and introduced me to his guests. They were longstanding safari clients of his and must have been severely bitten by the Africa bug. When he pitched the idea to them of building a camp in the middle of nowhere in Maasai-land, they'd agreed to come in as investors. Driving back to camp with Simon in the front seat next to me, I asked, 'Tell me, that rifle in camp, is it yours?'

'Greg, bwana, that is my old hunting rifle. I used to hunt down here with my dad, you know.'

'Tell me, Simon, I tested it yesterday and the sights seem really out?'

'No, they're not,' he said. 'You need to aim two feet lower than your target. The sights have always been that way and I learned to shoot with that rifle, so if I change it now, I will miss everything!' he said.

The Weders were quiet and they seemed a little anxious about all the money they had poured into the venture for they alluded to it more than once over lunch. To my mind they hadn't put enough money into it – the camp was sorely lacking when it came to basic infrastructure. While we were at lunch, our fresh produce was rotting in a charcoal room, which was our only cold-room, except that it was more of a 'cool room'. I didn't mention that *Marie Claire*'s fashion editor was in camp demanding fresh tuna.

That afternoon Simon took the Weders down to the river for a paddle and to no doubt ask them for more money to build the fly-camp. The fashion shoot was shooting poolside (thankfully the pool had filled just in time!) and Simon 2 had appointed himself as a grip. It was a still photography shoot, no sound, so quite what a grip would do was anyone's guess, but I suppose he was just keen to be in on the action. Claire was busy in the office, furiously trying to sort out the admin, and with everyone occupied, I saw a gap to head down to my waterhole.

Sitting in my hole had become my happy place. There might not have been animals to see but just the chance of them appearing for a drink was addictive. My Livingstone lions were out there somewhere – and at some point they had to drink.

Dinner was a grand affair. We seated the entire camp at the big fig wood table. The chairs were made from the same wood and they were really heavy, with high backs. White curvy walls, smooth cement floors and lanterns flickering everywhere made it feel like we were truly actors in *Out of Africa*. The waiters wore kangas and we had Kitengela hand-blown glassware on the table, including two glass dishes, one for salt and one for pepper. Kitengela Glass is a family-run glass factory just outside Nairobi and they make the most exquisitely rustic and elegant hand-blown glassware. We all sat down together, including the *Marie Claire* fashion editor and the supermodel, whose dress, I noted, looked a little creased. Claire

had made sure there was no tinned tuna on the menu tonight.

The starters had just been served when in walked Simon 2. More accurately, in swaggered Simon 2 and what an apparition he was. To start with he was dripping wet, having just taken a shower, and his wet hair, now shoulder length, draped around his chiselled features. That wasn't the worst of it. Simon 2 was wearing nothing but a very tiny, very skimpy, very tight-fitting pair of hotpants. No shoes. No shirt. Casually he sat down and reached for a fresh bread roll. I think Simon 1 wanted to reach for his ear! Instead he suggested that he go and find a shirt, to which Simon 2 responded, 'I don't have one, they're all dirty.'

'Well, go and get one from a guide,' said Simon 1, clearly embarrassed in front of the investors.

Simon 2 got up reluctantly and disappeared around the corner. When he came back he was wearing the tiniest shirt imaginable, bright blue and with the words 'Robben Island Swim Team' on the front. As it turned out, the only guide who had a shirt was Andrew, as the others were either Maasai or Samburu. Andrew was tall and skinny, so his T-shirt made stocky Simon 2 look like the Incredible Hulk. He sat down and began buttering his bread roll, while Simon 1 tried his best to steer conversation to the other side of the table. Thankfully the fashion editor seemed to have perked up after his shaky start and didn't complain about anything.

Over dinner we heard all about the Weders' canoeing trip and how Simon 1 had managed to get them almost killed by a hippo. The animal had charged at them and Simon had fired off a warning shot, right next to Mrs Weder's ear. I presumed that to fire a warning shot, he would have had to have aimed his rifle straight at the hippo so that the bullet missed the animal, but I didn't ask. Mrs Weder's ears were still ringing, and they all roared with laughter as they retold the story. Simon was a true Kenyan safari guide or 'Kenya cowboy' as they are known, and it wasn't the only reckless thing he did that day, as we were soon to find out.

37

Lions in the dust

In the early hours of the morning I heard a loud crackling sound. In my head it sounded like the water tank beneath our bed was overflowing, that the water was spilling onto the rocky ground below. I stirred and rolled over and as I did so, I noticed an orange glow coming from outside. It took me a few seconds to comprehend what was happening. Leaping out of bed, I stared across the rift valley in horror. A furious burning wall of flames stretched across the valley floor. What I had thought was water overflowing was in fact the crackling sound of flames tearing their way through two-metre high elephant grass on the plains below camp. By this time Claire was awake too. I told her I was going to go and rally up a fire-fighting team.

Fire ecology had been my favourite subject when studying nature conservation and I had quite a bit of experience with fires and burning fire-breaks. But this camp had no fire-break and with roofs made from dried papyrus, and being located on a hill surrounded by thorn scrub, the whole place could go up in flames in no time at all. I woke the guides, then grabbed a few dishtowels out of the kitchen, which I soaked in kerosene, poured out from lanterns. The night watchmen, who must have been in a deeper sleep than me for I seemed to have woken them, watched in bemusement as I attached the rags to the end of Mzee Tingo's rake. We then all jumped into a safari truck, including Claire, and tore off down the hill.

We drove along the same track that led to my waterhole. The fire was fast approaching, its licking flames an angry, hungry dragon devouring the grassy plains. It was as if the dragon was smacking its lips together, periodically sending dancing flames high into the sky. Soon the fire would be at the road and if it jumped it, the camp would be gone. I had to make the tough call of whether or not to start a back-burn. By starting another fire, I could extinguish the main fire: when the two met they

could put each other out. Or, I could start another fire which could itself jump the road and burn the camp down, in which case I would definitely be fired (no pun intended). There was no time to think, though. When they saw me lighting the rags and begin dragging the rake through the bush to start a second fire the guides seemed stunned. Although counter-intuitive, it seemed to be working. The back-burn made its way towards the main fire and, just as dawn broke, the two fires met. Watching the sunrise in amongst the flames was an incredible sight and is indelibly imprinted on my brain forever. Thankfully, literal fire fought fire and the two blazes extinguished each other.

Driving back to camp with soot-covered faces and the adrenalin wearing off, we were all ready for bed, except that the guests were all waking up!

The Weders and Simon had slept in and they arrived at breakfast look-ing much fresher than Claire and I, none the wiser that the camp had nearly burned down. This reminded me of that time in the Timbavati when I had slept right through a fire in camp and how Hap had never let me forget it. After ordering hot breakfasts, Mrs Weder started talking about the previous afternoon's adventures again. 'After the hippo charged ja, we were so full of adrenalin ja, we stopped for a sundowner on the plains and Simon lit a fire ja.'

We all looked at Simon, who said, 'The savannah needs a good burn every now and again. The Maasai should have lit fires by now.'

It took some time to sink in.

Our managing director had lit the fire that we had been up since the wee hours fighting and which had nearly burned the camp down – with the investors in it. It was like we were living in the Wild West.

'There's no bacon, I ordered bacon!' said Mrs Weder.

Still processing Simon's confession, I'd not been paying attention and her sharp words brought me back to the breakfast table. I jumped up and ran to the kitchen to enquire about the bacon. I was told that the crispy bacon had been put on the plate but that when the waiters carried the breakfast from the kitchen to the mess area, Eddie the eagle had swooped down and snatched it up. TIA (this is Africa), I thought.

On my way back to the mess I saw a safari guest literally sitting in the middle of a Boscia bush.

'Can I help?' I asked.

'Yes!' came the emphatic reply. 'I am scared of Christmas!'

December was a while away and anyway, he didn't need to explain. Our pet zebra had recently taken to the bad habit of chasing our guests. He had a nasty bite and a good kick on him, so it was beginning to be a real problem. Offering the frightened tourist a hand out of the bush, we strolled together towards the mess. We were about halfway when Christmas came charging down the path behind us, his lips curled back, displaying his large white teeth, catapulting both guest and me into instant flight. Screaming, with our hands waving above our heads, we skidded into the dining area where Mrs Weder was still patiently waiting for her bacon. When I explained that Eddie had stolen it and that Christmas was chasing us, the Weders exchanged a look, no doubt wondering where the company had found this new manager and whether they had invested their money in a sound venture.

Once everyone had left on their safari drive, and although I was super tired, I knew that I just had to visit my waterhole as this might be the day that my Livingstone lions turned up. Claire seemed surprised when I picked up my Pelican case, the rifle and a radio and headed out the door. But I was a man on a mission and I was damned if I was going to let a runaway fire, a bacon-stealing eagle, a tourist-chasing zebra and a pyromaniac boss keep me from my real purpose of becoming a wildlife photographer.

'Be careful!' Claire called after me, as she always did when I left. I trudged off down the hill and was soon ensconced in my hole in the ground. I imagined it to be a little bit like trench warfare in World War I, only far more pleasant, of course, despite the odd tsetse fly. As usual my geese had started hissing at me, protesting my arrival at their patch of water, but they no longer flew straight off; they just ran into the long grass instead. After an hour or so, they came walking slowly back to the water's edge and began grooming themselves. Although they were probably still muttering under their breaths, they were starting to accept my presence. This was a good sign, I thought, and I hoped that the other wildlife would follow suit.

I was sitting quietly, enjoying just sitting after a tough day, when the radio crackled.

'Greg, come in.' It was Claire's sweet voice. 'There is a really big dust storm on its way, love!'

'Roger. I will sit tight,' I replied.

We had been warned about these massive dust storms that sweep across the south rift but we hadn't personally experienced one yet. As I placed my camera gear back in the dust-proof Pelican case, I noticed the distant horizon turning a light and eerie yellow as a wall of dust rose from the valley floor, stretching to the sky above. Soon enough it looked like Armageddon was upon me. The wind picked up and dust swirled around the waterhole. Just when I thought my day could not get any worse, out of the corner of my eye I caught some movement. Squinting, straining to see through the swirling dust, I drew my breath in fright. I saw a lioness crouched and peering around the side of a Salvadora bush. Were my eyes deceiving me? It was hard to tell. The dust was the colour of a lion's coat. Slowly I picked up my binoculars and there she was. I met her gaze square on and then watched in horror as she inched forward on her belly.

I had seen this behaviour before so I knew she was stalking something. Knowing that lions are co-operative hunters, I swung my binoculars around to the other side of the waterhole and there I saw another lioness, also lying flat on her belly, realigning her back legs, shuffling them from side to side. It was clear to me that both lionesses were intent on hunting something but it was a most disturbing realisation that unless a gazelle was standing on top of the roof of my hide, they were hunting me. Many thoughts began to race through my head, the most prominent of which was: Do I grab the rifle or my camera? Deciding that the light levels were hopelessly too low and that focusing through the dust was futile, I slid a .458 round down the chamber.

Grabbing the radio, I blurted out, 'Claire ... lions ... send a car ... QUICK!'

Lions enjoy eating warthogs and as the painful realisation set in that the lions on either side of me most likely perceived me as a pig in a hole, I swallowed the lump in my throat and gripped the rifle tightly. I heard Claire radioing one of the guides.

'James, James, come in!' As irony would have it, James was one of the guides who drove too fast and Claire had recently told him to slow down, so her next command must have left him a little confused. 'Drive as *fast* as

you can to the waterhole and pick Greg up. There are lions!'

There were no vehicles in camp so I would just have to wait for James to turn around wherever he was and come and fetch me. By now the dust was really swirling in the fierce wind. Swinging my head from side to side, trying my best to keep an eye on both lionesses, I fought down panic. Claire, meanwhile, had hurried down to the main mess area where there was a Swarovski telescope. She had a better view of the scene at the waterhole than I did as the storm had not yet reached the camp. I can't imagine what she was feeling. With dust the exact same colour as the two tawny lionesses, I had temporarily lost sight of them both. In the spooky light of the dust storm I heard the radio crackle.

'The lioness on the left ... moving closer,' said Claire.

It was a bad situation: the lionesses were using the wind and dust to aid their stalk while I could hardly see a thing. I tried to suppress the thought that kept surfacing in my mind. The only thing the lions knew that lived in holes were pigs – and they liked pigs. They were just doing what they were wired to do. Clutching the rifle still tighter, I promised myself that this was one little piggy they would not eat!

Getting that feeling that you do when you are in a hole and being stalked by lions, that feeling that something is watching you, I swung around and pointed the rifle into seemingly nothing but dust. The hair on the back of my neck was tingling. Staring straight down the barrel, I looked into two large yellow eyes, less than three yards in front of me. They were the eyes of a young male lion, who must have been too inquisitive to wait for the lionesses to stalk in and had simply walked closer to investigate. I am not sure why I did it but I spoke to him. 'You take one more step, mister, and it's goodnight, you hear?'

As if responding, the sub-adult lion tilted his head and turned it to the side, giving me a puzzled look. The tension immediately dissipated. I realised that the lions were just inquisitive. If they were hunting me, it would have been over, one way or the other.

I lowered the rifle as James screeched to a halt next to my hole, sending the pride scurrying back into the bushes and leaving his safari guests wondering what on earth the camp manager was doing in his spare time. I leapt aboard and got dropped off back at the camp, allowing James to

continue with his safari. Claire was in need of some consoling and I did my best to quiet her fears.

Lying in bed that night I was too exhausted to stay awake for long but just long enough to know that I had indeed found my Livingstone lions or, more accurately, they had found me. In all the dust and tension I had failed to get any photographs of them. I still had no photographic proof that these lions existed. I needed this, if for nothing else but my own record. At least the lions were close – that much I now knew for sure – and I figured that in a week or so's time, I would have the photographs that had become vital to my well-being. This was the last thought I had before passing out. I am sure I slept with a smile on my face.

38

The Lunatic Express

Before we knew it, the fashion shoot was over, the investors were gone and our first stint working at Shompole was coming to a close. The camp was still standing and so were we, even if only just. When the day came for our off days we were like a couple of schoolkids waiting for the last bell to ring before the holidays commenced. Our relief manager arrived and he seemed like a terribly nice fellow.

Tim Tucker wore short green shorts, sandals and a khaki T-shirt and as he greeted us, he added a nervous laugh between sentences. Tim had renounced his British passport and had taken up Kenyan citizenship, as dual citizenship in Kenya is not allowed. Tim was as Kenyan as they come and the laugh he threw between sentences came no doubt from many years of experience living in Kenya. It was a reassuring kind of laugh, one that said, and far more effectively than words, It's a crazy place, this Kenya, but everything's going to be all right. I immediately liked Tim – he was of the old school.

As I did a handover meeting with the staff, I watched how he interacted with them and I took mental notes. Tim was an old hand at this. He greeted the staff fervently, shaking their hands with both of his and exclaiming loudly, 'Habari, habari, habari.' He was genuine, firm and sincere. After the staff meeting, Claire did an admin handover and I saw Tim's eyes glaze over. He was from another era and had started in Kenya long before we were even born, at a time when they still did safaris on horseback. I was also immediately envious of Tim because he had seen Kenya in what I thought of as its heyday. Even now, although it was a spectacular country, I couldn't help the romantic view I had of it, imagining the present as an afterglow of what it once was. As Claire attempted to show Tim what an email was and how to send and receive via HF radio, he took copious notes, writing every step down point by point, including a diagram showing where to switch the computer on.

And then the two of us were on the road, creating a trail of dust across the floor of the rift valley. I felt a pang of regret as we passed my waterhole. When I returned I would have to start the process of general habituation all over again. My geese had just started to accept my presence in my hole and were behaving as if I was not there. The lions had not shown up again and the zebra stood way off on the horizon, waiting for me to leave each day, before coming in to drink. I was slowly winning them over but when I had suggested to Claire that for our off days we camp at the waterhole, she gave me the kind of look that a wife sometimes does, the kind that leaves you certain to never raise the subject again.

So, bypassing the waterhole and shouting to my geese, 'Kwaheri, tut-aonana baadaye!' I assured them that I would see them later. I then decided to try and take a shortcut across the valley. The heaving safari truck porpoised like a whale (to mix metaphors) as we hit pockets of deep volcanic dust. Each time we hit one such dust-filled pothole, a large plume of fine dust splashed over the bonnet and seeped into the cabin. We stuck our heads out of the windows, and I managed to keep my foot flat on the pedal.

The dust in the south rift is not to be taken lightly – one can easily get stuck in it. Take the case, just one week prior, of the two Russian safari agents. They were being driven in by a local guide whom they had hired in Nairobi. After he got stuck in the dust the two women decided that he was a complete and utter useless driver to have gotten stuck in dust, and they decided to ditch both him and the vehicle and proceed on foot to our camp. The driver eventually managed to get himself unstuck and carried on to Shompole, where we were waiting with welcome drinks in hand. The driver got out but because of all the dust we could not see into the cabin. We waited for him to open the back doors, which he didn't. He then told us that the two Russian women were out there, somewhere, on the floor of the desolate, dry and fiercely hot rift valley.

We sent the guides out to look for them. When they returned empty handed we called Nairobi on the radio and had an aeroplane on standby. Just as the plane was about to leave Wilson Airport, I scanned the rift valley floor one last time through the Swarovski telescope. To my amazement, way off in the distance I saw a mirage, which morphed into two wobbling

human shapes. I cancelled the plane and sent a car to fetch them. The Russian duo arrived looking the worse for wear and covered head to toe in dust. Despite being dehydrated, they both promptly ordered a double vodka before passing out in a heap, one on top of the other, on the couch in the mess area.

Fortunately, Claire and I did not get stuck. Once we were through Magadi and on the open road, I felt like we were really on leave. We popped into the Nairobi office to say hi. Amanda, the office manager, asked, 'So, what are your plans for your off days then?' When we told her that we planned on catching the Lunatic Express to the coast and back, she looked more than a little doubtful. I explained to her that ever since hearing the story about this train, I had wanted to do the trip.

'Greg, the train, back in the day, was a wonderful way to get to the coast but, you see, times have changed,' she said, adding, 'Tell you what. Go down by train but we will fly you back from Malindi.' She insisted on this last point and since the company was paying, we thought it would be rude to refuse.

The Lunatic Express is the name given to the railway line that the British built linking Mombasa on the Kenyan coast with Uganda. This line is an interesting part of Kenya's history and it's the reason why Nairobi developed into a city. Work on the Lunatic Express – it was not called this at the time, of course – began in 1896 and was carried out by thousands of Indian labourers brought in from India for the purpose. Of the over 2 000 labourers who died during the five-year construction, it was the death of those who were killed by the legendary 'man-eaters of Tsavo' – about 28 men, or so it was recorded – that grabbed world attention and led to JH Patterson's book of the same name. Nearly 100 years later, in 1996, it was made into a movie called *The Ghost and the Darkness*.

The pair of so-called 'man-eating' lions struck terror in the hearts of the railway labourers, who went on strike and sat on the train to avoid being eaten. They had every reason to be frightened. The man-eaters dragged

men out of their tents at night, ignoring both the erected thorn barriers and fires that were kept burning to keep them at bay. Despite after-dark curfews, the attacks escalated and the lions, as legend would have it, even ignored gazelle bait. It appeared that the coalition, consisting of two maneless lions, enjoyed the taste of human flesh.

The two lions managed to bring the entire project of building the railway bridge over the Tsavo River to a halt. One Lieutenant-Colonel Patterson decided to take matters into his own hands. Having had experience hunting tigers in India, he succeeded in his quest: he shot and killed both lions, the second on 29 December 1898. Both lions were exceptionally brute beasts, measuring 2.7 metres from nose to tail and requiring eight men each to carry their bodies back to camp. Patterson had built a platform in a tree and he had sat waiting for the lions, not unlike me sitting waiting in my hole in the ground, although my intentions of shooting my Livingstone lions were not the same as his. And my lions were not man-eaters, as I had recently proven. Sadly for the 'man-eaters of Tsavo', but probably not for the labourers who feared them, they ended up as floor rugs, where they lay for decades until they were resurrected and stuffed. They are now on permanent display in the Field Museum of Natural History in Chicago. After being trampled underfoot for all those years, the lion brothers hardly resemble the formidable beasts they once were but their legend continued.

The railway line was eventually completed successfully and was a definitive moment in the proverbial scramble for Africa. Very interestingly there was a Maasai laiboni or medicine man by the name of Mbatian, after whom one of Mount Kenya's peaks is named, and who died before the Europeans colonised East Africa. Mbatian on his deathbed prophesied that there would come an 'iron snake' that would divide the region and bring much trouble. He was correct in this. That snake did come and it spawned Naroibi, the centre of colonial rule.

The story of the Lunatic Express had always fascinated me and I could not wait to do the rail journey. When Claire and I arrived at the station we were met by a scene that was quite disconcerting. Thousands of people were busy clambering on board.

'Not to worry, dear,' I said. 'I booked us a First Class cabin.'

When we found our sleeping quarters, we shuddered to think what Economy Class looked like. We had our own cabin all right but it was pitifully small. The sleeping arrangements were two narrow bunk beds, one up one down. Back in the day the train had been a grand affair, offering its guests silver service in fine style. Theodore Roosevelt had begun his famous safari on this train in 1909. Today, to my disappointment, the train contained only the faintest, the very faintest, residue of its former grandeur. The conductor who came by our cabin to tag our tickets was wearing a jacket that once upon a time, a long time ago, had been a very smart uniform. Now the edges were frayed and only every second button was a grand brass knob with an insignia on it. The ones in between were thin plastic ones, made in China.

Once the train had creaked out of the station and the familiar clackety-clack sound was under way, we decided to go and have dinner. Unfortunately, in order to get to the dining car, we had to go through the kitchen. The latter had no door on it and we got a sneak peek at how dinner was being prepared. Soup was sloshing over the edge of the pots with every jerk of the train, the cooks were sweating profusely and the floor was a stained nightmare. I didn't spot any cow tails, but I instantly lost my appetite. Sitting down at the table we noticed that only half of the cutlery was still the original silver: I had a fork from Sheffield and a shiny metal knife from Nakumatt supermarket. We decided to skip dinner altogether and ordered tea instead, which was served on a beautiful antique silver tray. The milk came in an authentic silver jug but the teapot was a large shiny stainless steel one, the type you see in hospitals and canteens. Lying back in the top bunk bed and replaying Amanda's shocked expression when we told her that we were catching the train to the coast for our off days, I now understood why.

On the edge of our beds were nylon nets with loops on one side.

'Do you think we should attach these, love?' Claire called up to me.

It seemed like a good idea so I hopped down off my bunk to help her secure hers. This proved to be no easy task. The nylon seemed to have shrunk and getting the loops to reach the hooks required some force. When it came to my own bunk bed I gave up. We fell asleep to the rocking of the train. Sometime later in the night the train must have descended

an escarpment because it went screaming downhill at top speed. The carriages were travelling at different speeds and the train was jolting back and forth so violently that I got flung right out my bed, landing on the floor with a thud. I got into Claire's bed, where we both lay awake with eyes as big as saucers. Pulling the blanket up to our necks, we hung onto it for dear life.

The train managed to descend without incident and as the terrain flattened out I whispered to Claire, 'We are now in Tsavo, where the man-eaters live.'

'Well, we'd better not break down!' she whispered back.

Her words were scarcely cold when the train squealed to a halt. Befuddled, I squinted out of the small compartment window at the grand plains of Tsavo in the dawn light. The train passed through such incredibly beautiful terrain en route to the coast, so why did the service only run at night? TIA, I thought as I saw a conductor walking along the tracks.

'What seems to be the problem?' I called out to him.

'We are on a head-on collision course with another train,' he replied in a very matter-of-fact and surprisingly calm manner, 'so we are going to go backwards now.'

Sure enough, we started moving in the opposite direction.

The train ride to the coast should have taken four or five hours. Twelve hours later, sipping tea in the dining cart, I noticed coconut trees. Finally – we were getting close to our destination.

We had booked a banda at a local resort called Ocean Sports, which was known to the locals as 'Open Shorts', and it didn't take us long to understand why. It was the local hangout for fishermen and the pub had the same weathered look as its patrons. Our room was a simple affair consisting of a green tent and a small veranda. We spent our days walking along the beach where we saw more than our fair share of old Italian men wearing Speedos. Just north of where we were staying was the town of Malindi, also called 'Little Italy'. It is rumoured that in the old days when

the heat was on the Mafia they would escape to Malindi until things simmered down.

A honeymoon couple who had been guests at Shompole told us about their experience of Malindi. Friends of theirs in Nairobi had recommended a certain Italian restaurant and so they went looking for it, planning a quiet dinner. As they walked in, the manager told them that the restaurant was closed for the night. When they asked why they were told that the whole restaurant had been reserved for an exclusive and private dinner that evening. They then explained that it was their honeymoon and that all they needed was one small table in the corner, out of the way. After much pleading on their part, the restaurant owner obliged. The couple were served their first plate and the food was delicious. Just as their second plate arrived, in walked a large group of men, every one of them looking like they had just stepped off the set of *The Godfather*. Cigar smoke, bald heads and husky voices filled the room. The couple sat in the corner and were the proverbial flies on the wall, possibly witnessing a real-life Mafiosi meeting, and conducted in Italian to boot.

On one of our days there Claire and I caught a taxi to a forest where I went in search of the Sokoke scops owl. I didn't find the owl but I did notch a good few lifers. I have to say that that walk in the forest was the highlight of our holiday. Well, that and the braai night that Open Shorts had on the Friday night.

The scenery along the coast as we drove to the airport in Malindi was beautiful, with lots of thick-trunked baobabs growing in the middle of sisal plantations. The fruit of a baobab is said to have four times more vitamin C than an orange. It is believed that sailors planted the trees to help fight scurvy. This has always struck me as somewhat ludicrous as a sailor would have needed to plant the tree and wait a good few years before harvesting the first fruit.

We were very grateful to be seated in the small terminal building that was Malindi Airport. Amanda had been right: there was absolutely no need to catch the train back to Nairobi – or ever again for that matter!

When we arrived back at the camp, Tim gave us a handover brief which included a recap of all the crazy guests we had missed. The heat was intense. Although we had just had a holiday, we didn't feel quite ready for our next

stint, but the camp was full of safari guests and soon we were back in the saddle, trying our best to cope with the general chaos of Maasai-land.

I was anxious to get back down to my waterhole where it seemed that my absence had actually worked in my favour. The zebra herd had gotten used to my hide and were now drinking at the waterhole as they normally did, having accepted my covered hole as a part of the general landscape. Watching them through the telescope on our first day back, I could not wait for 3 pm, when the guests would leave on their afternoon safari drive and I could go and sit in my hole.

39

The bird that changed my life

Comfortably in my happy place once more, I saw, out of the corner of my eye, a large dazzle of zebra off to my left approaching the water from the open plains. I was facing forward, towards the water, and dared not to move; the slightest movement could send them running. Sitting motion-less and desperately wanting to take care of an itchy spot on my nose, I just had to wait for the herd to take their time arriving. When they still hadn't come into view after what felt like hours, I couldn't put it off a sec-ond longer. I scratched my nose and immediately the herd turned around and disappeared into the tall elephant grass on the horizon. Frustrated, I trundled back up the hill in the intense heat with my Pelican case and rifle. I decided that from then on, I would leave the radio and rifle behind as it was just too damn hot to carry everything down and especially back up – on a daily basis.

Every day for the next six weeks I walked down to the waterhole and took up my usual position, like a mannequin in a shop window. I sat there, not moving, not even clicking my camera, just waiting patiently for my Living-stone lions to appear, or actually for anything to appear. At this point I would have photographed anything that was in reach but the animals kept their distance. This was extra frustrating to me because the waterhole was always surrounded by a variety of animal tracks, and plenty of them. They were drinking from the waterhole all right – just not when I was there! The game in the south rift is unique in that they live alongside the Maasai community. This was not a national park or game reserve, where animals lived in a preserve, one exclusively set aside for them. This was *real* Africa and the animals were therefore *real* clever. They could smell me in my hide, they knew I was there and so they remained hidden.

Looking back on one's life, it is interesting how one can clearly pinpoint critical moments of the 'tipping point' variety. There are perhaps only a

few in a person's lifetime but each impacts another. If any one of these events had not happened, then your life (or career) would have turned out completely differently. Seemingly small and insignificant happenings can have a huge impact on a person's life. I was about to experience one such 'chance meeting' sitting in my hole, next to a waterhole on the floor of Africa's Great Rift Valley. I did not know it, but a cataclysmic event was about to unfold, a personal moment of gargantuan proportions. But I wasn't thinking about that possibility. I was more concerned with an annoying fly that kept landing on my face. I badly wanted to swish it away with my hand but I couldn't do that because a zebra herd was again standing off in the distance, looking intent on coming in for a drink.

Blowing air from my nostrils to try and dislodge the fly was proving futile and, glancing across the waterhole, I noticed something rustle in the grass. There was movement in the tall khaki grass! Not daring to move, I waited with bated breath for the animal to poke its head out. Could it be my Livingstone lions? I sat poised and patient. Suddenly a kori bustard popped its head out of the rank grass. It might have just been a bird but being one of the heaviest flying birds in the world, it was also the biggest living thing I had ever had come so close to the water's edge in the three months that I had been staking out my waterhole. Although my subject was of the feathered variety, it had a pumping heart and I was ecstatic at the prospect of being able to take my very first photograph of a living thing drinking there.

The bird, large and bold like some sort of wild turkey, seemed completely unperturbed by my presence. I picked up my camera just as he folded his legs to lower himself closer to the life-giving water and I took my first photograph at my waterhole! The sound of my Nikon F100's shutter shattered the silence. The bird cocked its head quizzically and looked in my direction. I stopped breathing, fearing the worst – again, expecting my subject to take flight. To my surprise, the bird gazed away and took another sip of water. I took another photograph. The angle that my hide gave me was just perfect. It really brought my subject to life. It might have been just a glorified turkey I was shooting, but it was a wonderful feeling to finally fire off a few frames. But this was not the tipping point. That moment was still to come.

A small herd of waterbuck was approaching the waterhole. The kori bustard was still at the water's edge drinking and this seemed to spur the waterbuck on. Simple logic must have told them that if it was safe for the bird to drink, it must be safe for them too. Composing a frame so that I had the bustard in the foreground and the approaching herd of waterbuck in the background, I felt like Frans Lanting, the famous National Geographic photographer. The waterbuck were super tentative but they steadily kept coming. Before I knew it, they were at the water's edge, drinking. The herd consisted of a group of female defassa waterbuck. After three months of patient waiting, I now had something with fur and hooves squarely sighted in my frame and I was clicking away.

Although I had set out to photograph lions and would have preferred something with claws and jaws at the water's edge, I was just ecstatic that my hole in the ground was starting to deliver wildlife. Just when my first film was spent and I thought my day could not get any better, I heard a neigh from my left, from the side where the zebra were standing. Taking a furtive glance in their direction, sure enough the herd was walking in towards the water, with nodding heads and front hooves kicking up dust. Time stood still. I dared not move. Holding my camera, I watched as the herd gingerly approached the water's edge. Every few minutes they would spook themselves; one would turn to flee, with the rest following suit. But seeing the waterbuck drink, this, combined with the pull of their long thirsts, made them turn around again. Finally, standing as far back from the water as possible, the herd stretched their necks out to reach for a cool drink.

They were drinking immediately to my left and within nine or so yards of where I was sitting. I could hear the air being expelled from their nostrils, like race horses at the starting gate. I could even see pieces of grass stuck between their teeth as they drank. From my eye-level angle, the zebra appeared larger than they were. The dust that they had kicked up from their constant toing and froing lingered in the air. Sitting dead still, not wanting to move and aim my camera in their direction because the slightest movement or faintest sound would send them bolting, I just watched in fascination and awe. Every now and again one of the zebra gave a little squeal. Sitting there I felt like I was actually inside the herd. What a fabulous creature a zebra is! The light was golden as the sun was almost about

to dip below the escarpment. It is now or never, Greg, I said to myself as I handled my camera as quietly as possible. Moving the viewfinder ever so slowly to in front of my right eye I framed a shot. My subtle movement was enough, however, to trigger a flight response from the zebra, who all lifted their heads simultaneously and looked in my direction, for a brief moment, before wheeling around and galloping off in a flurry of hooves, wet mud and dust.

The galloping equids spooked both the bustard and the waterbuck and before I knew it, I was sitting all alone at my waterhole. Not even crickets made a sound as I sat trying to process everything that had just occurred. I didn't fully realise it then, as is almost always the case with these rare pivotal events, but the brilliant bird of bustard variety, by simply coming into drink, had altered the course of my life's trajectory. It had brought the animals in. There was no way of appreciating it properly then but, as it turned out, this bustard was the catalyst that sparked my professional wildlife photographic career. It somehow seemed fitting that it was a bird that had changed my life.

Walking back along the dusty track and through the acacia veld, I had a definite spring in my step or, to be more accurate, I was walking on air. My plans, and my hide, had actually produced wildlife photographs and, with the unique angle offered by my hole, my subjects looked sublime. For the first time in my photographic journey I was taking groundbreaking photographs. The scenes I had witnessed in my camera that afternoon had the look and feel of professional photographers' work I had seen in the *Africa Geographic* magazine; the same golden light and captivating allure. I only hoped that the magic I had experienced through the viewfinder was also locked inside my camera. Shooting on film, there was no way of knowing if I had got my camera settings correct. There was no LCD screen to check afterwards and no live view while actually photographing. Shooting analogue meant that I was shooting blind. The real danger of this was that the scene only really existed in my mind's eye, a difficult thing for a photographer to deal with and something unimaginable in today's digital age.

As soon as I got back to camp, I placed my very first spent film canister in the gas fridge inside the charcoal cool-room. The storeman, James, seemed confused by the small white plastic container but I explained that

I needed to keep the film fresh for when I could return to South Africa to get it developed. The word 'fresh' seemed to throw him because he asked if I was going to eat it – and we both laughed when I explained further.

Later in the tent I shared the afternoon's experience with Claire. Neither of us knew the full impact of what had occurred yet, but I had found the proverbial crack in the wall. A thin metaphoric shaft of dust-filled light now illuminated my dream of becoming a professional wildlife photographer. I knew it was now just a matter of time – perhaps lots and lots more time – in my hole at my waterhole. But the dream of getting the ultimate shot of the ultimate symbol of an African wilderness, a free-ranging lion, a Livingstone lion to me, was within my grasp.

40

The Maasai marathon

There was a couple from Philadelphia in camp and the husband, Jake, was a marathon runner. At dinner he interrupted the banter and asked in an accent that reminded me of Rocky Balboa, 'Yo, Greg, is there anybody here who can take me for a jog tomorrow?' My first impulse was to ask him if he had ever watched the Olympics, where Kenya dominates the long-distance running, but I thought better of it. 'Yes, sure,' I told him. 'Your guide Innocent can take you for a run.' Jake looked pleased with my reply but when I suggested that he leave at sunrise, due to the extreme heat, he insisted that he wanted to leave at 8 am. Claire tried to help by reiterating how hot it gets and even Jake's wife chimed in ('You really should listen to the locals, dear'), but Jake was adamant. He had run the Boston Marathon, he said, and had the necessary experience to know at what time he could run.

I walked out of the back of the mess, where I saw Eddie the eagle fast asleep in the top window opening, bathed in moonlight, past Christmas's paddock and into the back, where Inno was sitting with his brother James. I told Inno that Jake wanted to go for a run at 8 am and that his wife would be sleeping in. 'Sawa,' Inno nodded in agreement, and I returned to the dinner table in time for dessert.

At around 2 am we were woken by voices yelling. It sounded distant, but it was persistent. I was expecting to hear the voices of our night watchmen, as we had three of them, but all I heard was this yelling from afar and so, eventually, I decided that I'd better get up and go and investigate.

Following the calls, I got to the very top of the hill where I met two Swahili gentlemen, both in a frantic state, to say the least. I couldn't tell if they were out of breath or simply just so upset that they were hyperventilating. When they finally calmed down, I got the full story. They were truck drivers from Nairobi and they had suffered a breakdown. The two

men feared for their lives for they thought lions were going to eat them. In the distance they had seen the lantern lights of our camp and had decided to walk for help. I thought it ironic that the two men were terrified of bumping into my Livingstone lions when that was the very thing I badly wanted to do.

Calming the two men down, I poured them some sugar water and told them to sleep in the mess area. In the morning I would ask Kihare, our mechanic, to give them a hand. They seemed so utterly happy to just be alive. As I went back down the hill a thought struck me: where were the three night watchmen? From the office I walked down the steps to the lantern hut where the night watchmen often sat. There I found all three of them lying on the long wooden benches fast asleep! Shining my torch in their faces, I cleared my throat and all three sat bolt upright, as if they had seen a ghost. Not wanting to deal with these sorry excuses for watchmen at 3 am, I bade them a good night's sleep and told them to come and see me in the morning.

Not long after falling back to sleep, I heard the cheery spotted morning thrush, greeting the dawn with its rich melody of jumbled whistles. This tiny bird looks like an LBJ but it sings like an angel and our particular resident thrush enjoyed singing from within the wag-'n-bietjie bush behind our bathroom, where our kuni-booster boiler was. I enjoyed walking back there at dawn where the smell of smouldering wood lingered and I could gaze east, clean across the rift valley, to the point where the sun rose, a large white disc on the distant horizon. With the valley floor sprawled out like a chequered canvas of African colours, I often stared out from this vantage point, knowing that my Livingstone lions were down there, somewhere.

All three night watchmen were standing outside the office waiting for me, looking like they were all suffering from constipation. I was genuinely annoyed. I mean, what was the point of hiring three night watchmen if two strangers could waltz into camp screaming at the top of their lungs without them noticing? The watchmen were supposed to protect the camp at night. What if a guest was in trouble and no one heard them call for help? I allowed my blood to simmer down before inviting the three men in. They had had four hours, since 3 am, to work on their story and it seemed they had an alibi of sorts.

Ole Simba, which means 'the son of a lion', was our oldest staff member, and he appeared to be their spokesperson. He was a short man, not much taller than 5 ft, with a face like a pirate. With his grey hair, he looked old, although he was wiry and strong. On his hip he had his rungu, the beating stick of the Maasai, as well as the customary knife that all Maasai carry with them, the one called a 'simi' and that is always sheathed. It is a killing weapon but is there for self-defence only. The blade is kept incredibly sharp by rubbing it against river stones. The rungu is used to settle milder disputes and disagreements. This stout stick ends in a large ball of wood, often with a small nub on its tip to add extra sting when connecting with an adversary's head. It was not an uncommon sight in Maasai-land to see two Maasai settle an argument by pulling out their rungus and clubbing each other. Culturally this was perfectly acceptable and once the matter had been settled, it was over. The rungu was an age-old, tried and tested, and very effective way of settling problems.

Ole Simba was an elder and as such he had a walking stick fashioned out of a branch from a local tree. The stick was straight, thin and yellowish in colour. The Maasai have a particular way of standing with crossed legs while leaning on their sticks. They have turned standing into an art form. Ole Simba also had large holes in his ears, with copper earings dangling well below his cheekbones. From a young age these traditional Maasai start stretching their earlobes, using progressively larger round blocks of wood, until their earlobes form a very large ring which, in older persons, hangs in a big loop.

Nairobi, the second night watchman, had his earlobes hooked around the top of his ears, which looked quite odd but it was something the Maasai sometimes did, probably to stop the hanging earlobe from getting caught on something. Mzee Patrick was the third watchman. All three of them were wearing the classic 'thousand-miler' sandals that the Maasai are famous for. The sandals are made from recycled car or motorbike rubber and they are held together by nails. They are indestructible, thornproof, light and airy. Their large concave soles are ideal for walking as a person's foot can roll from the toe through to the heel. In fact, modern research has revealed that the Maasai sandals are the ideal shape to promote a healthy walking style that helps eliminate back stress.

Although Ole Simba was standing when addressing me, he was not much taller than I was when seated at my desk. He was wearing a dark blood-red shuka wound around his torso and ending above his knees. This sleeveless traditional attire is perfect for the hot climate, with lots of places for a breeze to blow up or through. Sitting in my pants and shirt I was already sweating and it was not even 8 am. I wondered what I would look like in a shuka but the mental picture snapped me back to reality, where Ole Simba was speaking in Maa. Being the oldest and carrying the most gravitas, he had opened the address. When he had finished it was Mzee Patrick's turn to talk, and also to translate what Ole Simba had said, as my understanding of the language was still very limited. They were tag-team experts. Where Ole Simba had a deep voice and a face that simply said 'don't mess with me', Patrick was quite different. He was tall and skinny, his spindly legs not much thicker than the legs of the chair I was sitting on, but he was a real politician. What he lacked in brawn, he had in brains. Leaning forward to listen with all ears, I knew that the explanation as to why all three had failed to hear the commotion in camp was going to be good, but I wasn't prepared for the candid and earnest explanation that followed.

'You see, Mr Greg,' said Mzee Patrick, 'what Mr Ole Simba is explaining is that we heard the shouting and screaming last night. It was not because we were sleeping that we did not get up; it was because we were in a state of shock. And when you came down to see us, we were still in shock – totally not able to move.'

I knew I should be angry but I just could not be. These two old gentlemen had concocted an alibi second to none. The much younger Nairobi sat there smiling innocently, nodding his head enthusiastically and affirming what Mzee Patrick had just said. The three musketeers, all clad in their Maasai regalia, had won me over. I tried not to show it and, mustering as much anger as I could, I reprimanded them sternly all the same. After my reprimand was translated back to Ole Simba and Nairobi, who could also not speak English, I was expecting all three to get up and leave the office promptly, grateful to have not been further reprimanded. But the three remained where they were. I had come to realise that the Maasai loved meetings and these three were just getting started.

All I wanted to do was get down to my waterhole but that prospect was dissipating. Ole Simba stood up to speak again, and again Mzee Patrick interpreted.

'Mr Greg, the work we do is dangerous and Mr Ole Simba here has heard that further up the valley, beyond Pakasi, there is a man making bows and arrows. This bow is a very powerful weapon and we please ask that we could each get one.'

For the second time in just a few minutes I almost fell off my chair. How had a supposed disciplinary hearing turned into a platform to ask for increased weaponry power? While America was at war in Iraq, with state-of-the-art missiles, here I was, sitting in Maasai-land where the bow and arrow was the weapon of choice. Perhaps it was the boy in me who nodded in approval but just like that the three musketeers had not only avoided getting a warning letter, but had succeeded in increasing their weapons cache. As I watched them walk out the office I could have sworn I noticed a spring in old Ole Simba's crooked step.

I now had the two truck drivers to take care of. I called on the radio for Kihare, the camp's mechanic, who always kept a radio in case any of the safari trucks got stuck. After calling his name a few times on the radio I was surprised when this reply eventually rang out, 'I am okay ... I am okay!' A bit baffled as to why he was responding like this, I asked him to come to the office, only to get the same reply: 'I am okay ... I am okay!'

Was my day really starting like this, I thought, as Claire came down from our water tank house. When I told her about the state of shock that had petrified our night watchmen into immobility, she was considerably less sympathetic than me, so I thought it best not to tell her about the new bows and arrows on order. While Claire carried on with office admin, I was feeding the weaver birds some biscuit crumbs when I saw a swaggering frame appear at the bottom of the stairs. It was Kihare. I watched him navigate every step, noting how narrowly he avoided tripping and falling. The three bottom steps was all it took to conclude that he was as drunk as a coot.

Standing at the top, staring at him making the long climb, it was as if the flight of stairs was his own personal Mount Kilimanjaro. Every time he successfully navigated a step, he proceeded to stumble sideways along the

full length of it before navigating the next one. Finally, when he reached the top step he saw me. In a valiant attempt to stand upright, he threw his shoulders back, drew his tummy in and stared at me with bloodshot eyes. Swallowing and smacking his lips together a few times, he said, 'I am okay ... I am okay!' I told him that he was no longer needed. Watching him navigate the stairs on the way down was equally painful, although a little bit quicker as gravity aided his descent. I went back into the office where I told Claire that while the night watchmen might have avoided a warning letter, she must please draft one for the mechanic.

The two stranded truck drivers were still in the mess area. I told them to head down to the staff quarters for some tea and a mandazi, and that once our mechanic was sober enough, he would help them with their truck.

Before I knew it, it was 10 am and I realised with a niggle of anxiety that Innocent and Jake were not yet back from their morning jog. I stood waiting in the mess area, looking anxiously down the hill, but there was no sign of the joggers. Another hour passed and there was still no sign of them. I was about to send one of the guides to look for them when finally they appeared at the bottom of the hill. Jake was navigating the steep slope up, faring not much better than Kihare had, but for a different reason. When he reached me, he stood with his hands on his knees, bright red in the face and sucking in air with a loud wheezing sound.

Intending to give Innocent a death stare, I glanced over my shoulder only to see him standing with one leg crossed over the other, casually cleaning his teeth with a twig. Claire put her arm around Jake and asked if he was okay but in between his wheezing, he could not manage a single word, let alone a sentence. We were surprised when he walked into the mess in the same fashion that he had been standing, hunched over with one hand on each knee. He slowly and awkwardly jolted his way, one step at a time, over the walkway and onto a sofa, where he promptly fell over. It was as if he had been bitten by a mamba; he looked like he was at death's door.

Claire hurried back up the hill to prepare a rehydration solution, while I went over to Innocent, who was still standing in the shade of the myrrh tree.

'Inno, what the heck happened?'

'Nothing happened. We went for a run ... just like you asked.'

'Um, but why can Jake not walk or even breathe?' I enquired.

'I am not quite very sure,' said Inno, 'but I think that maybe the possible reason could be that when we ran down the hill we soon passed through the village which was full of Maasai morani. They were so excited to see a mzungu running through their village that they joined in, and with bwana Jake in the middle, we ran to Mount Shompole and back. We could not stop because the warrriors were singing their songs. They were very happy to see a mzungu run.'

Staring at the heavens, contemplating the scene Innocent had just described, I pictured poor Jake, fresh out of a Philly winter, being stuck in the middle of a Maasai bus of warriors, not able to slow down or to stop for a break, or even a drink of water. In a cloud of dust and chanting warriors, he would have been zealously pulled across the floor of the rift valley. I imagined it from above: a dust devil posse of tall wiry warriors, with one pale white American in the middle, all chanting in unison and lifting their spears up and down in rhythmic harmony, taking giant strides in their thousand-miler sandals. Poor bwana Jake would have been taking two steps for every one of the Maasai and he would not have been able to stop for love nor money. Judging by last night's dinner conversation about running, he would also have been way too proud to stop, even if he could have.

I looked across the valley to the east, where Mount Shompole, her volcanic creases now obscured by the heat haze, stood in all her majesty. Doing the maths in my head, I figured that while Jake had done the Boston Marathon, he had now also completed the Maasai Marathon. And he had done so in about 36°C, which is almost 100°F, and with zero water stations along the route. Leaving Inno standing under the tree cleaning his teeth, I went back in to the mess, where Claire was standing over Jake's wife, who was trying to dribble rehydrate solution into her husband's mouth. Jake had passed out.

When lunch was served he was still out for the count, but he was breathing, and his wife seemed strangely unconcerned. After lunch we got the waiters, Joseph and Jackson, to each throw one of Jake's arms over their shoulders and, like they were carrying a mortally wounded soldier, they took him to his tent. We gave his wife two more sachets of rehydrate and instructed her to feed them to him no matter what. Returning back to the

office after lunch, I tried to remain composed after what had so far proven to be a most trying day. All I wanted to do was get to my waterhole to begin again where I had left off. In less than a span of 12 hours I had taken in two lost souls and my night watchmen had claimed to have been in such a state of shock as to have been rendered utterly immobile. I had then had them tell me about the dangerous and potent weapons they coveted, and acceded to their request for a supply of bows and arrows. My mechanic was drunk and Innocent had this time not killed a buffalo, but had very nearly killed a tourist. I was sitting contemplating all this when I was jolted back into real time by a loud shattering sound.

There was no mistaking the sound of glass shards falling. Claire and I stared at each other in alarm. Then we heard a banging sound, followed by more shattering. We realised simultaneously as the sounds of destruction continued that they were coming from inside our bathroom, at the base of the water tank. We both took off running and what we saw made us skid to a halt. The bathroom mirror was completely shattered and vase fragments littered the floor. Before we had a chance to grasp what was going on, a large rock came flying through the opening that was our window and there, standing in the bushes outside, was Joel the tent steward – with a pile of rocks next to him. He had already shattered a massive mirror in the bathroom and he seemed hell-bent on destroying the rest of the place.

I ran outside where I pleaded with him to stop. When I finally succeeded in getting him to lower his arm he explained that he had seen a red spitting cobra slither into our bathroom. Deciding to not risk being bitten, he collected rocks to throw at the snake from the outside. The fact that the snake had slid behind the mirror had not deterred his efforts. It took some persuading but eventually he put the rock he was tightly clinging to down and obeyed my request to please step away from the pile of rocks he had diligently amassed. Claire and I began picking up the mirror and vase fragments. There was no sign of the snake, which no doubt had fled the violent scene. Deciding that an afternoon siesta was very much needed, we lay on our bed hoping that Jake was still alive and that the spitting cobra had not taken refuge in our tent.

41

Waterhole woes

Finally it was 3 pm, the time in camp when the guests were leaving on their safari drive and the staff were on break. For me, it was waterhole time! Grabbing my camera case, I plodded down the hill, into the wild bush country below. Recalling my first bush walks as a very young boy on the game reserve outside of Pretoria, I again felt a reassuring familiar feeling of being linked to both my past and my present. But I wanted more. I desperately wanted to attain my professional dream. I didn't just want to be a wildlife photographer. I wanted to break new ground.

Just before moving to Kenya I had sent Sarah Borchert, the then editor of *Africa Geographic* magazine, a collection of my best slides. I was most grateful to receive her reply. After looking at my work, she said that while there was nothing there that they could use, she thought I had a good eye and that she was keen to see how I progressed. This exchange gave me an opportunity to reply and to let her know that I was moving to Kenya and that I was planning on doing a story on the Maasai culture and on Lake Natron. Sarah replied to say that the magazine had done quite a few articles on the Maasai but perhaps a piece on Lake Natron could work.

For the moment, though, I was completely preoccupied with my Livingstone lions, an undertaking I did not foresee, not even in my wildest dreams, when moving to Kenya. This was a project I had to get done before I could pursue anything else. It was something I had to do before I could carry on living in twenty-first century Africa. I needed to do justice to the wild remote corner of Africa I had found before I did anything else and to do this, I needed to preserve the incredible fact that lions still roamed wild and free. I had seen my Livingstone lions just once, in that one dust storm, so I knew they were close. Sometimes walking to my waterhole I would glance over my shoulder just to make sure I was not their next meal. They may have been close but they were like ghosts. They had learned to

avoid the Maasai, or indeed any other bipedal creature. They operated almost exclusively under the cover of darkness, or dust storms. Most nights I heard them roaring, sometimes nothing more than distant groans, but sometimes sounding like they were right below camp. On one occasion the staff refused to walk to work and were ferried to the camp the next morning by Simon on the back of the tractor – that was how close the roars were at times. But as soon as dawn broke, the lions seemingly vanished into thin air.

I kicked myself for not getting any shots in the dust storm but it had been too dark, and besides, there was way too much dust to even have focused. Not forgetting that at the time I'd been seriously fearing for my life. Contemplating all this as I walked, I was feeling a bit insecure about my future career. I had already been met with rejection. After our Mashatu stint in Botswana, I sent a calendar publisher a few hundred slides of elephants but I heard nothing back. Deciding to be more proactive, I phoned them. The publisher told me that they were not interested in a single one of my photographs. But now, in Kenya, I felt that the photos I had taken recently, the ones of the kori bustard and the waterbuck, had the look and feel of a professional's work. Trying to convince myself that I could be the next big professional name in the business, I was also thinking that at least I had the right surname. Richard du Toit was one of Africa's best-known wildlife photographers at the time and I was a huge fan of his work. I had pored over every one of his books, including his *Essential Wildlife Photography* which my mother-in-law had given me for my birthday. Examining Richard's work confirmed what I already knew – that light was incredibly important. Daryl Balfour, another famous African wildlife photographer, had taught me, in his 'Getting It Right' segments in the *Africa Geographic* magazine about the different emulsions of film. Hap had taught me about animal behaviour and my studies in ecology had given me a sense of how everything fitted together in an ecosystem. As I became more proficient in the language of photography I was learning that a picture does not, as the old adage goes, paint a thousand words, but rather that a photograph says things that words cannot. With light as my paintbrush, my camera and lens allowed me to focus and home in on a single element, revealing mystery and detail often indescribable in words and altogether inconceivable

to the imagination. My photographs also had the power to arrest a moment so brief that it was, at the time of taking, imperceptible to the eye. Capturing invisible slices of time and creating these miracle moments is what I wanted to do with my life. Added to this, I now had professional gear for the very first time and, in Fuji Provia 100, I had professional slide film. Perhaps most importantly, though, I had a personal mission and goal: a passionate pursuit to claim my own corner of Africa and to prove that I had found the Africa of my childhood dreams. To put it more simply, I had a story to tell.

Having psyched myself up sufficiently by the time I arrived at my hide, and despite the rough day I had had, I felt lighter. The feeling was short-lived, however. When I climbed into my hole, my nostrils were immediately accosted, or more accurately, they came under aggressive olfactory assault. My hole was filled with the foulest odour imaginable. All around me were little landmines of baboon poo. My shooting ledge, which was the edge of the hole and which I used for its eye-level height, meant that I was now eye-level with baboon crap. The hairy bastards had shat everywhere, using my underground hide as a long-drop latrine! Baboons, as are humans, are omnivores – and their excrement smells exceedingly bad. I climbed back out of my hole to fetch a Boscia branch to sweep my bench and the ledge clean before sitting down. I held my camera on my lap with one hand; the other I used to block my nose.

A herd of zebra was approaching. Up to now I had not managed successfully to get a shot of them and I badly wanted one. My new strategy was to sit with my camera handheld and already glued to my face so that I would not have to make any movement whatsoever during the zebras' approach. I sat waiting, framing the edge of the left side of the waterhole, waiting patiently for the zebra to arrive in my frame. Peering through the viewfinder of my camera's locked position, not only could I not see the herd approach, but now I had no hand spare to block my nose. Finally the zebra appeared, gingerly, creeping into the very edge of my viewfinder.

I knew I only had one shot. As soon as the camera's shutter tripped, they would bolt. Two of the zebra were drinking with their heads close together, a perfect vertical composition. The problem was that I was holding my camera in a horizontal position. If I was to rotate it through to a portrait

orientation, I was going to need to do it very slowly, and smoothly. During what seemed like ages, I carefully positioned my camera in a vertical orientation. Thankfully, the two prison donkeys had kept on drinking, sucking the water through their pursed lips. Gently squeezing my shutter button until it reached its critical breaking point, the sound of the mirror flipping out of the way was almost deafening, shattering the silence and heightening the tension. As my camera's shutter curtains opened and closed, the zebras' heads shot up as if they were spring-loaded. For a moment they stared at me in total disbelief. Time stood still. I noticed again how many of them had grass stuck between their teeth. The light was golden. They had beautiful hazel-coloured eyes. Then the herd turned and bolted. All I saw was water and dust, mixing to form mud, flung up by fleeing hooves – driven powerfully by the motion of sizeable hindquarters. The zebra were gone. I was left sitting in my baboon lavatory, with no one for company except my faithful pair of geese. At least I had got one photograph, or so I hoped. There is really no way of knowing when shooting on film with no LCD screen or 'live view'.

With nothing else to do, I began daydreaming about the potential photo I had (or had not) just captured. The light had been like the honey of African bees with the setting sun not yet obscured behind the Nguruman Hills. The water, reflecting the golden sunlight, had the appearance of a silver halide solution. My euphoria was dampened when I thought about my camera settings and I started worrying whether they were correct. Should I have underexposed more? Had I focused on the first or second zebra? Had I managed to focus exactly on an eye? My aperture was at F5.6 but should it have been F8? As I walked back up to camp I replayed every 'Getting It Right' article I had ever read, trying to convince myself that I had in fact got the shot. As it happened, I had. In fact I had just taken the photograph that would not only be my very first magazine cover but would also be the cover story for *Africa Geographic* magazine about my time in Kenya. The piece would be titled 'Living on the Edge'.

The days rolled into weeks, the weeks into months. Life in Maasai-land was certainly never boring. Hot, dry and dusty perhaps, but not boring. Every day was unique, often offering up bizarre scenarios involving guests and staff. We sometimes felt like it was all just a dream. The only constant element was my waterhole, which I would visit every single day. Sitting, waiting patiently for my Livingstone lions to drink. While my geese were always in attendance, the rest was an unknown. Anything could pop out of the bush at any time. In time the zebra got used to the sound of my camera's shutter tripping and I was able to take multiple shots of them drinking. It took many more months, however, for them to be comfortable enough to drink the way zebras like to, wading knee-deep into the water.

Even though they had gotten used to my presence, the zebra were always nervous and shy on their approach. This, ironically, was because they were afraid of lions, who often ambush their prey at waterholes. I say ironically because I had not seen a lion for many months, not since the dust storm. While I sat in my hole waiting for them, all I could do was photograph the zebra, who themselves seemed to be willing the lions away.

I was of course not just photographing zebra. Other game would pop in for a drink too. One of my favourite visitors were the resident warthog family. They always ran to the water's edge with their tails up before plonking their buttocks in the mud and rubbing furiously to and fro. I saw this same little family every day; the piglets were growing fast. Then there was the other general game that would come down for a quick drink, like impala and waterbuck. No matter what was drinking, or not drinking, my pair of Egyptian geese were either in the water or standing at the water's edge. As far as they were concerned, the waterhole belonged to them, and while they tolerated other animals visiting, they were happiest when they were alone. This was when they could stand on the water's edge in the afternoon sunshine, vainly and busily preening themselves. As far as I was concerned the two geese were my friends. Sadly, as far as they were concerned, whenever I was in my hole, I didn't exist. This was made evident when the time came each day for me to climb out of my underground bunker. This caused them to get the fright of their lives and either fly off or walk off hurriedly into the bush, hissing and honking profusely, utterly astonished by this human mole that popped up randomly from time to time.

The waterhole was a place of life, especially birdlife. In the morning, at around 8 am, thousands of doves descended to take a few sips of water before flying off. The wind rushing over and through their wings became an all-time favourite sound of mine at the waterhole. I took up the challenge of trying to capture the doves in flight. Slowly but surely I shot one roll of film after the next, filling each with warthog, zebra, blurry doves and of course the odd goose thrown in here and there. Once spent, each film was placed back in its own little plastic container and inside a large ziplock bag that an American guest at camp had left for me. I was slowly building a portfolio of images.

Soon it was time for another leave cycle and we were going to be going on a safari with Albie and Freda. I decided to not go down to my waterhole on our last afternoon because I needed to wrap things up in camp and do a handover with Tim. One of the guides, Andrew, was an extremely keen naturalist. I first learned this when one afternoon he spent an hour explaining to me in detail how a fig tree is pollinated. I found it fascinating to learn that the male fig wasp spends its entire life inside the fig but just before he dies, he chews a hole through the fig's wall; this so the female can escape and go on and pollinate other figs. If not for the tiny fig wasp, none of the trees in the fig forest below our camp, or any other for that matter, would even exist.

Andrew wanted to go birding that afternoon and he asked me if he could sit in my hide. Handing him a clothes peg for his nose, I went up to the house to get packing while he walked down the hill to the waterhole. A few hours later, when it was nearly dark, Claire and I heard yelling. One of the camp cooks came careering up to our house shouting, '*KUJA ... KUJA!*' There was no mistaking from his voice that something was terribly wrong and we hastily followed him back down the pathway. At the top of the stairs outside the office was Andrew, huffing and puffing, his hands on his knees. He was cut from head to toe and covered in blood. His body looked like it had passed through a paper shredder; his clothes were ripped to shreds. Rushing over to him, Claire made him sit down and asked him to take deep breaths with her. A posse of staff had gathered around and we all stared at Andrew, waiting for him to speak. When he was finally able to muster the strength, still out of breath, he whispered, 'Lion.'

Claire gave him sugar water and encouraged him, between sips, to breathe in deeply. I went to get the first aid box to look for plasters, bandages and painkillers. Eventually Andrew was able to talk and the story he told came one sentence at a time, between heavy breaths.

'I was sitting in Greg's hide watching birds when I saw something watching me. It was a male lion. He was watching me closely and so I moved to the other end of the hole. When he saw me he put his head low to the ground. He wanted to pounce.' At this point Andrew took a breath while Claire and I, and all the staff, held ours. 'So I decided I must get out the hole. I wriggled out the side. The lion watched. When I stood up, I turned to face the lion and at this time the lion charged.'

This was it, that critical moment that every safari guide is trained for; the moment when whatever you do, you don't run!

'So I ran. I ran for my life!' said Andrew.

Not able to contain myself, I blurted out, 'And then what happened?'

'The lion chased. I ran straight through the wag-'n-bietjie bushes at the bottom of the hill. The lion got caught in them. I kept running. All the way up the hill,' said Andrew.

It's because of its stout backward-pointing, decurved thorns that the wag-'n-bietjie bush is used to construct cattle bomas. It is impenetrable and successfully keeps lions from getting in. Andrew, being skinny, had managed to wriggle through. The story was starting to make sense now. The cuts covering his body were not from a lion's claws, but from the thorns. Poor Andrew in his panic had run all the way up the hill, plunging through one tangled, thorny bush after the next, tearing himself to shreds in the process. As he drank sugar water, Claire sat beside him with tweezers, meticulously plucking every thorn from his flesh. Trying to console him, she assured him that it was nothing but a bad memory now and told him to keep the shredded shirt so that he could show it to his kids one day. As the saying goes, Andrew certainly had 'got the T-shirt'.

Armed with a bird book and binoculars, when the lion had charged at him, Andrew had run. There are not too many people, safari guide or not, who would stand their ground wielding a pair of 10x42 binoculars at a charging lion. Claire finished dressing Andrew's wounds and the bleeding finally stopped; fortunately the cuts seemed not to be too deep. I then took

Andrew down to the waterhole in a safari truck and the staff joined on the back. We must have had about 20 people aboard, hanging off the sides or standing on the back, all wanting to visit the scene of the crime. When we got down to the waterhole Andrew re-enacted the afternoon's events. We found his binoculars halfway between my hide and the thorn bushes at the base of the hill. When Andrew pointed at the clump of bushes he had run through, we could see bits of lion mane stuck on the thorns. The man had come to within an inch of losing his life. Going to bed that night I was relieved that Andrew was okay but, selfishly perhaps, absolutely gutted that I had missed my chance, again, of photographing a Livingstone lion.

42

Zebra and Dust

Driving out the next day for 10 days' leave, we stopped at my waterhole and I climbed out to inspect for lion tracks. Only seeing the tracks of the male from the prior afternoon, I spoke to my lions. Wagging my finger, I told them to not visit while I was away. Claire sat quietly in the car, watching her husband slowly losing his marbles. The only reason I had agreed to take leave in the first place was because we were going to Kenya's top bird-watching destination, Kakamega Forest. This is a finger of West African rainforest that pokes into Kenya and offers a smorgasbord of forest birds. I was especially looking for blue-headed bee-eater, blue-spotted wood dove and great blue turaco while Albie, who had sold us on the idea, had a much longer list of lifers he wanted to tick, including African grey parrots and a few exotic tropical butterflies he wanted to collect.

On the way back we went to see the famous great migration – which was in full swing – in the Masai Mara and while this certainly did not disappoint, I was single-minded in my personal quest. All I really wanted to do was get back to my waterhole ASAP.

Back in familiar territory after the great plains of East Africa, our first stop when returning to camp was at my waterhole for me to look for any signs of lion activity. The dry season was really kicking in now and there were lots and lots of zebra tracks from the morning, which would have covered any potential lion tracks from the night before. And my hide, the baboons having had 10 days' free access to use it as a convenience, smelled less than pleasant.

Back in camp and in safari camp manager mode, we went down to lunch and met the safari guests who had arrived while Claire and I had been away, but I was itching to get down to where my heart was. I counted the minutes to the moment the visitors left on their afternoon drive, and as soon as they drove off I headed down to the waterhole. This time I was fully

armed – with the dustpan and brush I had bought in Nairobi especially for the purpose of sweeping out baboon poo. Sitting back in my hole on my underground bench, I was delighted to be back and working on my Livingstone lions project again.

My absence seemed not to have jeopardised the project. With the dry season in full swing, the zebra were drinking in droves and they were still accepting of the sound of my camera's clicking. In between visits from the warthog, waterbuck and dazzles of zebra, my pair of geese were in constant attendance, providing me with hours of company and entertainment. Although they still walked off into the grass when I climbed into my hole, after just a few minutes of me sitting quietly they soon made their way back to the water's edge. They still muttered and hissed, but ever so softly. A few minutes later they would forget I was there. I watched them swim around the waterhole and stand on the edge for hours, preening and doing their special type of bird yoga, stretching one wing and one red leg out at a time.

Occasionally another pair of geese would fly overhead and my pair would stand upright, their chests thrust out in protest. With outstretched wings they hissed and honked, letting the interlopers know, in no uncertain terms, that the waterhole was occupied. In fact, my geese became my primary subjects while I waited for the lions to come and drink. I started playing a game whereby I placed one or both of my geese in the foreground of my frame, with an out-of-focus animal in the background. Painstakingly slowly, I assembled a unique portfolio of Egyptian geese standing, with a baboon or a waterbuck or a warthog or a zebra in the background. This one-of-a-kind portfolio remains unpublished to this day but it sure did help pass the time.

The best way to shoot film was to keep a notebook in your pocket and write down the settings for every shot – there was no EXIF data, like there is now, stored on digital files for you to check your settings after shooting and to aid your learning process. But wildlife photography often necessitates having to shoot in haste whenever a moment presents itself. Stopping between frames to write settings down was not something I wanted to do. As a result I was learning the really hard way and having to get a feel for my craft that involved a sort of sixth sense. I was slowly paying my 10 000 hour fee. This number I got from a book I read many years later, Malcolm

Gladwell's New York Times No 1 bestseller *Outliers*. He studied the most successful people in the world, including famous business and sports personalities like Bill Gates and Tiger Woods. He looked for common denominators that linked them all and he found one especially pertinent similarity, namely, that each of his subjects had completed 10 000 hours of doing whatever it was they did before they began to really excel at it.

Ten thousand hours is a big number, and when you are taking one photograph at a time, and only when the light, subject and background are all correct, it's quite daunting. When he was in high school Bill Gates lived down the road from IBM. They needed extra computer programmers and Gates put his hand up. Working overtime and on weekends, he finished his 10 000 hours before he graduated. I was no Bill Gates but slowly and surely, one click at a time, I was working my 10 000 hours off – and doing this moonlighting while managing a safari camp. This was the only way I knew how to fund my photography.

The sun was almost setting behind the Nguruman Hills behind my hole when I noticed a zebra herd approaching from the plains to the front. In the late afternoon the zebra tended to be shyer as the chance of an ambush from lion was greater than it was in the middle of the day; lions are nocturnal creatures after all. Every time the herd got to the water's edge one of the animals got spooked, causing the entire herd to turn and flee, but only for a few yards before the pull of their desperate thirst turned them again. Every time they fled they kicked up fine volcanic dust, until a cloud of it hung over the waterhole like a plume of orange smoke. During this time I did not photograph as the herd was already spooked and an additional clicking sound would chase them away for good.

Sitting, waiting patiently, looking through the viewfinder, my right index finger was twitching at the sight of golden light mixing with dust. Although the herd was super skittish, finally one brave zebra walked into the water and stuck its head through the cloud of dust to take a sip of the life-giving fluid. The view through my lens was incredible. Just the head of

a single zebra poked out from a wall of dust, a scene brilliantly lit by the setting equatorial sun. Warm light, dust and a zebra. What more could a photographer ask for? Perhaps a low angle but I had that too and on a whole new level, an underground level. At this point in time, underground hide photography was unheard of. Seizing the opportunity before me, I tripped my shutter and took the shot. I could only hope that the magic I had seen through my lens had been contained on the Fuji Provia 100 film emulsion loaded into the back of my camera.

Once the zebra finished drinking I packed up. It was getting dark as I started back up the hill. Walking around dense stands of Salvadora, I wondered where the male lion was that Andrew had had his run-in with. Carrying only a grey plastic Pelican case with which to defend myself, if it ever came to that, the walk home in the near dark was a precarious one, but I reached camp without mishap.

I noted that the canisters of film were slowly stacking up in the gas fridge – there were almost 40 now – each one of them containing my wildlife photography hopes and dreams. But still not a single frame of a Livingstone lion.

Lying awake that night, invigorated by the scene I had witnessed, I could only hope and pray that the magic of the dust had translated successfully into the language of photography. In fact, that prayer would be answered. When *Africa Geographic* magazine turned 15 years old, they assembled a '15 of the Best Wildlife Photos' gallery, choosing just one image to represent each year. My 'Zebra and Dust' was selected for this prestigious portfolio and featured alongside the biggest names in African wildlife photography, many of them, like Daryl Balfour and Richard du Toit, my photographic idols at the time. But that night I went to bed anxious. Truth be told, I had no idea if anything had recorded on the film. I believe it was Steve Jobs who liked the saying: 'Stay hungry. Stay foolish'. I was both. Perhaps it was a good thing that I had no idea that in fact I had captured the ultimate portrait of the drinking zebra because to get my ultimate dream shot, a Livingstone lion drinking, I would need to remain passionately hungry and foolishly determined.

Photographing the zebra on the far side of the waterhole, I realised that while they were just big enough in my frame, unfortunately, a lion, which is considerably less bulky than a zebra, would be too small. I only had one lens so, as I'd done in Mashatu when I'd used a stepladder to get closer to my subjects, I had to make another plan. Although the waterhole was only the size of a large domestic swimming pool, there was a small island of dirt in the middle of it. I reckoned that if I could position myself on the island, well, then, when the lions finally drank, I could get full-frame shots of them.

The very next afternoon, in addition to my camera gear I lugged my small camping tent down to the waterhole with me. As I waded into the water to the island of dirt, my geese protested at this unusual activity. They were not at all happy about me setting up a new shop. Once the dome tent was in place, I carried four big rocks into it to prevent it from blowing away in a dust storm. The island was so small that there was no terra firma to hammer pegs into; the boulders would have to do the job.

With thorns poking through the bottom, sitting on the floor of the tent wasn't exactly comfortable and I made a mental note to bring a Maasai stool down the next day. Then I zipped the front of the tent closed, except for a small gap which I left for my camera. Peering through my lens and panning it from left to right, I confirmed that I would indeed have a full-frame shot of a lion drinking, IF EVER ONE CAME DOWN TO DRINK. But because I had changed the look of the waterhole, it was a little bit like starting all over again in terms of habituating the wildlife.

For the first week nothing came to drink as my tent stuck out like a sore thumb. Sitting on the Maasai stool, while I was enjoying not having to deal with the stench of baboon faeces in my 'office', the tent was unbearably hot. With no breeze, under the canvas dome it was like I was sitting in a sauna. The sweat poured off my face. Not only that but the biting flies were far more of a nuisance here than in my hole – they flew into the tent and then got stuck inside!

My geese eventually got used to the idea and a couple of months later I was back in business, with wildlife coming down to drink at regular

periods. Slowly but surely, I was once more placing one film canister after the next in the gas fridge.

The tent was not the only change at the waterhole. I soon realised that for the morning light, it was facing the wrong direction. Sitting inside it, I could not photograph behind me. An additional plan would have to be made. So, on the eastern side of the waterhole, on the opposite bank to my original hole, I dug a very small hole with just enough space for me and my 80-400 mm lens to fit inside. With a roof consisting only of hessian cloth to conceal me, this was now the hide where I sat in the mornings. The lions were around. I was seeing their tracks and hearing them roar from up on the escarpment at night, but they were very nocturnal and very shy. Perhaps I could catch them drinking in the early morning or late afternoon? I had a strategy for both times of day.

43

I froze. He froze

We had a family coming from the USA who were going to be in camp over their Thanksgiving holiday and their travel agent had requested that we lay on a special Thanksgiving dinner for them. Thanksgiving is not a holiday we celebrate in Africa and we were rather clueless about what we should provide. Claire's parents were living in Virginia at the time as her dad was contracted to a company over there, so using our HF radio and bushmail system, we managed to get a message through to them, requesting them to please ask the good folk in Virginia what a Thanksgiving dinner entailed. Some days later we got a reply, which came with a recipe for pumpkin pie.

That was all well and good but pumpkin pie was also something of a mystery to us. Before the family arrived we asked Patrick, one of the camp's cooks, to do a test run. We duly ordered the ingredients he needed from Nairobi and asked our head office to source us a turkey, which in November proved to be very hard to find. Finally the day came for Patrick to make the dummy pumpkin pie and when he walked up to the office, carrying the pie carefully in one hand, Claire and I were excited to taste it. It tasted, well, let's just say, it tasted like cold pumpkin with pastry – yuck. We were absolutely convinced that Patrick must have misread the recipe but going through it with him, line by line, he seemed to have followed it to the letter. Perhaps it should be served hot?

In any event, the pumpkin pie saga was put on hold as into the office came all the camp's trackers. One thing about working in Maasai-land was that one never knew when the need, or perceived need, for a meeting would arise. We were always having meetings and with all sorts of people. On one occasion a group of Maasai elders walked into the camp, sat down and instructed one of the staff to get them tea.

Taken aback, I cleared my throat and said, 'Excuse me, but who do you think you are?'

'We are directors of the company,' replied the spokesperson.

Excusing myself to make a radio call, Simon confirmed that the men, and all community leaders, for that matter, were in fact directors as the camp was 50% owned by the community.

Walking back into the office I enquired, 'Would you like some biscuits with your tea, sir?'

On this occasion, however, it was my team of trackers, also called spotters, who wanted a meeting. None of them could speak English so they were conducting the meeting in Maa. Innocent, who was often in our office, was therefore also often the translator for meetings. Inno seemed to get lonely between safari drives and he would come up to the office and just chat away. It didn't seem to matter whether we were listening or not; he just wanted to talk. He would sit on the bench yacking away, while Claire and I would carry on with other work. When we had to talk to other people, Inno would simply pause until we were alone in the office again before resuming his story, picking up from where he had left off.

Every now and again his rambling stories would catch our attention and we would have to make him rewind so that we could get the context, like the time when we heard him say, 'We were naked and chased home by the lion.' Asking him to stop the proverbial lorry so that we could catch up with his story, another one from his childhood in Samburu-land, he rewound for us and told us how once, when they were kids and swimming in the river with no clothes on, a lion came down to drink. Feeling vulnerable in the water, they ran out and up a tree. The lion chased them but when he lost interest they came down and ran again. And again the lion chased them, only this time up a different tree. Slowly but surely, climbing one tree after the next, they made it back to their village, where the elders chased the lion away. Inno was a colourful raconteur and sitting in our office with his pheasant feather proudly aloft his head, he told us many a tale. Like the time he had not slept a wink because a giant cobra and a lizard monitor were having an almighty tussle in the rafters above his head. He gave us a blow-by-blow account of the ensuing battle.

In fact, the only time Innocent was not talking was when he was listening to be able to translate. On this particular day, he explained that the trackers were all of a similar age and that they needed to go back to their

villages to attend a very important ceremony called Olngesherr to become junior elders. This ceremony would last two weeks and they needed to be granted leave immediately.

The camp was at full capacity with tourists who had paid a premium price for their safari experience. There was no way I could grant anyone leave, especially not trackers, whose role in tracking wildlife was central. Inno translated my message, after which all the trackers got to their feet. One by one they shook my hand fervently, saying, 'Thank you ... thank you ... thank you,' before walking out the door. They seemed to have taken that very well, I thought. It was only when Inno explained that they had all just thanked me for giving them a job and that they had in fact all just quit, that I realised why they were thanking me.

The Maasai, being strict pastoralists, were completely self-sufficient. The staff in camp were therefore not dependent on a salary; they had never had a conventional job before the camp was built. Most of the men working in camp were just trying to earn enough money to buy enough cattle, so that their herds would be sufficiently large to be perpetually self-sustaining. The Maasai are excellent with cattle. Once they felt they had acquired a sufficient number, they would retire and we could not get them to stay, not for love or money. All they seemed to care about was cows!

This was a problem for us as every new staff member had to be laboriously trained by Claire or I, or by one of our Swahili staff, who were not Maasai. To have them quit once their herd reached the acceptable size meant that new staff had to be recruited and be trained from scratch.

I ran down the hill after the trackers with Inno and called them back to the office, where I invited (you could read begged) them to please come back once they were all junior elders. Being a safari camp manager in Maasai-land could be a humbling experience.

Visiting my waterhole in the early morning when the bush was just beginning to wake up had become my daily ritual, one that never failed to fill me with delight. The fine volcanic dust revealed the complete menagerie

of critters that had used the waterhole in the night. Walking around the water's edge for me was a bit like reading the daily news. I would then jump into my new small hole, pull the sacking over the top, and sit and wait – patiently. Every day could be 'the day' and that really sums up the life and work of a wildlife photographer. You never know when it is going to be 'the day' for an award-winning shot.

In the larger hide I had felt like a World War I soldier in a trench, but in my new one-man hole I felt more like a tank operator, except that I was not staring down a tank's barrel but down a lens barrel and one mainly pointed towards the immediate shore where, once the sun was up, hundreds of doves descended to drink. To get a shot of one of the doves flying I would have to choose one dove amongst the hundreds and wait for it to take a few sips of water, after which it would almost certainly take flight. I needed to press my shutter button synchronously with its taking off, and not a moment later. I also tried shooting with a slower shutter speed but this motion-blur technique was always a gamble because I never quite knew what was being recorded on the film.

That was the thing about film. You didn't know whether you were shooting well or not. It was a huge mental battle. Some days I thought I was really off my game and not getting any shots, when in fact I might have taken an award-winning photograph. Other days, when I felt like I was Frans Lanting himself, I was in fact shooting utter rubbish. The motion-blur shots of doves drinking, as it turned out, only existed in my mind – I never ever got the shot. Of course I would only discover this once the film was developed, but sitting in my hole in the ground next to my waterhole, in the middle of nowhere, I needed something to occupy my time while I waited for my Livingstone lions to show.

One problem with spending reams of film on drinking doves was the cost. Each roll cost me just under $10 and my salary was $800 per month, which equated to 80 rolls of film. I always measured my salary by how many rolls of film it could buy me. Luckily, living in Maasai-land there was nowhere to spend money, so unless you were in the market for a new goat or a pair of thousand-miler sandals, your money was no good except to be saved or, in my case, to be spent on film. In this regard, safari camp management was a good vehicle for my photography: it put a roof over our

heads and paid for my film. All our living costs were covered.

Mornings at the waterhole were considerably less productive than the afternoons. Besides the droves of drinking doves, most of the game would only come down to the waterhole at around 9 am and this was too late as the light was already very harsh. It was also tough to sit in my hole knowing that the camp was waking up and that Claire was all alone, having to cope with whatever new (and often bizarre) circumstances might be brewing up on the hill above. The afternoons were better by far. Not only was most of the day done, with camp crises either dodged, avoided or sorted out, but the wildlife tended to come down to drink at a time when the light was getting better, not worse, like in the mornings. But the lions were strictly nocturnal in this remote corner of the rift valley. This meant that they could drink in the early dawn or at dusk and so I had to be ready and waiting at both ends of the day.

One morning I had just climbed into my hole and was sitting on my tiny Maasai stool with my camera and lens on my lap, when suddenly I heard a covey of francolin shriek. Staring in the direction of the squawks, I saw the birds flying up to the heavens as if their lives depended on it. Not having the ability to soar, the pull of gravity seemed to slowly suck them back down to earth, despite much wing flapping on the part of the partridges. Something had spooked them. I stared at the clump of Salvadora bushes behind which the bush chickens had got their big fright. It was eerily quiet and if my heart hadn't been beating so damn hard, I would have been able to hear a pin drop. Could this be my moment?

Suddenly, and without further warning, a large male lion with a black mane sauntered out from behind the bushes. Dawn is a time of day when male lions appear to be particularly frisky and this male was on his dawn patrol, scent marking and rubbing up against the foliage. He stood tall as he rubbed his head against the leafy vegetation, leaving his scent for all in his kingdom to smell. With a lump in my throat the size of a small potato, I watched as the brute beast made his way down to the waterhole. He swaggered towards the water, his large front paws displacing puffs of fine dust. He was massive! There was no doubting it – this was the male lion that had almost caught Andrew. I had only ever seen the tracks of one male lion at the waterhole. Even though the sun was not yet fully up, his

eyes shone golden, offset by his jet-black mane. He had no idea I was there. I was not going to risk giving my position away by moving, not until he had started drinking.

He kept walking, following the edge of the waterhole as if also inspecting the tracks. If he continued following the contour of the waterhole, he would eventually bump into me. I suddenly felt very exposed. The hessian cloth covering which I had pulled over the top of the hole was, I realised, utterly lacking in even basic protection. Slowly, steadily, the lion worked his way around the waterhole. I waited anxiously for him to stop to drink, but he did not. I now found myself pinned in a corner. If the lion continued walking around the waterhole, he would walk right into my hole and what would he do when he saw me inside?

The chances of a photographic opportunity quickly evaporated. The lion did not stop once to drink and in the low light, with an ISO of 100, my shutter speed was wholly insufficient to photograph him moving. On he came towards me. At this point I totally understood why Andrew had decided to run. Sitting in a hole in the ground one feels trapped and this is a feeling not helped by the unusual perspective, one that makes the lion look even bigger than he is. Feeling like a shivering shaking terrified termite underground, I didn't even have a tripod with which to defend myself. When the lion got to less than five yards from where I sat motionless, he paused to sniff the morning air. I could hear every one of his deep rasping breaths. I could see his saliva-covered chin-hairs. Was he smelling me? He looked away from the waterhole, over onto the plains beyond. This was it, I thought. I wanted a shot of a Livingstone lion, even if it was literally going to be last thing I did on earth, and so I raised my camera, slowly. But before I could get it up to my eye, the lion spotted my subterranean movement and swung his magnificent head around and stared straight at me. His golden eyes seemed to be burning a hole through me.

I froze.

He froze.

Time froze.

The eternal moment lasted a mere second before the beast swung his head left again, sauntered round the back of my hole and disappeared into the long grass behind me. Or at least I hoped he had disappeared

and wasn't waiting for me. After letting a suitable amount of time pass, I climbed out of my hole and walked back to camp – practically backwards the whole way, checking that I wasn't being stalked. The further I got from the waterhole the happier I was to be alive!

Looking up at a lion from ground level is an almost indescribable experience. I had not realised how massive they are, nor had I factored in how puny I was in comparison and how vulnerable I would feel with nothing but a thin piece of hessian cloth separating him from me. It was a moment and an experience I would never forget, but one which, sadly, I had no photographic evidence of.

Walking up the hill contemplating what had just happened, I was more just happy to be alive than disappointed at not having got a photograph. I concluded that sitting in a small hole with this male lion around, the one that had tried to catch Andrew, was nothing but folly. I would fill my tiny one-man hole back up with sand. From that day on I would only visit the waterhole in the afternoon where, in my tent on the small island, I would be afforded better protection. Besides, I was wasting far too much money on those blasted flying doves.

Walking back up the hill to camp the heat must have been responsible for putting a bit of a red blush back into my cheeks, which I'm sure were still pale with shock, because Claire noticed nothing untoward. Not wanting to get my wife worked up over nothing, when she asked how the waterhole was, I replied, 'Oh fine. Lovely.' I continued back to the house for a quick shower and a change of underwear. And to drop off my Pelican case, of course.

Thanksgiving Day finally arrived. We had asked Claire's folks to send us not just a pumpkin pie recipe all the way from Virginia in the USA, but also for a full brief on what to do. We set a special private table for the family, which we decorated with pumpkins – much to the consternation of the cooks, who couldn't quite accept that the pumpkins were mere garnish, and kept asking, 'When should we cook them?' We had managed to secure

a turkey and when it arrived I thought it might have been a kori bustard, it was that large! The highlight of the evening would of course be the serving of the pumpkin pie, which we had been told to serve cold. This still seemed odd to us, but then the pie had also tasted really odd. Claire and I bade the family of Americans a good night before they went off to their special dinner table.

The next morning I went down to see the family before they departed on their early morning safari. Walking up to them, I nervously asked how their Thanksgiving dinner was.

'Delicious! Perfect!' they all chorused appreciatively.

And then the father of the family, whose name was Randall, completely took the wind out of my sails. He slapped me on the back and exclaimed with his American twang, 'Say, Greg, that pumpkin pie was the best darn pie we ever ate. Don't let me leave without the recipe now, you hear!'

44

Operation Flamingo Flunk

Many high-end safari clients visited the camp and some even arrived by helicopter. Living so close to Lake Natron, a peculiar and unique landmark, I longed to be able to photograph the lake, especially from above, to capture flamingo masses. Lake Natron is the largest breeding ground in the world for the lesser flamingo and it's the only breeding ground in East Africa. Natron is on one of the remoter rift valley lakes and while some of the other lakes offer the pink birds more food, it is Natron where they choose to breed. Its remoteness and its hostile environment prevent predators from getting to the eggs and chicks.

The lake is so remote that up until the mid 1900s it was a complete mystery as to where the birds were breeding. As mentioned earlier, the Maasai believe that the flamingos hatch straight from the lake's surface, and while this sounds unlikely, it does in reality appear this way because the flamingos travel at night only and do just seem to appear out in the middle of the lake when dawn breaks. Occasionally when I was lying awake thinking about my Livingstone lions, I would hear the flamingos, in their thousands, flying over camp and towards the lake.

Lake Natron is not exactly the kind of lake that one goes to for a Sunday picnic; besides being in the middle of nowhere, the lake surface is regarded as one of the most inhospitable surfaces on planet earth. The water is the most alkaline in the world and with a PH almost equal to that of pure ammonia, if you were to walk into the water you would suffer caustic burns. The ornithologist who discovered the breeding site of the flamingos, Leslie Brown, learned this the hard way when he walked into the lake and got stuck, very nearly losing his life. He spent six weeks in recovery and needed numerous skin grafts; at one point doctors were even considering a double amputation.

In the book *Pink Africa*, of which there was a copy at the lodge, the

author talks about how the ornithologist 'reserved a particular invective for Lake Natron'. Brown described the lake's heat to be 'such as to make one wish one had never been born'. He also described the lake as being filled with 'appalling smells; treacherous surfaces and sheer daunting size'. Both before his discovery and after, Brown used the following words to describe the lake: evil, fetid, foul, frightful, ghastly, horrible, horrid, leprous, stinking and vile. Putting Brown's infectious love for Lake Natron aside, one can see exactly why the flamingos breed there – because no one else wants to go there!

Although our camp was a mere hour's drive away from the lake's northern shore, the breeding birds remain at the epicentre of the lake itself and frustratingly out of reach. Standing on the shore you can see a large pink mirage in the distance but you cannot comprehend the spectacle that lies within, let alone photograph it. Not wanting to suffer the same fate as Mr Brown, I puzzled over how I could get photographs of the breeding birds. Of course a helicopter would be a good way. The other issue was knowing when the birds were in fact breeding. They build mud nests in the shallows and breeding is, therefore, at best, temperamental. If the birds get it wrong the chicks can drown or alternatively get baked by the sun and encrusted in volcanic salts. If I tried to walk to the breeding grounds I feared that history might repeat itself and I'd get stuck in the mud like Leslie Brown. Not knowing when the birds were breeding and not being able to afford a toy helicopter, let alone a real one, the flamingos remained a photographic conundrum for me.

This was until a family arrived in camp with both a chartered plane and a helicopter. They were a group of four, which meant that they were going to need to do two flips over the lake as the helicopter could only take three people at a time. Although they had a Kenyan private guide, if he went on one of the flips, there would be a seat spare on the second flight. After doing the maths, I very happily volunteered to drive the family down to the airstrip for their helicopter flip. Sure enough, as predicted, the Kenyan guide and two passengers, father and son, hopped in the helicopter and took off in the direction of Lake Natron. They returned an hour later, practically speechless. The spectacle they had witnessed had blown their minds – millions of pink birds, nests, eggs and chicks. So the flamingos were

breeding and they had seen with their own eyes what the largest breeding colony for lesser flamingo in the world looked like. This was what I had dreamed of seeing and photographing, even before we had taken the job in the south rift.

My heart started racing at the thought. As the pilot prepared for a second flight it was all I could do to restrain myself from jumping straight onto the helicopter. As the Kenyan guide began ushering the mother and daughter to the helicopter I made my subtle move. Trying to look as nonchalant as possible, I leaned against the front bull bar of the safari truck, making sure I was in full view. Surely he would offer me the empty seat? But it was not to be. The guide himself jumped into the passenger seat. I watched the helicopter take off into the sky, covered in its dust.

Actually, I was gutted. Claire and I had made big sacrifices to come and live up in the middle of nowhere so that I could photograph, and here I was, living a mere stone's throw away from Lake Natron, and after a whole year I had still not captured any photographs of the flamingo breeding spectacle. Driving back to camp with the guests, who were all still on a high from their aerial adventure, describing to me in great detail what I had missed, I'll admit I found it hard to share their enthusiasm or engage in the usual chit-chat. The Kenyan guide sat in the front next to me, grinning. My camera case was between us. I wondered if he had even noticed I'd brought it along.

When I arrived back in camp, Claire saw the storm cloud above my head. After not getting a shot of the male lion, plus now missing out on one of nature's greatest spectacles, I felt my photography dreams slipping through my fingers. This was becoming an all-too-familiar feeling and one I would really wrestle with for the next few years of my life.

Sitting stewing in the office I had a thought, a crazy, harebrained thought. The camp had an inflatable raft for paddling on the river for when Simon 2 had finished clearing the logjams. 'What if I paddle out to the flamingos?' I said out loud and to no one but myself. With that I ran out of the office and down to the storeroom to check out the raft. It was brand new and still deflated, which was perfect because I could throw it in the back of the safari truck. I then went looking for Andrew, the guide who was a keen naturalist and birder, and asked him to meet me at 4 am

the next morning in the car park. After Andrew had nearly died while bird-ing in my underground hide I did not want to tell him about my plan to enter Tanzania illegally the following morning and to row into the middle of a lake that is protected by the international RAMSAR treaty. The less Andrew knew the better.

From there I went into the storeroom and began assembling a ration pack of food and water. I would need lots and lots of fresh water for the expedition. Leslie Brown had not carried fresh water and that had nearly cost him his life. Not only was Lake Natron one of the hottest surfaces on planet earth but the caustic mud on her bottom literally burns through human skin. Although I was planning on paddling my way to the flamin-gos, I might need to get out of the raft at some point and if I got stuck, I would need fresh water to wash off the mud before it burned me. I had thought this through meticulously – or so I hoped.

Lake Natron is surrounded by a series of extinct volcanoes, including one active one, Ol Doinyo Lengai. All the volcanic salts from these surrounding volcanoes have, for thousands of years, leached into the lake's basin and because the lake has no outlet, it has become a literal soup of salts. I didn't know it at the time but Lengai was preparing for another eruption. One night from our tent, Claire and I would see the lava flowing down the mountain. In the daylight the lava has a white appearance and that is why the Maasai call it Ol Doinyo Lengai which means 'The Mountain of God'. Since the Maasai believe that God dwells in a high place, they perceive the white ash to be his beard. All of these volcanic factors combined make Natron one of the most diverse and inhospitable places on the planet.

The waterbody itself is actually in Tanzania and usually, to visit it, I would just have sneaked into Tanzania, remaining on the northern side and close to the Kenyan boundary. The following morning's expedition would be very different, however, in that I would be paddling into the very middle of the lake and deep into Tanzania. For this reason I packed my passport, just in case I landed up in a Tanzanian jail and needed proof of my citizenship. I also packed some greenback notes, in case whoever arrested me could be persuaded to let me paddle back across the border and say no more about it. I am not one for paying bribes but taking some cash along just seemed like the pragmatic thing to do. The

other issue was that the Maasai on the Tanzanian side of the border could potentially be hostile.

On previous visits to the northern shore I had met Maasai warriors who were covered in scars and carried long spears, and didn't speak any Swahili. On one occasion I was photographing from the shore and I heard the familiar crunch of thousand-miler sandals coming across the salt flats. Two Maasai morani came to a stop and thrust their spears through the salt crust and into the mud beneath. Usually when they did this it was because they wanted water, but on this occasion they motioned for me to get into the car. They stood on the back and pointed to the other side of the valley. Not too sure where I was going, they kept directing me by pointing their long spears over the bonnet, which was not only an effective way of pointing out the direction I should drive, but also a great way to keep me motivated to get them to wherever they were going. Racing across the mudflats with two warriors on the back, at dusk, was exhilarating on many levels. When the two morani jumped off the back of the vehicle, it seemed they had arrived at their destination – not that I could see any sign of habitation or other people. I turned around and drove back to camp.

Having had a few uncomfortable experiences with the Maasai on the Tanzanian side, I decided that I would take Mzee Patrick along too. He was a Maasai elder and the one thing the Maasai have great respect for is age. In fact, this is perhaps one of the greatest distinctions between that of the Western world and the Maasai. The latter have deep reverence for age and the elders' sage advice in the community directs the young testosterone-filled warriors. Mzee Patrick was a night watchman so he would be off duty and free to join me, provided, of course, I could wake him up without him going into a state of shock again. With him along all would be fine; he could placate any young hot-headed warriors we might meet along the way.

I went down to the mechanic's workshop and filled a further drum with fresh water, which would be used to rinse off with should anything go wrong and, heaven forbid, I fell into the lake. I also packed two hand-held radios so that I could communicate with Andrew on the shore, and a rope – just in case I needed to be yanked out of mud. With a water drum, rope, raft and radios packed, it was looking like a real expedition. 'Operation Flamingo' was a go! Who needs a damn helicopter, I thought as I added

five litres of drinking water, a paddle, loads of film and some cashew nuts to the mix.

I'd decided not to tell Claire about my plans to illegally paddle into the middle of one of the world's most hostile environments. That night I lay awake feeling like a naughty schoolboy.

Natron is such a dynamic landform that NASA regularly photographs it from space. The algal blooms combined with the excessive rate of evaporation that is 10 times greater than the annual rainfall cause the lake's surface to be in a continual flux. The photos I had seen taken from space all presented the lake as a barren wilderness, more akin to the surface of Mars than to planet earth, especially since the algae gives the lake a bright red colour from above. It is actually this algae that the flamingos feed on and which gives them their pink coloration. Somehow I just could not imagine myself in a small raft afloat in the middle of the fiery red cauldron that I had seen on NASA's pictures. Would NASA get a photo of me in my raft was the last thought I had before finally drifting off to sleep.

BAAP, BAAP, BAAP. My alarm clock woke me up at 3 am and Claire, having no idea what time it really was, just assumed I was getting up as usual to go and photograph. She didn't stir. Knowing full well that this was not a normal morning, I felt compelled to gently rub her on her shoulder and whisper, 'Love, I am going to Natron. Not sure when I will be back ...' As my words sank in I could see that she was waking up some more and before she could put a halt to my clandestine plans I quickly added, 'Andrew is joining me so all will be fine. Love you!' And with that I walked down to the safari truck. My two companions were ready and waiting, Andrew in the passenger seat and Mzee Patrick sitting on the back with the raft and gear. Not surprisingly, they both seemed rather puzzled. I was keeping them on a need-to-know basis; I did not want them to try and talk me out of the adventure either.

We drove down the hill, through the bush country and across the Pakasi River. We then drove through the most southerly settlement in Kenya's

portion of the Great Rift Valley. The village was eerily quiet; it was still dark and not even a rooster stirred as we sped through the dark street. Passing by the shacks, some of which had candles burning in the windows, we veered off right towards the Tanzanian border and straight for the western wall of the escarpment, which in the pre-dawn light loomed like the Great Wall of China. Passing through a Maasai village literally on the border, it was also quiet, with no bleating of goats or bellowing of cattle. They were all still asleep in their bomas and their owners asleep in their mud huts. Once we reached the wall of the Great Rift Valley, we followed it down and into Tanzania.

The wall itself signals a 1 700 metre (5 576 ft) drop in gradient, along an ancient fault line that runs right through Africa and further north into the Middle East. Slowly but surely the black veil of the night began to lift and the yellow headlights of the safari truck grew dimmer. I pushed my foot flat on the accelerator and the cool morning air flowed through the cabin, carrying with it the acrid smell of soda. We were just two degrees south of the Equator; the sun would rise fast. Racing across the mudflats that led to the northern shore of the lake, I knew that later in the day the surface temperature would exceed 60°C (140°F)! Once we reached the shore, I began inflating the raft, blowing air so hard that I felt like I was going to faint. It was a race against time and I feared that the rising sun was winning.

Finally the raft was full of air and throwing a bag of cashew nuts into it, plus a few bottles of water, I pulled gumboots on and started walking out into the lake, dragging the raft behind me. Andrew and Mzee Patrick stood on the shore with their arms at their sides, staring at me as if to say, The mzungu has finally gone mad. I kept walking. Slowly the lake started showing signs of wanting to pull me in; my gumboots were sticking to the muddy bottom. The water was clear and very shallow. The lake here was more like a mudflat covered in a liquid veneer only a few inches deep. I kept walking, pulling the raft behind me. Surely at some point this lake must get deeper? I kept walking, then paused for a moment to take in what looked like a pink mirage on the distant horizon. My heart began to beat a bit faster. I knew what that pink mirage was – thousands upon thousands of flamingos. Standing still for a moment, I took my camera out of the raft and, zooming in with my 400 mm lens, I gazed upon the pink mass. 'It's

not even 7 am and there is already a heat haze!' I said out loud to myself. It was deathly silent. I felt like I was the only person sent to colonise a new pink planet.

Glancing back towards the shore, I picked out the safari truck, which now looked like a Dinky toy. I had walked further than I thought and I suddenly felt quite alone. Pulling the rope, I forged on as the lake's bottom clung ever harder to the soles of my gumboots. The pink mirage seemed to remain on the distant horizon – no matter how far I walked. I was fast beginning to appreciate that the lake is in fact 55 km long. I was also aware that I was falling into the same trap that Leslie Brown had fallen into all those years ago, with the pink mirage beckoning me on. The mud was now ankle deep and it was sapping my energy, draining my strength with each heavy step. Thankfully, I had read Brown's account and I was very aware that if I fell into mud too deep to lift myself from, I would be in a tremendously precarious situation, not to mention unreachable. No vehicle would be able to get to me and since I was deep into Tanzania, the only helicopter that could reach me would be the one that arrested me, or found me dead from dehydration.

With each step I began to feel more and more foolish. The flamingos remained just a pink mirage and the safari truck was now completely lost behind me in a distant heat haze. I was all alone and not yet afloat, still dragging my raft behind me. The water had mysteriously remained only a few inches deep across the entire part of the lake I had just traversed. With the mud up to my calves now, every time I pulled a leg free my quadriceps burned. As I heaved one foot out of the caustic mud at a time I could feel myself beginning to panic. A few pieces of soda and grit splashed down my legs and into my gumboots. Rubbing between my skin and the nylon inside of my boots, this sodic gravel caused a stinging sensation. I realised that I was on a fool's errand. Why had none of the literature I had read mentioned that not only is Lake Natron the most alkaline lake but also the shallowest lake in the world?

I had spent the last couple of hours walking into the lake and the ambient temperature was now rising at a rapid rate. Feeling panic constricting my chest, I knew I needed to gather myself, and admit when I was beat. Although utterly fatigued, there was no time to rest. I feared the heat would

soon become unbearable. Turning around I mustered all the strength I could and slowly began the long walk back. The Darwin Award is an award given to any person who does the human gene pool a favour by removing themselves entirely from it. I feared that I was making a bold attempt to be a recipient! One of the best-known recipients of a Darwin Award was the man who attached hundreds of helium balloons to a deckchair and floated off into space. Practically stuck in the mud as I was, I earnestly wished I'd thought to bring a few balloons myself.

My leg muscles were now not the only thing burning. Bits of soda grit rubbing between the uncompromising inner of my boots had now made it into my flesh. With sweat pouring down my face I no longer looked up at the horizon, for fear of losing hope. Taking it a literal step at a time, I considered abandoning the raft. But what if I needed the fresh water it contained? I plodded on.

By the time I made it back to the truck there were a group of Maasai standing with Mzee Patrick and Andrew. They looked astonished to see me appear out of the lake. I wondered if what they were saying to each other was something like 'We knew the lake gives birth to flamingos but it seems on this day to have spewed a mzungu!' Being too tired to talk, I held up two index fingers, five inches apart, and pointing them in opposite directions, I indicated the depth of the water. Sitting on the side of the raft, on the shore, munching cashew nuts to replace the salts I had lost and washing my feet clean with fresh water, I felt like a right idiot. The worst of it all was that I had not got any shots of flamingoes except for one dead one I passed on the way back to the truck. It was calcified and covered in salt, and had been a great motivation for me to keep going.

'Operation Flamingo' was now officially 'Operation Flamingo Flunk'. It would be 14 years before I finally got photographs of the flamingos on Lake Natron.

45

Christmas is dead

I arrived back in camp to some bad news. While I was very happy to be alive, Claire was distraught.

'Christmas is dead!' she sobbed when she saw me.

Our pet zebra had passed in the night. He died of what is commonly called 'turning disease' whereby a parasite tickling his brain caused him to walk in circles, until eventually he succumbed. Claire was upset not only because Christmas was one of only two pets we had (excluding the white-tailed mongooses who would come and clean our plates at night, and Eddie the eagle) but on account of the old Maasai mzee we employed to look after Christmas. Claire felt terrible for the mzee. What was he going to do now? And then there was our other pet, Merry the donkey – Christmas's best friend.

The more immediate problem was that we had a dead zebra in its pen which was just behind the camp's dining room. I called Simon on the radio to bring the tractor. He was relieved to hear that I did not need him to go check on the water tank but rather just to scoop the limp striped equid up with the front basket of his tractor. Bouncing down the hill, sitting on the wheel arch of the tractor, I directed Simon to my waterhole, where I instructed him to offload Christmas on the bank right in front of my tent.

I still maintain that any photographer worth their salt would have done the same thing but when Claire asked where I had buried Christmas and she found out that I was using him as bait to lure my lions, she was so unimpressed that I was given the silent treatment for a week. No matter how much I tried, I could not convince her that since he was dead, it was a far better thing to do – 'you know, to donate his corpse to the ecosystem' – than to just bury him. But she was not buying any of it.

I spent more time at the waterhole the following week than usual, not just because the mood in camp was a little tense, but because I hoped I'd

given my lions added incentive to visit. Despite sitting beside the rotting carcass for the entire week, I got no photographs of anything eating Christmas. What I did get was a god-awful stench up my nostrils, which Claire would probably have said served me right. It seemed my Livingstone lions were not that easily fooled, and why would they be when they could grab their own fresh zebra steaks anytime? Finally I instructed Simon to bury poor Christmas next to the airstrip. Claire started speaking to me again.

I found myself sitting in my tent one afternoon and it was hot with a capital H. The heat was building to the long rains, which come typically in April, and the sun was beating down. My tent became a sauna turned up several notches. Because I had to keep myself concealed, it had no air moving through it. Even worse than the heat was the biting flies, which always found their way in through the tiny slit I had open for my lens and feasted at will on my exposed skin. Sitting and sweating so much that a puddle of water formed on the groundsheet and being bitten by half a dozen flies with proboscises that went through my soft flesh like hot syringes, I considered that this was maybe my punishment for using the family pet for bait. Be that as it may, on this particular day I simply could not stand it any longer.

Unzipping the tent, I jumped out of it and, to escape the swarm of flies that followed me, I leapt into the water, which was about knee-deep. I lay on my back with my arms outstretched. I must have looked, from above, like the flies had crucified me. I didn't know it then, but I was about to experience another moment of the tipping point variety. One was when the kori bustard came down to drink. Another was seconds away.

As I lay, oblivious, on my back in the warm soup-like muddy water, staring up at the blue yonder, I heard a sipping sound. Raising my head, I was stunned to see a large male waterbuck having a drink right in front of me. I was especially shocked because I had never, ever, in the entire year I'd been here, seen a male waterbuck at the waterhole. It was usually only the females that came down to drink. The males, being more solitary in

nature, were also more shy and they must have been drinking only when I was away.

Lying on my back and craning my neck to look at the waterbuck, who would at times lift his head to scan the surrounds, I had the most incredible view of his long frontward-curving horns. Accentuated by my low angle, they seemed to reach to the heavens. All I could see was the waterbuck's immense head with the African sky as a backdrop. It would have made for a wonderful photograph but alas, my camera was in the tent. The waterbuck seemed completely oblivious to my presence. It was at this moment that I realised that the water was not only covering my human shape but my scent too. As far as he, the waterbuck, was concerned, I was akin to a floating log or perhaps a really large anaemic turtle. Whatever he saw me as, I clearly offered zero threat, for he carried on drinking. He gave no sign of even knowing I was there.

Long after he finished drinking and had left, I sat in the waterhole, simply dumbstruck. With my buttocks firmly entrenched in the muddy bottom, I pretended like I had a camera and lens in my hands, and resting my elbows on the inside of my knees, I bent forward to take an imaginary photograph. Forget eye-level, I could get water-level portraits of anything that came down to drink. 'Even drinking doves would tower above me from this angle!' I said out loud in excitement. The only concern, and a quite significant one at that, was that, sitting in the water like I was, I felt like a proverbial sitting duck. I had no cover except the water and my back would be exposed to the shore and bush behind me. The water was also shallow, which meant that any wallowing buffalo or elephant could potentially trample me if they decided to take a bath.

After a year of waiting for my Livingstone lions at this one little waterhole, one thing I was sure of was that there were no crocodiles or hippos to contend with. That sealed it. I decided that the water itself would become my new hide. Carrying the huge boulders out of the tent and dumping them one at a time next to the waterhole, I took down my tent and walked back to the camp with a tingle of excitement inside me.

The next afternoon I could not wait to return to the waterhole. This time I carried with me a small table made from fig wood. I stuck the table in the middle of the waterhole and on it I placed the rifle and a walkie-talkie

to compensate for my new reckless strategy. I then sat in the water on the muddy bottom next to the table. And so began chapter three of trying to get shots of Livingstone lions drinking, a hope and dream that seemed to forever be just beyond my grasp.

After a couple of months of trudging up and down the hill, carrying my camera, the rifle and the radio, in punishing heat, I made a few necessary adjustments: I started to leave the rifle and radio behind. I removed the table too.

Sitting in the water, the waterhole took on an entirely new dimension. Being immersed, actually physically immersed, I became one with the environment – a mere floating prop in the ecosystem. Nothing was afraid of me, and I do mean nothing. My geese would only hiss and honk at my arrival, but once I sat down and remained still, they would walk back and carry on as if I was not there. They swam around me as if I was invisible. They even had sex in front of me! After witnessing their brief but passionate embrace, I watched as they built a nest on the very island that my tent had been on. While they prepared for a family, white-throated bee-eaters flew all around me like avian butterflies, dipping in for a drink, sometimes right in front of my nose.

While the creatures above the water were oblivious to my presence, the creatures in the actual water thought that the waterhole gods had dropped manna from heaven, in the form of a juicy, blood-filled, soft-skinned Nikon photographer. Tiny green aquatic midge-like insects, with miniature piranha-like teeth, fed on my flesh, leaving a rash of tiny red bumps that kept me up all night scratching. Other things ate me in places I dare not think about, even now, and because the water was the colour of diarrhoea, I never knew exactly what was eating me because I couldn't see anything below the murky surface. While I tried to keep very still and quiet, in the initial days of sitting in the water I occasionally let out a yelp or a whimper when something bit my more tender parts.

The dry season was coming to a head and the lions were hanging around closer to the waterhole, their roaring keeping me up at night while I scratched and itched. It was as if they, the lions, were tormenting me to return to the waterhole each day. As the months passed, my waterhole shrank due to the excessive heat and subsequent evaporation. The water,

now a greeny-brown colour, a tropical soup of putrid elements, meant that the shorts and T-shirt I wore when sitting in it stank so badly I had to hang them on the Boscia bush behind our tent to dry. The next day with both clothing items dry but as stiff as a board, over-starched with dried mud, algae and dung, the only way to get them back on was to wet them again.

Each afternoon I walked down the steps with my Pelican case, passing the kitchen on my way, as well as random staff members and sometimes guests who were waiting in the car park to leave on their afternoon safari drive. Not only did I stink to high heaven but I was starting to get a wild look and developing a twitch. My obsession with getting photographs of the Livingstone lions started to take possession of my appearance and personality. In the safari business we call it 'going feral' and I was well on my way.

When I arrived at the waterhole, the bright colony of resident white-throated bee-eaters greeted me with twittering calls as they took flight. Taking my camera out and hiding my Pelican case under a bush I waded into the water, wrestling each foot free from the muddy bottom, until I got to the middle. Then, by simply collapsing backwards, while holding my camera in both hands above my head, my bottom formed its own seat in the muddy floor. Once securely settled, I leaned forward, cradling my camera and lens in my hands, with my elbows resting on the inside of my thighs. I was a human tripod. I had to be my own tripod because my real tripod only had a cumbersome and wonky tilt-pan head for landscape shooting. I needed the flexibility and speed that only my arms could deliver. The lions could drink at any point along the edge of the waterhole. I needed to be ready, right behind my camera, so that I could wheel it in the direction of any drinking cats.

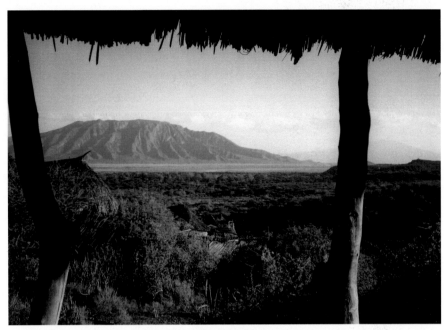

A view from our water tank tent in Maasai-land.

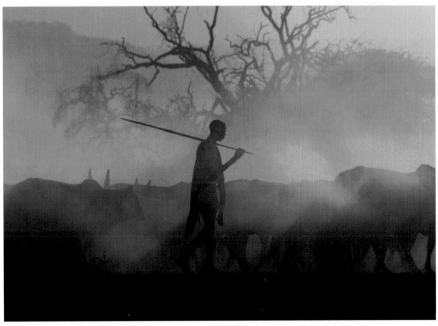

A Maasai herdsman traversing the dusty floor of the Great Rift Valley.

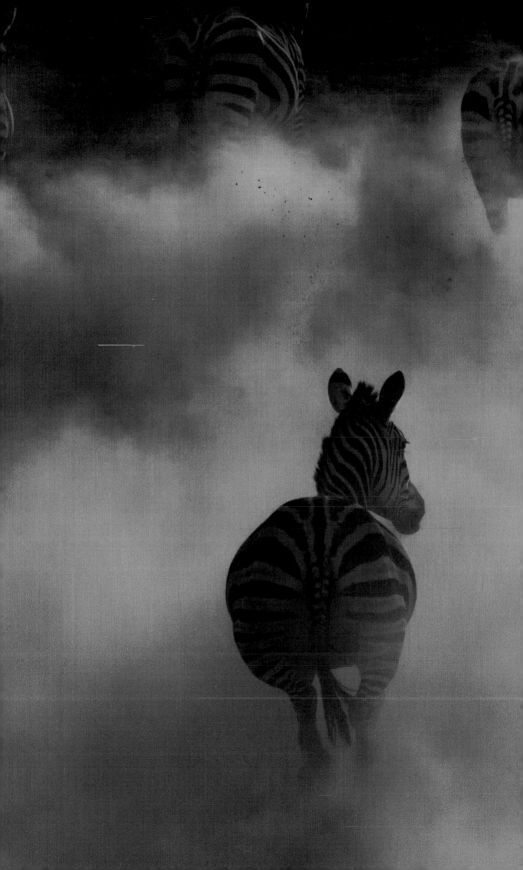

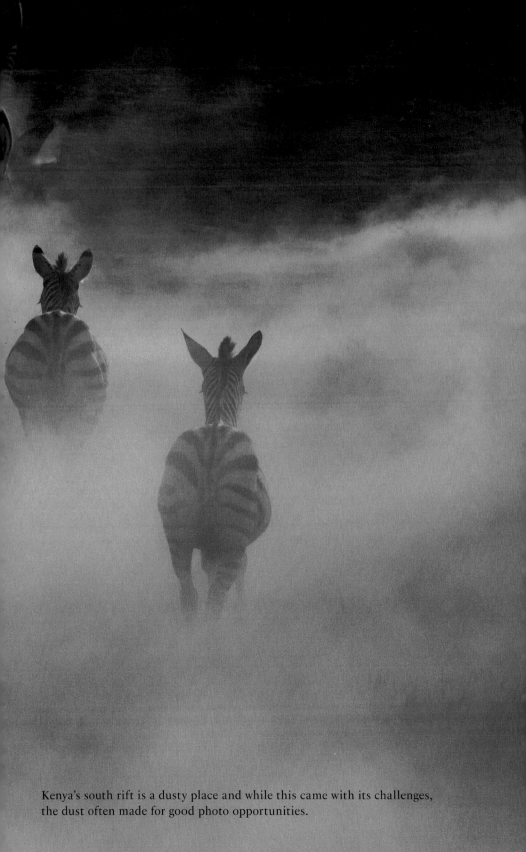

Kenya's south rift is a dusty place and while this came with its challenges, the dust often made for good photo opportunities.

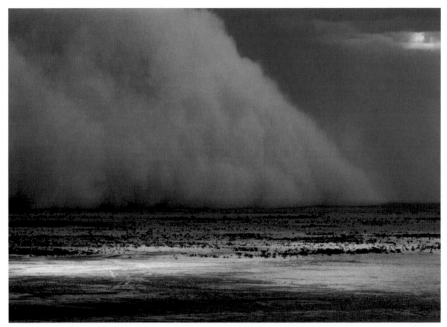

A dust storm sweeping the valley floor. It was during one such storm that I was trapped in my hole with the lions circling.

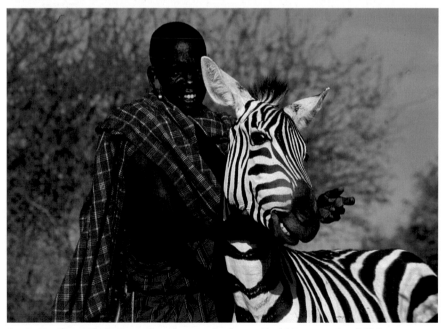

Our pet zebra, Christmas, for whom a donkey called Merry and a fulltime babysitter were especially appointed.

The bird that changed my life. When this kori bustard came down to drink the other wildlife deemed my waterhole to be safe.

My faithful friends the Egyptian geese were there every step of the way. While waiting for my lions I assembled a unique portfolio of geese and other animals.

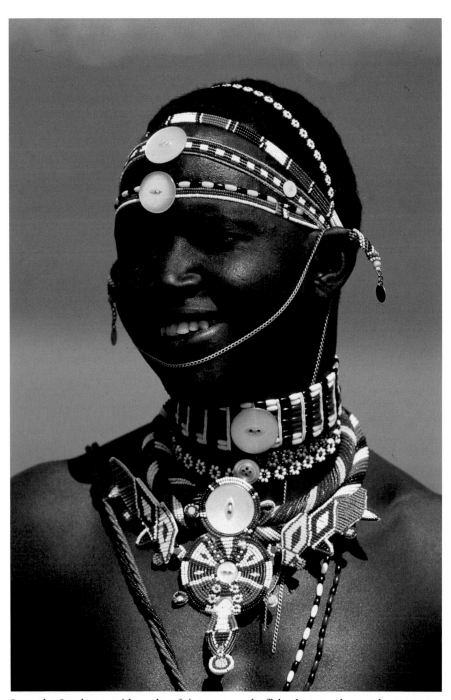

Inno the Samburu guide, colourful raconteur, buffalo slayer and marathon runner.

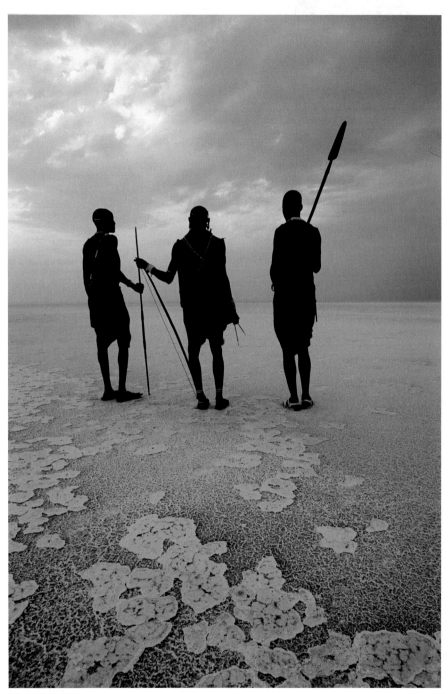

Three Maasai out on the salt flats of Lake Natron.

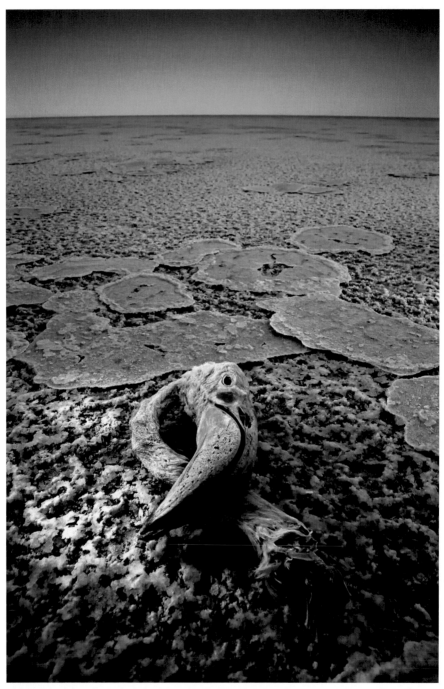

A flamingo that never made it. I am glad to have survived 'Operation Flamingo Flunk'.

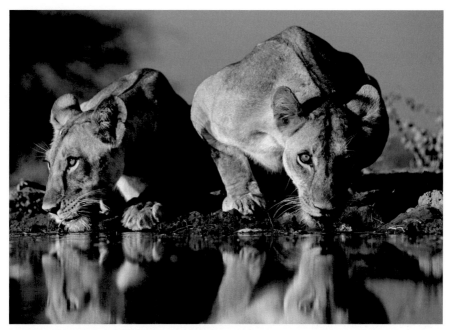

Two thirsty felines drinking right in front of me.

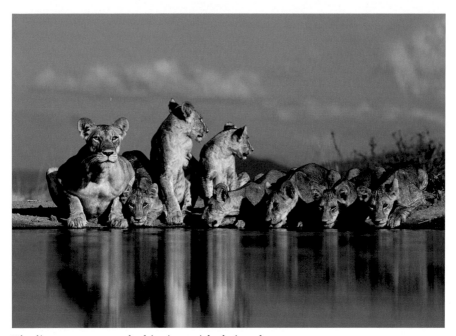

The lionesses returned, this time with their cubs.

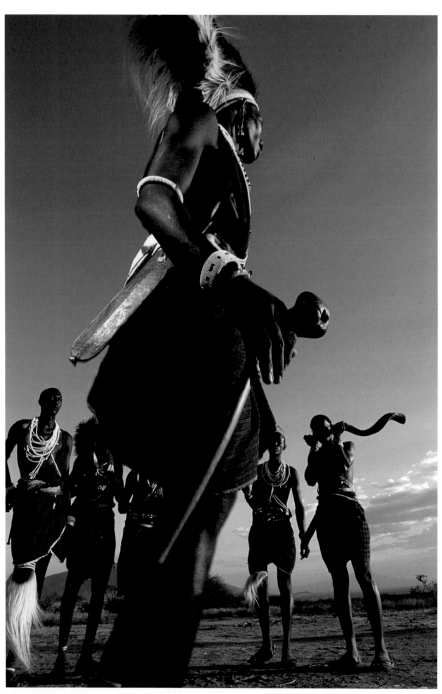

Maasai warriors dancing on the floor of the rift valley. A wonderful send-off to what had been an incredible adventure.

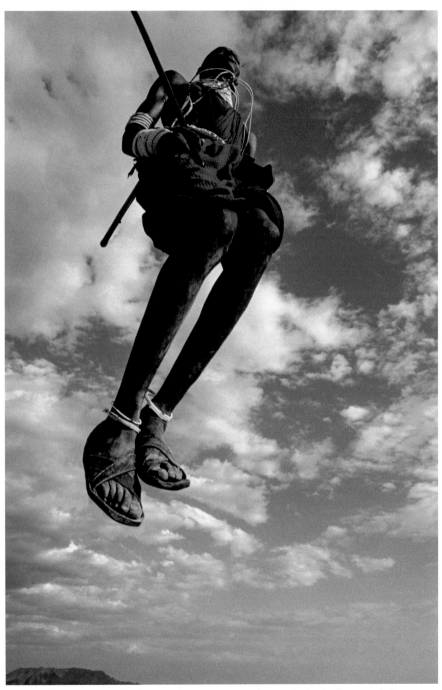

A Maasai moran leaps high into the air. Mount Shompole in the bottom left corner.

My lightbox with some of my favourite slides from the project, including of course the vertical shot of the lioness drinking ... the one that nearly cost me my life.

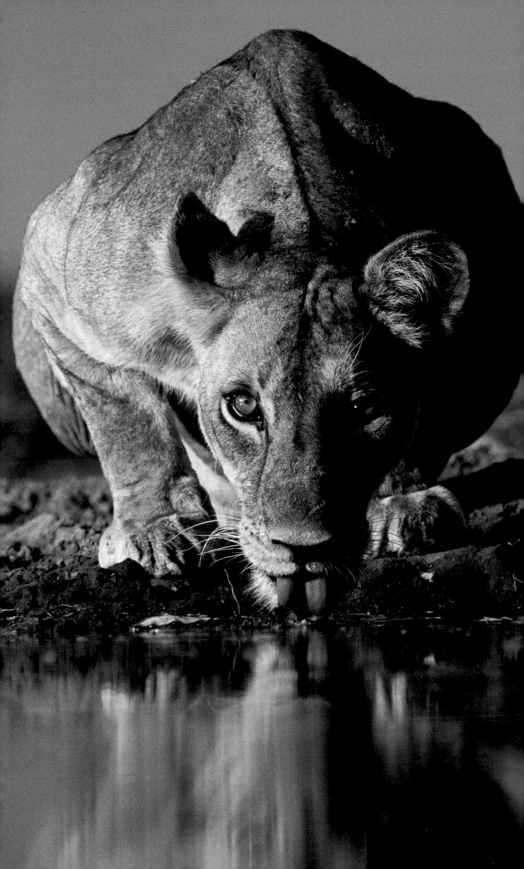

46

Worms and other parasites

The water and ambient temperature was far too hot for a wetsuit, or for fishing waders, for that matter, and besides, not owning either of these items, I had no option but to present myself daily as a living larder to the aquatic life of the rift valley. Occasionally a safari truck would leave the camp late and drive past the waterhole, and while most guests didn't notice me sitting in the water, if they did, they stopped and took photos while I muttered under my breath for them to bugger off. I had work to do.

Sitting inside the actual water worked far better than I could ever have imagined. The wildlife was simply oblivious to my presence. Appearing out of the rank growth to drink right in front of me one day came a small herd of reedbuck. Over the course of a year I had not once seen a reedbuck in the south rift. I didn't know that they even existed in the ecosystem and yet, here they were, right in front of me – mere paces away. Of course the usual visitors came too. The same little warthog family seemed not to mind my company and we all sat in the water together, scratching our bums on the bottom. As happy as a pig in mud is a phrase I can relate to. Shooting water-level portraits was simply pure exhilaration for me as a wildlife photographer.

A big challenge, however, was not being able to change my film in the water. I could squeeze 37 frames out of one roll of film but I was having to choose my frames very carefully and also having to keep a careful count. My geese were no longer a temptation to place in my frame for they were busy incubating their eggs. While I ignored the temptation to shoot doves in flight, they attracted the attention of numerous birds of prey. All I heard at times was the sound of rushing air. This was the sound of the air passing over the leading edge of an eagle's or a falcon's wings, travelling at close to terminal velocity and swooping in from the heavens above to ambush the drinking doves. This sound, eerily calm and loud,

was always followed by total chaos, with doves fleeing in all directions and right past my head – like avian bullets. The action was so fast that my eye could not follow it, let alone my hand-eye coordination. Once the powerful wing-beats of the frenzied doves dissipated, the waterhole fell silent again, a stark contrast to the preceding flurry of flight. The only evidence that the raptors had succeeded in their quest would be dove feathers floating down, landing gently at the water's edge and in the water around me.

On one particular afternoon I witnessed the most bizarre and unusual avian interaction. A pair of falcons had pulled off a tag-team Top Gun manoeuvre from above and had swept in on the unsuspecting drinking doves, but they had mistimed their swoop ever so slightly. As one falcon took off with the dove, it dropped it, right next to the waterhole. A kori bustard had just finished drinking and while the falcons made a circle to come back and collect their quarry, the bustard did a most peculiar thing. It picked up the dove and began to swallow it, head first and whole! While it was doing this, both falcons dive-bombed in protest, but to no avail. The bustard swallowed the dove, feathers and all, and then, not surprisingly, came to the edge for another long drink. The waterhole was an enchanting place, one where the circle of life played out in its many forms.

As the dry season tightened its grip, so did I – on my camera.

The lions were close by. I could sense it.

Sitting in the water there were of course many times when absolutely nothing was happening at all. During these times I simply looked up at the gigantic cumulus clouds filled with their empty promises of rain. I watched them sail across the blue sky like vanilla candy-floss clumps drifting over the Great Rift Valley, casting dark round shadowy blobs on the scorched earth below. Whiling the time away was not difficult for me. There were always birds calling and I attached my own words and song lyrics to their calls. And there were always 'animals' of various varieties inside the water to keep me occupied. Tiny fish sucked on my skin and occasionally tickled me, making me squirm. There were also small water snails that crawled slowly around my body as if I was a mollusc jungle gym, before settling beneath my watchstrap. To some of these creatures I was food and boy, did I know it. Even worse than the green piranha

midges were what I suspected were the larvae of a dragonfly. They gave an excruciating pinch every now and again that was so sore it made me yell out loud, giving my geese a heart attack.

But the worst by far were 'my friends' the baboons. The same resident troop that used to use my hide as a latrine came past the waterhole every day. They drank and then often peed and pooped in the water. What god-awful creature pees in the same waterhole it drinks from, I used to wonder in disgust. The baboon urine caused my skin to go dry. Over time I learned to distinguish between the various forms of rashes on my body, whether they were caused by baboon urine or aquatic life. A red flat rash was from the baboon urine. A smaller more aggressive rash consisting of tiny raised bumps was the work of the green midges. Sitting at the dinner table, hosting our high-end clientele, I would frequently have to excuse myself to go round the corner and scratch – which I did, like a man possessed. Occasionally I would rub against the acacia tree behind the mess like a rhino with an itchy bottom, much to the amusement of the waiters. I feared that my waterhole was consuming me, slowly but surely, bit by bit, one bite at a time.

<p style="text-align:center">***</p>

Just when I was beginning to lose hope of ever getting the shot of my Livingstone lions, I was sitting in the waterhole as per usual one afternoon when I heard a loud lapping sound behind me. The sound was coming from the other side of the little island on which I had pitched my tent, and from a part of the waterhole I could not see because it was behind me. The lapping continued for what seemed like ages. Sitting with my back to the sound, I clung to my camera for security. What if it was a lion and what if it was the brute that had almost eaten Andrew? Half expecting to feel claws rake my hunched over back, I waited ...

The lapping stopped. Silence. Too scared to turn around, I sat motionless before a herd of zebra came in to drink. The equines milled about the waterhole long enough for me to be convinced that whatever had made the lapping sound was gone. After they were done drinking, I climbed out.

I walked along the water's edge to where the lapping sound had come from and looked for tracks, but all I could see was the zebras' spoor. The lapping had been a lion drinking, I was sure of it. I lay awake that night pondering whether the beast had seen me climb into the water. Had he been sitting in a bush watching or had he just come down for a drink afterwards? Perhaps it was a lioness that was denning close by? Recalling the story of *The Ghost and the Darkness* and the horrendous train trip Claire and I had taken on the Lunatic Express, I realised not for the first time that I really was a sitting duck in my pond. It mattered not though; I had come too far to turn back now.

The goslings fledged and while I sat in the water they swam in circles around me, cocking their little heads and peering up at me, making me feel like Roald Dahl's BFG. They were adorable little balls of fluff, but hopelessly too close to photograph.

The dry season had the Great Rift Valley fully in its grip. The waterhole had shrunk even further and grown even more fetid. The storm clouds now marched in ranks overhead, with a faint and menacing 18% grey tone (old-school photographers will appreciate this analogy). I knew that once the rain arrived, the wildlife would disperse for there would be water everywhere. My dream shot of a lion would dissolve with the onset of the rainy season. I had photographed every other animal at the waterhole; all that was missing was the shot of a lion drinking. But not just any lion, a lion living truly wild and free in Africa, like all lions once did. A Livingstone lion!

These days if you want to see a lion in Africa you can go to the Masai Mara National Reserve or to the Kruger National Park where you can often see fat lazy lions lying about. If you want them to sit up, you practically have to drive over their tails. These were not the kind of lions I was after. Free-ranging lions, especially those living on communal lands, are lean, cunning beasts – surviving outside of parks or reserves. They have learned to be like ghosts, moving only at night and lying up in the thick bush during the day. They are skilled hunters and expert stalkers; they have to be to survive in such marginal and harsh conditions. These free-ranging lion are highly endangered as human population across the globe has mushroomed, like the cloud of an atom bomb, causing the lion of Africa to run out of space.

At the time of independence, in 1963, Kenya had around 8 million people whereas today the population number is well over 50 million. Conflict between lion and livestock has resulted, in some areas, in herdsmen lacing carcasses with poison. Lions are already extinct in 26 African countries and have vanished from 95 per cent of their historic range. Kenya has less than 2000 lions left in total, and this includes the ones in parks. I feared that soon my Livingstone lions would be extinct and that soon Africa would be a place where a lion's roar will only be heard in an official park. These dark thoughts, like the cumulus clouds above me, spurred me on. My desire to get a photograph of a Livingstone lion had become my sole reason for living.

The future expansion of mankind threatened me ever having another chance to photograph an ancient wild Africa. A more immediate threat was the parading clouds above and so these puffs of water vapour became my sworn enemy. As each day passed I became more frantic, spending every moment in the water that I possibly could. My skin transformed into a living, breathing rash, intensified by the dropping water levels. The baboon urine was less diluted and sitting in the water – for over 270 hours in total now – my skin had wrinkled, dried and peeled, much to the delight of the fish who nibbled on it. I also had a worm living inside my foot. Claire and I marked it with a permanent marker each night, to measure how far it had travelled in my flesh while I slept. I had ordered a can of liquid nitrogen from Nairobi but alas, the ice-cold spray had failed to kill it.

The waterhole was now a part of me. Or perhaps I was a part of it? Since my time began at the waterhole, I had had malaria twice and, treating myself with a drug from the sweet wormwood tree (native to temperate Asia and used to treat malaria by Vietnamese troops in the war), I managed to keep it at bay, and to keep myself out of hospital so as to not miss any precious time waiting for my lions.

Unbeknown to me at the time, the water snails that were clambering over me were also playing intermediate hosts to a type of worm parasite. Once released from the snails and complete with devil-tails for swimming, the larvae swam in my waterhole and penetrated my rotting skin. Once inside me, they shed their forked tails and travelled to the blood vessels of my lungs and heart before maturing in my liver. The male and female

worms then copulated inside of me, before migrating to my bowels, rectum and bladder to lay eggs. This internal infestation of eggs resulted in a new kind of rash. It had a life of its own and moved around my body like a living red devil. I couldn't discern whether the fever, abdominal pains and dysentery were the result of malaria or bilharzia. As I felt more ill by the day, I'm glad I didn't know it then, but the long adult female worm can lay up to 300 eggs per day! I was releasing these eggs in my blood-stained urine, thus completing their life cycle, much like the baboons had done in my waterhole in the weeks and months prior. It would take me the next 10 years to get rid of the liver flukes and this by swallowing nine pills at a time, each the size of a bullet. With my shirt wet and me hunched over for hours, waiting for my lion, a type of blow fly (also called 'skin maggot fly') delighted in my wet exposed back; their larvae had burrowed in and were feeding on my living tissue as they slowly matured into maggots. Poor Claire spent her evenings pushing and squeezing bumps with black heads, popping white larvae out of my back.

In the African bush nothing goes to waste, everything gets consumed – eventually. My waterhole was slowly consuming me, from the outside in and from the inside out. It was consuming not just my body but my mind too. Every lion roar in the black of the night saw me sitting upright in bed, trying to determine their distance and direction like my bush mentor, Hap, had taught me to do. Every distant flash of lightning got the same reaction, with me standing staring over the rift valley with clenched fists, cursing the heavens.

47

My moment

It was hot, excruciatingly hot. The mercury rose above 38°C (100°F) every day of the week. In my waterhole I persuaded myself that the lions would have to come down and drink in the daylight – it was just too hot for any creature to go without water for a day. The baby geese had fledged so it was back to normal; me sitting in the middle of the waterhole and just my two faithful friends, the goose and the gander, for company. I had been down to the waterhole every day and every day had been relentlessly hot. The rift valley was acting as a giant heat sink, there was no respite. Even at night-time the mercury hung around 30°C (86°F).

My waterhole had become a cesspool. Despite the heat, the week had been thoroughly unproductive in terms of lions drinking. Frustratingly, they still only drank under the cover of darkness. But I knew they were hanging around the waterhole as it was the last available water source and their roaring at night had become so loud that the camp staff refused to walk anywhere. The tractor and trailer were being used again to ferry them between shifts. Walking down to my waterhole each day, and especially walking back in the evenings, was very much a running of the gauntlet. I could not drive down, even if a safari truck was available because the presence of my vehicle, even if I parked it out of sight, would upset the balance. I could not afford the slightest hiccup. My only option was to walk down. On the walk home in the evenings I was especially nervous because I knew that the lions, wherever they might be lying up, would be stirring and waking from their slumber. Then there was also that brute of a male that had chased Andrew, lurking somewhere in the shadows, alone.

The afternoon clouds were now quite pregnant with the promise of a deluge; they hung above me as I sat in the water, like the Grim Reaper's sickle. Waiting, in a semi-psychotic state, I could not believe that getting a

photo of a Livingstone lion drinking could be such a seeming impossibility. It had been 15 months since I first began my pursuit. Over the wall of the rift valley, in the Masai Mara, tourists were taking thousands of photos of lions and here I was, sitting in a quagmire, with parasites in my blood and water snails giving me hickeys, all in an attempt to get a single photo of a Livingstone lion drinking. Of course it was much more than just getting a photo. I was clinging to the last hope that wild Africa still existed. Sitting in my waterhole was my way of protesting that all that is wild had not yet been lost. Eroded maybe, but not yet gone forever. My literal sit-in was a campaign for the wilderness. It was my attempt to cling to the last vestiges of a lost Africa, one I had only dreamed about and heard about from my heroes, Ian Player, Hap and Dr Livingstone. I was damn well going to get a photograph of a wild lion drinking, even if it killed me.

Monday produced no lions. Tuesday produced no lions. Wednesday produced no lions. Thursday produced no lions. On Friday afternoon, the end of the hottest week I had ever experienced in the bush, nothing stirred at my waterhole. Even the birds panted in the heat. It was oppressively quiet. My geese were taking a nap, standing on one leg with their heads pulled back and tucked in. The tall khaki grass on the plains beyond stood still. There was not a breath of wind. Even the white cumulus clouds seemed stuck in the sky. All I heard was the occasional shrill call of a bush hyrax in the Nguruman Hills behind me. Huddled over, I cradled my lens with the last ounce of sanity I had left. The waterhole had become my world, my life. Although there was nothing happening, I could not, not even for a single moment, lose concentration. I only had one lens and one camera so a single slip would see both dipping into the water. I was holding them just centimetres above the surface.

Plop. Suddenly my two geese leapt from the bank and landed in the water in front of me, where, with powerful leg strokes, they moved past me in a hurry. What on earth is their problem, I wondered. They had never before behaved like this. I scanned the plains beyond the waterhole.

Two Livingstone lions were walking straight towards me.

Using my shoulder to wipe the sweat out of my right eye, I looked through my lens, just to make sure that I had not succumbed to delirium and that this was not a figment of my imagination. Sure enough, two lionesses

were heading straight towards my waterhole – straight towards me. They sauntered with a steady purpose, like lions do, especially thirsty, hungry lions. It had worked! The furious heat had forced them from their slumber and out of the tall elephant grass. The draw of their desperate thirst was bringing them to the water's edge, and in the daylight.

This is it! I thought, the moment I had not just been pursuing for 15 months but for my entire life, metaphorically speaking. One of the biggest moments, not just of my photographic career but of my human existence in Africa, was about to unfold. It felt to me like I was about to pass through a rite of passage. As a boy born in suburban Africa, I had dreamed of becoming a man in the wilderness. This was my moment.

Looking down, I checked my camera settings. The sun was already quite low on the horizon. I had a fresh film loaded in the back of my camera but I needed as fast a shutter speed as possible. I decided to push my film a stop and expose for the shore where I hoped the lions would drink. I managed to get my shutter speed up to 1/250th of a second. With a 400mm lens, this was the bare minimum. Quickly giving my camera the once-over and checking my settings again, I looked up and got the fright of my life. Both lionesses were at the water's edge, a mere five paces in front of me and lapping water at a furious rate. Their front feet were close together and their bums high in the air as they leaned forward to reach the water. Their shoulder muscles were clearly defined, bulging to the point that their heads were quite dwarfed by the surrounding muscle mass.

With not an ounce of fat on them, they looked like feline bodybuilders. Their eyes were a piercing golden yellow colour, their whiskers long and white. I could see each individual hair in the tufts of their ears. I had of course seen many lionesses before but never from this angle and sitting beneath them, staring up at the two apex predators, I was like a terrapin *kakking* itself. Nothing that had gone before, not even 15 months of waiting, could have prepared me for this moment. With the two cats towering above me I realised just how vulnerable I was. A wave of fear and panic hit me like a freight train. I had not taken a single photograph yet, my eyes mesmerised by the muscular masses in front of me. My mind raced as I calculated the odds of me getting out of this one alive. My relatively large brain, the only physical attribute superior to that of the

lionesses, ascertained, and quite quickly, that the odds of me surviving this experience were very low.

As this message of peril got relayed to my limbs, I began to shake. My feet shook under the water, my hands quivered above. Adrenalin flowed into every muscle fibre I possessed and seeped into my hair follicles, covering me in adrenalin-filled goosebumps. My body was readying itself for fight or flight. My many years walking in the Timbavati had trained me to never, ever run, and that was what my mind was telling me now – Whatever you do, don't run! – but my limbs were sending their own message back, which was a great big middle finger to that idea. *Get the hell out of here – NOW!* was what my shaking appendages were advising.

My hands began trembling violently and, drawing my elbows into my ribs, I tightened my biceps to try and control them. The last thing I wanted was for the lionesses to think I was an animal shaking in distress. The felines, still lapping water in an attempt to quench their thirst, were in crouched positions – coiled springs of fur and fang. Sitting right in front of them, I was just one leap away.

This was it. The big moment had arrived. A photo of a Livingstone lion was there for the taking. The light was perfect. So was the angle and background. All I had to do was lift my camera to my eye and shoot.

But instead of doing this, I cowered, hiding behind my camera with my cheek pressed tightly against the back of it. I was trying to not panic. Just then a switch flipped in my mind and everything went into slow motion. Not again, I thought, as my brain slowed time down, allowing me to see and act more clearly. It reminded me of that other time-freezing incident when the buffalo bull had walked out of a dark forest in Zululand before charging. Refusing this time to let my limbs respond in flight, the resultant adrenalin had nowhere to go and this made it impossible to photograph. My hands were still trembling uncontrollably.

My mind then did an interesting thing. It extracted me out of my body and out of the perilous situation I was in. Like a black-shouldered kite hovering above my waterhole, I could see my predicament perfectly clearly. It did not make for pleasant viewing. There I was, a tiny human head in front of two lions. With a clarity of thought that seemed almost supernatural, I assessed the situation further. I was also well aware of the irony. I

had been waiting 15 months for this moment. This was it. I had found my lost Africa, I had found the real Africa of my dreams. Here I was, a mere limp stone's throw away from two wild free-ranging lionesses. The light was perfect, the angle unbelievable. All I had to do was take the damn shot.

I might have been in shallow water, but in fact I was in proverbial deep water, unarmed, except for my Nikon. The threat of the life-ending danger I was in had triggered my natural flight, fight or freeze response, making it impossible to do the one thing I'd come here to do: take a photograph of a Livingstone lion. The selfish gene, the one all my surviving ancestors in Africa had possessed, simply took over. There was no radio, no vehicle, no back-up of any kind. I doubted that even the most intrepid of early explorers had ever been in such a position. Not even Dr Livingstone himself had sat in front of two thirsty felines.

No! I said to myself, although not out loud this time. *This is your moment. It is your life-defining moment.* I simply could not let it slip through my fingers, even if they were shaking. Deciding that I would have to get shots and that even if doing so cost me my life, it was just what I had to do, I re-entered my body. I closed my eyes. I could hear my heart's rhythmic thumping. I focused on it. Slowly, the lapping sound of the lionesses grew fainter. Taking deep breaths, I prayed. This was the second closest I had come to death. The first was when as a 17-year-old I suffered sleep apnea after being allergic to the anaesthetic I had been given to extract my wisdom teeth. I remembered that I had prayed then too. With my eyes still closed, I felt my trembling hands start to steady. The minutes that had passed felt like a lifetime but thankfully the cats were still there, still drinking. The extreme heat had caused extreme thirst in the lionesses. I opened my eyes.

A photograph is in its essence just a moment and this was my moment. Pulling my cheek away from behind my camera, I placed my right eye, my shooting eye, behind the viewfinder. Lightly tapping the shutter button, my lens snapped into focus. The image I saw on the other end was a mesmerising sight. Sunlight streamed in from the side, turning the fur of my subjects a bright rich golden colour. Their yellow eyes sparkled. I had never before seen a photograph of a predator drinking from such a low angle. The photo I was about to take was groundbreaking in that it

was from below ground level and from inside the water. The image in my viewfinder was simply awesome. I pulled my elbows deeper into my ribs and drew a big breath. Cradling my lens, I depressed the shutter button all the way. CLUNK! The mirror tripped, sounding like a firecracker going off in Catholic mass. With the mirror now out of the way, the shutter curtains opened, allowing, in a mere fraction of a second, for the lionesses to be transported on long wavelengths of light down my lens and into my camera body, burning them onto the 35 mm sheet of film I had loaded in the back.

48

Fifty-fifty

I waited for the cats to react. They kept drinking. I exhaled. Predators are almost entirely visually stimulated. The sound of my camera had not disturbed the two felines in the least. It seemed impossible that they hadn't seen me. I mean, I was sitting right in front of them. Then again, all that was exposed was my head, shoulders and hands. Just like all the other creatures had not noticed me sitting in the water, neither had the two lionesses. Despite their superior vision, allowing them to see every hair follicle on my head, I seemed quite invisible to them in the water.

Taking another photograph, I counted in my head: two, and then three ... four ... five. I counted like this all the way to 27. I had just one film and only 37 frames available. With the females crouched, side by side, like Olympic sprinters in the blocks, I decided that the ultimate photograph would be a vertical, frame-filling shot of one of them drinking. A portrait orientation of my camera would allow for my entire viewfinder to be filled by a singular golden mass of drinking feline perfection. I decide that once I had gone vertical, I would then compose my photo so that the lioness, the one on my right-hand side, would have her neatly set front feet at the bottom of the frame. Her piercing golden eyes would be staring straight down my lens's barrel.

To take this portrait, however, I needed to rotate my camera 90 degrees and into a vertical portrait-orientated position. Instinctively, I have always rotated my camera anticlockwise to do this and so, dropping my left shoulder, I lifted my right shoulder and rotated my camera. My right elbow popped out of the water. Both lionesses immediately stopped drinking and lifted their heads. Their golden eyes widened and their jet-black pupils concentrated into single focused black dots. The game was up. They had seen me.

Up until this point they had just been drinking and to them I must have just been a floating piece of debris in the water or some unfamiliar swamp

ornament of benign description. Now that I had changed position, they realised that I was a living, moving entity – for the time being anyway. Both lionesses stared at me. There was nowhere to hide from their circular highly focused pupils trained on me. I was petrified. Crouched and tense with heads lifted, the felines stared down at me. Their forequarter muscles bulged, then twitched, like bodybuilders overdosed on anabolic steroids. Their eyes were burning a hole right through me! They knew now that I was a living creature. If the water had been deeper I would have sunk below the surface and drowned myself; it would have been much easier than having to sit there – helpless.

My life, my beautiful short life, hung in the balance. The outcome would be solely determined by what kind of creature the two beasts thought I was. If they thought I was an ungulate, stuck or trapped in the water, they would surely pounce. If they thought I was a bird, perhaps an albino flightless bustard stripped of its feathers, they might leave me be. But what if they thought I was a human? Trying to process these questions, my world again slowed down to a snail's pace. My brain sought more clarity on the life-threatening situation I was in. It was as if someone hit the slow-motion button once more.

Out of the blue, as if conducting my own interview, a series of questions popped into my head. Has any other human ever been in this predicament? As far as I knew, I was the first (and possibly the last) photographer to be in such a quandary. I was in a unique situation; there was nothing I could glean from anyone else's previous experience. The fact that I was the first human being in history, possibly, to be in such a silly scenario, either meant that I was doing something extraordinary or something extraordinarily stupid. What can you do about these cats? came the next question. I knew I could not run. That would be signing my death certificate. Lions are simply overgrown pussycats – anything that runs is instinctively chased down. A lioness can run the 100 metre dash in six seconds flat; I would not even make it out of the waterhole. Every fibre in my being wanted to run but fortunately my years of training as a wilderness walking guide had given me the ability to overcome this adrenalin-filled urge to take flight.

Another thing my days walking in the Timbavati had taught me was that all predators are scared of the human shape and form. What if you leap up

out of the water and stand your ground? I asked myself. This was certainly the most plausible option available to me but it was a fifty-fifty gamble with my life. The problem, as again my days as a wilderness trails guide had taught me, was that animals have two imaginary circles around them: a larger circle, known as the flight circle, takes effect when an animal feels threatened from a distance and takes flight, but there is a smaller circle surrounding every animal. This circle is what is known as the fight circle. If an animal faces a threat at close proximity, within this circle, it instinctively attacks. Lions are not only superior apex predators but free-ranging Livingstone lions, like the two lionesses before me, were already nervous, twitchy and on edge – at the best of times!

After some time contemplating this, I concluded that the chance of them either fleeing or attacking was indeed fifty-fifty. Russian waterhole roulette seemed like a dicey move, so I decided against standing up. What do these lionesses think you are? came the penultimate question, closing the loop on my initial thought process. The answer to whether or not I would survive hinged on this single simple question. The irony is that the lionesses were trying to answer the exact same question that I was. Staring at me with a burning intensity, I feared that they might come up with an answer before I did – one I wasn't going to like!

It was as if someone hit the play button again. Things sped up fast, back to the pace of real time. I was now left with just one more question: why did you not think about any of this earlier? Considering my current predicament, it seemed like a blatant oversight on my behalf to have landed up sitting where I was with no plan A, or plan B, or a back-up plan of any description. In practice all I had been doing was trying to get a photograph of a Livingstone lion drinking. This endeavour had consumed my every thought, so much so that I had simply not thought past the point of actually getting the shot. The problem was that I was now, in reality, beyond my initial goal and ... I had no plan whatsoever. The sun was now touching the top of the escarpment. Being just south of the Equator, night would fall quickly and when it did, the lionesses would be in their element, able to see perfectly. I would be nearly blind.

With my life under immediate threat, I decided that if I was to go, I was damn well going to go doing what I loved. I framed the lioness, the one

on the right, squarely in my viewfinder. She looked immense! Her bulging golden eyes stared straight back at me, her ripped shoulder muscles the epitome of stealth and strength. Her lower jaw dropped ever so slightly, surrounded by black moist rubbery skin. The white fur on her beard was wet, her eyes focused forward – on me. A pure vision of terrifying potency and power. This was it, the ultimate shot I had been pursuing for 15 solid months. With a wild Livingstone lion in my sights, I was ready to claim my prize. After this my life would be in her hands, or more accurately perhaps, in her claws. CLUNK! went my shutter after the preceding pregnant silence, so loud that I half expected it to echo down the valley.

I froze. She froze. Peering around the edge of my camera I saw a twitch of a tail. The lionesses had not blinked for what seemed like an eternity. I sat motionless in the water in front of the two felines, like a crash test dummy about to collide. To say that reality took on a surreal dimension would be quite an understatement. Soon I would die, either in the jaws of two lionesses or from a heart attack, I was certain of it.

49

Some sort of strange swamp creature

Without warning, completely unexpectedly, the lionesses started drinking again. I started breathing again. After contemplating my existence, both felines had decided, or so it seemed, and without any dialogue between them, that I was a neutral party. I was neither a threat, nor was I prey. In their mind's eye I was perhaps just some sort of strange swamp creature, which was possibly the most accurate description of what I had become. The two cats lapped water furiously. The heat was affecting them and luckily for me it was affecting their behaviour too – they seemed more concerned about quenching their thirst than anything else.

The sun had now set behind the escarpment and the critical switchover point, whereby the two felines in front of me would become apex predators of the night and I would become utterly blind, was fast approaching. I needed to get out of the waterhole, but how? The lionesses kept drinking. A new wave of panic came over me. Things were not going according to the script. The Livingstone lions were supposed to have arrived to drink in the golden light and while at least this part had gone to plan, albeit a 15-month plan, they were then supposed to leave. I was supposed to have climbed out and walked back to the camp, triumphant. I had not antici-pated this. With no radio or any way to call for back-up, with each passing minute it was getting darker and darker.

Unfortunately, all the same rules of the game still applied. If I stood up in front of the two lionesses there was a good chance that their fight response would kick in, and after seeing their taut, bulging muscles, I in absolutely no way wanted to trigger such a reaction. But soon it would be completely dark. The lionesses would be able to see perfectly. I would be blind as a mole. And not only this, but it would be time for their breakfast. *You just have to get out of here ... now ... before it gets dark*, I told myself. *Think, Greg ... think! Why did you not think, Greg?* These were

the words playing over urgently in my mind.

Then instinctively, as if my muscles were responding to my mind's retort, gripping my camera in my right hand, I grabbed the muddy bottom of the waterhole with my left. I then wiggled my bottom to the left and much to my delight, I shifted my entire position a few centimetres – the width of one bum cheek, to be exact. The lionesses spotted my movement immediately because, although they had been drinking, they had kept their eyes locked on me. Now that I had moved, they had stopped drinking again. Their ears swung forward in my direction, their large round pupils narrowing some more. Once more I had their undivided attention.

What was going through their minds? Now that I had moved – twice, they realised – I was definitely not an inanimate object. I was a moving creature; this they knew now beyond a shadow of a doubt. Seemingly having lost interest in the water and with heads raised in interest, they both stared at me intently. With their thirsts sufficiently quenched, I hoped that eating me was not their next order of priority. I wanted to be well and truly out of that wretched waterhole! I had my precious portraits of a Livingstone lion. I just wanted my life now. I wanted to live. *Don't move now ... wait ... wait ... wait.*

The felines were all set to pounce. I looked down at their front paws but it was too dark too see if they had unsheathed their claws. Barely breathing, I sat on, motionless. It was an extreme test of willpower. *Now would be the worst time to run, Greg ... don't you do it ... just don't.* Not only was this a tense situation for me but for the lions too. I had never before been in such a situation and neither had they. They would at some point need to decide if I was worth eating. As each second passed, it got darker, and the two lionesses got closer to making their decision.

Suddenly there was a twitch. I noticed that one of the lionesses had moved an ear backwards. All four ears were no longer pointed towards me. This, the smallest change in body language, triggered my flight response. Pushing down on the muddy floor with my left hand again, I performed another bum-slide manoeuvre. As soon as I shifted another whole bum cheek to the left all four lioness ears were forward again, and locked in on my position. Another wave of adrenalin coursed through me. At any point either one of the predators could simply do what they are hardwired to do.

Pounce. Pounce on me! I wanted to run. I wanted to scream. But I sat. I sat and I waited.

I could barely see through the gathering darkness. I strained my eyes. I watched. I watched for the slightest change in their behaviour. Suddenly they swung their heads around. They had seen something on the grassy plains behind them. *Oh God, I hope it's not the male coming for a drink.* There was no time to wait and see. I had to move while the cats were distracted. I did another bum-slide and was left with a ball of mud in my left hand. The two lionesses swung their heads back around in my direction. I closed my eyes. I squeezed the mud in my hand as if it was a type of stress ball. I winced in anticipation of an attack. The way in which both lionesses had swung their heads around so fast made me certain that a pounce was imminent. There was no flashing of my life before me. Just darkness as my eyelids slammed shut. The moment passed. *I am still alive!* Opening my tightly shut eyes, I hoped to wake up in bed having realised that the last hour was just a dream.

50

Terra firma

In the near darkness and battling to see, I waited for the slightest sign of distraction in the felines' posture, before performing another death-defying bum-slide. Every time I did one, I got the same alert reaction from the lionesses. Moving, even just slightly, was the emotional equivalent of hitting a nerve on a rotten tooth; I winced in agony every time I had to do it. With the firm fixed gaze of both lionesses on me, I waited an agonisingly long few minutes each time, until they showed even the slightest loss of interest again, before performing yet another bum-wriggle.

The lionesses were hardwired to turn their attention to behind them, onto the grass plains. Behind them was the direction from which any unsuspecting prey would appear and the direction from which other pride members would approach the waterhole. Luckily, they still didn't quite know what to make of me. Every time they turned to look behind, even if just for a moment, I slid my bum to the left. By God, I was going to wrench myself out of the waterhole, one bum-slide at a time!

I had two major problems though, the first being that it was dark and getting darker. The other was that as I inched my way towards the edge of the waterhole, the water was getting shallower. As a result, more of my body was becoming exposed and this did not go unnoticed by the predators, who were now watching my every move and with an interest that grew proportionally to the degree at which I was exposing more of myself. They had altogether lost interest in anything going on on the plains behind them.

I wriggled again and when I did, in the shallow water, one of my legs popped above the surface. It was a bad mistake to make but bum-wriggling out of a muddy waterhole was not a discipline I'd practised. The lionesses grew excited, their ears now flat on their heads, their tails twitching. Being overgrown pussycats at heart, they were now VERY interested in finding out just what kind of peculiar creature I in fact was. Would my flailing

mud-covered left leg make me look like an animal dying, perhaps, with rigor mortis setting in? That would be a familiar sight to the two felines. They were, after all, predators of the highest order. The last thing I wanted to do was appear like I was an animal in distress and dying – that would not be good. It would soon, in a matter of minutes, be pitch dark. I would be dinner. The time to make an exit was now or never.

The cats had completely forgotten about the thought of zebra steaks or of another lion approaching the waterhole. I had their utter undivided attention. I was their sole distraction, the object of their feline focus. With my twitching body so full of adrenalin, my limbs took on a life of their own, each shaking at its own unique frequency. It became pointless trying to retain any ascendance of composure and so, flopping over onto my belly, I adopted a new modus operandi to propel me. The water was only a few inches deep now and holding my camera above it in my right hand, I clawed at the muddy bottom with my left, pulling myself frantically towards the water's edge, my legs doing a sort of unsynchronised type of froggy kick.

There was no need to look back. I knew that the lionesses were watching me, excitedly. *If you feel claws on your back, throw your camera onto the shore,* I told myself. It was imperative that my photos survived, even if I did not. This way there would be evidence that I had found my Africa. Even if I lost my life in the process, I had found what I had been searching for, the lost Africa of my dreams, what I steadfastly still thought of as the 'real Africa'. If I died doing this, well, then I could not think of a better reason to die really. If my pictures survived, Claire, and my family back home, would know that I had found peace in my death. *Just throw it ashore, Greg!*

But I didn't want to die. I wanted to live! Clawing my way through the mud, with the two lionesses behind me I could not see if they were licking their lips, but I could certainly imagine it. Suddenly, I left my body again. Oh, so this is how it happens. I am on my way to heaven, I thought. I mean, how many out-of-body experiences can one person have in a day? But no, my ascendance stopped above the waterhole, where I hovered with arms outstretched and my legs spread-eagled, like Superman stuck to a flytrap and from where this tale about my life story began. Looking down, I saw myself leopard-crawling through the mud with two inquisitive lionesses watching in wonder.

How stupid I looked flailing in the mud like a catfish with limbs. Before I knew it my life was flashing before my eyes. I was seeing the very stories you have just read, but my viewing was in fast forward. There was no pause button and before I could even reach for the popcorn, my conscious state again merged with my body. *Whatever you do, don't run.* There was the mantra again. *Never, ever run, no matter what the circumstances.*

With my mind and my body joined again, I jumped up and I ran! These are damn well mitigating circumstances, I thought, as I took off away from the lionesses, mud and water flying everywhere. Finally I was out of the waterhole. Needing to know if I had two lionesses barrelling down on me, I turned to look over my shoulder. I saw both felines on their feet and, with eyes as big as saucers, I swear I heard one say to the other, 'Gee whiskers, that was a human being after all!'

The look of surprise on their faces was as priceless as it was comforting. Immediately all the tension left the scene. The two lionesses had very evidently not had a clue as to what type of creature I was and when I showed myself as being the bipedal opposing-thumbs kind, they had gotten the fright of their life. The expression of surprise and confusion on their faces was barely visible in the darkness but it is forever burned onto my mind.

Not stopping, I hurriedly walked through the bush below camp. How ironic it would have been if I had been taken out by a buffalo or a puff-adder on the way, but I couldn't even entertain that thought. I made it up the hill and back to camp in the dark. As I walked past the kitchen I bumped into Charlie Grieves-Cook, a chef doing some training with our cooks. Charlie was also an avid photographer. His horrified expression told me that I was quite the sight. Covered in mud and smelling like the fetid quagmire I had been sitting in for months, my camera and lens were also covered in mud – as happens when one leopard-crawls through a waterhole.

Charlie looked at me with a similar type of quizzical expression that the lionesses had as he asked, 'How was that, mate?'

'It was good, Charlie, it was good.'

That was all I said as I made my way up the stairs to our tent to shower and change before hosting guests for dinner. I only had time to give Claire a nod and a terse, 'I got the shot, love.'

In fact, I told no one else about this project for years and years. The reason for this is that it was a deeply personal one. I had undertaken to capture photographs of Livingstone lions for no one else but myself. I was lost in the twenty-first century; I knew that I would be lost my entire life if I did not find my Africa, the Africa I envisioned. My life was crippled by the feeling that I had been born too late to see and experience the Africa of my dreams; the Africa my heroes got to see and live. My life would always be stuck, like a computer hanging – an appropriate analogy from our modern era, I think. Searching for true wilderness and finding it in Kenya's south rift, and in my quest to bag a photograph of a Livingstone lion, I had scratched my primordial itch for WILD-er-ness.

Hosting our guests that night at dinner and asking them what they had seen on their safari drive, I felt different. It was as if I had passed through a personal rite of passage. Every safari author whoever wrote about their life in Africa wrote from a perspective of having drunk deep of the continent. Karen Blixen did it perhaps the best, or perhaps just the most poetically, and so did the Mirella Ricciardi in her *African Visions – The Diary of an African Photographer.* I, too, had drunk deep of Africa, in my own way.

I never ever dreamed of writing a book or that my photographs of lions would be displayed in the National Geographic storefront's window on Regent Street in London. I was just relieved. Relieved that I had found wild Africa. Relieved that it still existed. I was also very happy to be able to ask at dinner, 'Could you pass me the butter, please?' Just a couple of hours prior, I had almost *been* the butter. When I went to bed that night I was dizzy, probably due to the wave upon wave of adrenalin that had flowed through me in the waterhole. I only hoped that the film in the back of my Nikon F100 had captured the lioness portrait in the golden light, and had done her justice. I was also not too sure what I would get up and do the next day. Just then, I heard a lion's roar in the valley below. I found the sound deeply soothing.

51

Was my horizon straight?

The first thing I did the next day was take my precious film out of the back of my camera. I had never held an inanimate object more precious to me. Inside the tiny outer shell of the film's canister, barely bigger than an acorn, lay my wilderness dreams, still tightly wound and undeveloped. I hoped the small 35 mm canister contained the weighty evidence of me having found an Africa that I thought was lost forever. Having grown up in South Africa where almost all wildlife is fenced off and where free-ranging lions no longer exist, I could only have dreamed of the Africa I had found.

The single, cool to the touch, white and green film canister I held in my hand contained the only proof and evidence. Placing it in a tiny white plastic film container with a back lid, I wrote on the outside with a permanent marker: 'The One'. I then walked down the stairs to the gas fridge where I placed the canister carefully on a shelf inside. Staring at it as if it was the golden ring in *The Lord Of The Rings*, it certainly was 'my precious'!

I stood there, trying to replay what had happened the previous afternoon, my mind full of questions. Had I at all times pressed my shutter button halfway first, to make sure the lens focused correctly? Was there sky in my composition? How much sky was in my composition? Would the sky have altered my exposure? Was centre-weighted metering the way to go? Was underexposing by a third of a stop correct? Did any water seep into the back of my camera at any stage? Was my horizon straight? These questions had no clear answers and my brain, when it came to taking myself back to that afternoon, as if fatigued by the questions, was now foggy. Closing the fridge door, I was beside myself with anxiety.

I paced up and down in our small office. Claire didn't know what to do with me. I was in no state to work. Still covered in bites and still scratching, and peeing blood, it was more my emotional state of being that was the problem. If I had not metred the light correctly, or if I had not composed

or focused correctly, I would never forgive myself. Not being able to help Claire with the camp admin was no big deal, I was pretty useless at administration anyway. When we had worked at Mashatu in Botswana, although I was the operations manager, it had taken me three hours to arrange the day's activities and transfers. It took Claire just five minutes to rearrange the entire thing, and the day would flow beautifully. She is gifted when it comes to logistics and operations.

The one thing I was gifted at was bantering and talking nonsense with safari guests. While this might seem like a trivial thing, it is actually a very important aspect of managing a safari camp, and one which camp managers either find incredibly easy or incredibly difficult to do. Sending me out of the office, Claire told me to go host the safari guests. On my way down to the mess area I could not pass the gas fridge without opening the door and staring at my precious film. The same questions played over and over in my mind each time I stared at the canister in the fridge. James thought I had lost the plot as I had my head in the fridge for ages, muttering expletives to myself. Then again, when your manager spends more time sitting in a waterhole than he does in camp, he already knew that I had lost my marbles – a long time ago! But, in true Swahili style, he remained ever polite and respectful. The Swahili really are the nicest people I know.

With my mind so preoccupied and my body so itchy, I was not the best host either and after a short while trying to be convivial with our guests I decided to go back up to the office. On the way there I swung by the charcoal storeroom again and with my head in the fridge, again, I tried my best to recall my actions performed behind the camera. I had been shooting for long enough to develop significant muscle memory, which meant that lots of my composing and focusing had been done subconsciously, kind of like when you are driving a car and you suddenly realise that you cannot remember the route you drove but you got there anyway. But what if, due to the excessive fear and adrenalin, I had not handled my camera properly? These were the days before Photoshop; you had to get it right in camera. *Getting It Right in Camera*, incidentally, is the title of a book I would publish many years later.

I was about to close the fridge door when I noticed tiny droplets of water on the outside of the plastic container. Because the ambient temperature

was so high, every time I opened the fridge, hot air rushed in and this time it had condensed on the cool plastic. If the moisture inside the canister had done the same, my precious film would also have tiny water droplets on it. It would be ruined. Shutting the door hurriedly, I put my head in my hands and started muttering, 'No, no, no, no!' James stood in the corner of the storeroom staring. He was literally scared of me, like I was mentally unstable or something. In effect I was. If I had just ruined my film, I had lost 15 months of work and a lifelong dream had gone up in smoke.

I went up the stairs and into the little office, mumbling and muttering, directing some of the choicer Afrikaans swear words I had in my vocabulary at myself. Claire walked right up to me, took me by the shoulders and, turning me around to face the door, said, 'Go back to your waterhole.'

'But ... but ...' I tried to protest.

'No buts. Just go,' she said. 'GO!' And with that she shooed me out of the office.

And so, in a really strange turn of events, my wife sent me back down to the waterhole. She could see that I was not coping very well on terra firma where, trying to be a safari camp manager again, I simply could not take my mind off what the little film canister contained, or did not contain.

After my harrowing experience with the two lionesses, there was no way on God's green earth that I was going back *into* the water. Until yesterday I had only thought about getting photos of Livingstone lions drinking – giving no thought whatsoever to anything beyond that point. Now, with the wisdom of hindsight, I knew that once the lions were drinking, I was only halfway to achieving my ultimate genetically intrinsic goal of surviving. After the lions drink, they must leave. I was not going to risk them not leaving, again.

I set about getting my original underground hide cleaned out and operational. Soon I was back on my bench in my bunker, with a new roll of film loaded into the back of my camera and waiting again for the lions. The rains had not yet broken. It was still hot. The familiar sounds of the waterhole were like a soothing balm; bee-eaters twittering and the cooing of doves helped to soothe my anxious soul. The kicking, biting, farting and squealing sounds of a dazzle of zebra coming down to drink were the sounds I had grown to love. Zebra actually fart an inordinate amount and

it's due to a special kind of bacteria that live in their hindgut, which helps them to digest grass – they do not ruminate like antelope. The byproduct of this symbiotic relationship is a lot of gas, which bursts forth audibly.

While my geese had chased their young off to go and find a waterhole of their own, the parents were still there, standing on the edge, as always. They continued to defend their territory from invaders, hissing and honking in outrage, and making the waterhole look as uninviting as possible. At times the waterhole was deathly silent in the oppressive heat. Knowing that the lionesses were around made the silence somehow extra portentous. Although I hoped I had bagged a photograph of them drinking, until that film was developed, there was no way of telling for sure that I had. I hoped that I could have a second chance. But second chances don't come often for a wildlife photographer.

52

The end of the game

A week had passed since I had photographed the two lionesses and again I was watching the waterhole, praying and waiting for them to return. Not being inside the water meant that I would hopefully be less nervous and therefore able to photograph with more thoughtful consideration. Although, it must be said that sitting in a small hole in the ground, surrounded by a 60 cm (24 inch) high gap between the roof and the ground, was not exactly overly reassuring, especially after that incident when the lions had thought I was a warthog in its burrow and another had chased Andrew. But anything was better than sitting in the water again.

It was late on the Saturday afternoon when I noticed something small moving behind a thorn bush to my right, on the far side of the waterhole. At least I thought I had seen something. I wasn't sure. Perhaps it was a mongoose or a francolin? But no, lo and behold, a tiny head poked around the corner of the bush. If I hadn't been sitting inside a hole, I might have fallen off my chair. It was a lion cub! Scarcely able to believe my eyes, another head appeared, and then another, and another, and another, and another, and another. Seven tiny lion cubs stared at me from across the water.

But where was their mother? Or rather, their mothers? Lionesses tend to only have two or three cubs per litter. The tiny cubs loped clumsily along the edge of the water on stocky legs, their feet seemingly a size too big, especially their front ones. Their inquisitive hazel-coloured eyes had a twinkle in them, but it was their long-large hairy-tufted ears that tipped the cute scale to adorable level. They were thirsty and soon all seven were lined up drinking. I picked up my camera and zoomed in, working my way down the line of cubs, searching for a composition. It was while I was doing this that I had to do a sudden double-take: I had passed over two giant paws in my frame. Swallowing hard, I pulled my shooting eye away

from the viewfinder. To the left of the seven cubs, standing at the water's edge, was a lioness. She was watching me. Graceful, elegant, beautiful and frightening. Tawny, white, long, sleek. She stood, neatly and composed, her front feet close together. Assured and confident, she was the feline equivalent of both ballerina and assassin.

With her eyes still fixed on me, she crouched alongside the seven cubs as they drank. There was nowhere to hide from her gaze. She was a protective mother and like all mothers, humans included, I knew that this was way more serious than our previous encounter. The stakes were higher. This was not a game of 'guess the animal in the water'. It was not a game at all. It was a mother that would do anything to protect her cubs. Looking away briefly, sinking lower and swallowing harder on the lump in my throat, I could not escape this mother's steady stare. Ask any safari guide and they will tell you that a lioness defending her cubs is one of the most dangerous animals in Africa.

A second lioness appeared behind the cubs. She seemed more anxious than the first. Standing off to the side, she stared at me nervously. There were two litters of cubs, now two mothers. One had three cubs and the other four, the slight size difference being the only indication of this. There was no doubt about it: these were the same two lionesses that had lapped in front of me just a week ago. That time they had left their cubs behind, hidden away somewhere. Although both lionesses had drunk right in front of me, they were crouched forward and facing me head-on, so I had not been able to see if their teats were swollen.

Now the cubs seemed to have insisted on joining their mums for a drink and had even come down to the waterhole ahead of them. Sitting in my hole, I felt that now familiar wave of adrenalin come over me once more. Soon enough, the questions came. Do these lionesses know me? Are they happy for me to be this close to their cubs? Can I move slightly, to better compose and photograph? These were just a few of the questions racing through my mind.

Lifting my camera slowly, I framed the seven tiny cubs in my viewfinder. The mother that had arrived first was on the left, crouched on her haunches alongside the cubs. She was not drinking. She was watching me. She and all seven cubs fitted nicely into my frame. The second lioness was out of frame, to the right. As the cubs lapped water, the lioness on the left stared

straight at me, not even blinking. She was the image of composure. It was as if she was saying to me, 'You just stay in your hole, boy, and we will all be okay.' I sensed her calm. I sensed her power. I sensed her control.

The shot in my viewfinder was like something straight out of a coffee-table book. I had the lioness and seven cubs in a straight line on the water's edge; the blue African sky and white puffy clouds made a perfect backdrop. How many times had I sat and stared at the meaningless clouds? Now, finally, they were doing something useful by being a fitting background to a scene that was wholly African. It looked like a movie set. Except it was the furthest thing from a movie. These were free-ranging Livingstone lions, eight in a row to be exact.

I was not in the Masai Mara or the Kruger, I was in the south rift of Kenya, miles from any tourist mecca. I could hardly believe my eyes. With the cubs lapping water endlessly, their heads down to do so, it was hard to choose the right moment to trip my shutter button. Just then, two of the cubs looked up and to their left. Still to this day I have no idea why they stopped drinking and what they were looking at. Maybe at their mother or perhaps my geese?

Whatever the reason, as soon as those cubs lifted their heads and turned them sideways, I saw my frame. Two cubs with heads up, the full-grown lioness staring straight at me, the cub next to her looking straight down my lens barrel and another four cubs drinking unperturbed. The light bright but golden. I knew that this was 'the shot'. This was the clincher. There was something dynamic about the scene. Wildlife photographers all around Africa dream of such moments. Moments where our subjects, backgrounds, behaviour, light and a shooting angle all align, in perfect unity – if only for a split second. All we require, all we search for, are these split seconds of perfection.

Racking my lens to an aperture of F16 to accommodate the incredible scene before me and making sure that this time I gently focused, the next thing I heard was a loud CLUNK! The shutter curtains of my Nikon F100 opened and in the blink of an eye, travelling at the speed of light, the lioness and seven cubs travelled towards me, through the air, over the small waterhole in a dusty corner of Africa, down my lens and into my camera. Burned into the film forever, the shutter curtains then closed again and the film advanced to the next frame. My camera became like Aladdin's

lamp, containing my wilderness dreams, to be extracted and printed at a later stage. The lioness and seven cubs were frozen for the time being, locked away in a photograph – a time-stopping miracle.

I had just taken the photograph that would define my professional photography career. It would become the cover photo of my coffee-table book, appropriately titled *AWE*. My life would never be the same again. My soul had been exposed to wild Africa and I, through the gift of photography, had exposed this wild Africa. I watched the cubs finish drinking and their mothers lead them away, back into the tall elephant grass behind the waterhole. As soon as they had appeared, they had disappeared. I just sat there. Ecstatic, overwhelmed, shocked.

I had been far calmer than when I was actually sitting in the water and so I knew that I had taken a decent exposure; I had focused and composed correctly. I knew that it was the end of the game. It was over. Although my entire physical body itched, I had scratched the internal itch, the burden that I had been carrying since I was 16 years old. I had found true wilderness. A weight fell off of my shoulders as I sat there, letting the moments and the reality of the past 15 months and one week sink in.

Walking back up the hill, I was no longer afraid of the lionesses. I felt like they knew who I was, and that I knew them. They were the last of a rare breed of lion, ones living beyond formal park and reserve boundaries, like all lions once did. Little did I know it then but I, too, was the last of a rare breed of photographers. Sitting behind my camera I had used light and patience to tell my story. In years to come, technology would take wildlife photography to a different place altogether. Photographers would not need to sit and wait to get shots of rare subjects; they would use camera traps with infrared beams instead. To get the low angle shots that I did, remote controlled cars would be driven up to animals, and underground hides, with air-conditioners and one-way glass to shoot through (something utterly unimaginable to me at the time), would become commonplace. Photoshop would replace patience. Digital would replace ink. Photography would become instant. Viewed mostly as small squares on mobile phones, photographs in the future would offer little context, here one second and gone the next. Would wildlife photography in the twenty-first century lose its wild soul?

53

Fires and warriors

It was that time of year again. The Maasai were burning their land to increase the grazing yield for their cattle. Standing on the edge of the rift valley at night, we saw the fires blazing across the valley floor and during the day bits of burned grass floated down from the heavens like black snow. Not that I or Claire knew what snow looked like – neither of us had ever seen snow. We were living in another world, a fiery one with black ash raining down from the heavens. Not feeling that desperate need to keep shooting at my waterhole, there were a few other things I wanted to photograph in Maasai-land. One of them was definitely a big fire!

Driving down the hill and into the rift valley was always a great feeling, one of total freedom. I didn't know where exactly I was going, I was just following the smoke ... you know how the saying goes. The drive took me through a tiny Maasai settlement, just a few kilometres down the road and then on towards Mount Shompole. I could not help but remember how Inno had taken the marathon runner from Philadelphia for a little 'training run' to the mountain and back. With the window down, the hot air gusted in, carrying with it the now distinct scent of the south rift. The dust eventually gave way to dry mud, which cracked under the wheels as I neared the base of the mountain.

To my right I saw a large cloud of smoke so I swung the truck in that direction and soon I was barrelling over tufts of coarse grass, heading back towards the escarpment. The rift wall looked immense and with the afternoon sun in the west, it was in deep shade, giving it a sinister yet soothing dark blue tone. A herd of dust-sprinkled wildebeest scattered in front of me. The closer I got to the smoke, the more the sun became obscured and diffused, adding an otherworldly yellow glow to the scene. Soon I was inside the smoke. Switching off the engine, I jumped out with my camera. I'd only just cleaned all the mud off it, now I was walking into a fire!

Through the smoke I saw the wide silhouetted horns of Maasai cows, grazing peacefully, not in the least bit perturbed by the fire or smoke. Fire was just a part of life in this corner of Maasai-land, the cows were used to it. The jingle of their bells, the yellow diffused light, the pale white and brown splotchy colour of their hides, their long horns, the smell of smoke and the crackling of the fire all combined to create a scene that felt ageless. Following the herd and emerging from the smoke, with smooth silver silent spears, were the warriors – lean and wiry men. Sometimes photographers see scenes that are forever burned into their memory; not all photographs are taken with a camera. This was one such time.

This was Africa. Raw, wild, rugged. An enchanting place of timeless coexistence. Wildlife and cattle grazed across the veld and through the smoke – the watchful eye of warriors with long glistening spears never far away. Livingstone lions roared, roamed and stalked in the dark African night. This was a primordial Africa, one so wild and ageless that I knew no camera, including mine, could ever do it justice. The scene before me was simply too immense to photograph. I tried anyway and then gave the warriors some water to drink. That was all they wanted and that was all they needed. Their cows were everything to them – they lived off the land as self-sufficient pastoralists. With the sun now set and the fires having died down, a cool blue smokey calm settled across the valley. I drove back to camp, making it back just in time for pre-dinner drinks.

New guests had arrived. One of them had just come from southern and western Tanzania, where he had completed a wild safari. I was intrigued. I knew little about Tanzania and as the man spoke, he mentioned wild-life parks like Selous, Ruaha, Mahale and Katavi. These were some of the wildest parks left in Africa and I felt a tingling in my feet. It was the same feeling I'd got when I'd heard about the safari camp manager job 'somewhere in Kenya'. It was the feeling of needing to explore a new off-the-beaten-track destination.

Like the title of my favourite Johnny Clegg song, 'I Call Your Name', wild Africa was again calling my name. It was during this conversation about the wildest parks in Tanzania that the seeds were sown in my heart to go and explore, and photograph, down there.

The next morning I sat outside our tent. Facing south towards Lake

Natron, I could just make out Ol Doinyo Lengai and for the first time I wondered what was beyond it. Where were Katavi, Ruaha, Mahale and Selous? What was it like there? What if it was wilder? Could it be wilder?

There was only one way to find out and that was to go there. Using the rudimentary bushmail system, I contacted a company called The Selous Safari Company and offered Claire and my services to run their remotest camp. It was in fact the remotest camp in East Africa. Just like that, a new adventure beckoned and Claire and I handed in our resignation at Shompole. It did not matter that we had never been to Tanzania before. All that mattered was what lay beyond the horizon.

We had one more month in Maasai-land. There was a long list of activities happening at the camp, including a 40th birthday party for Simon's girlfriend. After working out our month's notice, we would return to South Africa to get my film developed and to wait for the safari season in Tanzania to begin. As I have mentioned before, the Swahili word for a white person is mzungu, which means 'to spin', 'roam around' or 'walk in a circle'. Safari camp managers and safari guides across Africa 'spin in circles' as we try to scratch the perpetual itch of exploration and discovery. There were many reasons for our ancestors leaving the lands of their birth and coming to Africa, but perhaps one of them – and I believed this deep in my being – had been the thrill of exploring territory unknown to them. This gene obviously still lingers.

My time in the waterhole had taken its toll on me. Besides the already mentioned ailments of a worm living inside my foot and maggots hatching out of my back, when you throw in a couple of bouts of malaria and a rampant rash that moved around my torso like an angry living entity, I had to come to the conclusion that the human body was not designed to sit in a stagnant pool of water in the tropics. I was still peeing blood, a sure sign of bilharzia, the flukes of which were now clinging to the walls of my bladder. On top of all this, I had a very full feeling, constantly. It felt like my insides were riding up my gullet. This was due to the high internal parasite load I was carrying, something which blood tests would later confirm. I needed to get my health seen to but – far more importantly – I needed to get my film developed. This loomed like some huge occasion in the future, like a wedding, a graduation, or perhaps a funeral. Would

it be a celebration or a disaster? I would only know once I saw the film.

The old questions came back to haunt me and played over and over on my mind like mental whooping cough. Had I focused and exposed correctly? Were my shaking hands negated by the vibration reduction technology? Would the lab even develop it correctly and remember that I had pushed it a stop? Not being able to sleep one night and contemplating all this while sitting on my Maasai stool outside our water tank tent, I looked up at the new moon, which, as Karen Blixen so eloquently described, and accurately so, was lying on her back.

Soon it was our last week in Maasai-land and I got a message from the local group of Maasai morani to say that they wanted me to photograph them before I left. It was a strange request as warriors are generally tough and aloof. Perhaps they had heard about my exploits with lion and deemed me suitably qualified to photograph them. They had obviously heard via bush telegraph that we were leaving. I felt honoured by the request. It was a photographer's dream come true to be invited to photograph a regiment of warriors.

I had been following various famous National Geographic photographers' work for a long time, like Michael 'Nick' Nichols, where shooting lowlight scenes with rear-curtain flash was very much their style. I decided that I wanted to shoot the warriors using this technique – to convey a sense of mood and mystery. In years to come I would employ this style of rear-curtain motion-blur on wildlife, and at a waterhole in Botswana I would take a photo that would see me achieve the highest accolade in world wildlife photography, when the BBC named me their Wildlife Photographer of the Year. Nick Nichols would win it the year after me.

I arranged to meet the warriors at around sunset time on a grassy knoll situated close to the wall of the rift valley. Not only would the escarpment make a suitable backdrop, but being so high, I could shoot from a low angle and still have a black background. I was so excited for the shoot. I was going to photograph a group of genuine authentic Maasai warriors! There would be no tourists, just me. Perhaps the Maasai warriors thought

that if I was brave enough to photograph Livingstone lions, I was brave enough to photograph them. Whatever the reason, it was an opportunity of a lifetime and a great privilege.

Throughout the afternoon, I watched the clock until finally I decided it was time to leave. I drove down the hill, along the road that led to the village, and turned right and up a steep gravel-clad koppie where all the umbrella acacia trees had neat little woven balls dangling from them. These were the handiwork of the tiny grey-capped social weavers. These swinging abodes added a poetic nuance to the trees and landscape.

My mind got to wandering along a theme – the African bush being a peculiar place. If you break it down, into its individual components, it is quite messy. There are lots of straggly bits and pieces, mainly bushes and dead grasses, with the odd untidy tree and a few random mounds of dirt that are the work of termites. Yet all these elements combine to form visual poetry. This 'Africa poem' is only complete when read as a whole. Each individual line, if read on its own, seems out of place. Africa is very much the sum of its parts. My rambling thoughts took me to some of Africa's iconic animals. Taken in isolation, individually they are very peculiar. A zebra, for example, is a most bizarre creature. Animals are all about colour and camouflage in Africa, everything is made to blend in. The kudu has white lines on its flanks to blend in with the sticks. A leopard has rosettes to blend into the dappled forest light. A lion is the colour of the tawny grass and so on. Almost every creature is made to be camouflaged. Then you have the zebra, bright black and white, and most decidedly not blending in. What about an ostrich? A bird taller than a horse and with an eye bigger than its brain. It has feathers, yet cannot fly. And the elephant, with its upper lip and nose fused into a trunk that is actually a limb, and the only boneless limb in the animal kingdom. Its ears are ridiculously big and its front teeth grow out of its head! How about the giraffe – could an animal be more ungainly by design? Its neck is so ridiculously long that not only would one expect the animal to topple over, but we are missing half a dozen or so 'missing links' between it and the animal with the next longest neck, which, incidentally is the okapi – a cross between a zebra and a giraffe. Don't even get me started on the warthog, a creature so ugly that it is beautiful. The wildebeest, you ask? The wildebeest is just plain ugly!

As if the residents of the bush are not peculiar enough, we have the sounds too. Some birds in Africa have the most outrageous sounds. Outrageously bad! Like the call of the go-away bird or the hadeda ibis (which we call Johannesburg fish eagles). What about the shriek call of a spurfowl, which sounds like it is being strangled every time it yelps out. When the leopard coughs it sounds like it is choking on an impala hoof. The cheetah chirps like a bird and rutting impala sound more like a lion than a lion does! Kudu bark, baby rhinos squeal, hyenas whoop – I mean, really!

Yet when you take all this individual bizarreness and you congeal it into one ecosystem, what you have is a picture of perfection, a symphony of the highest order. The shriek call of the spurfowl becomes the soprano in the dawn chorus. The hornbill clucking in the midday heat is a percussionist. That random scraggly little bush – a perfectly placed prop on the stage. The lone tree is a sentinel of stature and elegance and the leaning termite mound a work of macro art by a micro creature. The ungainly giraffe out on the savannah is a vision of stately nobility. Migrating wildebeest pure poetry in motion. A dazzle of zebra, strangely, are in fact very camouflaged. Warthogs run with tails high, making us smile every time. Elephants use their strange long noses with a dexterity that simply bewilders. The ostrich might not fly but boy, can it run. The cooing ring-necked dove keeps time and rhythm by day, the crickets and scops owls by night. All these elements, like bits of odd-shaped, different-coloured crystallised fruit suspended in the same bar of gooey nougat create a place so wonderful that it makes one feel the same way Karen Blixen did when she wrote, 'Here I am, where I ought to be.'

Driving through the bush, contemplating how all this randomness combines to form a perfect Pierneef, I continued up and onto the grassy knoll. There they were, no fewer than eight Maasai morani in full warrior regalia. They were standing chatting to each other like any group of young men would. Some were leaning on sticks or spears and each had one foot crossed over the other. Simply just standing, they looked like they belonged. They were where they ought to be. They were a part of the environment; a stanza in Africa's poem. Even though my family has been in Africa for over 300 years now, I cannot stand like they were standing. I cannot stand in such a way that I belong to the environment or, better

still, add to its beauty. If I want to blend in, I need to sit in a waterhole.

The Maasai warriors blended in naturally and effortlessly. I was in awe of my photographic subjects. When I climbed out of the car they had already begun their rhythmic chanting. The warriors were in the mood to put on a show and the energy was palpable. Frantically I fumbled for my camera and flash. While I tried to get the balance of my camera's exposure settings and the light emitted from my flash to complement one another, the warriors continued their hypnotic chanting; their voices in harmony and their bodies rising and falling in synchronicity. Their rhythmic song was ancient, eerie, and primal. It pulled at the same part of my being that a lion's roar does.

The light was sublime, turning yellow, then orange, then red, then blue. The deep dark shadow of the wall was a perfect backdrop. Finally it got too much for one warrior who let out a loud shriek and leapt into the air as if his legs had been coiled springs the whole time. The warriors began to really sing now! They sang of past war victories. They were preparing for battle. There was no one else around, not even any other Maasai. Moving up and down the line of warriors, I photographed from a low angle, up close and with a wide-angle lens. I was at the coalface of warrior-hood. My heartbeat quickened and so did the frame rate of my camera. Each warrior took turns yelling, leaping forward into the African sky blue. Sticks waved and spears glistened. One warrior leapt so high into the air he leapt right over me! It was wild, crazy – incredible. Working themselves into a frenzy, the warriors seemed to have forgotten that I was there. By the time it was nearly dark, bursts from my flash in the twilight added to the tension and the excitement.

The Maasai were once such a feared tribe that slave traders avoided their area altogether. Other tribes feared them, too, as their territory expanded across most of East Africa. Listening to the blood-curdling yells, seeing for myself the jumps, long spears, body scars, colobus skins and feathers, I could well believe that slave traders avoided Maasai-land.

With all my rolls of film spent (eight in total), I stood back and let the warriors finish their dance. When they were done, each came and shook my hand before disappearing into the night without so much as a glance behind them.

There was something ancient, regal, primordial and epic about what I had just witnessed and experienced. The warriors possessed a spirit of strength and self-assurance that was hard to put into words, but exquisitely expressed through their song and dance. It said simply: 'I belong here.'

It was not lost on me that the winds of change were already blowing, even in Maasai culture, and the experience I had just had I would one day write about. Driving back to the camp, it was again as if I was dreaming. Africa is that kind of place. You can be awake and dreaming, both at the same time.

On our last day in Kenya, our general manager, Anita, had come down and was frantically trying to make sure everything was in place for a handover when a wave of Maasai ladies arrived at the office. They took Claire by the arm and led her outside, where they showered her with gifts in the form of beads. They then sobbed, uncontrollably. It took us all by surprise and I think most of all Anita. It was a wonderful testament to Claire's soft-hearted and kind nature. As her husband, I was immensely proud of her. Anita then gave us a lovely 'last supper' and a gift, a wire rhino artwork made from recovered snares found in Tsavo. It lives on a windowsill in our Johannesburg home to this day.

My last night in Maasai-land was a difficult one and I hardly slept. The thing that was keeping me awake was no longer the lion's roar in the valley below but rather the airport scanner at Jomo Kenyatta International Airport. In a series of plastic bags, now smelling pretty rancid from being stored for well over a year in the same fridge where we kept our dairy, meat and vegetables, I had more than a hundred film canisters, which I needed to get back to South Africa. The catch was that I could not get the film scanned. This risked ruining it completely. What this meant in reality was that the success of my entire 15-month photographic project at the waterhole would hinge on the whims of the security official manning the scanner. I woke up that morning in a cold sweat, which might have been the bilharzia, or malaria again, or just my shattered nerves.

54

My Africa

Before I knew it, we had cleared customs and our bags were on their way to the plane to be stowed. My precious film canisters, however, were in my hand luggage. Walking towards the scanner, I whispered to Claire that if they wanted to scan the film, I would simply refuse and live at the airport. It would be very tricky to refuse though because I was already stamped out of Kenya and my other bags already checked in.

Standing in the line at security, tapping one foot nervously, I broke out in a sweat. There would be no time to explain to the officials how long it had taken me to get the photographs on the films contained in the clear, now disgustingly old and smelly (despite having wiped them down) ziplock bags. By the time we got to the front of the line, not only were my palms sweaty but the soles of my feet were too.

After placing our belongings in a tray, I raised the plastic bags of film canisters and motioned to pass them over the top of the scanner. The security official motioned for them to be placed through the scanner.

'Um, sir, this is professional slide film … very sensitive,' I said.

'No, my friend, don't worry. Our scanner is very good,' came the earth-shattering response from the airport official.

My world froze. The scanner could cause my film to 'fog', an irreversible and unfixable problem. Thinking on my feet, I blurted out, 'No, but this film is extra sensitive with a very high ISO. It is the latest modern film and very, very, VERY sensitive to X-ray. Please, sir, can we not scan it?'

It might have been the quiver in my voice or the tear in my eye, or my Oliver Twist-esque tone, but whatever it was, the security guy motioned for me to pass him the film. He opened each bag. I had already removed each roll of film from its plastic container to add as much transparency as possible. After shrugging his shoulders he handed the film back to me once I was through the body scanner. I had the same sensation as when the

two lionesses drinking had decided not to eat me – a feeling of utter relief!

We were on the plane, me with my film on my lap. The next hurdle would be getting it developed.

To be back in South Africa was simply wonderful. Falling asleep that night in my parents' house in Pretoria, I pondered the miracle of modern travel. Just that morning we had woken up in the remotest corner of Maasai-land, where goat bells jingled and lions roared. Now, a mere 16 hours later, I was in a big city where the night sounds consisted of dogs barking and police sirens.

The next day I was out of bed early. I sat in the kitchen with a cup of coffee watching the clock. Prolab opened at 7.30 am but by 7 am I was already sitting in their doorway. This was the same doorway in which I had paused before leaving to go to Kenya, when I had looked down at the two brown bags in my hands containing nothing but film and filters. I had sold my car to afford to buy the film. Now I was back, with the same films, only now to be developed. In the interim I had been on a journey of discovery and had undergone a personal rite of passage.

Unlike the Maasai, who have a definite initiation as they progress from boyhood to adulthood, through a series of ceremonies and one that includes becoming a warrior by being circumcised without so much as flinching, in my culture there was no such tradition. Sitting in the doorway I had the realisation, for the very first time, that the waterhole and my pursuit of Livingstone lions was akin to my photographic initiation. But only if my films contained what I hoped they did. The thought of them perhaps not caused me to wince. I was emotional, tired, shaky and feeling very ill.

By the time the doors opened I was beside myself with anxiety. When I handed the canisters to the person behind the counter (a new face, someone I didn't recognise) I said: 'Please be VERY careful with the film.' The sweet young lady replied, 'Yes, sir, we are careful with all our customers' film.' If she was trying to reassure me, she had just failed, miserably. Picking one of

the film canisters up off the glass counter, I held it up, prepared to give her a full breakdown of the 15 months. I stopped, realising there was no way I could ever get her to understand. So instead, I told her to write, 'DEVELOP ONLY' on the package. I did not want anyone splicing my precious film.

It was bad enough that the film would need to be treated with chemicals to bring it to life but if something went wrong, I risked losing everything – my sanity too.

Walking out the doorway and saying a prayer, my next stop was the doctor. I had been going to the same family GP for years and it felt very reassuring to be sitting in his office. For the past few months, from a health point of view I had been flying by the seat of my pants. I had treated myself for malaria twice and I knew I had bilharzia. I decided not to tell him about my waterhole project, for fear of a severe scolding, but he sent me for a series of blood tests.

Sitting in front of the TV that night, I could not concentrate on what we were watching, nor could I participate in any meaningful conversation. My film was being soaked in chemicals. That was all I could think about. I was to pick it up the next morning. As the sound of the TV turned into background noise, I thought about how all those years ago in the same city as I was now sitting, a pivotal event had given impetus to the life I was now leading. My mind roamed back to Dr Ian Player and the talk he had given at Boys High's wildlife society about his life in the wilderness. How he had returned from the war and had found healing and restoration in the wilds of Zululand. I had wanted to live a life like his, one filled with danger and adventure. I wanted to find my own piece of wilderness. Ever since that day I had been wilderness dreaming. I had gone in search of my Africa and I had found it in the south of Kenya's Great Rift Valley. I had thrown everything I had into seeking out my lost Africa and as proof that I had indeed found it, I had photographed lions that roamed freely beyond park and reserve boundaries. Lions like these, the ones I had dubbed Livingstone lions, represented the wildest parts of Africa.

Just then the phone rang. It was the doc.

'Greg, your blood tests are back and they are alarming to say the least. Have you been in any foreign bodies of water of late?'

'Um, yes, doctor, I might have been,' I mumbled.

My blood tests indicated that I was carrying an unusually high parasite load. I was placed on a course of pesticides to rid me of my internal parasites, as well as a single dose of nine tablets for bilharzia, each one the size of a bullet.

Driving back from the photo lab the following morning with the film now in a stack of white envelopes next to me, I pitied the poor criminal who might attempt to hijack the car. He would have a fight on his hands second to none as there was absolutely no bloody way I would get out of the car and leave my film behind. He would just have to shoot me. The film not only contained my hopes and dreams; it was also my validation and the foundation on which I would build a photographic career. This film was an accurate culmination of my life so far; it had almost cost me my life to get. The envelopes next to me contained the dreams of a boy who grew up in suburbia and became a man in the wilderness.

Back at my parents' house I had already prepared the lightbox and the magnifying glass, called a loupe, on the dining room table. Everything had been cleaned of dust and was ready for me. Once I placed the film on top of the lightbox it would be lit from behind so I could examine it through the loupe. This would be the ultimate test of quality, exposure and sharpness. I had absolutely no idea what to expect. Back in film days there were no screens on the back of cameras and no live view so you could get it all horribly wrong and quite easily in fact. Film could come back completely black, or white, for that matter. To make things worse, I was completely self-taught. Before switching the lightbox on, I walked out of the room and placed my hands behind my head. I took a few deep breaths. This was the moment of truth. My day of reckoning had arrived.

I pulled back the chair, sat down in front of the lightbox and removed the first sheet of film from one of the white envelopes. Then, removing each strip from its plastic sleeve, I placed it on top of the box. Too scared to look down, with great trepidation I picked up the loupe. My hands were

shaking. Placing the magnifying glass squarely over a single frame, I lowered my head and peered through with one eye.

The next six hours were a blur. Time completely disappeared. My loupe became a window into another world as I discovered that the camera truly is capable of remembering the minutest nuanced moments, long after the eye and mind have forgotten them. There, inside my magnifying glass I saw a tiny, beautiful sunbird drinking from the water's edge, a picture I did not even recall taking. Of course I saw the photos that I remembered taking too, like the zebra stallion suspended in a cloud of dust. Then there was Lake Natron, rendered serene and blue on the Fuji Velvia 50 film emulsion. The Maasai warriors appeared before me like ghosts dancing in the twilight. My two Egyptian geese, my friends, standing proudly on the water's edge. The lioness portrait – perfectly framed and tack sharp, her piercing eyes glaring back at me. I was captivated. I could see every hair and eyelash. The kori bustard, the bird that changed my life when it decided to come down for a drink, its cocked head and sparkling eye staring back at me. The waterbuck bull standing above me, a blue sky and white puffy clouds behind. The lioness and seven cubs, so close it felt like I could reach out and touch them. A zebra standing in the midst of a massive approaching dust storm. The Maasai herdsmen surrounded by cows, smoke and flames. One frame full of doves drinking, another full of zebra. It seemed almost miraculous how every moment I had witnessed had been seemingly transported into my parents' dining room.

Contained in each frame, as if by some miracle, were my childhood dreams. The slides told the story of my life. They told the story of an Africa as wild and as free as Livingstone must have known it. The photos I had obtained of my lions would forever be a reminder of my very personal journey to find 'my Africa'. Leaning back in the chair, my brain frazzled from hours of intense staring through one eye, I felt a wave of peace and of tiredness sweep over me.

My journey had ended. My journey had begun ...

Acknowledgements

I would like to thank my mother for distilling in me her spirit of fun and her fascination for wild creatures and of course for purchasing me my very first car, the infamous yellow Beetle. To my late dad, for pushing me when I needed it most and dropping me off in the Timbavati. To my brother Clive for his companionship in my earliest bush forays. To Mike and Michelle Esterhuysen for many great bush breaks at Olifants. To Bill 'The Boss' Schroder and the school on the hill for some of my best years. To Duncan MacFadyen for arranging so many incredible guest speakers to the wildlife society. To Mike Buchel for giving a young apprentice a chance. To the late Eldred 'Happy' Hapelt for showing me what a respect and appreciation for all wild creatures looks like. To Jim and Elsie for entrusting your daughter to me. To James Alexander for teaching me about straight horizons! To all the camp colleagues and safari guides I have worked with and the safari guests I have hosted, you have made my life colourful. Last but not least, to my beautiful wife Claire for following me into the remotest corners of Africa and patiently letting me work out my destiny (and while doing all the administration). To God my Father for a life lived in Africa's wild places, I could ask for no more. To the wild creatures of Africa and my Livingstone lions, long may your thunderous roars resonate. Nkosi sikelel' iAfrika!

See **www.gregdutoit.com** and **www.GDTprints.com** for more.